Publication of this book has been aided by a
grant from the Millard Meiss Publication Fund
of the College Art Association of America.

MM

Pop
L.A.

Art and the City in the 1960s

Cécile Whiting

University of California Press / Berkeley Los Angeles London

Pop
L.A.

University of California Press, one of the most
distinguished university presses in the United States,
enriches lives around the world by advancing scholar-
ship in the humanities, social sciences, and natural
sciences. Its activities are supported by the UC Press
Foundation and by philanthropic contributions from
individuals and institutions. For more information,
visit www.ucpress.edu.

Figures 36, 10, 41, 47, 51, and 68 are reproduced as details,
with permission where required, on pages ii, 20, 62, 108,
141, and 168.

University of California Press
Berkeley and Los Angeles, California

University of California Press, Ltd.
London, England

© 2006 by The Regents of the University of California

Library of Congress Cataloging-in-Publication Data

Whiting, Cécile, 1958–.
 Pop L.A. : art and the city in the 1960s / Cécile Whiting.
 p. cm.
 Includes bibliographical references and index.
 ISBN 0-520-24460-5 (cloth)
 1. Pop art—California—Los Angeles. 2. Arts, American—
 California—Los Angeles—20th century. 3. Los Angeles (Calif.)—
 Intellectual life—20th century. I. Title: Pop LA. II. Title.

NX511.L67 W55 2006
709.794'9409046—dc22 2005055910

Manufactured in Canada
15 14 13 12 11 10 09 08 07 06
10 9 8 7 6 5 4 3 2 1

The paper used in this publication meets the minimum requirements
of ANSI/NISO Z39.48–1992 (R 1997) (*Permanence of Paper*).

what a city is/
a coming together, a
meeting
or market, a
proximity
what a city is/
a dream, a
container of
dreams, a
structure
what a city is/
a scene, a place
a place to
blow, to die, a
limit &
a tool

Stuart Z. Perkoff
The Venice Poems
(1957–58)

Contents

Acknowledgments

It is a pleasure to be able to thank those who willingly assisted me while I was doing research, writing the manuscript, and preparing it for publication. Many artists and their assistants were extremely generous with their time and thoughts and kindly lent me photographs of their work. I would like to thank in particular Trish Battistin of the David Hockney Studio, Vija Celmins, Mary Dean of the Ed Ruscha Studio, Llyn Foulkes, Karen Freedman of Easy Rider Productions, Dennis Hopper, Robert Landau, Kendra McLaughlin of the McKee Gallery, Jerry McMillan, Claes Oldenburg and Coosje Van Bruggen, Kenneth Price, Sue Welsh of the Noah Purifoy Foundation, Ed Ruscha, Tracey Lewin of Through the Flower, and Julian Wasser.

Collectors and many individuals at various institutions also contributed helpfully to this project: Harry W. and Mary Margaret Anderson, Giselle Arteaga-Johnson of the Los Angeles County Museum of Art, Dennis Bell and Larry Cole of the Athletic Model Guild, Gerald E. Buck, Betty and Monte Factor, Lisa Griffin of the Norton Simon Museum, Henry Hopkins, Phil Huge of the Eastman Kodak Company, Paul Karlstrom of the Archives of American Art, Claudia Kishler of the Ansel Adams Publishing Rights Trust, Dianne Nilsen and Denise Gose of the Center for Creative Photography, Dennis Reed, Radoslav Sutnar, Drew Talley of the California African American Museum, Dace Taube of Special Collections at the University of Southern California, and Wim de Wit of Special Collections at the Getty Research Institute.

A Clark Fellowship at the Clark Art Institute in Williamstown, Massachusetts enabled me to have a year free from teaching and administration to complete my manuscript in the Berkshires, while enjoying the friendship and intellectual camaraderie of Brian Allen, Caroline Bruzelius, Michael Conforti, Wanda Corn, Martin Donoho, Peter Elvin, Darby English, Peter Erikson, Carter

Foster, Tamar Garb, Laurie Glover, Marc Gotlieb, Roman Grigoryev, Werner Gundesheimer, Charles Haxthausen, Guy Hedreen, Michael Ann Holly, Elizabeth Hutchinson, E. J. Johnson, Ludmilla Jordanova, Liz McGowan, Karen Merrill, Nick Mirzoeff, Keith Moxey, Carol Ockman, John Onians, Gail Parker, Marc Phillips, Ruth Phillips, Richard Rand, Adrian Randolph, Rudolph Rapetti, Susan Roeper, Angela Rosenthal, Fronia Simpson, Marc Simpson, Ellen Todd, Martha Umphries, and Kathleen Wilson. The Humanities Center at the University of California, Irvine, provided a subsidy to help pay for photographs and copyright permissions. And the Millard Meiss Publication Fund also provided a grant to underwrite the book.

My research assistants at the Clark, Emy Kim and Jordan Kim, and my research assistants at UCLA, Jennifer Marshall and Amy Pederson, advanced the project with their rapid responses to all of my requests for help. Jewel Wilson at UCI assisted me with the laborious process of obtaining photographs.

Several friends read my chapter on David Hockney and challenged me to think further about it. While I have probably not satisfactorily answered all of their queries, I would like to thank David Joselit, Richard Meyer, Kenneth E. Silver, and Jonathan Weinberg for their attentive readings and helpful comments. Richard, who is also writing about Hockney and *Physique Pictorial,* deserves special thanks for commenting on my manuscript and for generously sharing his own work with me.

The chapter on Ruscha evolved thanks to invitations to participate in several symposiums on Pop art or to present talks at various institutions, and my thanks go first to the organizers, who also, with their comments on my talk, contributed to the development of the argument: Michael Ann Holly and Darby English at the Clark Art Institute, Leo Mazo at Lebanon Valley College, Connie Hungerford at Swarthmore College, Patricia Kelly and Serge Guilbaut at the University of British Columbia, Anna Notaro at University of Nottingham, Angela Miller at Washington University, Dora Appel at Wayne State University, and Jonathan Weinberg at Yale University. Many members of the audiences at these presentations offered insightful remarks that caused me to revise the chapter. While I have undoubtedly forgotten to name some of those interlocutors, let me nevertheless extend my thanks to Ken Allan, Patrick Andersson, Richard Field, Marc Gotlieb, Guy Hedreen, Ed Halter, Camara Holloway, E. J. Johnson, Caroline Jones, Kaori Kitao, John O'Brian, Karen Merrill, Nick Mirzoeff, John Onians, Andrew Perchuk, Joachim Pissarro, Jock Reynolds, Sarah Rich, Marc Simpson, and Rebecca Zurier. I also benefited from questions asked after I delivered an early version of a paper on Ruscha in the Works in Progress series at the Getty Research Institute. My thanks to David Joselit, who responded to

my talk with great insight, as well as to Martin Fox, Richard Meyer, and Nancy Troy for their comments.

The love and companionship of friends and family have been dear to me over the past several years. I am grateful to Sara Clignet, Melissa Dabakis, Miriam Golden, Amy Lange, Julia Lupton, Talya Press, Ken Reinhard, Ellen Todd, Alex Whiting and Sonya Mead, Charles and Monique Whiting, Peter Whiting, Sarah Whiting and Ron Witte, and, of course, to Jim, Nicole, and Pauline.

Several people carefully and thoughtfully read the entire manuscript. My thanks to three anonymous reviewers for the University of California Press, who raised important questions for me to consider in revising the manuscript for publication. Finally, I would like to single out three people for special thanks. First, my husband, Jim Herbert, read my words with attentiveness and interest, offered helpful insights, and engaged me in sustained and fleeting conversations about my ideas as only someone can with whom one shares the pleasures and pressures of daily life. Second, my editor Stephanie Fay is a remarkable person who encouraged me from the beginning of the project; when I completed the manuscript, she edited it with scrupulous attention, correcting many infelicities of style. Third, my sister, Sarah, read and commented on the manuscript with great enthusiasm and intellectual generosity, and her friendship and love have been integral to the completion of this book.

Introduction

"PROMISING SCHOLARS AND PHILOSOPHERS, THE STORY GOES, MOVE TO California and then just play tennis and swim for years." This cliché, simultaneously acknowledged as such and endorsed as truth, opens an article on the art scene in California published in 1971 in *Artforum*, an art journal that itself had abandoned the sun and surf of Los Angeles four years earlier for the brisk, bracing intellectual currents that presumably swirled around Manhattan. The goddess California, in this tale, circulated by *Artforum* and other magazines, emerges as a seductress, luring the scholar and the philosopher to a modern-day land of lotus-eaters, where they lose all desire for civilization and the rigors of sustained thought. According to *Artforum,* civilization resides in New York, while in Los Angeles the sunshiny days prompt superficial pursuits: "There is that whole shallow, indulgent, Republic-of-Trivia aspect to [Los Angeles] which reminds us here in New York that not since the invention of bronze casting has anything of consequence happened in that climate."[1]

And what of artists who made California their home in the 1960s? Did they abandon paintbrushes for tennis rackets and surfboards, as Kenneth Price, triumphantly surfing a wave in the photograph on the cover of his Ferus Gallery exhibition catalog in 1961, suggests (figure 1)? Did the works produced by such artists-qua-beach bums blindly emulate the superficiality and hedonism attributed to Los Angeles? More specifically, did Pop art, owing to its affiliations with popular culture, prove particularly adept at mimicking the shallow mindset considered emblematic of Los Angeles when it took up the city's popular motifs? Did Pop art, in a narcissistic gesture, reflect the undisputed world capital of middlebrow purchase and pleasure back onto itself?

Given the reputation of Los Angeles as the mecca of popular culture, Pop art's natural home would seem to have been Los Angeles all along. Andy Warhol's first exhibition of Pop art images, his Campbell Soup Cans, took place at the Ferus Gallery in Los Angeles. New Paintings of Common Objects, organized by Walter Hopps at the Pasadena Art Museum in September 1962, can claim credit as the first group show of Pop art. So quick was the development of a cadre of Pop artists in southern California, in fact, that in 1963 the Los Angeles County Museum of Art supplemented the traveling exhibition Six Painters and the Object, from New York's Guggenheim Museum, with a companion show entitled Six More, featuring Pop art made in California. Despite this flurry of exhibitions and the presence of a small but noteworthy indigenous Pop art scene in Los Angeles, however, Manhattan retained its grip on the contemporary art world. The key big-name players associated with Pop art during the period—Warhol, Tom Wesselmann, Roy Lichtenstein, Claes Oldenburg, and James Rosenquist—all resided primarily in New York City, and dealers and crit-

KENNETH PRICE

FERUS GALLERY 723 N. LA CIENEGA BLVD. LOS ANGELES 69, CALIFORNIA OCTOBER 16, 1961

1 Cover of Ferus Gallery catalog, Kenneth Price exhibition, 1961. © Kenneth Price.

ics alike did not for a moment consider shifting their collective gaze away from Manhattan Island to the urban sprawl on the continent's western shores.[2]

Nevertheless, Pop art, in the galleries and museums of New York, always projected its principal object of interest—popular culture—elsewhere, outside Manhattan: above all else, perhaps, to the homes managed by, and supermarkets patronized by, efficient homemakers in the vast plains of American suburbia. Consider Warhol's comment about his road trip to Los Angeles in 1963: "The farther West we drove, the more Pop everything looked on the highways."[3] Indeed, the critical debate about Pop art—Did it critique or celebrate popular culture? Was it the same as popular culture or different from it?—posited a tropological difference, and thus a geographic distance, between the art, located in Manhattan, and the popular, which seemed to dominate everywhere else.

What happened to Pop art, its critical reputation, and its relation to place, when it left the cloister of Manhattan and ventured to Los Angeles, a place wittily described at the time as "100 suburbs in search of a city?" In the 1960s, however, the actual character of Los Angeles remained open to debate. Was it nothing more than sprawling suburbs—100, or any such number—or did it instead define a new form, decentralized or multicentered, of the city? In a parallel cultural controversy one could ask, was Los Angeles nothing more than the capital of popular culture, the perfect habitat for the sprouting up of such noteworthy establishments as Randy's Donuts; or might it also be seen as an emerging center of high art, home to the expansive, new buildings of the Los Angeles County Museum of Art and other ambitious museums and galleries?

Alison Lurie's novel of 1965 about Los Angeles, pointedly titled *The Nowhere City*, encapsulates these competing assessments of cultural life in southern California in the perspectives of two outsiders moving to the megalopolis from the East Coast.[4] Paul Cattleman, an ABD in history at Harvard, takes a job with the Nutting Research and Development Corporation, writing a history of this electronics company, located in Los Angeles. "When Paul's acquaintances called him a southern California type," Lurie has Cattleman muse, "they were probably thinking of his love of the beach and other outdoor pleasures, and of the pleasure he took in movies and even T.V. Yes, he thought, . . . this city suited him: it suggested a kind of relaxed energy, the sense of infinite possibilities" (6–7). His wife, Katherine, responds to the sun, surf, and popular culture of Los Angeles in quite the opposite way: "I don't like the climate. I don't like the sunshine all the time in November, and the grass growing. It's unnatural. . . . Everything's advertisements here. . . . We were driving back from the airport, and we passed a doughnut stand, and on top of it was this huge cement doughnut about twenty feet high, revolving around. I mean revolving . . . that big

empty hole, going around and around. . . . Well I thought, that's what this city is! That's what it is, a great big advertisement for *nothing*" (38). Although Lurie wrings much comic misadventure out of the couple's different valuations of the city, Paul and Katherine share an underlying assumption, that Los Angeles is, in fact, nothing other than the perfect realization of the popular.

Precisely at the time Lurie published this novel in the 1960s, however, Los Angeles was attempting to claim a new identity as a center of high culture. The opening of the Getty Center as the Parthenon of Los Angeles in 1997 has renewed that effort, launched with great gusto more than a quarter of a century ago in the mid to late 1950s. Local efforts to consolidate a contemporary art scene in Los Angeles began then with Gerald Norland's and Philip Leider's promotion of Abstract Expressionist and Assemblage art in *Frontier* magazine (which billed itself as "The Voice of the New West" and modeled itself on the *Nation*), and the establishment of the Ferus Gallery by Edward Kienholz and Walter Hopps in 1957. Los Angeles could even boast a counterpart to bohemian Greenwich Village when a Beat subculture emerged in Venice. In the early 1960s the various art galleries assembled along La Cienega Boulevard—the Ferus as well as other galleries devoted to contemporary art, such as Ankrum, Felix Landau, Primus-Stuart, Esther Robles, and Paul Rivas—inaugurated the Monday evening promenade, remaining open to the public until 10:00 P.M. A new complex of buildings on the Miracle Mile section of Wilshire Boulevard opened in 1965 to house the Los Angeles County Museum of Art, the largest museum structure built in the United States since the National Gallery of Art, in Washington, D.C., completed in 1941.

In 1965 *Artforum* relocated to Los Angeles from San Francisco, and Ken Tyler established Gemini Ltd., which, along with the Tamarind Lithography Workshop, founded in 1960, fostered the production of prints by contemporary artists. Curators and critics too, including Irving Blum, John Coplans, Henry Hopkins, Walter Hopps, Jules Langsner, Philip Leider, and Peter Plagens, actively promoted contemporary art in Los Angeles. Often they published their articles in magazines with a national (indeed, international) readership such as *Artforum, Art in America,* and *Art News.* These people and institutions joined together to bring artists and artworks from both Europe and New York to Los Angeles, as well as to advance the local talent.[5] As a consequence, Los Angeles could legitimately boast a thriving contemporary art scene.

The city promoted high culture so successfully that as early as April 1963 *Art in America* dubbed Los Angeles, America's Second Art City. Art, in fact, promised to transform Los Angeles not simply into a city of culture, but into a city *tout court*.[6] *Art in America* introduced Los Angeles as a "megalopolitan

congeries of 70 towns and suburbs with over 6,500,000 persons . . . netted together by a system of freeways," going on to declare that culture had transformed the metropolis into a recognizable city, that is, a place with a center. "Absence of a focal point no longer applies to art activities," the article in *Art in America* insisted. "Some two dozen first-rate galleries . . . are clustered on La Cienega Boulevard."[7] Three years earlier, *Life* magazine had found signs of cohesion in Los Angeles in the new system of freeways built in the late 1950s, which knitted the suburbs together, and in the construction of architecturally designed multistory buildings, which provided islands of real function in a sea of "garishly tinted, rococo homes and ice cream cone-shaped drive ins."[8] *Life* also noted that the establishment of important art institutions in the metropolis heightened its urban identity: "Long sensitive about its past as a city without a center, Los Angeles has been even more embarrassed by critics who write it off as a cultural cactus patch. . . . But as surely as the sprawling city is gaining cohesion, the cultural cactus patch has begun to bloom, even beyond the dreams of art patrons, concert impresarios or dealers in pictures, records or books."[9]

Despite these optimistic assessments, the emergence of Los Angeles as a city and as a cultural center nonetheless always took the form of a rebirth, figured against a background of a dominant popular culture residing in undiminished force across the great homogenous plains of suburbia. *Art News* described the dynamic of swimming against the flood in the following manner: "As the image of San Francisco as an outpost of well-bred, cosmopolitan culture in the woolly West began to give way, so did the myth of Los Angeles as exclusively the home of vulgar money, Hollywood taste, and palatial hot-dog stands. April 1965, the month in which the new Los Angeles museum will have opened its doors to the public, will probably turn out to be as good a date as any for a definitive emergence of Los Angeles as the center of serious art activity on the West Coast."[10] When boosters argued for the artistic significance of Los Angeles and against the city's unremittingly middlebrow image, they noted that art there was lucky to have found a home alongside the popular. In contrast to Manhattan, this was a locale where no one could imagine art seriously challenging the preeminence of popular culture.

Given this failure of high art to conquer southern California, it is no surprise that critics on both coasts cast Pop works by artists residing in California—whatever their motifs and, often, wherever in California they were produced—as a mirror not of America's Second Art City but of Los Angeles as the home of the popular in all its vulgarity. "The question, at least for Southern California," the homegrown art critic Peter Plagens ruminated in 1974, "is not so much whether the area was/is ripe for Pop, but whether the whole ambience—from

show business to aircraft industry to the Gobi of suburbia—is not preemptively Pop in itself. The inventory is practically endless . . . there was nothing too vulgar or banal about Los Angeles to prevent it from becoming a Pop subject."[11]

The pinups Mel Ramos painted came to emblematize the worst of Pop art and the worst of Los Angeles in all of its tasteless vacuity. Ramos himself, ironically, was from northern California. Consider, for instance, one critic's recollection of 1965: "Ramos's art became for me a definition of Pop art on the West Coast and an archetypal expression of the California lifestyle—confident, hedonistic, glamorous, and disarmingly impudent."[12] That Ramos had one of his first solo exhibitions at the David Stuart Gallery in Los Angeles and continued to show works there regularly probably secured the implicit, sometimes explicit, relationship posited between his pinups and southern California. According to one critic, Ramos's paintings "project a particularly Americanized fantasy: the suburban pseudo-playboy's dream girl." The term "suburban" here inevitably evokes with some disdain the sea of houses stretching in all directions from the gallery's doors.[13] Other critics identified Ramos's canvases specifically with Los Angeles by finding in them traces of the world of movie stars and Hollywood charm schools.[14] Indeed, the buxom blondes seen in Ramos's paintings are more like the young starlets who purportedly typified, and eroticized, Los Angeles in the 1960s than like the well-bred matrons associated with San Francisco—a geographic contrast represented to sterling effect in a photograph published in the *Saturday Evening Post* in 1962 that juxtaposed "Stylish San Franciscans," outfitted in jackets, skirts, hats, and gloves, and "Sunset Boulevard strollers," sporting sunglasses and wearing stretch pants, promenading with a decorative poodle (figure 2).[15] Ramos's paintings, which coupled artificially lush pinups with corporate logos and mass-produced foods, spoke to many critics of the coarseness of commerce and Hollywood and, by extension, of suburban, middle-class life. The art mirrored the fantasy of Los Angeles seen from afar as a place of pagan values and starlet sex.

This book examines how a number of artists, often only loosely identified at the time as Pop, represented the city of Los Angeles in the 1960s and contributed to its urban identity as an emerging art center while avoiding the clichés of either the city's boosters or its detractors. In the 1960s critics consistently applied the Pop label to paintings by the two best-known artists to represent Los Angeles: David Hockney and Ed Ruscha. But others, including Billy Al Bengston, Vija Celmins, Llyn Foulkes, and Dennis Hopper, who alluded to the surf, streets, storefronts, and signs of the city in their art, were at one point or another in the early 1960s named Pop by critics, even if the artists themselves repudiated this designation. My selection of artists highlights that Pop in Los

Point of conflict: Stylish San Franciscans (like those above) disdain . . . *freestyle L.A. fashions such as these Sunset Boulevard strollers wear.*

2 "Tale of Two City Sibling Rivalry," *Saturday Evening Post*, 3 November 1962. Reprinted with permission of *Saturday Evening Post* © 1962 BFL&MS, Indianapolis.

Angeles never coalesced into a tightly coherent group or an aesthetic category. Often critics merged Pop with other movements—Assemblage, Finish Fetish, and so forth.[16] Indeed, as more and more artists engaged in a dialogue with Ruscha's and Hockney's paintings of Los Angeles (Judy Chicago is a case in point) and depicted alternative views of the Pop city, Pop increasingly lost its specificity. To the extent that the rubric Pop referred as much to Los Angeles as to works of art, I use it to encompass art in a variety of styles that evoke and redefine the urban vernacular. Ultimately, I emphasize place—the Pop city—rather than style as a bond among artists in this book, to allow for juxtapositions between, say, a collaborative project such as Womanhouse, typically considered feminist rather than Pop art, and Hockney's depictions of tract houses, or between Ruscha's paintings of commercial institutions and the Watts Towers. I am less interested, then, in coining a new art-historical designation, such as L.A. Pop, than in exploring how a fascination with place inspired experiments in the visual arts in Los Angeles during the 1960s and how such representations, in turn, made sense of a city increasingly paved in concrete, navigated by car, and dotted by palm trees basking in the heat of the blazing sun.

Until the 1960s most artists distinguished California from the rest of the United States by showcasing its natural landscape. Chapter 1 considers paintings, drawings, and photographs by Celmins, Foulkes, Ansel Adams, and Edward Weston that extend and/or challenge that earlier artistic heritage, defining a difference between northern and southern California according to the relation of nature and culture in each region. Chapters 2 and 3 focus on the changing built environment of southern California by considering Ruscha's view from the car and Hockney's revision of the home. Chapter 4 analyzes how the transformation of Simon Rodia's Watts Towers into a cultural and historical landmark was undertaken to redeem the banality of domestic and commercial architecture in Los Angeles and the empty artifice of Hollywood and Disneyland; it also interprets works that Noah Purifoy and other Assemblage artists fabricated out of urban detritus in the wake of the Watts uprising as commemorating and reimagining a local site and a momentous event in the social life of the city. I close, in chapter 5, with a discussion of Happenings by Judy Gerowitz (who in 1970 adopted the name Judy Chicago based on her hometown), Allan Kaprow, and Claes Oldenburg as well as Performance pieces by Chicago and other feminist artists at Womanhouse to highlight how artists reimagined the urban identity of Los Angeles after the Watts uprising: while Happenings disrupted, at least temporarily, the new, emerging physical landscape of the city, feminist Performance art posited a relationship between the neighborhoods forgotten in the rush toward urban growth and the repressed frustrations and aspirations of middle-class white women.

Although my book focuses on a local manifestation of modernist artistic practices in the 1960s, I also examine how and why a group of artists, collectors, critics, and curators regarded the bid of Los Angeles for cultural ascendance as a form of regionalism that nevertheless avoided the pitfalls of provincialism. Accordingly, I acknowledge institutional and artistic connections between Los Angeles and other capitals of culture, including San Francisco, New York, and London. A number of artists and critics arrived to sojourn in Los Angeles, often extending their stay. Certain works resulting from these pilgrimages—the paintings of Los Angeles by the English émigré Hockney and musings about the city by Reyner Banham, also English—had an enormous impact on the identity of Los Angeles during this period. In 1963 the French artist Marcel Duchamp traveled to Los Angeles for the opening of his first retrospective, organized by Walter Hopps at the Pasadena Art Museum, and a number of Nouveaux Réalistes, including Arman, Martial Raysse, and Niki de St. Phalle also visited Los Angeles in the early 1960s when the Dwan gallery mounted exhibitions of their art. With the arrival of Duchamp and the Nouveaux Réalistes, a number of local

artists, who shared the French engagement with the mass-produced commercial object, developed a connection to Europe no longer based on an expressionist adaptation of the grand tradition of modernism (as seen in paintings by an older generation of artists such as Rico Lebrun).[17] Simultaneously, exhibitions featuring Pop artists from Los Angeles traveled across the nation and around the world.[18] But the flowering of contemporary art in Los Angeles was momentary and, in retrospect, seems but one of many passing instants in a boom-and-bust cycle that has characterized the city's art scene over the decades. By the late 1960s, even as Los Angeles worked up the gumption to declare itself the second art city of the nation, the Ferus Gallery closed its doors and *Artforum* relocated to New York.

A number of important books have already examined art from the 1960s in Los Angeles, most notably Peter Plagens's *Sunshine Muse: Art on the West Coast, 1945–1970* (1974) and, more recently, William Alexander McClung's *Landscapes of Desire: Anglo Mythologies of Los Angeles* (2000). The exhibition catalogs *L.A. Pop in the Sixties* (1989), *Sunshine & Noir: Art in L.A., 1960–1997* (1997), and *Made in California* (2000) also contain insightful analyses of art from the 1960s.[19] Other books have examined the architecture of Los Angeles, including its theme parks and malls, and in the past few decades the city has been used to exemplify both utopian and apocalyptic versions of postmodernism.[20] Thematically this book focuses more closely than any of these on art's relation to the urban identity of Los Angeles and expands its purview beyond the artists typically discussed in books on Pop art. Throughout I refer to other artifacts of the period, including novels such as Alison Lurie's *The Nowhere City,* tourist guides to Los Angeles, and underground films such as Kenneth Anger's *Kustom Kar Kommandos.* The art and other visual works at the heart of my study, by engaging the built environment and often recasting the standard rhetoric about the city, forged an urban identity for Los Angeles that embraced high art and mass culture, nature and artifice. My reigning assumption is that the visual culture of the early and mid-1960s showcased and reimagined certain new forms of the city, thus impacting the understanding of urban life in Los Angeles as significantly different from that in other cities.[21]

In writing this book I have learned much from the articles and books that in recent decades have highlighted artists' representations of London, New York, and Paris as emergent capitals of modernity in the nineteenth and early twentieth centuries. Each of these cities was transformed in a relatively short time: Paris, by the building campaign inaugurated by Emperor Napoléon III and Baron Haussmann, Prefect of the Seine under the Second Empire; London, by the modernization and improvement undertaken by the Metropolitan Board of

Works; New York, by the construction of skyscrapers, nighttime illumination of the city, and the new bridges and tunnels that connected the boroughs to Manhattan. When artists—French Impressionists; British realists and illustrators; American Ashcan and modernist artists—depicted the new buildings, boulevards, transportation networks, commercial entertainments, and inhabitants of the cities where they lived, they invented ways of representing their fleeting experiences in modern urban space while probing the limits of modernity.[22]

Like Paris, London, and New York in earlier eras, Los Angeles after World War II experienced tumultuous growth at a rapid rate. The city's population swelled as staggering numbers of people arrived, lured by new jobs in the aerospace industry and a lifestyle promoted nationally in images of beaches, single-family homes, and sunshine.[23] "In the fall of 1962, the national media discovered California once again," Peter Schrag asserts. "But the real story, for the editors, for California, for the country, was bigger—the re-rendering of the old myth of El Dorado into yet another form: California not as promise but as the embodiment of the American future—the dream made flesh."[24] The suburban amenities of Los Angeles distinguished it from localities elsewhere in the state, as single-family homes and planned communities mushroomed to accommodate the stream of newcomers. Los Angeles, moreover, proposed many agreeable pursuits to resident and tourist alike. As one reporter exulted, "Los Angeles is the fastest-growing great American city, and it is now the nucleus of one of the world's most populous metropolises. To ambitious youth, it offers employment opportunities in a rapidly expanding market. To senior citizens, it offers varied recreation and refuge from mid-latitude winters. Tourists go there to see its new man-made attractions and enjoy the climatic amenities."[25] As the city spread, it also began to soar when, in 1956, restrictions on building height were rescinded. The redevelopment of downtown began in the late 1950s, and during the decade that followed new skyscrapers arose in two clusters, one along Wilshire Boulevard and another at Century City, to compete with downtown. The reporters Wes Marx and Gil Thomas wrote enthusiastically in 1962 of "a new city . . . rising in our midst, a stylish city with a long, lean profile that arrogantly peers down at its patriarch, central Los Angeles."[26] Skyscrapers containing shops, apartments, and corporate headquarters now cast their shadow upon nearby suburban homes.

The fantasy of Los Angeles as the embodiment of the California good life was short-lived, marred by commuting, crowding, smog, and ultimately by racial and economic upheaval. The Interstate Highway Act, passed in 1956, underwrote the construction of the freeway system in Los Angeles, contributing to the city's development and decentralization. The massive expansion of the city

both authorized the dream of suburban living and, by the late 1960s, turned it, for some, into a nightmare, an ideal gone awry. Finally, the upheaval in the Watts district in August 1965 challenged the myth of Angeleno good life by exposing tensions between police, city officials, and residents of Watts, as well as evidence of economic and racial disparities in the city at large. For Edward Soja, a key voice in the new school of Los Angeles urban geography that originated in the 1980s, "The Watts rebellion and the series of urban uprisings that followed it in the late 1960s all over the world . . . marked one of the beginnings of the end of the postwar economic boom and the social contract and Fordist/ Keynesian state planning that underpinned its propulsiveness."[27]

During the 1960s the proliferating skyscrapers, single-family homes, and freeways and the increased pollution, punctuated by fires lit out of frustration in Watts, transformed and obscured both the landscape and the skyline of Los Angeles. Many tried to categorize the changing metropolis—as a failed city, as a modern city, or as a new, multicentered city. Those raising their voices in alarm condemned the numbingly identical tract homes and subdivisions sprouting across the landscape, the new malls and skyscrapers that drained life from the city center, and the traffic congesting the freeways and filling the sky with smog. "Megalopolis," "franchise city"—these were some of the terms enlisted to condemn the city's sprawl and suburban composition. Consider how Lewis Mumford, theorist of American culture, technology, and cities and a staunch critic of urban renewal, expressed his revulsion:

> Los Angeles has now become an undifferentiated mass of houses, walled off into sectors by many-laned expressways, with ramps and viaducts that create special bottlenecks of their own. These expressways move but a small fraction of the traffic per hour once carried by public transportation, at a much lower rate of speed, in an environment befouled by smog, itself produced by the lethal exhausts of the technologically backward motor cars. More than a third of the Los Angeles area is consumed by these grotesque transportation facilities; *two-thirds* of central Los Angeles are occupied by streets, freeways, parking facilities, garages.[28]

Boosters of Los Angeles countered such despair by championing the skyscrapers for their heroic modernity, the freeway system for its practicality, and the emerging contemporary art scene for its promise of a cultural center that would redeem the city from the prevailing ethos of consumerism and popular entertainment. Boosters and critics alike, however, began to recognize Los Angeles as an alternative urban model, neither the classic city with a downtown nor a vast suburb. For Marx and Thomas, writing in *Los Angeles: Magazine of the Good*

Life in Southern California, this "first metropolis on wheels, and without any center is also the first metropolis with many focuses."[29] Commentators in both the local and national press noted repeatedly that Los Angeles, unlike any other city in the United States, had multiple centers, scattered clusters of skyscrapers surrounded by a web of freeways.[30]

Exceptionalist narratives in the mid-1960s that singled out the multicentered peculiarity of Los Angeles would be replaced in the final decades of the century by analyses that cast it as the prototype of the postmodern city now in evidence all over the United States, if not the world.[31] Soja summarizes the attributes of the city with a center: "The classic model of urban form, built primarily around the nineteenth-century industrial capitalist city, presented a monocentric picture of increasing geographic regularity patterned by the dynamics of employment and residential agglomeration. Everything revolved around the singular city center."[32] The development of Los Angeles, in contrast, has been "marked by continued decentralization of residential population, industrial establishments, corporate offices, and retail activities into the outer reaches of the sixty-mile circle." Soja urges an analysis of Los Angeles that considers "urban form more as a complex and polycentric regional mosaic of geographically uneven developments affecting and affected by local, national, and global forces and influences."[33]

It is tempting to claim, retrospectively, that some art of the 1960s, such as Ruscha's photographic books, anticipated the city's postmodern urban condition, and indeed I argue in the chapters that follow that the first efforts, by writers such as Reyner Banham, Denise Scott Brown, and Robert Venturi, to define the difference between Los Angeles and the modern city depended on Ruscha's visual example. It turns out, somewhat paradoxically, that just as the art scene in Los Angeles waned, the Pop vision of the city began to inspire a new generation of writing about Los Angeles and its debased sister city, Las Vegas; both Banham's *Los Angeles: The Architecture of Four Ecologies* (1971) and Venturi and Scott Brown's *Learning from Las Vegas* (1972) exemplify this trend. My book examines both the specific relation of contemporary art to the city of Los Angeles in the 1960s and the broader impact of Los Angeles Pop on debates about urban life. During the 1960s, I suggest, the conception of the city pioneered by Pop artists in Los Angeles began to spread, eventually characterizing cities and cultural life throughout the United States.

During the 1960s, however, artists achieved no visual consensus about the rapidly changing built environment of Los Angeles: many of them weighed in on the key features of the sprawling megalopolis. Before 1960 few artists even recognized in their paintings how the built environment in Los Angeles had

altered since World War II: Emil Kosa's watercolor *Freeway Beginning* (circa 1948), depicting a freeway ramp under construction against the backdrop of downtown Los Angeles, and Roger Kuntz's oil painting *Santa Ana Arrows* (circa 1950s), with its signs for the 5 and 101 freeways, were among the few works of art to acknowledge the physical presence of the freeway system and the signage mounted to regulate the flow of traffic (figures 3 and 4).[34] Thus it is not surprising that when Hockney traveled to Los Angeles in 1963, he remarked, somewhat bewildered, "There were no paintings of Los Angeles. People then didn't even know what it looked like. And when I was there, they were still finishing up some of the big freeways. I remember seeing, within the first week, a ramp of freeway going into the air, and I suddenly thought: 'My God, this place needs its Piranesi; Los Angeles could have a Piranesi, so here I am!'"[35] The knight with shining paintbrush arrived from London to give Los Angeles an image of itself. Hockney depicted not the city's freeways but its tract homes, backyards, and swimming pools—often graced by male nudes rather than the nuclear family. Celmins, who hailed from Latvia by way of Indianapolis and New Haven, did depict the freeway on canvas, while Ruscha, transplanted from the Midwest, captured in paintings and photographs the commercial signs and structures of the city seen from a moving vehicle. More often than not, artists in the 1960s, including Kenneth Anger, Bengston, Chicago, and Kienholz, found inspiration in southern California's distinctive car culture. With the exception of Anger, all the artists came from elsewhere to Los Angeles. Indeed many of them were lured there by the promise of sunshine, a relaxed lifestyle, and professional opportunity; and in their art they recalibrated or commented upon the promotional myths that had motivated them either to visit or to settle in Los Angeles.

The visual culture in Los Angeles that imagined the city during the 1960s, when its built environment was physically and conceptually redefined, often played on the relation between surface and depth.[36] Ruscha and Hockney, for instance, paid attention in their paintings simultaneously to the two-dimensional surface of the canvas and the facades of the built environment—of private homes, commercial structures, and advertising signs. They refrained, however, from treating the surface of the city as a metaphor for the purported superficiality of its inhabitants, whom many cultural analysts presumed were as banal as the suburban lifestyle, popular entertainment, and consumer culture they embraced. If anything, Ruscha's and Hockney's artworks redeemed the surface of both the canvas and the city, providing exciting visual designs, highlighting a new urban spatiality, or enabling sexual display. Other artists, such as Foulkes, Kienholz, and Purifoy, countered the supposed superficiality

3 Emil J. Kosa, Jr., *Freeway Beginning*, circa 1948. Watercolor on heavy wove paper, 22 × 30 3/8 in.
 Photograph courtesy of Gerald E. Buck Collection, Laguna Hills, California.

4 Roger Kuntz, *Santa Ana Arrows*, circa 1950s. Oil on canvas, 50 × 60 in. Photograph courtesy
 of Gerald E. Buck Collection, Laguna Hills, California.

of the city with works of art whose surfaces and recesses stirred memories of particular locations. Such works, by way of a historical resonance, a macabre evocation of death, or a moralizing judgment, attributed to place both depth of meaning and portentous significance. To the extent that surface and depth were mutually dependent and defined one another, the canvases, assemblages, and happenings about Los Angeles could be considered "profound surfaces":[37] the actual surfaces and interiors of the works of art acknowledged the exhilaration and the limitations of a multicentered urban space dominated by the commercial facade. They insisted on the possibilities of reinventing the self and reimagining the built environment, even while pointing to the restrictions imposed by place on such projects of renewal.

Some of the competing and complementary views of the city artists presented during the 1960s gained more authority than others over time in defining urban life in Los Angeles. Having myself resided in Los Angeles for twelve years, though I completed this book elsewhere—in bucolic Williamstown, Massachusetts, and in a planned suburban community in Irvine, California—I find that even as I consider new narratives and visual representations of Los Angeles, produced from both within and without, the paintings, photographs, assemblages, and happenings dating from the 1960s continue to mediate my understanding of the city. I hope this book contributes to an understanding of the visual arts in relation to place, debates about high and low, and theories about the city and urban development, as well as offers insight into how and why Los Angeles and its visual culture from the 1960s continue to exert such influence on theories of postmodern urban space.

1

For Purple Mountain Majesties

IN 1964 THE ROLF NELSON GALLERY IN LOS ANGELES EXHIBITED AN OIL by Llyn Foulkes that might be said, in retrospect, to ruminate on the end of landscape painting (figure 5): five stacked, nearly identical views of a mountain flank a tall rectangle containing diagonal stripes. The layout of the landscapes, each with a thin white border, mimics the format of a strip of photographs produced by a coin-operated photo booth.[1] Even the title of Foulkes's painting, *Kodak*, the name of a camera company rather than a geographic site, conjures the snapshot to haunt this landscape. In 1888 George Eastman, who coined the slogan "You push the button, we do the rest," launched the Kodak camera and turned photography into a pursuit for amateurs. A little less than a century later, in 1963, the introduction of the Kodak Instamatic camera, with its easy-to-load cartridge film, made snapping a photograph even easier and more popular. Other canvases by Foulkes from the 1960s—for example *Post Card* (figure 6), with its depiction in sepia tones of a mountain ridge, and *Canyon,* with its doubled format reminiscent of a stereograph (both 1964)—recall a century-old tradition of photographic representation of the landscape, as do drawings of the ocean by Vija Celmins from the late 1960s and early 1970s in which the minute graphite marks coalesce to capture the silvery gray tones of photography. The landscapes of Foulkes in paint and Celmins in graphite acknowledge the ascendancy of photography in the twentieth century as a medium sanctioned to preserve and popularize nature on the West Coast.

The twentieth-century photographer who set the standard for the majestic view of the western landscape and its imitation by tourists was none other than Ansel Adams. As *Time* magazine proclaimed in 1951, "No artist has pictured the magnificence of the western state more eloquently than photographer Ansel Adams. This summer thousands upon thousands of tourists will follow Adams' well-beaten trail up & down the National Parks, fixing the cold eyes of their cameras on the same splendors he has photographed."[2] Adams, together with his colleague Edward Weston, inherited, perpetuated, and at times reinvented the nineteenth-century practice of western landscape photography, to the enthusiastic response of the American public.[3] Weston's photographs of Death Valley and Adams's images of the Sierra Nevada sustained the ideal of California as a place apart, distinguished from the rest of the United States by its empty sweep of frontier territory and its soaring, untouched grandeur.

For the most part painting had relinquished its claims on the sublime landscape of the West Coast. Few painters after 1900 followed the path of Albert Bierstadt, Thomas Hill, William Keith, Thomas Moran, and others who heralded the geographic wonders of the west—cataclysmic waterfalls, majestic mountains, and dramatic sunsets. The California Impressionists in the early

5 Llyn Foulkes, *Kodak*, 1964. Oil on canvas, 96 × 87 1/2 in. Location unknown.
 Photograph courtesy of Llyn Foulkes.

6 Llyn Foulkes, *Post Card*, 1964. Oil on canvas, 63 1/2 × 62 1/4 in.
Norton Simon Museum, anonymous gift. © Llyn Foulkes.

twentieth century painted pleasant ocean prospects, like the coves and sun-dappled bluffs around Laguna Beach. And Richard Diebenkorn perfected his pastoral views of the Berkeley hills in the 1950s.[4] The exceptions, painters such as Colin Campbell Cooper, Edgar Payne, and Elmer Wachtel, extended the heritage of the great romantics. Eventually, however, painters ceded authority to photography, and Adams increasingly asserted a virtual monopoly over the genre of the sublime landscape.

If Adams's photographs of California's pristine beauty generated pride in the natural landscape, they also produced anxiety. The awe-inspiring nature Adams memorialized risked disappearing in an era that exerted relatively little control over the exploitation of natural resources, growth of cities, and tourism. Adams's photographs addressed environmental questions that other artists also

pondered during this period: What was the relationship between a nineteenth-century ideal of California as an unspoiled paradise and the twentieth-century reality of rapid modernization? Did sublime nature still exist, and if so, where? Did photography, or for that matter painting and drawing, reproduce and preserve nature or recognize and advertise its loss?

Ultimately, visual culture in the 1960s defined a sharp difference between nature in northern and in southern California. Adams, on the one hand, maintained that sublime nature still existed in northern California. In his photographs of dramatic skies, majestic mountains, and sweeping valleys he extended the practice of nineteenth-century landscape photography. Foulkes and Celmins, on the other hand, resuscitated the materials of oil and graphite to portray the untouched landscape and considered how processes of mechanical reproduction mediated nature. In their landscapes and marines they initiated a dialogue between the mechanical medium of the camera and the touch of the handheld paintbrush or pencil, questioning the very possibility of direct visual access to the sublime in southern California. Their works represent sublime nature—but only as Los Angeles's memory of a lost past.

Touring Death Valley

When the critic Fidel Danieli, in 1963, categorized Foulkes's canvases as "handmade photographs," he could have had *Death Valley, USA* in mind (see plate 1).[5] This painting proffers a vista across a valley onto a desolate mountain range, its crest sharply defined against a bleak sky. But this is no simple landscape painting: both its format and its tonalities pay tribute to photography. The thin, white border around the landscape, for instance, mimics the frame of a snapshot, even as the landscape has been enlarged from a small-scale photograph to fit, slightly off-center, the dimensions of the 65 1/2-by-64 3/4-inch canvas. Other elements of the painting allude to photographic practices long outmoded. The shadowy haze obscuring the valley floor and shrouding the far right edge of the mountain slope re-creates the soft-focus effect of a pictorialist photograph from the turn of the century, and the sepia tones of the ridge recall the hue of many a nineteenth-century albumen print depicting the western landscape. Foulkes's landscape has the look of an aged snapshot saved from another era.

The mountain range Foulkes depicts most closely resembles the Panamints, made famous in a widely reproduced print by Edward Weston, the best-known photographer of Death Valley (figure 7).[6] Weston, funded by a Guggenheim Fellowship in the late 1930s, made three trips to Death Valley and took numerous

7 Edward Weston, *Cloud over the Panamints, Death Valley*, 1937. Gelatin silver print, 7 1/2 × 9 1/2 in,
© 1981 Center for Creative Photography, Arizona Board of Regents, Collection Center for Creative
Photography, University of Arizona.

photographs of its exceptionally varied landscape. Books on the photographer
and exhibitions devoted to his career over the past three decades have celebrated
the Death Valley photographs that eliminate the horizon line to focus on stri-
ated rock-walled canyons or the swirling patterns of the salt beds. These im-
ages exemplify the same uncompromising formalist aesthetic at work in other
Weston photographs from the 1920s and 1930s, of the female body and of nat-
ural objects such as shells and vegetables.[7] As the curator Karen E. Quinn re-
marks, "Weston recognized the inherent abstraction in the topography spread
out across the valley . . . he found abstract form where others had seen only
scenery."[8]

From the late 1930s to the early 1960s, when Foulkes painted *Death Valley,
USA,* however, Weston was acclaimed not for his Death Valley abstractions but
for his more conventional scenic photographs of the national park. *The Federal*

Writers Project Death Valley: A Guide (1939), for instance, comfortably includes three photographs of canyons, craters, and salt beds by Weston with photographs provided by the California National Guard, Spence Air Photos, and the photographer George A. Grant. All of these photographs emphasize empty panoramas or canyon heights and highlight extraordinary topographical shapes and patterns. Indeed Weston's most widely reproduced and exhibited Death Valley photograph, *Cloud over the Panamints, Death Valley* of 1937 (see figure 7), offers a relatively conventional prospect from a distance onto the mountains—but also captures the spectacular rain clouds hovering above the ridge along the southwestern edge of the valley.[9]

In the 1930s and 1940s, photographs of Death Valley, including those by Weston, cultivated an aesthetic appreciation of the desert's eerily empty topography as a manifestation of the otherworldly. Originally the valley's lure had been its promise of hidden mineral riches, but in the 1920s efforts began in earnest to convince tourists to endure its scorching heat. These efforts accelerated after 1933, when Death Valley was declared a national monument.[10] Roads were graded to give tourists access to the most spectacular views, beginning with Dante's Point, from which Weston took a number of photographs of the salt beds below. Indeed Weston's Death Valley photographs were first published in *Westways,* the magazine of the Automobile Club of Southern California, which publicized the state's scenic pleasures; his photographs were also included in several books that encouraged tourism in Death Valley, including *The Federal Writers Project Death Valley,* already mentioned; *Seeing California with Edward Weston* (1939); and *California and the West* (1940).[11] The first of these listed tours organized around "outstanding points of interest" and printed tantalizing black-and-white photographs of the salt beds, the Panamint Ridge, and the sand dunes. The guide's text and photographs reinforced an aesthetic perspective in which the desolate and alien terrain embodied the earth's primordial past: "The Valley . . . retains a sublime impersonality that has changed little in a million years."[12]

Adams reminisced in his autobiography: "As I brought Edward to the Sierra, he introduced me to Death Valley. . . . When I first traveled to Death Valley in 1941, my vision was encouraged by Weston's photographs, and successive excursions convinced me of the area's grandeur and beauty; its vast wildness is unmatched in North America."[13] The force of Weston's example was such that when Adams, in 1946, received a Guggenheim to tour national parks and monuments, he traveled first to Death Valley. In the early 1950s he returned there with the writer Nancy Newhall, a friend and frequent collaborator, after they had "offered their services [to the editors of *Arizona Highways*] for a series of articles on the national parks and monuments of the Southwest."[14] Newhall's

published essay enticed tourists to the famous desert by dwelling on the hair-raising Death Valley adventures of outlaws and prospectors and on the impressive landscape. Newhall both reassured visitors about the desert and coaxed them to brave it: "Thanks to swift cars and smooth roads, they cross the Ground Afire in an hour to the cooler mountains. But in that hour they see only the huge supernatural theme and the unearthly brilliance."[15] Given the number of photographs by Adams printed to illustrate Newhall's brief travelog (sixteen in all), the landscape as sheer visual spectacle overwhelmed Newhall's account of the historical lore.

Revisiting some of the Death Valley sites Weston had photographed, Adams dramatized the unique desert topography. Where Weston balanced scenic scope with the particularities of abstract topography, Adams aggrandized the dimensions of the landscape. He shot canyons from their bases so that they soared upward to dwarf the viewer (see plate 2), or he perched on Dante's Point to capture the dizzying immensity of the salt beds below. But it was Adams's resplendent color in ten of the sixteen photographs published in *Arizona Highways* that distinguished his Death Valley images most starkly from those of Weston.

Jonathan Spaulding, in his biography of Adams, sheds light on the commercial pressures that account for the choice of color film: "*Arizona Highways* had built its million-plus circulation on its brilliantly hued pages, and, as he had with Kodak, Adams was willing to supply color images if that was what the client wanted."[16] After World War II the Kodak Company began to market color film to westward-bound tourists, placing advertisements in travel magazines promoting road trips to view the natural landscape. To address those who preferred train travel, the company launched its 18-by-60-foot Colorama displays of natural landmarks in New York City's Grand Central Station.[17] In one of the Colorama triptychs Adams produced for Kodak—of Yosemite National Park, not Death Valley—he included tourists in the foreground taking snapshots of mountains, valleys, and waterfalls, undoubtedly with Kodak color film (figure 8). Spaulding implies that Adams had mixed feelings about color film: "Color photographs, especially in reproduction, seemed too saccharine, the kind of 'superior postcards' some accused his black-and-white images of being."[18] The suspicion that the western landscape in color verged on cliché was also fueled by the popularity of the Hollywood western, epitomized by John Ford's movies set in Monument Valley, in which breathtaking vistas of the Southwest glowed with the color of dramatic sunsets.[19] Art museums as much as the tourist and entertainment industries stirred Adams's anxiety about the cultural divide between amateur color snapshots and black-and-white fine-art photography. For example, when in 1963 the curator John Szarkowski traced an indigenous tradition

8 Ansel Adams, *Yosemite Colorama*, circa 1950. Used with permission of the Trustees of the Ansel Adams Publishing Rights Trust. All Rights Reserved. Photograph courtesy of Eastman Kodak.

of landscape photography in the exhibit The Photographer and the American Landscape at the Museum of Modern Art, he included only black-and-white shots, four of them by Adams, in the exhibition catalog. In the 1950s Death Valley as Technicolor spectacle circulated outside the walls of the museum, in the travel magazines that encouraged both tourism itself and reproduction, in color, of the western landscape by the amateur photographer.

Photography transformed Death Valley from an arid desert whose only riches lay below ground to a breathtaking landscape, awesome in its antiquity and dazzling in its unusual topography and radiant color. In the late 1960s the strange emptiness of Death Valley took center stage again, not in photography but in Michelangelo Antonioni's film *Zabriskie Point*. Antonioni, however, conforming with photographic practice, pictured the desert as an otherworldly space beyond societal convention. The film's title names the site of stony ridges and dry streambeds in Death Valley where the counterculture couple consummate their sexual relationship. Their lovemaking turns hallucinatory when they are suddenly joined by a multitude of nude hippies engaging in sexual gymnastics in the parched and cracking canyons. The film underscores the surreal intensity of the landscape when it culminates in the climactic explosion of a lavish desert hideaway, precisely like the modernist ranch-style homes promoted by *Sunset: The Magazine of Western Living* as ideal for outdoor living on the West Coast.[20] Photographs and films of Death Valley repeatedly emphasized the dramatic, even overpowering and transformative, allure of the topography.

In 1949 Kenneth Clark, in his book *Landscape into Art,* attributed the demise of naturalistic landscape painting to the emergence of photography.[21] How could a painter depict Death Valley, given the dominion of photography, both black-and-white and color, over its representation? What claim could a painter stake to the landscape at Death Valley, given the theatrics of Adams's photographs and the sublime scenic abstractions of Weston's? Foulkes, taking up the daunting challenge of naturalistic painting in *Death Valley, USA,* acknowledged the camera's mediation. He painted the western landscape, in other words, through the lens of loss.

Death Valley, USA, in affirming the role of photography over the past century in transforming nature into a reproducible view, claims the desert landscape for painting. Precisely because photographs of the Panamints by Weston and others are so well known, viewers can identify the site Foulkes depicted in his canvas. Yet he avoids creating a signature view of the mountain range— like the sensational rain clouds that hover above the distinctive silhouette of the ridge in Weston's *Cloud over the Panamints, Death Valley* (see figure 7) or the mountain, its summit hooded in snow, reflected in a crystalline pool on the

valley floor in Adams's photograph of Telescope Peak, the tallest mountain in the Panamint Ridge (see plate 3). Instead Foulkes depicts a gently curving rim and flattened slope. In *Death Valley, USA* the Panamint Ridge becomes familiar and mundane. Foulkes presents the landscape not as an awe-inspiring site but as a reproducible sign for nature, as iterative and banal as the machine-made traffic sign bordering two edges of the canvas.

Even as the format and tonalities of the painting foreground the role of the camera in mediating the view of nature on the West Coast, *Death Valley, USA* does not pretend to be anything other than a painting. Brown paint visibly sweeps across the surface of the canvas to give contours to the softly undulating mounds and to render the age of the mountains. Gray paint tinted with green and touched here and there with pink and cream yields the desolate sky. Foulkes does not revive the medium of paint, however, to claim direct access to nature by rhyming the hand-painted with the natural; he makes no attempt here to capture an original view of nature from a time before the camera-wielding tourist reduced the sublime to a visual cliché. The references to both the amateur and fine-art traditions of photography prevent *Death Valley, USA* from becoming a throwback to the nineteenth-century romanticism represented by Bierstadt's theatrical views of Yosemite Valley.

Nor does *Death Valley, USA* resuscitate illusionism without simultaneously recognizing its displacement by abstraction in the period since World War II. Random drips of paint, like those on canvases by Jackson Pollock, descend over the barren surface of the mountain and valley floor, some even extending into the border of burnt ocher paint beneath the landscape and the band of black and yellow diagonals. Foulkes captures topography and spatial depth with the tools of the representational trade, but the evenly applied paint that frames the desert scene, as in the Color Field abstractions of Kenneth Noland, refuses illusionism, recognizing instead both the frame and the flat surface of the canvas. Plain bands bordering the landscape and splatters of pigment on the mountain and the borders—both devices insist on the two-dimensional surface of the canvas and, in so doing, fulfill a mandate of modern painting given by the art critic Clement Greenberg. Foulkes has it both ways: he represents the landscape of Death Valley illusionistically, and he wrestles with the challenges introduced by Abstract Expressionism and Post-Painterly Abstraction.

The inclusion in *Death Valley, USA* of painterly notations that recall the style of Abstract Expressionism might seem to privilege the unique and haphazard impressions left by an individual—whether the drips of cream, gray, yellow, and blue paint or the illegible scribbles in black crayon across the sky—over the reproducibility of the photograph. Well into the 1960s Abstract Expressionism

stood as the hallmark of a modernist practice in which drips and strokes of paint evinced the movement of the painter's body and hand as he translated his turbulent inner emotions into art. In *Death Valley, USA* any claim to individual expression based on the splatters of paint covering the desert landscape must take into account the presence of those exact same drips on any number of other landscapes by Foulkes from this period. *Post Card* of 1964 (see figure 6) also contains painterly bravura, illegible crayon scribble, and handwriting nearly identical to that in *Death Valley, USA*. Even the most apparently spontaneous and singular gestures constitute reproducible signs.

Marks self-evidently applied by hand in *Death Valley, USA* never reassert the privilege of the unique over the iterative. The random drips and wild scribbles do not exemplify the accidental or unique traces of an individual, nor do the handwritten sentences applied to the landscape qua snapshot exist as indexical marks, conveying the original and purposeful expression of someone wielding a pen. In *Death Valley, USA* Foulkes reproduces a variation of the sober dedication Ulysses Grant wrote for his memoirs. Grant's original phrase, written in black ink with a quill pen, reads: "These volumes are dedicated to the American soldier and sailor." Foulkes, nearly eighty years later and one hundred years after Grant's critical victory in the battle of Vicksburg during the Civil War, scrawls, "This painting is dedicated to the American," twice across the sky and inscribes two variations of the sentence vertically along the left side of the landscape. Foulkes duplicates variation(s) of Grant's dedication on a number of other landscapes he painted at this time, often alongside the same drips and scribbles found in *Death Valley, USA*. Transcribed from a book, altered and applied to multiple paintings, the words on the canvas are not original to either Grant or Foulkes; nor are they unique to either a single book or an individual painting. Confusing matters further, the artist mimics Grant's handwriting, itself mechanically reproduced with each printing of the memoirs. Even if viewers do not recognize the dedication from Grant's book, they can identify the handwriting as nineteenth-century script, given the extent to which individual letters conform to historically determined codes of writing.[22] In the end, even the handwriting cannot be attributed to Grant; it is reproducible by the printing press and by the artist Foulkes.

Yet unremitting reproducibility does not win the day. What appears machine made and reproducible in *Death Valley, USA* turns out to be carefully crafted by hand. Immediately above the view of Death Valley, the three eagles apparently printed by a franking device on a band of pale orange are characterized by slight differences in the width of their feathers that belie serial reproduction by a machine. Likewise the black-and-yellow diagonal stripes along two edges of

the canvas, reminiscent of a hazard sign, occasionally manifest fuzzy or uneven edges. When scrutinized closely, the apparently machine-made motifs provide faint evidence that they are in fact handmade; what at first looks mechanically reproduced is painted by hand to look machine made.

The production and dissemination of multiples symptomatic of photography, if not modernity, on the one hand, and, on the other, the unique aesthetic expression exemplified by high modernism set the terms for the entire painting. Insistence on the interdependence of the reproducible motif and the unique mark challenges a binary opposition and cultural hierarchy central to modernism and modernist art criticism: the valuation of aesthetic expression precisely because of its claim to individuality and originality over and against the mass-produced, everyday thing. *Death Valley, USA* undertakes landscape painting in full recognition of the importance of the medium of photography and recent style(s) of abstraction while engaging in the logic of reproducibility and originality that these aesthetic practices put into play.

One after another, critics confronting the coexistence of motifs and styles from the past and present in Foulkes's landscapes confessed to a sense of loss. "Foulkes' art is a personal reliquary—he reconstructs an imaginary past that haunts him like a mirage," John Coplans remarked in 1963.[23] Critics such as Coplans found in Foulkes's canvases a compulsion to remember the past (a past that might even be illusory), to mourn its loss by re-creating it in the present. In the case of *Death Valley, USA* the painting looks backward, re-creating an untouched desert frontier, complete with a dedication from a Civil War hero. Yet the canvas also recognizes the pastness of the past in that the obvious antiquity of the barren mountains, shrouded in the amber tonalities of turn-of-the-century photographs, juxtaposed with the graphics of a modern-day hazard sign (or, alternatively, a geometric abstraction of the Noland variety), insists on the sobering passage of time, a bit like a movie flashback shot slightly out of focus in silvery hues in a present-day narrative filmed in color. It is not just the landscape itself that resonates with the past; so does its illusionistic rendition in oil. Yet in that rendition the painting does not ignore change over time. It reclaims nature for illusionistic painting in the present while acknowledging, with its references to photography and the traces of Abstract Expressionism and Post-Painterly Abstraction, the loss of the authority illusionism once had over nature. *Death Valley, USA* re-creates a past that remembers its pastness, in both the landscape motif and the illusionistic technique. Consequently, the naturalistic landscape as the trace of a unique and breathtaking encounter between the individual artist and nature is present only as a memento of the past.

The West Coast Sublime

Adams located the sublime not only in the desert Southwest but also in the mountain ranges of northern California, the Pacific Northwest, and Alaska. In the late 1950s and the 1960s his views of majestic nature on the West Coast were increasingly juxtaposed to their horrific opposite: photographs of southern California sprawl. Such pairings effectively made the case for nature conservation, while at the same time resisting efforts after World War II to redefine the nation's image of California around Los Angeles and its suburban amenities, heralding instead the greenness of northern California over the paving of southern California. Maintaining an ideal of the California landscape that dated to the nineteenth century, Adams insisted that the sublime could still be discovered in northern California, indeed everywhere on the West Coast but Los Angeles—a claim Foulkes disputed forcibly in his contemporaneous paintings of the West.

When art museums exhibited Adams's photographs in the 1960s, curators treated them as the grand culmination of a venerable tradition of western landscape photography. John Szarkowski, appointed director of the Department of Photography at the Museum of Modern Art in 1962, mounted his first major show the following year. The Photographer and the American Landscape began with the practice of frontier photography and climaxed in the twentieth century with Adams. Praising Adams's achievement, Szarkowski exclaimed: "A few have continued to photograph, with conviction and incisiveness, those remaining fragments of the American landscape that recall the original site. The master of these is Ansel Adams. . . . At its best—intense, extroverted, and heroic—Adams' is a major vision." Szarkowski's exhibition was not the first to showcase nineteenth-century photographs of the West. Adams himself had included prints by Alvin Langdon Coburn, William E. Dassonville, George Fiske, William Henry Jackson, Eadweard Muybridge, Timothy H. O'Sullivan, and Carleton Watkins in A Pageant of Photography, organized for the San Francisco Golden Gate International Exposition in 1940; in addition, he and Beaumont Newhall, the founder and first curator of the Department of Photography at MOMA, planned Photographs of the Civil War and the American Frontier at MOMA in 1942.[24] Nevertheless, Szarkowski can claim to have inaugurated and institutionalized at the premier museum of modern art in the United States a history of American landscape photography that had enormous consequence; it ushered in a flurry of exhibitions and scholarly publications on individual photographers of the West that continues to this day.

Szarkowski highlighted prints that in recording extraordinary sites manifested a modernist sensibility favoring sharp focus and simplicity of compositional design.[25] Praising O'Sullivan for his "minimalism," Szarkowski situated him, along with Jackson—but not the more theatrical Muybridge—at the beginning of a visual tradition reinvented in the twentieth century by such modernists as Alfred Stieglitz, Paul Strand, Weston, and Adams. Scholars have subsequently challenged Szarkowski's aesthetic evaluation of landscape photographs and its basis in modernism of the mid-twentieth century by examining the original patronage, publication, and reception of such images.[26] Interests other than Szarkowski's system of aesthetic evaluation guided the federal government as well as the railroad and mining industries when they commissioned photographers to survey and explore the West. Nevertheless, even in the nineteenth century, art galleries displayed landscape photographs, and the American public purchased them not just as documents of wondrous sites but also as aesthetic objects. According to the historian of photography Joel Snyder, Carleton Watkins in particular combined "technical virtuosity and formulas derived from, but not coextensive with, the picturesque and sublime modes of landscape depiction. . . . His photographs were well known through the turn of the century, and his approach was emulated by nearly every important photographer of the American West up to and including Ansel Adams."[27] Whether an aesthetic sensibility inhered in the practice of photographers such as Watkins or Szarkowski imposed it retrospectively, Adams emerged as the linchpin between nineteenth-century photography and twentieth-century modernism.

Szarkowski, in advocating a modernist sensibility in landscape photography, was informed (consciously or not) by a technical and formalist mode of evaluation established in the 1930s by Adams himself. When Adams began to emulate and exhibit nineteenth-century photographs of the West, he treated them according to the aesthetic criteria of "straight photography." In 1932 Adams and other like-minded photographers had organized themselves into Group f/64, so-called after the smallest aperture on the lens of a large-format camera; members of Group f/64, reacting against the soft focus of Pictorialist photography, had adopted a sharply focused lens to capture the essentials of form.[28] The aesthetic stance of Group f/64 indelibly marked Adams's understanding of nineteenth-century precedents as demonstrated by his keen interest in O'Sullivan. Snyder points out that it was actually Adams who rediscovered some of O'Sullivan's survey photographs in 1939 and sent them to Beaumont Newhall, then director of the Department of Photography at MOMA, who in turn exhibited and published them as prototypically modernist.[29] Thus in its appreci-

ation of straight photography Szarkowski's exhibition promoted modernist predilections first defined in the interwar years.[30]

In *The Tetons and Snake River* of 1941, one of four photographs by Adams published in the catalog *The Photographer and the American Landscape,* the morning light breaks through swirling storm clouds to illuminate the snowcapped Tetons on the horizon line, while the Snake River twists through the uninhabited valley floor in the foreground. To capture this view, Adams perfected what he called the process of visualization, whereby he used his technical mastery of his medium to transmit his convictions about nature's grandeur. As the historian of photography Sally Stein cautions, however:

> In many respects visualization could be as manipulative as the Pictorialist technique of manual embellishment it sought to supplant. It was certainly more calculating, while the appearance of manipulation was far more subtle, embedded in the range of mechanical controls so that all effects seemed to emanate from the scene rather than being externally imposed. Given Adams's abiding love of unspoiled nature, it was only fitting that the photographs he made should appear to be wholly natural, that is, direct "objective" recordings of the natural scene.[31]

The technical attributes of the camera and the development process—film, lens, filters, smooth-coated glossy papers—enabled Adams to produce photographs that appeared to be direct recordings of nature at its most dramatic and inspiring. Of course, the success of the entire enterprise depended on the time of day and viewpoint Adams chose. His collaborator Nancy Newhall recalls the hardships Adams readily endured to obtain the perfect shot: "He will get up at any hour, drive all night, or camp out on the spot if necessary in order to have the cameras set up when the high snowpeaks turn ashen, then violet, then glow rose and red and suddenly, gold."[32] He manipulated the photograph so as to ascribe the aesthetic drama of the sublime to the site itself rather than to his artistic intervention or modernist principles.

So deeply did these photographs of sublime nature impress the board of the Sierra Club that it enlisted Adams to the cause of conservation and preservation. The club, founded by the naturalist John Muir in 1892, invited Adams in 1935 to be its representative to a conference in Washington, D.C., on the national and state parks. Adams accepted, undertaking a lifelong commitment to lobby the federal government to safeguard nature as part of the national heritage.[33] In the *Sierra Club Bulletin* in 1945, Adams shared his growing belief that photography should communicate nature's emotional and spiritual grandeur, whether in the land's minutiae or in its magnificence.[34] From 1936, when he

lobbied to transform Kings Canyon into a national park, to 1964, when he campaigned for the ratification of the Wilderness Act, Adams sent his photographs to key members of Congress, hoping that nature's sublimity could sway political convictions. Inspiring awe acquired an instrumentalist function, to encourage preservation of the environment.

Undertaking new tactics to promote conservation, the Sierra Club launched the Exhibit Format series of books at the outset of the 1960s with *This Is the American Earth,* which became a best seller. In it Adams and Newhall assembled examples of utopian and dystopian nature, grounding the distinction in the geography of northern and southern California.[35] Under Adams's photograph of the majestic Sierra Nevada that extended across the opening two pages of *This Is the American Earth,* Newhall's admonition reads: "This, as citizens, we all inherit. This is ours, to love and live upon, and use wisely down all the generations of the future." *This Is the American Earth* does not reserve its respect for remote pristine landscapes in northern California or the Pacific Northwest. San Francisco, which had not only served Adams as a home base but had also consistently granted institutional support to his professional career, apparently embodied for him the harmonious coexistence of nature and culture.[36] In a key photograph of the city that he took from San Bruno Mountain across a forested valley, San Francisco rises in the distance, illuminated by the sun's rays, and spreads along the edge of the land jutting into the bay (figure 9). The photograph casts much of the inland area of the city in shadow, camouflaging urban sprawl. As a consequence, San Francisco glistens like a jewel in the spectacular crown of the bay. The section of the book that includes this photograph asks: "What, to continue their renewal, do air, water, life require of Man?" Opposite Adams's view of San Francisco, Newhall answers: "Only that in cities air and light be clear and enough leaves remain to shadow a living land."

Newhall and Adams's plea to preserve and respect nature gains urgency as they catalog the havoc wreaked on the environment by modernity. The fourth section of the book, "The Mathematics of Survival," details the reckless destruction of nature ensuing from the mindless haste to build in the name of progress:

Hell we are building here on earth.
Headlong, heedless, we rush
 —to pour into air and water poisons and pollutions until dense choking
 palls of smog lie over cities and rivers run black and foul
 —to blast down the hills, bulldoze the trees, scrape bare the fields

> to build predestined slums; until city encroaches on suburb, suburb
> on country, industry on all, and city joins city, jamming the shores,
> filling the valleys, stretching across the plains

The fallen angel Los Angeles exemplifies modernity's pillage. Above Newhall's apocalyptic passage, a grim photograph by William Garnett captures the city engulfed in smog, while three aerial photographs by Garnett on the opposite page feature identical housing developments mushrooming across the land-scape of southern California (figures 10–12). A dizzying aerial view of the Los Angeles basin spreads across the following two pages, revealing a city covered with concrete—the antithesis of Adams's sublime revelation of the Sierra Nevada, which opens the book (figure 13).

Many others, alarmed about rampant growth and increasing pollution in Los Angeles, joined Adams and Newhall in voicing deep concern not only about

10 William Garnett, *Smog, Los Angeles,* 1949. Gelatin silver print, 9 15/16 × 13 3/8 in.
Collection the J. Paul Getty Museum, Los Angeles. © William A. Garnett.

11 William Garnett, *Los Angeles Sprawl,* 1954. Gelatin silver print, 10 3/16 × 13 7/16 in.
Collection the J. Paul Getty Museum, Los Angeles. © William A. Garnett.

12 William Garnett, *Foundation and Slabs, Lakewood, California*, 1950. Gelatin silver print,
7 7/16 × 9 3/8 in. Collection the J. Paul Getty Museum, Los Angeles. © William A. Garnett.

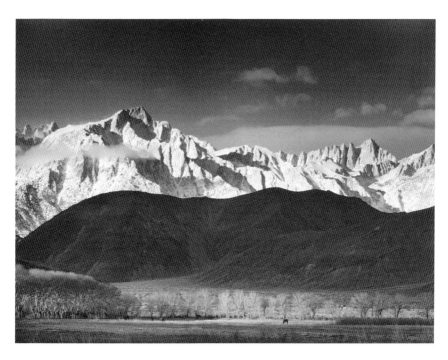

13 Ansel Adams, *Winter Sunrise, the Sierra Nevada from Lone Pine, California*, 1944. Gelatin silver
print, 14 5/8 × 19 3/8 in. Used with permission of the Trustees of the Ansel Adams Publishing Rights
Trust. All Rights Reserved. Collection Center for Creative Photography, University of Arizona.

the city's arrogant disregard for nature but also about the example it set for urban growth throughout the nation. For instance, in the book *Fiat Lux,* a collaborative venture undertaken in the 1960s by Adams and Newhall at the behest of the regents of the University of California to commemorate the university's centennial, Franklin D. Murphy, the chancellor of UCLA, designates solutions to the problems of urban and industrial modernity as the university's central mission:

> California itself, in the 1950's, was facing the problems of sudden and enormous growth. Thousands were coming into the state daily; an average fifteen hundred a day stayed. Cities began to sprawl out through suburb after suburb and merge with the next city. Urbanization was gouging the massive hills, bulldozing the orchards, and filling some of the world's richest agricultural valleys with ill-planned commercial housing. Traffic, snarling the highways, became, during rush hours, unmanageable; freeways began slicing through canyons and along the shores. New industries multiplied. Smog from the automobiles and the industries not only choked the cities, darkening the light and obscuring the distances, but drifting through the mountain passes, killed crops in the inland valleys and damaged even the alpine forests. The need to escape from confusion and pollution and find pure air and clear water, space, quiet and wild beauty, was causing the destruction of these very qualities in the State and National Parks. . . . In 1963 California became the most populous state in the nation. . . . It stood to lose what it most loved and treasured—its magnificent landscape and brilliant climate.[37]

Though claiming to speak about the state of California in general, Murphy focused his critique on the "megalopolis," the term most frequently used at the time to characterize Los Angeles. Moreover, the specifics of his description resonated more with Los Angeles than with, say, San Francisco: his dire statement was printed on a page facing an aerial photograph of the Los Angeles freeways.

As prominent figures were raising concerns about urbanization, *Westways* and *Sunset: The Magazine of Western Living,* home and travel magazines published primarily for regional mass consumption, found no contradiction between sublime nature and a modern, motorized lifestyle on the West Coast. These popular magazines rarely featured Pacific coastal cities and expressed no dismay about either sprawl or tourism. Indeed, beginning in the 1920s, as more and more southern Californians piled into their cars and traveled on newly paved roads, publications such as *Touring Topics* (renamed *Westways* in 1954), the organ of the Automobile Club of Southern California, offered "an urban perspective of nature as recreational, therapeutic, and easily penetrated for con-

sumption."[38] The Automobile Club's magazine began in the 1930s to include photographs of sublime nature by Adams and Weston. Although well into the 1960s it published views of wilderness as far north as British Columbia, as far south as San Diego, and as far east as Montana and Arizona, the magazine increasingly favored photographs of scenic roads wending into the landscape and shots of hikers, campers, skiers, and fishermen enjoying outdoor sports. *Sunset* went even further in promoting a regionally specific lifestyle in harmony with nature, depicting ranch-style homes nestled against mountain slopes and surrounded by eucalyptus trees. When *Westways,* in the mid-1960s, began to publish aerial views of the new freeways snaking through ravines in southern California, citing their convenience and giving advice on navigating them, or photographs heralding skyscrapers under construction on the Westside of Los Angeles, the magazine relied on natural metaphors to characterize the urban landscape: "Through one of Wilshire's condominium *canyons*—the Westwood-Holmby Hills area," proclaimed the caption to one such photograph.[39] The motorized eye could enjoy scenic views of nature on a drive down Wilshire Boulevard between towering skyscrapers or along a winding mountain road.

Did the southern California sprawl pictured from the air terrify magazine readers, or did views of ranch-style homes thrill them with the promise of a new life lived out of doors, with unspoiled nature only a short road trip away? Did photographs of Half Dome encourage preservation, or did they only entice to the national parks the tourists who trampled the very landscape that Adams and others at the Sierra Club fought to preserve? Whatever their stance in these particular debates, photographers increasingly imagined southern California nature as it was made accessible by cars and freeways—that is, a nature absolutely distinct from that experienced by climbers of the soaring peaks of the Sierra Nevada.

The rapid commercialization of Adams's practice gained attention for the awe-inspiring landscape as one located anywhere but in southern California and at the same time undermined his photographic vision of the sublime. After World War II, Adams's photographs were reproduced in multiples as postcards, calendars, and posters. For instance, in 1954 the Standard Oil Company distributed scenic views of nature, including two by Adams, at its gas stations.[40] Adams's photographs set a standard not only for the images published in *Westways* and *Sunset* but also for tourist snapshots in an era when *Time* magazine heralded the amateur photograph as harbinger of a new national folk art.[41] Tourists with cameras quickly transformed Adams's archetype of the sublime into a visual cliché as they rushed to visit and photograph the national parks in the 1950s and 1960s. Adams himself voiced anxious criticism of amateur snapshots in the late

1950s: "It is not at all unlikely that photography may become a 'push button medium.' . . . But in the domain of creative photography we find that such an automatic approach fails dismally."[42] An awareness that commercialization and amateurism had compromised Adams's photographic vision of the sublime underpins some of the published reviews of the grand retrospective of his photographs the M. H. de Young Museum mounted in San Francisco and circulated nationwide. The critic Henry J. Seldis, for instance, acknowledged that "the panoramic visions of the gigantic aspect of nature found in its highest mountains, its tallest trees and its grandest canyons . . . have become the hackneyed hunting grounds of all shutterbugs."[43] Actually Adams's own aesthetic practice made critics question his grasp of the sublime. Even as critics and curators gave Adams institutional recognition, they implied that his style depended on well-established modernist conventions, some apparently dating to the nineteenth century, implicitly out of touch with contemporary photographic tendencies seen in the gritty urban realism of such practitioners as Robert Frank and Garry Winogrand. Commercial reproducibility, amateur imitation, and historicist conventions threatened to drain Adams's sublime vision of its power to overwhelm, except perhaps by virtue of its stark contrast to clumsy mimicry.[44]

Adams's grasp of the sublime was challenged on other fronts as well. Some art critics even maintained that the nineteenth-century sublime had been reinvented not by someone like Adams but by the Abstract Expressionist artist.[45] In a celebrated essay of 1961 the art historian Robert Rosenblum uncovered a connection between Abstract Expressionism and landscape painting of the nineteenth century based on their shared apprehension of the sublime rather than on any similarity in style. Rosenblum, repudiating a purely formalist and intellectual interpretation of Abstract Expressionism (implicitly that of Clement Greenberg), insisted on the emotionally overpowering effect of the large-scale abstract canvases of Barnett Newman, Jackson Pollock, Mark Rothko, and Clyfford Still:

> Much has been written about how these four masters of the Abstract Sublime have rejected the Cubist tradition and replaced its geometric vocabulary and intellectual structure with a new kind of space created by flattened, spreading expanses of light, color and plane. Yet it should not be overlooked that this denial of the Cubist tradition is not only determined by formal needs, but also by emotional ones that, in the anxieties of the atomic age, suddenly seem to correspond with a Romantic tradition of the irrational and the awesome as well as the Romantic vocabulary of boundless energies and limitless spaces.[46]

Clyfford Still, an artist who had developed his signature style in San Francisco while teaching at the California School of Fine Arts between 1946 and 1950, enjoyed special favor in Rosenblum's review.[47] Finding that Still "abandon[ed] measurable reason for mystical empathy," Rosenblum located Still's sublime vision in the geography of the American West: "We move physically across such a picture like a visitor touring the Grand Canyon or journeying to the center of the earth."[48] Critics of Still's paintings had often relied on a topographical vocabulary—"sprawling, ragged-edged terrain," "a dried river bed," "Western skies, limitless plateau"[49]—that resonated with the landscape of the West. Sometimes they were even more explicit in locating Still's paintings geographically, as when the critic Hubert Crehan commented, "There will be those who will respond to the awesome nature images he creates, as if they were on a tour through the national parks. On this level, Still's paintings are an echo of that wonder of what it was like to cross the Great Divide on the Oregon Trail."[50] But it was Rosenblum who fully elaborated on the wonder elicited by Still's abstract topography, so reminiscent of the Grand Canyon.[51]

Rosenblum imagined an astonished viewer on the eve of Abstract Expressionism's fall from grace. Just as the commercial reproduction of Adams's photographs of majestic mountains in calendars, on postcards, and in coffee table books and the imitation of Adams's example by tourists made his views all too familiar, so too in the 1950s the reading public of *Life* magazine became increasingly aware of Abstract Expressionism and collected reproductions of abstract paintings as postcards and posters. Art critics began to predict the demise of the Abstract Expressionist art movement owing to the emergence of second-rate painters churning out formulaic abstract canvases.[52] The advent of Pop art in the early 1960s delivered another blow to the movement by repudiating abstraction in favor of the reproducible commercial image. The ability of either the photograph or the painting to evoke the sublime was in serious trouble by the 1960s, threatened by reproducibility and imitation.

Foulkes acknowledged these troubles in his painting *Mount Hood, Oregon* of 1963 (see plate 4), the year the landscape motif began to dominate his art. The painting recalled the Pacific Northwest of his childhood, but from the perspective of someone trained and living in southern California. Foulkes left his birthplace, Yakima, Washington, just northeast of Mount Hood, to attend Chouinard Art Institute, where he studied painting from 1957 to 1959 with Richard Rubens. Like other emerging young modernists in Los Angeles in the late 1950s and early 1960s, many of whom studied at Chouinard, Foulkes experimented with the verve of Abstract Expressionism, incorporated the found ob-

14 Albert Bierstadt, *Mount Hood, Oregon*, 1865. Oil on canvas, 72 × 120 in. Location unknown. Photograph courtesy of Peters Gallery, Santa Fe.

ject of Assemblage, reproduced the commercial motif of Pop art, and wrestled with the two-dimensional surface of Post-Painterly Abstraction. His art found favor in southern California, and Foulkes had his first one-person show at the Ferus Gallery in 1961. A second major exhibition, at the Pasadena Art Museum in 1962, featured over seventy works, including his first landscape paintings entitled *Geography Lesson*.[53]

By his very selection of Mount Hood as a motif, Foulkes summoned the memory of Albert Bierstadt's operatic paintings of this same mountain peak from the 1860s, such as *Mount Hood* of 1865 (figure 14). Based on sketches Bierstadt made on a trip to the Oregon territory in 1863, *Mount Hood* formulated a particularly theatrical interpretation of the sublime landscape. The mountain, blanketed in fresh snow, rises like a celestial vision on the horizon line to tower over lush green foothills with pine trees and waterfalls. Deer graze quietly on the grass along the edge of Lost Lake, their diminutive size accentuating the monumentality of Mount Hood in the distance. Such paintings, wildly popular in their day, had fallen out of favor by the end of the nineteenth century.[54] Critics continued to voice suspicion about Bierstadt's bombast in reviews published well into the 1960s, often dismissing his romantic paintings of the western land-

scape as overstated, hyperbolic, and defunct. Even at the end of that decade, when revived interest in Bierstadt's grand paintings coincided with a wave of scholarly publications devoted to the so-called Americanness of American art,[55] Bierstadt's bluster still generated unease. In her key book *American Painting of the Nineteenth Century*, the art historian Barbara Novak grudgingly conceded: "The wish to astound and awe the beholder invites a study of rhetoric, and both Church and Bierstadt might be considered from this point of view without the irritation that we habitually feel in the presence of such emotional inflation."[56]

Foulkes in his *Mount Hood, Oregon*, perhaps sharing Novak's reservations, recalled Bierstadt without resuscitating his theatrical technique. Instead of elaborating on the precedent set by Bierstadt or, like Clyfford Still, providing an alternative abstract model of the sublime, Foulkes invited viewers to recognize the extent to which the sublime landscape had itself become a visual cliché in the twentieth century. Indeed Foulkes aligned his painting with photographic reproductions of the landscape. But not with those of Ansel Adams. Rather, as the art historian Peter Selz recounts: "In 1963 . . . [Foulkes] found an old stereoscopic photograph of Mount Hood and, intrigued by the possibilities of the three-dimensional effect achieved by the old-fashioned instrument, he bought an old stereoscope at a junk store and proceeded to paint almost identical pairs of the same scene in paintings that resemble old double photographs."[57]

In basing his painting of Mount Hood on a stereograph, Foulkes paid tribute to the many nineteenth-century photographers, such as Carleton Watkins, who had followed in Bierstadt's footsteps in the 1860s and disseminated stereographs of Mount Hood's peak to the curious. Watkins first traveled to Oregon in 1868 to take stereo and large views of the landscape, and in 1870 he was hired to photograph the volcanic chain along the Pacific coast for the U.S. Geological Survey.[58] Shooting with a twin-lens camera, Watkins took two almost identical photographs, which he mounted side by side to produce a stereographic image. Enjoying enormous popularity in the nineteenth century, these images, according to the cultural historian Richard Maesteller, "satisfied a desire for scientific realism as well as a desire for imaginative flights of fancy."[59] Viewers using a stereoscope to look at such pictures penetrated deep recessional space and observed, in sharp focus, topographical details of distant lands.[60] Continuing to believe in the photograph's ostensible objectivity, even viewers who began to reject Bierstadt's painterly shenanigans in the late nineteenth century could still express wonder at a stereographic view of the western landscape.

The double view of Mount Hood imprints Foulkes's painting with the memory of the stereograph even as *Mount Hood, Oregon* draws attention to its phys-

ical existence as a painting. The very scale of *Mount Hood, Oregon* precludes any-one's viewing it through a stereoscope. Foulkes, further distancing the paint-ing from its source, mimics neither the stereograph's exacting detail nor its spa-tial effect. Instead, he simplifies the peak into a triangular shape, while flattening the mountain slope into stacked masses alternately dark and light. Finally, any distinctions between the two views of Mount Hood in Foulkes's painting result from the paint that delineates the contour and surface striations of the masses, rather than from the distance between the two lenses on a cam-era that cause foreground elements to occupy slightly different positions. With its flattened landscape and painterly surface, *Mount Hood, Oregon* cannot be mistaken for an actual stereograph. If anything, Foulkes in this painting elim-inates the key features—precise detail, sharp focus, deep recession into space—of the stereographic sublime.

Indeed, doubling the view of the mountain re-created neither a majestic landscape scrutinized through a stereoscope nor, as Peter Selz remarked, "a landscape explored on a stroll through the countryside." It gave, instead, "a view observed quickly from a speeding automobile."[61] As if to emphasize further that the double prospect of Mount Hood captures what the driver might take in at a glance, orange hazard stripes frame Foulkes's landscape and situate the viewer on the road.

Mount Hood, Oregon not only duplicates the motorists' perspective on the landscape but also preserves it as a picture postcard. In an assessment of Foulkes's *Kodak* (1964; see figure 5), the critic Anita Ventura conflated the view from a vehicle with that captured by postcards: "The painting is explicitly the vision of the long-distance driver: up against contiguous danger signs as he flashes past a landscape flattened into a remembered post-card by the speed of his glassed-in auto."[62] *Mount Hood, Oregon* makes this connection by referring to postcards in its format. Under the two nearly identical views of the moun-tain peak placed side by side, the words MOUNT HOOD OREGON, stenciled in uppercase letters, transform the double view of the landscape into a postcard enlarged to the size of a painting. A contemporaneous landscape painting by Foulkes actually includes the word "postcard" in bold sans serif type above a mountain ridge (see figure 6). The tourist postcard, commemorating travel with icons of a geographic place, encouraged the cursory glance according to many critics. For instance, Szarkowski argued that postcards resembled other exam-ples of mass-media imagery that were reproduced in multiples, widely dis-seminated, and quickly consumed: "Popular magazines, newspapers, outdoor advertising and television programs are conceived as experiences to be flipped

through, driven past or glanced at."[63] Foulkes's *Mount Hood, Oregon* arrests a modern mode of scanning and, with its nod to such visual memorials as the postcard and the stereograph, preserves it as a historic artifact.

In *Mount Hood, Oregon* Foulkes retains the sublime of nineteenth-century painting and photography only as a trace—in the reference to the site and the doubling of the image—allowing it simultaneously to be remembered and recognized as a thing of the past. Unlike sublime prospects of nature, *Mount Hood, Oregon* delineates neither awe-inspiring peaks nor vertiginous spaces; nor does it solicit a quiet stroll or drive through the scenic landscape, intense observation of topographical details, or astonished sighs before natural wonders. It delivers no display of painterly gusto like that of Clyfford Still's abstract geography. Rather *Mount Hood, Oregon* glances at the landscape, acknowledging how modernity mediates the visual consumption of sublime nature in the Northwest, transforming that landscape into a tourist cliché. An actual encounter with sublime nature in the Northwest proves impossible in Foulkes's art.

Foulkes cited Eagle Rock, a neighborhood where he lived from 1961 to 1979, located on a rise near downtown Los Angeles, as the geographic inspiration for many of his landscape paintings: "The cow and rock images were influenced by the 'Rock' in Eagle Rock, California. One day I drove by it and saw it as a cow's skull. Near it was a black and orange striped construction sign that said 'Hood Construction Company.' I realized the earliest double-image painting called Mt. Hood, Oregon had orange and black stripes."[64] Foulkes, glimpsing nature through the clutter of construction signs, would no doubt have agreed with Adams that the urban landscape of Los Angeles preserved no sublime wonders. Adams documented the soaring peaks, vast deserts, and rocky shores that still remained in the West with a sense of urgency, a concern that the natural landscape, unless preserved, would be sucked into the ever-growing black hole of Los Angeles. Unlike Adams, Foulkes incorporated signs of urbanization into his paintings of the natural landscape but shunned the vision promulgated in *Sunset* and *Westways* of modern western life as motorized yet at ease in nature. If anything, Foulkes, a resident of Los Angeles, was even more pessimistic about nature on the West Coast than Adams. When Foulkes cast his eye on regions outside Los Angeles, he combined nature with reproducible motifs—traffic signs, sans serif type, or photographs—denying any unmediated visual access to the West Coast's sublime landscape. None of his landscape paintings from the 1960s delivers a direct encounter with the region's natural wonders—whether in Death Valley, the Pacific Northwest, or, closer to home, Los Angeles.

Southern California Surf and Sea

Beginning in 1968 Vija Celmins pictured California's other defining natural feature, the swelling ocean. When she undertook a series of drawings based on photographs of the Pacific Ocean that she snapped from the Venice pier, however, she did not locate the sublime in Los Angeles or, for that matter, anywhere else on the West Coast. Nor did she evoke it through scale, producing neither soaring peaks nor large canvases. Instead, in her drawings she covered entire sheets of paper (from 14 by 18 inches to 32 by 43 inches) with stilled waves, mesmerizing in number. The ocean, contained arbitrarily by the borders of these works, implicitly expands beyond them, its vastness unbound. The drawings, in other words, precisely because of their small scale, convey the sublimity of the ocean; as circumscribed views of waves, they are but tokens of unimaginable expansiveness.

Celmins's drawings of the ocean invite an encounter with the sublime that simply ignores the outdoor lifestyle for which Los Angeles became famous in the 1960s. Although, as we have seen, some residents of the city, choking on the smog, raised their voices in alarm, newcomers continued to arrive in southern California, searching for a relaxed year-round life—by the pool, on a sandy beach, in a convertible under a sunny sky. The single-family homes, apartment buildings, and commercial structures sprouting in the city and beyond generally paid less heed to the contours and beauty of the natural site than similar structures in San Francisco—at least according to Adams. Nor did the city integrate into its design lush public oases like Golden Gate Park in San Francisco and Central Park in New York City. Yet Los Angeles did promise escape to the wilderness with a mountain range at its eastern border and deserts readily accessible by car: "Wilderness at the Doorstep," announced *Los Angeles: Portrait of an Extraordinary City,* with photographs of sturdy hikers in the San Gabriel Mountains and of dazzling wildflowers in the Mojave Desert attesting to the unsullied natural landscape on the outskirts of the city.[65] And even nearer, at its western edge, Los Angeles boasted the beach.

Many a Hollywood movie, rock-and-roll lyric, and photograph imagined attractive, healthy bodies pursuing seaside pleasures in southern California. *Los Angeles: Portrait of an Extraordinary City,* under the heading "Exhilaration of Surf and Sea," made the grandiose claim that "few urban areas offer such a variety of activities and facilities as the waterworld that stretches for 100 miles along the Southland's leading edge."[66] The accompanying photographs displayed crowds of (predominantly white) people reveling in a range of leisure activities at the beach: family walks, evening barbeques, swimming, volleyball

15 Max Yavno, *Muscle Beach, Los Angeles*, 1947. Gelatin silver print, 7 3/4 × 13 3/8 in. © 1998
Center for Creative Photography, the University of Arizona Foundation. Collection Center for
Creative Photography, University of Arizona.

games, dune buggy rides, sailing, and fishing.[67] In particular, the beach photographs in the book celebrated the cultivation and display of the body. Numerous photographs—amateur, touristic, fine-art—circulated an ideal of
tanned, taut, and well-toned bodies on the beaches of southern California. It is
not surprising that when the photographer Richard Avedon, with his keen eye
for fashion, visited the beach at Santa Monica in 1963, he focused his lens on
the body beautiful: an adult male, flaunting both his physical strength and
his progeny in an Olympian feat of virility, holds a little boy perched on his
outstretched palm. The body—young, healthy, and vital—triumphed along this
sunny coastline and, in its most extreme form, even emerged as a curiosity
for tourists. In a famous photograph by Max Yavno of Muscle Beach, from 1947,
a throng of spectators, most wearing only bathing suits, jostle one another to
see a muscular man toss a trim woman up into the air (figure 15). Muscle Beach,
an outdoor weight room along the Venice boardwalk, promoted the development and display of hyperbolic muscles for the appraisal of anonymous
passersby. As a caption in a newspaper pictorial on the Southland asserted in
1957: "Cult of the body beautiful comes to full flower at Muscle Beach."[68]

 If the most exaggeratedly fit body type flocked to Muscle Beach, a more attainable version of fitness (at least for teenage boys)—that of the surfer—could

be found on any beach in southern California. As a reporter for *Life* magazine put it: "The Hawaiians started it, but Johnny-come-lately Californians have taken it from there. Now the surf that sweeps in on the beaches bears flotillas of enthusiasts standing on long buoyant boards. Almost every wave carries a 'hot dogger' doing tricks. . . . Surfing, just beginning to catch on around the U.S., has become an established craze in California."[69] When *Life* decided to track the latest southern California trend, it featured the surfer Hugh Foster as a model of the grace and mastery to which other teenage surfers presumably aspired. Despite its nod to the local "hot dogger," *Life* highlighted the sport's sociability with shots of fair-haired boys heading for the beach together in surfwagons, waiting for the perfect wave, and riding their boards. Such coverage sustained the wide interest in surfing initiated in 1959 by the movie *Gidget,* which brought the southern California sport to national attention. *Gidget* tells the tale of a tight-knit group of male surfers who welcome the movie's title character, played by Sandra Dee, into their gang only because she presents herself as a feisty tomboy. Ultimately, however, Gidget ensured the heterosexuality of the sport as she turned Moondoggie's attention from the surfing boys to herself. Many a Beach Boy lyric also coupled surfing with heterosexual courtship, while transforming the sport from a subculture into a southern California lifestyle.[70] Before long, surfing became identified with the state as a whole. When in 1969 *Time* pasted the headline "California: Here It Comes!" across its cover, most of the motifs the magazine had collated into an imaginary California referred, in fact, to southern California—sun, ocean, surfer, bikini babe (see plate 5). The reporter for *Time* even opened his travelog with a drive from Santa Monica to Malibu, where he encountered surfers on the beach. By the late 1960s, in other words, surfing, though characteristic of an emerging southern California lifestyle, contributed to a national ideal of California. The Beach Boys certainly promoted surfing as the state sport and made California the envy of the nation, when they crooned in *Surfin' USA* that everyone else would surf "if everybody had an ocean."

Celmins, whose studio was located in Venice, California, strolled to the end of the pier there to photograph the Pacific Ocean. Turning her back on the sunbathers as well as the robust weightlifters on the beach and the tattered storefronts along the Venice boardwalk, she photographed the waves, without surfers, swimmers, and sailboats. Taping two photographs side by side, she produced a panorama of the ocean, with the horizon line bisecting the vista—a relatively conventional marine view, in other words, though bereft of boats and humans (figure 16). In at least one instance, she covered the sky with a strip of paper (figure 17)—note the traces of two pieces of tape used to hold down the flap—leaving visible only a wide-angle view of the ocean waves. Other times,

16, 17 Vija Celmins, *Working Photograph of Venice Pier*, circa 1965.
Photographs courtesy of Vija Celmins.

instead of gazing out toward the horizon, she tilted her head down and focused
on the waves through the camera's viewfinder, snapping photographs of the
water at a 45-degree angle. These photographs, in which she scrutinized the
surface of waves, served as models for her drawings; with graphite pencil she
re-created waves on paper, larger in the foreground, smaller in the background,
filling entire sheets with them.

The minute graphic marks coalesce to mimic the silvery gray tones of a pho-
tograph. The tonality and reflective surface of Celmins's drawing in figure 18
result chiefly from her choice of pencil and, most important, from her appli-
cation of the graphite marks on paper covered with acrylic ground. Although
she experimented with different grades of pencil, she used only one grade in
each drawing to achieve a particular hue. In an interview with the art historian

18 Vija Celmins, *Untitled (Big Sea #2)*, 1969. Graphite on acrylic ground on paper, 34 × 45 in. Private Collection. Photograph courtesy of McKee Gallery, New York. © Vija Celmins.

Susan Larsen, Celmins comments that the hard H lead has a different quality from the softer B: "I explored this quality in a series of scales . . . fourteen oceans moving from H's to B's. I hit each one like a tone, the graphite itself had an expressive quality." Equally important in bestowing a photographic countenance on a drawing such as *Untitled (Big Sea #2)* of 1969 (figure 18), the pencil marks are so finely, so densely, so uniformly distributed across the page that no sign— for instance, a sweeping line singled out against blank paper—remains to insist on the picture's status as a drawing. Rather the minute pencil marks disappear into the small rippling waves they delineate. In her exchange with Larsen, Celmins notes that her application of graphite actually creates a layer over the paper: "The graphite pencil was a very fine point. It was a matter then of maintaining an even tension so that the surface was just lying there. It was a matter of keeping a certain skin, finding a density that felt right. The paper has a skin and I put another skin on it."[71] The waves, evenly placed across the page and illuminated with a dull consistent light, lack a focal point. Forming a surface membrane over the sheet of paper, they invite the glance, the cursory look

19 Vija Celmins, *Pink Pearl Eraser*, 1967. Acrylic on balsa wood, 6 5/8 × 20 × 3 1/8 in.
Collection of Orange County Museum of Art; gift of Avco Financial Services,
Newport Beach, California. © Vija Celmins.

that from a distance can *almost* mistake drawing for photograph. Sometimes a
drawing even pays direct tribute to the format of a photographic print—for
example, *Untitled (Big Sea #1)* of 1969, in which Celmins left a white border
around the paper.

Even so, the surfaces of her drawings emulate the tonality, precision, and
reflectivity of photographs without being selfsame with their sources. Seen close-
up, the drawings manifest carefully worked pencil strokes that invite a viewer
to study the craft of rendering a wave with graphite. "These drawings became a
kind of record of mindfulness," Celmins reveals to Larsen in their discussion.[72]
The drawings demand attentiveness both on the part of the artist, to draw the
waves with innumerable meticulous, fine touches of graphite, and on the part
of the viewer, to see the handiwork. The drawings thus transform the ocean into
something understandable as an aesthetic feat, knowable in terms of the possi-
bilities and limits of drawing, and contained by the edges of the paper.

The sculptures of erasers and pencils that Celmins completed at the time when
she began her series of drawings of the ocean pay tribute to the tools of her
trade and allegorize her artistic practice: *Pink Pearl Eraser* of 1967 approximates
the color, gummy opacity, rubbed edges, and printed label of a used eraser (fig-
ure 19). As in trompe l'oeil, the material appearance of the sculpture deceives
viewers into mistaking it for an eraser. But its size, 6 5/8 by 20 by 3 1/8 inches,

ensures that no viewer can confuse it with its model, which can be held comfortably in the hand of a child, and requires that a viewer recognize the difficulty of simulating rubber with acrylic on balsa wood. Scale, which prevents any viewer from being taken in by the deception, also invites admiration of the artist's craft. Likewise in Celmins's drawings, the waves of modest size that ripple across the relatively small sheets of paper call for physical proximity and close scrutiny on the part of viewers and their acknowledgment of the skill with which the touch of the pencil emulates the surface of the ocean.

Yet just as the sheet of paper on which Celmins honed her craft cannot contain the incomprehensible ocean or deny its inherent strangeness, neither can craft itself. Indeed, craft transforms the expanse of water into an alien landscape. Consider most photographs of water. Typically these highlight the unpredictable forms of water's liquidity. For instance, Kentaro Nakamura, in his photograph *Evening Wave* of 1926 (figure 20), includes an array of dazzling surface effects: striations as water passes over a rocky ledge, white froth where it crashes into a pool of liquid below, surface ripples as it shifts imperceptibly, illuminated by a ray of light. Or, closer in time to Celmins, Jerry McMillan, in his photograph on the cover of the catalog *West Coast, 1945–1969* (figure 21), reveals the physical attributes of water—a mixture of swirling, bubbling white spume and dark liquid—as it glides onto the sandy shore. Celmins, in contrast to these photographers, converts temporary and accidental waves into solid and still masses. The pencil marks emphasize opacity rather than translucence or reflectivity, palpability rather than wetness, nearly transforming water into earth. The frequent exhibition of these drawings alongside contemporaneous drawings by Celmins of the desert and moon secured the similarity of water to vast, inhospitable lands.[73]

The apprehension of the ocean's strangeness and expanse occurs not just materially—in the resemblance of Celmins's drawings to unfathomable landscapes—but also perceptually. Viewers looking at these works experience a disorienting simultaneity of proximity to, and distance from, the waves. On the one hand, *Untitled (Big Sea #2)* presumes a viewer who stands near the water, looking down at a 45-degree angle. As if unable to lift her head to see the horizon, she scans the ocean's surface, observing larger waves in the foreground and smaller ones in the distance. On the other hand, inasmuch as the stilled, solid waves resemble the craters of *Moon Surface (Luna 9) #2* of 1969, they dislocate viewers from comfortable proximity and propel them to a distant place (figure 22). From there, they look down, as if from a spaceship, onto a slice of alien, empty territory. The drawings, conveying what the eye might

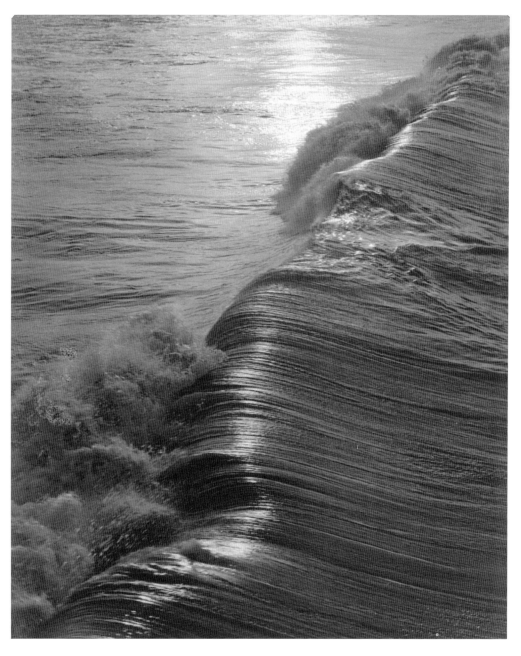

20 Kentaro Nakamura, *Evening Wave*, 1926. Gelatin silver bromide print, 13 9/16 × 10 9/16 in.
Photograph courtesy of Dennis J. Reed.

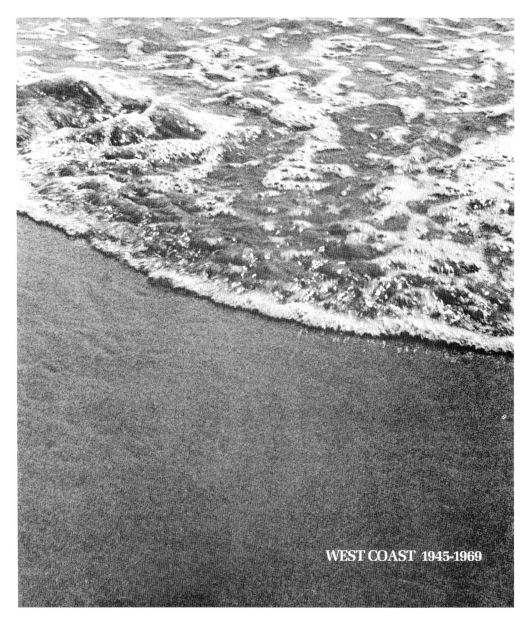

WEST COAST 1945-1969

21 Jerry McMillan, cover photograph of *West Coast, 1945–1969*. Design by Jerry McMillan.
Exhibition at the Norton Simon Museum, 24 November 1969–18 January 1970. Published
in 1969 by the Norton Simon Museum. © Jerry McMillan.

22　Vija Celmins, *Moon Surface (Luna 9) #2*, 1969. Graphite on acrylic ground on paper, 14 × 18 3/4 in. Orange County Museum of Art. Photograph courtesy of McKee Gallery, New York. © Vija Celmins.

see of a landscape, from either a proximate place or a distant perch, bring attention to the limits of human vision—the eye sees only a fragment of an immense terrain—while invoking the sublime scale that extends beyond the edges of the paper, indeed beyond comprehension.

Critics, if and when they attributed Celmins's drawings of the ocean to the environment of southern California, did so for reasons of aesthetics, not motif. For instance, Melinda Wortz, writing in *Artweek,* pointed to location to account for Celmins's choice of medium: "An involvement in perceptual process has long been cited as a recurrent phenomenon in southern California art, as has a sensitivity to ambient light. The latter characteristic is also shared by Celmins. She is attracted to graphite as a medium because of its highly reflective surface."[74]

Reflective surfaces characterized the work of a group of artists alternatively labeled Finish Fetish, Hard-Edge, or L.A. Cool. Beginning around 1965 a slew of major exhibitions and significant articles shone a bright spotlight on these artists for exploiting new materials—fiberglass, Plexiglas, polyester resin, acrylics—to form sleek, gleaming surfaces with radiant optical effects. According to John Coplans, who in these years served as the editor of *Artforum;* chair

of the Art Department at University of California, Irvine; and curator at the Pasadena Art Museum, the materials and surfaces of this new art had a direct link to both the natural surroundings of Los Angeles, its space and light, and the city's technological environment, especially the aerospace and plastic industries. In his introductory essay for the catalog *Ten from Los Angeles,* for an exhibition at the Seattle Art Museum in 1966, Coplans ventured the following pithy account: "A sense of ambience manifests itself in the handling of subject matter, in the overall treatment (by the incorporation of aspects of the intensely reflective quality of California light) and in the relative newness of all surfaces (Los Angeles proliferated within living memory)—for example, by the use of shiny, bright new materials and clean surfaces."[75] When the catalog *West Coast, 1945–1969,* for the exhibition mounted at the Pasadena Art Museum to feature Finish Fetish, reproduced McMillan's photograph of water striking the shoreline on its cover (see figure 21), it cast the ocean as a sign for both a geographic place (the westernmost boundary of Los Angeles) and a new aesthetic practice focused on gleaming surfaces.[76]

Given the vigorous promotion of Finish Fetish in Los Angeles, it is no surprise that a few critics interpreted the craft manifested in Celmins's drawings as exemplifying an aesthetic practice linked to the region. Her motif of the ocean, however, resisted assimilation to geographic place. Although inspired by the snapshots she took from the Venice pier, Celmins's drawings of the ocean never achieved recognition as representations of the Pacific waters swelling there. No sign of the Beach Boys, surfing, and body building—all the superficialities and pleasures of the body mingling with other bodies soaking in the sun or splashing in the water. No view of the shoreline as seen in McMillan's photograph. Instead, Celmins's drawings represent waves mindfully crafted, hypnotically numerous and regular, oddly alien in their opaque solidity, perceptually close and distant. The waves hint at the immensity, the ungraspable wonder of the ocean and of other sublime spaces such as desert and moonscape lying beyond the confines of the paper and the borders of southern California.

Foulkes's paintings and Celmins's drawings, inspired by the stereograph, the fine-art photograph, and the amateur snapshot, emulated the format, pictorial effects, and reproducibility of photographs. Given their choice of landscape motifs, Foulkes in paintings and Celmins in drawings brought attention to the role of photography in defining, circulating, and debasing the ideals of sublime nature that have historically set California apart from the rest of the nation. Com-

ing to terms with photography became the only means of fathoming the sublime, of assessing whether or not it still existed or could be painted or drawn in the wake of the tourist snapshot. Foulkes, developing a dialogue between mechanical reproduction and the handheld paintbrush, reproducibility and originality, ultimately cast doubt on claims of direct access to the sublime in photographs or paintings. Celmins combined the mechanical and handmade so as to make them difficult to discern from each other. Just as the hand replaced the mechanical (the photograph), the hand became mechanical. But neither artist, no matter how he or she resolved the challenges posed by photography's reign over nature, grounded the sublime in southern California as a geographic site. Rather, both artists displaced it to the past or to other vast and expansive spaces. The sublime reemerged in paint and graphite only as a memory, as a glimpse of somewhere else.

In the 1960s the ideal of the California landscape as pristine and majestic existed, if at all, largely thanks to Adams's photographs. Yet Adams and others manifested anxious awareness of the threat the state's industrialization posed to that ideal vision—of California, of the West Coast, and, most important, of nature itself. As a consequence, a number of publications in the 1960s juxtaposed Adams's soaring mountains with fragments of freeway seen from the air that insisted on the horror of concrete extending beyond the photographic view, where it solidified over nature. Celmins viewed the landscape from above as vast tracts of ocean, not suburban homes. Although her drawings evoke the ocean's sheer immensity, they locate the sublime elsewhere, beyond geography. Foulkes, like Celmins, depicted nature, but in his paintings nature could no longer inspire; its sublimity remained only as a trace from the past.

Other artists, however—most artists working in Los Angeles during the 1960s—ignored nature altogether and turned their attention instead to the paving of southern California, not as debased sublime but as dazzling in its own right, an alternative visual aesthetic. These are the artists who will emerge in the chapters that follow.

2

Cruising
Los Angeles

A STANDARD GAS STATION, NORM'S RESTAURANT, 20TH CENTURY FOX: in the 1960s Ed Ruscha envisioned a city defined not by nature but by commercial facades and signage seen from a moving car. Even if few of these structures are landmarks identified with a particular location, they nevertheless evoke the modern infrastructure of Los Angeles that emerged after World War II. His paintings treat Los Angeles as the place of the popular, distinguished by its standardized architecture and mass-produced advertisements. And unlike those who indicted the city as a land of false illusions filled with empty facades, Ruscha's paintings pointed to a dramatic and compelling commercial aesthetic peculiar to Los Angeles. Shifting from painting to photography enabled Ruscha to do more than simply highlight the syntax of the urban environment; he also gave form to its new spatiality. The artist's photographic books about Los Angeles foreground the uniformity of building and space in the city with occasional instances of subversive dissonance. In characterizing Los Angeles by its distinctive aesthetic of commercial facades and its particular configuration of urban space, Ruscha's imagery repudiated both the booster's vision of Los Angeles as a modern city with a center and the doomsayer's outrage about untrammeled growth.

Studs on the Range

Ruscha and his cohorts associated with the Ferus Gallery in Los Angeles flirted with stereotypes of southern California—babes, beaches, cars, the strip—to imagine themselves as a new type of regionally specific artist. In photographs printed on the covers of exhibition catalogs and in the pages of *Artforum*, they fashioned themselves as artist studs roaming the urban range. In so doing they implicated themselves in the clichés about Los Angeles that circulated widely in the popular media, which they took up simultaneously as the motifs of their art.

Dennis Hopper's photographs from the 1960s of painters and sculptors in Los Angeles proclaimed the advent of the artist stud on the West Coast. Hopper, who befriended many of these artists and avidly collected their art, took striking black-and-white photographs of the painters and sculptors who resided in Los Angeles or visited the city during the 1960s.[1] In so doing, Hopper turned his eye away from the romantic ideal of the creative artist exemplified by Arnold Newman's photographs, which focused on the head as the locus of creative genius, and the precedent established by Hans Namuth's images of Abstract Expressionists caught up in frenetic bursts of painting in the studio.[2] Typically

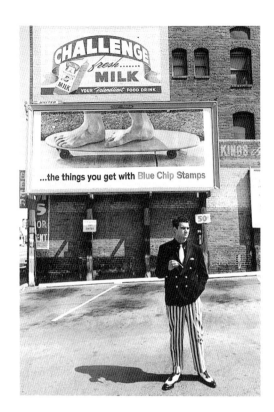

23 Dennis Hopper, *Larry Bell,* 1964. Gelatin silver print,
24 × 16 in. Courtesy of the artist.

24 Dennis Hopper, *Bruce Conner's Physical Services,*
1964. Gelatin silver print. Courtesy of the artist.

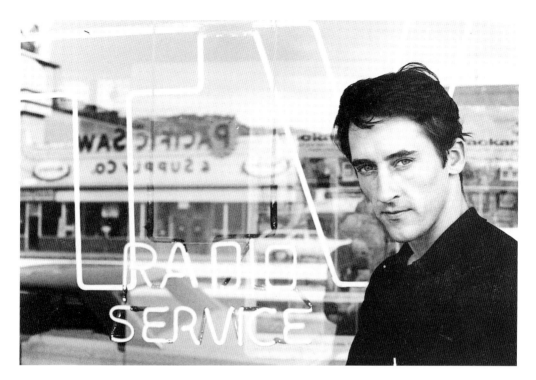

25 Dennis Hopper, *Ed Ruscha*, 1964. Gelatin silver print, 16 × 24 in. Courtesy of the artist.

Hopper instead depicted the Angeleno artists amid the city's signage, store-fronts, and parking lots. Larry Bell, for instance, is the brash and successful businessman qua mafia boss, in pinstripe slacks and double-breasted jacket, standing in a parking lot below two billboards, one promoting Challenge Milk and the other Blue Chip Stamps (figure 23). Sometimes signage in Hopper's photographs does double duty, locating the artist in the city and broadcasting his virility. Clad in a business suit, Bruce Conner poses with four bathing beau-ties, two in scant bikinis, below text promoting a gym club; given the name of the artist and the presence of his companions, the words "Bruce Conner's Phys-ical Services" take on obvious sexual connotations (figure 24). Both of Hopper's photographs from 1964 not only locate the artists in the commercial vernacu-lar of Los Angeles, its anonymously produced billboards and signs, but also present them as young studs thriving in the sun and surf of southern California.

Hopper's photographic portrait of Ruscha from 1964 (figure 25) captures the seductiveness of both the artist and the commercial landscape. The dash-ing young man, dressed in black, poses in front of a neon sign, with the an-gle of his chin and cheekbone perfectly aligned with the V of the letters "TV,"

26 Ed Ruscha, advertisement, *Artforum*, September 1964.

as if to merge with the neon and the glitzy commerce and entertainment it represents. Ruscha coolly catches our eye, drawing our attention to the urban drama of commercial signs and facades. Hopper's composition casts Ruscha as both reflected in and reflecting on an urban landscape whose commercial signage becomes, through that reflection, anything but mundane. Indeed it even promises the frisson of sex; debonair Ruscha may well be ensnared by the commercial landscape, but he also seduces it while inviting us to take pleasure in his conquest.

In addition to posing for Hopper, Ruscha and other young L.A. artists exploited advertising culture—placing outrageous photographs in the art press—to promote their identity as studs as much as their art. A full-page advertisement in *Artforum* in September 1964 announcing Ruscha's solo exhibition at

the Ferus Gallery plays around with the V-shape of the chevron (figure 26). Ruscha's fellow southern Californian Billy Al Bengston had used it in 1960 to mimic sergeant's stripes, enveloping the shape in the dazzling colors and optical effects of 1960s motorcycle, car, and drug subcultures. The connotations of masculinity it derived from such allusions resonated with Bengston's titles, which often referred to male movie stars, ranging from the acrobatic comedian Buster Keaton to the tough guy John Wayne. In the advertisement for Ruscha's exhibit, the shape appears first as a word on the Chevron National Credit Card that peaks out from the fashionable model's plunging neckline. That neckline is itself an inverted chevron of the sort displayed on the logo of Chevron gas stations. The image relates less to the commercial, militaristic, and macho heritage of the shape than to an age-old Hollywood formula—the affiliation between art, money, cars, and sex. The advertisement may even feminize the chevron by inverting it and turning it into cleavage.

Three years later, in January 1967, one month before he married Danna Knego, Ruscha took out an announcement in *Artforum* in which he appears in bed between two women over the caption "Ed Ruscha says goodbye to college joys" (figure 27). Here Ruscha staged a scenario recalling advertisements for contemporaneous sexploitation films (such as the posters promoting Russ Meyer movies that invited viewers to glimpse the pleasures of a ménage à trois) and by aligning himself with the presumed promiscuity of college students, thought to be on the forefront of the sexual revolution.[3] Seen in contrast to the generally serious small-scale advertisements for exhibitions published in the opening and closing pages of *Artforum*—typically characterized by brief, informative text and a single illustrative artwork—Ruscha's high jinks in the magazine could be read as youthful brazenness and Hollywood crassness humorously invading the hallowed territory of the highbrow art world. Alternatively, the advertisements could promote the tale that the promising young artist, ensnared by the city of Los Angeles, had mortgaged his soul to that fickle goddess, Hollywood.[4]

Ruscha joined other male artists affiliated with the Ferus Gallery who flaunted themselves as studs, circulating in the print media photographs featuring their exploits in bed, on surfboards (see figure 1), and on motorcycles (figure 28). Ruscha, in particular, moved easily between his Ferus buddies and his female companions, who hailed from Hollywood. As the curator Jay Belloli writes of California Pop artists: "They didn't paint movie stars; at least, if they were Ed Ruscha, they dated them. They made customized cars and ultimately bought fancier ones, raced motorcycles, surfed, and did many of the things that were

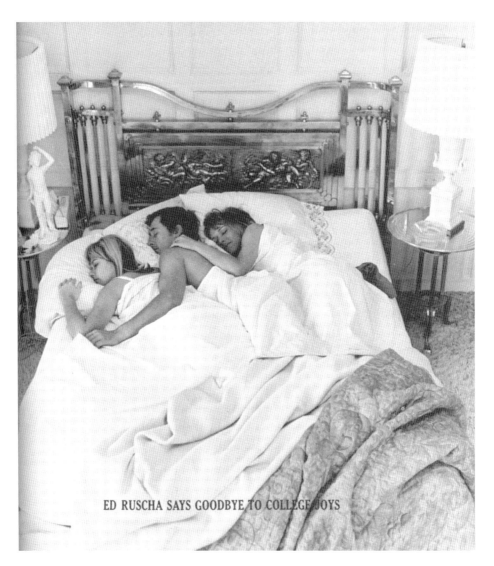

ED RUSCHA SAYS GOODBYE TO COLLEGE JOYS

27 Ed Ruscha, advertisement, *Artforum*, January 1967.

the pop dreams of American youth growing up in the '40s and '50s."[5] Ruscha in bed with two women, Price balanced on a surfboard, and Bengston astride a motorcycle: these artists constructed their personas as cocky young men by taking part, with obvious enjoyment, in the clichéd activities associated with Los Angeles.

Their presentation of themselves as virile artists was evidently self-conscious, even tongue-in-cheek. The drawing on the cover of a catalog entitled *The Studs,* printed for a show featuring the work of Robert Irwin, Edward Moses, Bengston, and Price at the Ferus Gallery in 1964, plays on the epithet (figure 29): the male

28 Billy Al Bengston exhibition announcement, Ferus Gallery, 1961. Collection of the artist.
Photograph courtesy of Los Angeles County Museum of Art.

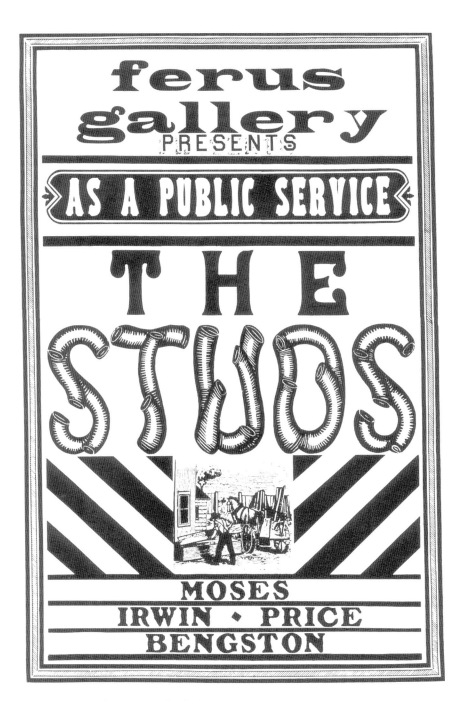

29 Cover of Ferus Gallery catalog *The Studs*, 1964.

sexual champion, but also the wood uprights of the house built by the small depicted pioneer. The protuberances that form the word "studs"—are they limp macaronis or semi-erect penises?—overlap and lean gently toward each other as if yearning to create a homosocial community of mod-1960s frontiersmen, while alluding to the precariousness of this barely whispered wish. At least in this instance, their playing with the image of southern California machismo hinted at the tentativeness of their pose.

Overwhelmingly, however, imagery promoting the artists affiliated with the Ferus Gallery portrayed a new type of creator: young, handsome, heterosexual, and inspired by a hedonistic California lifestyle. Hopper's photograph of Ruscha (see figure 25) artfully combines what at first may seem separate realms: Ruscha's *Artforum* advertisements, in which he appears with female companions and displays his virility, and his paintings and photographs of the urban landscape, typically emptied of bodies and other signs of sexuality. Hopper's photograph reveals how much Ruscha's identity as a stud implicitly framed his paintings as an expression of heterosexual seduction and triumph, in contrast to, say, Warhol's swish persona, which situated his imagery of commercial culture within the queer dynamics of camp.[6]

Aesthetics of the Facade

Ruscha's art, much like his self-presentation as a Hollywood playboy—flirting knowingly, perhaps dangerously, with stereotypes about Los Angeles—managed to do more than merely reflect the surrounding city. In 1956, attracted to the promise of professional opportunity and a relaxed lifestyle, Ruscha drove his Ford along Route 66 from Oklahoma City to Los Angeles, intending to become a commercial artist. During the 1960s Ruscha emerged as one of the two most famous Pop artists in California who took Los Angeles as the central motif of their art. (The other was David Hockney.) Eventually, in the 1970s, the New York art dealer Leo Castelli took him up, and Ruscha had his first museum retrospective in 1982. In many respects, his career exemplified how an important art scene developed in Los Angeles. His art contributed to the idea that Los Angeles could sustain a vibrant art community as it also repudiated the booster's vision of Los Angeles as a traditional city with a center and saw the city instead as one with a particular aesthetic of commercial signage.

In both the painting *Large Trademark with Eight Spotlights* (see plate 6) of 1962 and the screenprint *Hollywood* (see plate 7) of 1968, Ruscha featured an

environment dominated by commercial signs, specifically those promoting the movie industry in Los Angeles. The signs Ruscha depicts loom larger than life: these oversize images—*Trademark* measures over 5 1/2 by 11 feet, while *Hollywood* is 17 1/2 by 44 7/16 inches, a monumental size for a print—have the horizontal sweep of the movie screen. The proportions of the Hollywood print more specifically mimic the Cinemascope screen, the filming and projection system first introduced by 20th Century Fox in 1953 that offered a wide-screen ratio of 2.55:1.[7] In *Large Trademark with Eight Spotlights,* the 20th Century Fox logo dominates the nighttime sky, its bold red letters crowned by eight beams of yellow light filling the upper left corner; stark white structural elements seen from below—as if the thing were an enormous building—recede at a dramatic diagonal across the right side of the canvas. To make the word "Hollywood," Ruscha transposed the letters of the Hollywood sign from their actual location, on the slope of the Santa Monica Mountains, to the crest of the ridge. The increasing size of the letters from "H" to "D" suggests deep spatial recession; the letters themselves glow in the golden light created by a sunset lifted straight out of a western. In neither picture, however, does anything exist beyond these signs, which dominate the landscape. No movie theater, but only the words 20th Century Fox: a Hollywood sign to read, but no Hollywood to see. All the same, these signs are replete with telling, almost visceral, references to the movies, to the legendary neighborhood where it all started, to "the industry," as the movie business is called in Los Angeles. These commercial signs present Los Angeles as a series of dramatic facades that arrest the eye and trigger associations.

Plenty of Hollywood, then, but not only Hollywood; there is art here too. Even as Ruscha's images draw attention to the signs of the industry, they manipulate those commercial surfaces so as to highlight the hand of the abstract artist trained to master color, shape, and perspective with the precision of a Piet Mondrian or, closer to home, John McLaughlin. All this is to say that Ruscha's pictures find common ground between commercial signs, themselves exemplary of such manipulation, and modern art—and do so under the aegis of *design.* Ruscha's own training may help to account for that successful match. He studied at the Chouinard Art Institute from 1956 to 1960, the year before the local art school, established in 1921 by Nelbert Chouinard—and serving from its inception as training ground for the Disney studios—changed its name to the California Institute of the Arts, or Cal Arts, as it is known today. During Ruscha's years at Chouinard a student spent the first year mastering the elements and principles of design and, as a course catalog stated succinctly: "After basic training the student proceeds to a practical application of design principles to work in his chosen field, whether fine arts or any of the commercial

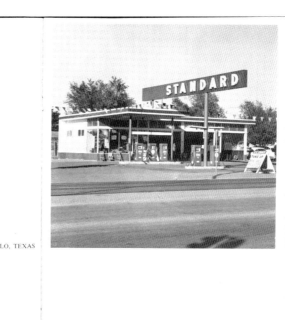

STANDARD, AMARILLO, TEXAS

30 Ed Ruscha, *Twentysix Gasoline Stations* (detail), 1962. Artist's book with photomechanical reproductions, 7 × 5 1/2 in. Photograph courtesy of Gagosian Gallery. © Ed Ruscha.

arts."[8] Ruscha worked at a fine arts press for six months after leaving the school, and also found employment at an advertising agency. During the 1960s, while he pursued a career as a fine artist, he did layouts—design work—for *Artforum* under the pseudonym Eddie Russia (a playful reference to a typical mispronunciation of his name and a wink to cold war fears). Ruscha's training in design manifested itself not only in his ability to move easily between the commercial and fine arts, but also in his emphasis on design and structure in his paintings of southern California signs.

That Ruscha's images underscore the design of commercial signs while presenting them as facades is particularly evident in a comparison of the painting *Standard Station, Amarillo, Texas* of 1963 (see plate 8) to the photograph on which it is based, taken by Ruscha himself and included in his book of 1963, *Twentysix Gasoline Stations* (figure 30). The photograph, in a relatively straightforward documentary style, adopts a banal point of view that, from the middle distance, frames the building at a 45-degree angle. A plethora of details, ranging from flags hanging overhead to tires leaning on the interior wall of the garage, bespeak the building's various practical functions. In the context of the book, the Amarillo Standard station looks diminutive, one of a series of small photographs

cataloging different styles of gas stations that dot the landscape between Los Angeles and Texas. In contrast, the painting, borrowing its two-point perspective, the bold use of red and white, and even the beams of light from *Large Trademark with Eight Spotlights,* transforms the Standard sign and gas station into a visually arresting design of simplified forms, saturated colors, and plunging perspective. This painted gas station, now all high-design razzle, has been transported, as if by magic, from the dust bowl of WPA photographers to the aesthetic wonderland of Tinseltown's glitz.

"Los Angeles to me is like a series of store front planes, that are all vertical from the street. There's nothing behind them; it's all façade here. That's what intrigues me about the whole city of Los Angeles. It's the facadedness of the whole place," Ruscha has famously remarked.[9] Other visitors also drawn to the "facadedness" of Los Angeles tended to be more judgmental, often treating physical surfaces as metaphors for the superficiality and false illusions of the city and its inhabitants. For instance, when Robert Frank drove through Los Angeles in 1956 and when Diane Arbus traveled there in 1963, each photographed facades—of signs, of buildings—in black and white. In contrast to Ruscha's screenprint *Hollywood,* its letters bathed in the golden hues of a Technicolor sunset, Frank singles out the "H" of the Hollywood sign rising from the rugged terrain of Mt. Lee (figure 31). He looks at the sign from behind and slightly above, showing its metal frame and the support beams propping up the letters, just as Toto in *The Wizard of Oz* reveals a fellow with a balding pate behind the curtain. It's all humbug. Frank gives us Hollywood, stripped of its glamour, its stark reality exposed, including the armature behind the sign, the weeds encircling the base of the letters, the twinkling lights of the L.A. basin glimpsed through fog—or is it smog? Arbus likewise gravitates to a facade, in Hollywood no less, to unmask the glittery illusions of the movie industry. In *A House on a Hill, Hollywood, California, 1963,* a three-story building dominates an incline overgrown with dry scrub. Yet Arbus, by taking her photograph at a 45-degree angle from the bottom of the slope, insists that viewers acknowledge the scaffolding that buttresses the regal facade. As the historian of photography Carol Armstrong thoughtfully comments: "The building's difference from a gothic ruin is urged by the photograph's deadpan title and the double-take realization that this must be a Hollywood set, a counterfeit habitation forsaken of its ersatz uses at some indeterminate time likely not so very long ago. This is a picture of the movies, we are all of a sudden reminded, and the past that it evokes is that of movieland illusions."[10] The disclosure of armature in both photographs strips the facade of its power to conjure wondrous fantasies. In contrast,

31 Robert Frank, *"H" for Hollywood Sign,* 1956. Gelatin silver print, 12 7/8 × 8 1/2 in. Gift of Bowen H. McCoy. Photograph courtesy of Iris and B. Gerald Cantor Center for Visual Arts, Stanford University.

Ruscha's paintings, instead of removing masks to reveal reality, capitalize on the reality of the facade itself.

Not all of Ruscha's paintings depict facades and signs, but even those that do not rely on those subjects manage to capture the city with an aesthetic akin to the design principles of commercial signage. Consider *The Los Angeles County Museum of Art on Fire* (see plate 9), painted between 1965 and 1968. This painting portrays precisely that institution around which urban boosters strove to define Los Angeles as a new cultural center. The viewpoint Ruscha adopts, in fact, closely matches that in aerial photographs of the museum typically published alongside articles trumpeting the opening of William Pereira's museum complex in 1965. Yet the structure in Ruscha's painting is not really a building: with its roof stripped of ventilation ducts and other mechanical equipment, it resembles the architect's model more than the actual museum. Ruscha gives us a sign of the building, in other words, rather than the building itself. Nor does he site the structure in its actual urban landscape. Instead, he surrounds it with a yellow haze and sets it on top of a blue reflective surface. (Originally, a pool of water surrounded the plaza on which the three museum pavilions stood.) In Ruscha's rendition, the buildings look absolutely sterile, more like an abandoned casino in the flat desert landscape than a museum at the center of a city. If it were a casino, however, brightly lit signs would cover its facade— precisely the sort of commercial signage to which this stark modernist structure was presumably meant to stand in noble contrast. Unlike Ruscha's images of commercial signs, which locate visual excitement in the design elements of size and bright color, the boxes of the museum seem worthy of the artist's attention, and by extension ours, only when they are being destroyed by fire. It is as if Ruscha were claiming that without this fictive conflagration, the Los Angeles County Museum of Art (LACMA) could not hold a candle to commercial signage as a landmark for the city. The museum, Ruscha proposes, needs this fire as its sign.

The flames, however, seem more than a surface effect. The fire, much like the sunset in Ruscha's painting of the Hollywood sign, begs to be read referentially, as a comment on the ills of the city. Critics have been known to attribute the bright colors of Ruscha's sunsets to smog, and they have likewise interpreted the fire in *The Los Angeles County Museum of Art on Fire* as an evocation of the Watts riots, which erupted in the city, if not this neighborhood, in August 1965. "At the time of the 1965 Watts riots," the novelist Joan Didion recalls, "what struck the imagination most indelibly were the fires. For days one could drive the Harbor Freeway and see the city on fire, just as we had always known

it would be in the end."[11] Does the fire, by alluding to social upheaval, comment ironically on the booster's hope, embodied in the museum, that Los Angeles would emerge in the 1960s as a thriving city and cultural center? The very size of the canvas—its 11-foot width made it the largest canvas Ruscha had painted to date—seems to mimic and perhaps thus to mock the pretensions of the museum and the city. Commentators have also tied the fire in Ruscha's painting to more trivial matters that deflated the grandiose ambitions of the museum, namely the many administrative squabbles that plagued the institution during these formative years.[12]

It would be a mistake, however, to push such referential readings too far. Ruscha was asked: "The fire and damage and violence generally, do you think that's a reflection of the American scene?" We need to take his answer seriously. He replied "No that has nothing to do with it. Absolutely nothing to do with the destruction and people carrying guns around. No, it's visual."[13] Indeed, the canvas is hardly a political polemic: it delivers no obvious moral verdict on the riots, the city of Los Angeles, or even the museum's mundane administrative disputes. Ruscha never resorts to the apocalyptic tone of either Joan Didion's extravagant prose about the Watts fires or the photographic views of fires raging out of control and engulfing private property that were published in the pages of popular news magazines of the day. If anything, in fact, Ruscha's is a picture that flirts with prettiness—the flames light up the sky with a soft yellow glow that gently envelops the sterile building.

Moreover, the fires that break out in Ruscha's other works from the period diminish the credibility of a charged referential reading of *The Los Angeles County Museum of Art on Fire*. Ruscha's book *Various Small Fires and Milk* of 1964, which inventories such flaming objects as a torch and a cigar, as well as his paintings *Damage* of 1964 and *Norms, La Cienega on Fire* of 1964, predate the painting of *The Los Angeles County Museum of Art on Fire* and the litany of social ills to which it may refer. The only other canvases he completed after the riots that featured fires—two versions of the Standard gas station on fire, one painted between 1965 and 1966 and the other between 1966 and 1969—cannot maintain the referential freight that commentators have loaded on *The Los Angeles County Museum of Art on Fire*. In these two works it is only a gas station being engulfed in flames.

This is not to say that the gas stations on fire have not been interpreted as social commentary. Critics have suggested that the fires in these canvases pass no judgment on the city's race relations but cast aspersions on deadening conformity. As Dave Hickey wrote in the catalog for Ruscha's one-person retro-

spective at the San Francisco Museum of Modern Art: "It wasn't a standardized station but a station which dispensed standards, like a restaurant which served norms, or a museum which did both."[14]

In all these canvases, however, the design of the fire and its relation to the building's own plan rivets attention as much as any social reference ever could. The swirling flames and smoke that consume the gas pumps in *The Burning Gas Station* of 1969, for instance, establish a stark contrast between the formlessness of the fire and the sharp lines of the station.[15] The flames in *Norms, La Cienega on Fire* nicely extend the red structural elements of the restaurant's distinctive facade and stacked-lozenge sign, while the orthogonal of the roofline continues beyond where the building ends, to the lower-right corner of the canvas (see plate 10). The pencil markings sketching out the remaining architectural features of the building visible on the surface of the painting also testify to the importance of the design process. Finally, the horizontal patches of blue paint hovering above the restaurant or the swatches of red articulating the flames suggest that the sky and fire are an effect of paint rather than nature. *The Los Angeles County Museum of Art on Fire,* accordingly, might be one in a series of works that Ruscha initiated in 1964 and produced over a number of years that explore the motif of fire not as a means of moral judgment, but as a source of visual excitement ignited by a combination of design and painterliness. These paintings, representing the urban landscape of Los Angeles, always keep the formal and the referential in play, neither canceling out the other.

The drama of fires and sunsets in some of Ruscha's canvases, even the rare appearance of natural topography, such as the mountains in Hollywood, might seem to tie the artist into the long heritage of western landscape painting in which the West is a place of sublime, if sometimes dangerous, beauty. I discussed in chapter 1 how in the nineteenth century painters such as Albert Bierstadt began to define the West by its unique and dramatic topography, featuring distinctive sites such as Yosemite Valley. Bierstadt at Yosemite and others of his ilk throughout the West characterized the region in scenes portraying a majestic and forbidding landscape, often bathed in theatrical light. Ansel Adams's photographs, often approximating Bierstadt's perspective and motifs, reinvented that legacy according to mid-twentieth-century principles of modernist formalism.

Even Ruscha's contemporaries Richard Diebenkorn and Wayne Thiebaud, in their depictions of northern California, can be seen to have worked in the visual tradition established by nineteenth-century landscape painting, defining the West by its distinctive topography and light. Diebenkorn's *View from the Porch*

32 Richard Diebenkorn, *View from the Porch*, 1959. Oil on canvas, 70 × 66 in. Collection of Harry W.
and Mary Margaret Anderson. © Estate of Richard Diebenkorn. Photograph by Lee Fatherree.

of 1959, in contrast to Bierstadt's wild, magisterial mountains, presents a mundane, indeed domesticated, pastoral landscape, with home in the foreground and softly rolling hills in the background (figure 32). Nevertheless, Diebenkorn's view, like Bierstadt's paintings of Yosemite, identifies place by emphasizing the distinctive silhouette of the scenery and by featuring the vegetation and light peculiar to the region. In a similar spirit, Thiebaud's paintings of San Francisco, such as *Curved Intersection* of 1979, glorify the city in exaggerating, to the threshold of geographic caricature, its vertiginous drops and rises and the startling, crisp vistas such a topography affords—coupling that treatment with the distinctive light of northern California.

How might we position Ruscha in relation to this long-lasting and malleable

tradition heralding the uniqueness of the western landscape? On the one hand, Ruscha's works—with their regionally specific light, their Cinemascopic sublimity, their dramatic atmospheric, if not indeed conflagrant effects—celebrate the particularity of the southern Californian landscape. On the other hand, his images seem to lack—or perhaps avoid—precisely that tradition's sense that the West comes by its uniqueness naturally, which is to say, owing to its natural characteristics. Thiebaud may depict the heart of the city, but the odd contours of its roads derive from a geographic abruptness already present in the natural site on which civilization has imposed itself; Diebenkorn in northern California peers through a porch but as if to get past that architectural feature to a topographic expanse that not only maintains its basic shape from a previous era but also shows only limited traces of urban development. Ruscha's paintings always emphasize the built over the natural environment. The Hollywood sign reshapes the crest of the Santa Monica Mountains. Flames reminiscent of the stylized flaming applied to automobiles by Von Dutch, the famous car customizer from Los Angeles, consume gas stations and restaurants; the museum floats on a pond of purely human manufacture. Even the sunset in the *Hollywood* print probably owes its intense ruddiness to the ubiquitous smog. All this is not to say that nature is absent in Ruscha's works: it is always there, in fact—if not in the Hollywood Hills, then at least implicitly in sun-drenched architecture. The point is that Ruscha's aesthetic, unlike the archetype represented by Bierstadt, does not presume that the purpose of nature in the West is to redeem the ills of overcivilization, exemplified by the cities of the East. Nature and the signs of society do not oppose each other in Ruscha's Los Angeles; the sunset in the *Hollywood* print evokes commercial western movies as much as it depicts the Santa Monica Mountains. Nature here, in short, is yet another sign (of the natural); and as such it melds perfectly with signs for, say, the movies or for gasoline. Reyner Banham, a British admirer of Ruscha and an influential writer on architecture, design, and popular culture, adopted the artist's tastes as his own for all intents and purposes when he wrote his book *Los Angeles: The Architecture of Four Ecologies* in 1971 and extolled "the light in which I personally delight to drive down the last leg of Wilshire towards the sea, watching the fluorescence of the electric signs mingling with the cheap but invariably emotive colours of the Santa Monica sunset."[16] For Banham the intermingling of natural and artificial light and, more than that, a sunset, which Banham illustrates with Ruscha's screenprint *Hollywood,* owe their character to the delightfully "cheap" filmic tricks of Tinseltown itself.

In the end, the positing of compatibilities under the aegis of the sign as ex-

emplified by Ruscha emerged as a widespread aesthetic in characterizations of Los Angeles—and not only in Banham's written account. Consider, for instance, Diebenkorn's series of Ocean Park canvases, produced after the artist had moved to southern California and set up his studio not far south of where Banham drove his car into the Santa Monica sunset. Redolent of southern Californian light, colored in the hues of verdant lawn, blond sand, and sparkling sea, Diebenkorn's canvases have long been praised for evoking both the semitropical natural splendor and the freeway system of the Los Angeles region seen from the air.[17] And yet the form of the pictures—their flatness (markedly different from the spatial recession of the Berkeley paintings), their constant reliance on rectilinear elements; above all else, their signature incorporation of the chevrons and diagonals that recall Ruscha's glosses on southern California architecture—cast such nature as yet one more sign in and of the city (figure 33).

Ruscha's aesthetic of the sign recast the western landscape, then, to efface the opposition between nature and human artifice. But it could do more than even that. Ruscha's signs split the difference between high art and commercial display. His works—and by extension Diebenkorn's—may well have managed to set up, by analogy, parallel sets of compatibilities, resolving the dichotomy between high art and commercial culture much as they resolved that between nature and artifice. Ruscha's *Hollywood* print, mounted as a billboard (reversed in this instance to allow it to slip into view in the rearview mirror) across the street from the Los Angeles County Museum of Art is a case in point (see plate 11).[18] It would be hard—indeed, it would be meaningless—to determine whether the backward image on the board owed more to the paintings hanging in the galleries across the street or to the advertisement for Salem cigarettes soaring overhead. Likewise, Diebenkorn's brushstrokes and lines may speak equally well of ocean waves or the misregistrations of a badly installed billboard, or the stylistic precedent of an Abstract Expressionist artist such as Willem de Kooning. Whereas once high art—or, more precisely, whereas once high art in the East—had need to distance itself from the popular to maintain its critical stance, by the time we get to Ocean Park, high-art painting—with all its abstractions and painterly finesse, of which Diebenkorn was so famously capable—attained its heights precisely by joining Banham in that neon-laced drive down to the Santa Monica Bay. Once again, Banham exemplifies this sensibility: his Los Angeles is not only both neon and sunset, it is also both the high modernism of Richard Neutra's Lovell house of 1929 and the commercial kitsch of the Brown Derby restaurant. The author, like the artist Ruscha, revels in the ultimate compatibility of the high and low.

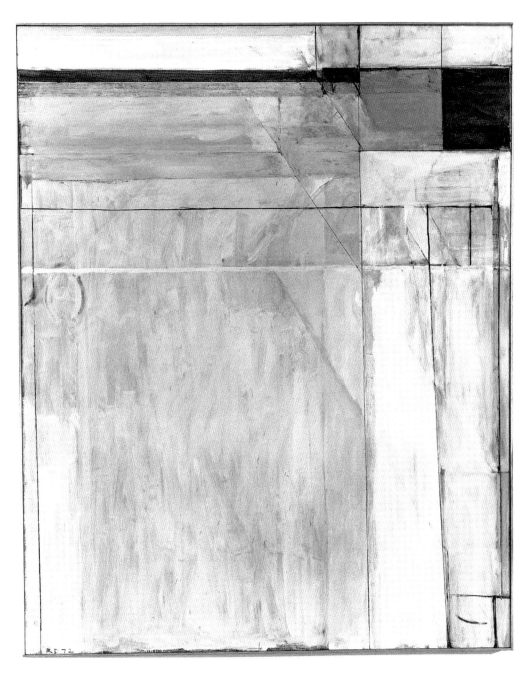

33 Richard Diebenkorn, *Ocean Park #54*, 1972. Oil on canvas, 100 × 81 in.
San Francisco Museum of Modern Art; gift of Friends of Gerald Nordland.
© Estate of Richard Diebenkorn. Photograph by Don Myer.

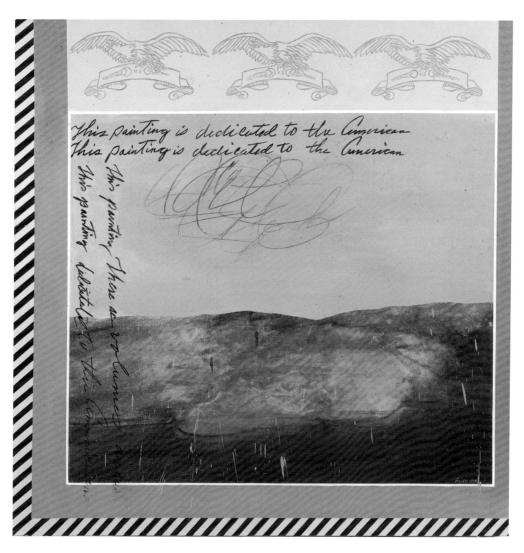

1 Llyn Foulkes, *Death Valley, USA*, 1963. Oil on canvas, 65 1/2 × 64 3/4 in.
Photograph courtesy of Betty and Monte Factor. © Llyn Foulkes.

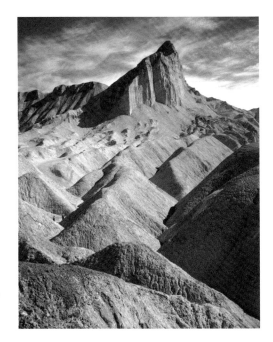

2 Ansel Adams, *Manley Beacon, Death Valley*, circa 1952. Posthumous digital reproduction from original transparency. Used with permission of the Trustees of the Ansel Adams Publishing Rights Trust. All Rights Reserved. Collection Center for Creative Photography, University of Arizona.

3 Ansel Adams, *Sunrise, Telescope Peak, Death Valley*, circa 1952. Posthumous digital reproduction from original transparency. Used with permission of the Trustees of the Ansel Adams Publishing Rights Trust. All Rights Reserved. Collection Center for Creative Photography, University of Arizona.

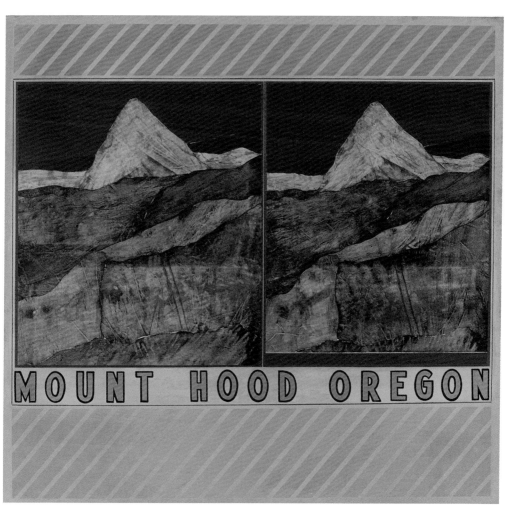

4 Llyn Foulkes, *Mount Hood, Oregon,* 1963. Oil on canvas, 87 1/2 × 84 1/2 in. Photograph courtesy of MUMOK, Museum Moderner Kunst Stiftung Ludwig, Vienna. © Llyn Foulkes.

5 Milton Glazer, "California: Here It Comes!" 1969. Foldout cover of *Time* magazine, 7 November 1969. Photograph courtesy of Getty Images.

6 Ed Ruscha, *Large Trademark with Eight Spotlights*, 1962. Oil on canvas, 66 3/4 × 133 1/4 in. Photograph courtesy of Gagosian Gallery. © Ed Ruscha.

7　Ed Ruscha, *Hollywood*, 1968. Screenprint, 17 1/2 × 44 7/16 in. Los Angeles County Museum of Art, Museum Acquisition Fund. Photograph copyright 2004 Museum Associates/LACMA. © Ed Ruscha.

8　Ed Ruscha, *Standard Station, Amarillo, Texas*, 1963. Oil on canvas, 65 × 124 in. Hood Museum of Art, Dartmouth College, Hanover, New Hampshire; gift of James J. Meeker, class of 1958, in memory of Lee English. Photograph courtesy of Gagosian Gallery. © Ed Ruscha.

9 Ed Ruscha, *The Los Angeles County Museum of Art on Fire*, 1965–1968. Oil on canvas, 53 1/2 × 133 1/2 in. Photograph courtesy of Gagosian Gallery. © Ed Ruscha.

10 Ed Ruscha, *Norms, La Cienega on Fire*, 1964. Oil on canvas, 64 1/2 × 124 1/2 in. Photograph courtesy of the Broad Art Foundation. © Ed Ruscha.

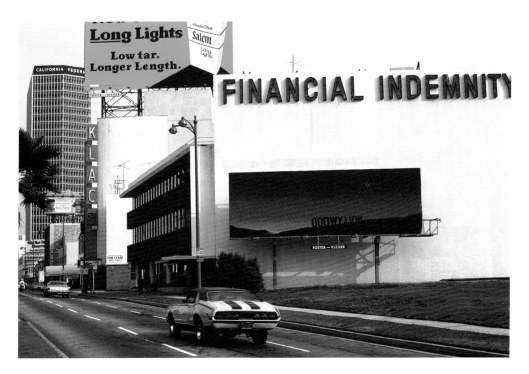

11 Robert Landau, photograph of Ed Ruscha billboard, 1977. © Robert Landau.

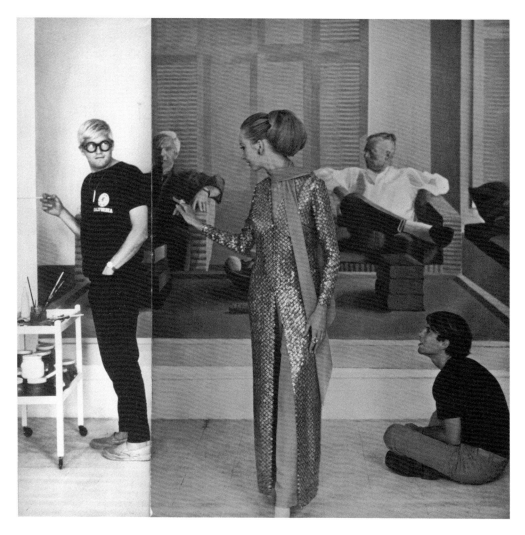

12 Cecil Beaton, photograph of David Hockney, 1968. *Vogue*, December 1968.
 © Vogue/Condé Nast Publications Ltd.

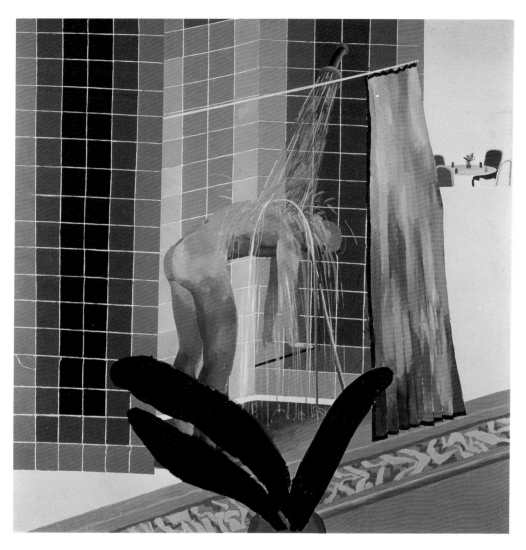

13 David Hockney, *Man Taking Shower in Beverly Hills*, 1964. Acrylic on canvas, 65 1/2 × 65 1/2 in. Photograph courtesy of David Hockney.

14 David Hockney, *California*, 1965. Acrylic on canvas, 60 × 78 in.
Photograph courtesy of David Hockney.

15 David Hockney, *Building, Pershing Square, Los Angeles*, 1964. Acrylic on canvas, 58 × 58 in.
Photograph courtesy of David Hockney.

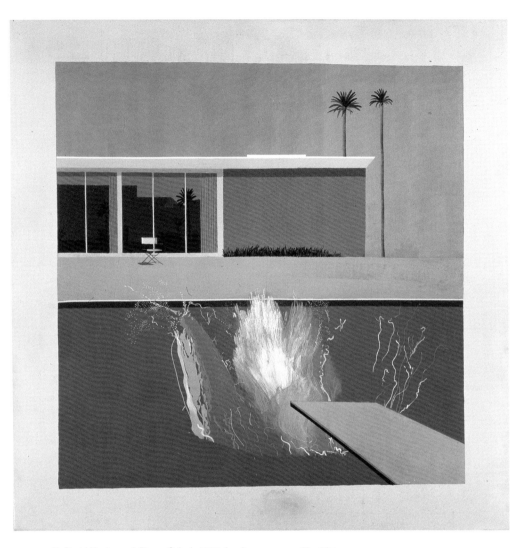

16 David Hockney, *A Bigger Splash*, 1967. Acrylic on canvas, 96 × 96 in.
Photograph courtesy of David Hockney.

17 Simon Rodia, *Watts Towers* (detail), 1921–1955. Photograph by the author.

18 Noah Purifoy, *Watts Riot*, 1966. Mixed media assemblage, 50 × 36 in. Bequest of Alfred C. Darby. Photograph courtesy of California African American Museum. © Noah Purifoy estate.

19 Claes Oldenburg, poster for *Autobodys*, 1963. Letterpress, 22 × 14 in. Photograph by David Heald.
© Claes Oldenburg Coosje van Bruggen, New York.

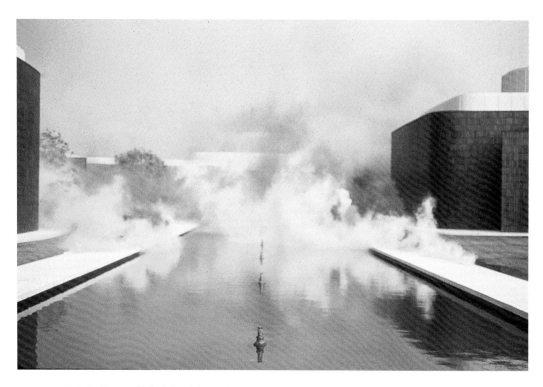

20 Judy Chicago, *Multi-Colored Atmosphere*, 1970. From Atmosphere's Norton Simon Museum,
 formerly the Pasadena Museum, Pasadena, California. Photograph courtesy of Through the
 Flower Archives. © Judy Chicago 1979, Fireworks.

The View from the Car

Banham shared Ruscha's aesthetic sensibility in more ways than one. When the British theorist visited Los Angeles, learned to drive, negotiated the new freeway system, and appraised the city's architecture as he drove, he joined Ruscha and other L.A. artists in their fascination with car culture. The car, essential for traversing long distances in the sprawling city, emerged as something more in works of art: a fetish object—its allure predicated on gleaming chrome surfaces—and a prosthetic device to augment vision. Ruscha in his paintings distilled the driver's fleeting perceptions of the urban landscape. But it was in his photographic books that Ruscha ruminated on the visual and spatial experience of Los Angeles from behind the wheel of a car.

An article by Tom Wolfe from 1963, published in *Esquire* magazine, brought the hot rod and "kustom kar kulture" of Los Angeles to national attention. In 1965, Wolfe took a phrase from that article's headline as the title of his first book, *The Kandy-Kolored Tangerine-Flake Streamline Baby;* it became a manifesto for his brand of New Journalism and captured the sensibility of the 1960s by combining reportorial facts with the stylistic experimentation of fiction.[19] Slipping into the lingo and cadences of car customizers and fans, Wolfe voiced his heartfelt appreciation of the hot rod, stripped to its bare essentials and outfitted with a souped-up engine; he also applauded the customized car, its sleek surface coated in custom-mixed paints and new petrochemical plastics. Evaluating kustom kar kulture with the seriousness that critics traditionally lavished on paintings, Wolfe praised the "art" of customizing and singled out several "stars" for special mention. Among them was the legendary cult figure Von Dutch, who introduced the art of custom painting, pinstriping, and flaming cars in the 1940s, and Ed "Big Daddy" Roth, who actually fabricated, from fiberglass, his own custom-designed vehicles, such as the *Outlaw* (1959), *Beatnik Bandit* (1960), and *Orbitron* (1964). Von Dutch and Big Daddy Roth set the standard in custom car design, attracting teenage fans, who formed male-dominated subcultures in Los Angeles. As the custom car and hot rod craze exploded in the 1960s, many teenagers decorated their own cars, attended car fairs, read *Hot Rod* magazine, and bought plastic model kits of Big Daddy's hot rods. Eager to demonstrate their individual flair at design, car customizers, hot-rodders, and their fans treated the car as a surface to ornament, much like a skin to be imprinted with eye-catching tattoos.

Acknowledging the importance of kustom kar kulture in Los Angeles, many L.A. artists turned to the car for inspiration, emulating its surface decor or exploring its inner recesses.[20] Beginning in 1960 Billy Al Bengston, for instance,

borrowed paints and application techniques from motorcycle and car subcultures in Los Angeles to create abstract canvases that achieved critical notice for their dazzling designs and lustrous surfaces. Bengston himself encouraged viewers to connect his art and the motorcycle subculture in which he participated: he straddled a bike on the cover of a catalog accompanying a show at the Ferus Gallery in 1961 (see figure 28) and roared to first place in the amateur category, as documented in a photograph from 1964 taken at Ascot Park in Gardena. (This photo appeared in the catalog published for Bengston's retrospective at LACMA in 1968.) Aficionados in both the art world and the motorcycle industry reviewed Bengston's exhibition at the Ferus Gallery, which displayed his oil canvases featuring bike parts, including carburetor, gas tank, tachometer, and BSA insignia. His *Skinny's 21* represented an entire motorcycle, and, as if to underscore the motif, the gallery included in the exhibit a 350cc Gold Star motorcycle.[21] Even Bengston's colors resonated with the design of cars and motorcycles, as a critic for *Life* magazine was quick to point out: "A motorcycle buff, Billy Al Bengston keeps two of the vehicles in his studio at Ocean Beach primed for racing at nearby tracks. Their gleaming surfaces harmonize with the dazzling images of his paintings, which he produces with the aid of spray guns, oil paints, plastics and lacquer."[22] In other paintings featuring abstract shapes rather than engine parts, Bengston wielded spray guns to apply polymer or polyurethane on hard surfaces—Masonite, aluminum, and Formica—over which he layered lacquer finishes; these glossy surfaces also recalled the vibrant colors and distinctive designs invented by customizers.

Judy Chicago, a student of Billy Al Bengston's and the only woman artist accepted into the inner circle of Ferus studs, spurred by her male peers' aesthetic fascination with cars, attended auto body school. As Chicago recalled, "I decided to go to auto body school to learn to spray paint. . . . I was the only woman among 250 men, all of whom lined up to see me do my final project, which was spraying an old Ford truck with metallic chartreuse paint."[23] In *Car Hood* she flaunted the skills she had mastered at the auto body shop, spraying acrylic lacquer onto a 1964 Corvair hood, transforming it into a decorated surface, and hanging it vertically on a wall (figure 34). Chicago experimented with the radiant colors available in car paints and the spray paint techniques perfected in auto body shop to highlight the physicality and opticality of surface.

The lustrous surfaces of Bengston's and Chicago's artworks emanate sensuality, and perhaps even eroticism. Chicago, speaking retrospectively, claimed to have juxtaposed female and male sexual symbolism in *Car Hood:* "The vaginal form, penetrated by a phallic arrow, was mounted on the 'masculine' hood of a car."[24] In 1965 Kenneth Anger, the underground, experimental filmmaker,

34 Judy Chicago, *Car Hood*, 1963–1964. Sprayed acrylic lacquer on 1964 Corvair hood. Radoslav L. Sutnar & Elaine F. Sutnar Collection. © Judy Chicago.

explicitly highlighted the erotics of car culture in a three-minute segment of a film he never completed, *Kustom Kar Kommandos.* In the opening shot a teenage boy attired in a short-sleeved T-shirt and tight blue slacks polishes the gleaming chrome engine of a hot rod with a gigantic white powder puff. The California license plate locates the boy in a regionally specific kustom kar subculture. As the camera lingers over the reflective chrome, the car's cherry-colored casing, the red fabric covering the seats, and the sparkling dashboard, the surfaces of the car do more than glow; they arouse sexual desire, as the soundtrack, "Dream Lover," suggests. In the version of the song Anger selected, recorded in 1964 by the Paris Sisters, the desired lover had notably changed from a girl (in Bobby Darin's original 1959 tune) to a boy. The combination of the Paris Sisters chanting "Dream Lover" and Anger's camera angles confuses any obvious heterosexual dynamics of desire by introducing a number of double entendres. When the Paris Sisters croon, "I want a boy to call my own" just as the camera lens pauses on the boy's shapely buttocks, the teenager emerges as the object of desire—for the Paris Sisters perhaps, but also, given the boy's

provocative pose, for a presumed male viewer, a member of the kustom kar subculture. The engine itself takes on male sexual connotations when, just as the teenager lovingly touches the chrome with his powder puff, the soundtrack emits "Dream Lover." At the song's refrain the camera closes in on the boy's crotch, framed by two huge shiny carburetors, confusing boy and engine into one phallic object of desire. This sequence culminates in a shot of the boy caressing the carburetors in what can be read only as a masturbatory act. In the prospectus for the film, Anger explicitly grants the car an identity that oscillates between male and female: "The treatment of the teenager in relation to his hot-rod or custom car . . . will bring out what I see as a definite eroticization of the automobile, in its dual aspect of narcissistic identification as virile power symbol and its more elusive role: seductive, attention-grabbing, gaudy or glittering mechanical mistress."[25] Anger, much more insistently than either Bengston or Chicago, endowed the radiant surfaces of hot rods and customized cars with a sexual charge by overlapping same-sex and heterosexual desires.

Edward Kienholz had sex on his mind as well when he turned his attention to car culture. Yet he did not revel in the carefully crafted surfaces of hot rods and customized cars; rather, he cast a heterosexual drama in the gloomy interior of a dilapidated and rusting car in *Back Seat Dodge '38* of 1964 (figure 35). The car door of the truncated vehicle swings open to reveal two figures—a man constructed out of chicken wire, a woman of plaster—entangled in a sexual embrace. Olympia beer bottles from the 1940s strewn on the green Astroturf and littering the interior of the car tie drinking to fornication. *Back Seat Dodge '38* memorializes a sordid, furtive encounter in a seedy interior, not some *Playboy* fantasy. Kienholz, often motivated by anger, outrage, or a satirical impulse to explore highly charged topics ranging from illicit sex to illegal abortions, summoned forth passionate responses to his art. The Los Angeles County Board of Supervisors famously tried to close his one-person exhibition at the Los Angeles County Museum of Art in 1966 when two members of the board deemed the art pornographic, particularly *Back Seat Dodge '38* and *Roxy's* (1961), a tableau re-creating a brothel interior. Museum officials compromised with the Board of Supervisors by shutting the door of the *Back Seat Dodge* except during tours given to those eighteen years and older.[26] This brouhaha and its resolution only aroused further curiosity and increased attendance.[27] At the same time, the theatrical staging of the private in public and its monitoring by the museum inevitably made viewers aware of their own voyeurism and sexual desires.

Artists, responding to car culture in Los Angeles during the 1960s, brought attention to the sensual pleasures of gleaming surfaces and the secret sexual

35 Ed Kienholz, *Back Seat Dodge '38*, 1964. Paint, fiberglass and flock, 1938 Dodge,
chicken wire, beer bottles, artificial grass, and cast plaster figure, 66 × 240 × 144 in.
Los Angeles County Museum of Art, Art Museum Council Fund. Photograph © 2004
Museum Associates/LACMA. © Nancy Reddin Kienholz.

encounters possible inside the car. Bengston, Chicago, and Anger honored the
reflective chrome, new paints, and inventive decorations of kustom kar kulture.
In contrast to these explorations into the optics and erotics of surface design,
Kienholz, much like the directors of film noir, exposed a sordid world beneath
surface appearances by transforming the back seat of a car into a tableau of il-
licit sex. The car, its surface styling an object of desire, its interior a substitute
bedroom, functioned in this art as much more than a mode of transportation
through the urban landscape.

Taking a somewhat different approach, Celmins and Ruscha looked out
through the windshield rather than into or onto the car. In *Freeway* of 1966
Celmins, for instance, re-created the spatial experience of the driver on the free-
way (figure 36). Based on a photograph of the recently completed 405 freeway
taken during her trips by car between Venice, where she lived, and the Univer-
sity of California, Irvine, where she taught, *Freeway* depicts the view looking
south onto the San Diego Freeway. Celmins grants the viewer a corporeal ex-

36 Vija Celmins, *Freeway*, 1966. Oil on canvas, 17 1/2 × 26 1/2 in. Private collection.
Courtesy of McKee Gallery, New York. © Vija Celmins.

istence, an awareness of the body's containment in a car, by including the dash-
board and a thin sliver of the hood of the car, visible at the bottom of the pic-
ture. Her vision, determined by the driver's view and the orientation of the road,
is perspectival, directed forward down a stretch of asphalt; that the roadside sig-
nage is cast in shadow only accentuates the forward momentum of vision. But
the eye, rather than gaze on an empty road and distant horizon line, jumps from
the rear of a truck in the foreground, to the backs of cars clustered in the mid-
dle ground, to an overpass hazily outlined in the distance. With her view of an
endpoint blocked by cars and the freeway infrastructure, the driver in her car
in *Freeway* occupies a narrow corridor of space that opens skyward as it draws
her relentlessly forward, always in relation to other vehicles. If anything,
Celmins's painting captures Banham's fourth ecology, that of the freeway, which
he described as "in its totality . . . now a single comprehensible place, a coher-
ent state of mind, a complete way of life."[28] Celmins's painting transforms the
urban freeway into a landscape with its own unique space and topography while
drawing attention to the experience of viewing through a car's windshield.

Ruscha traveled by car along the streets of Los Angeles rather than on its
freeways. In his paintings the orientation of commercial facades and signs as

well as their towering scale and distinctive design hail the eye of an approaching driver. Thematically, the various paintings of the Standard station even seem to solicit the viewer in the role of driver, to turn in to the gas station and advance toward the pumps. Yet in each painting the elevation of the facades and their attenuated orthogonals actually situate viewers significantly lower than the driver's seat and reveal much more than can be seen through the windshield; if anything, Ruscha's paintings locate the viewer's eye at the license plate, and sometimes even lower, at ground level. The facades, both aligned toward and dwarfing the driver, bring attention to the visual experience of a commercial landscape built around cars. The size, design, and color of buildings and signs as well as their placement in space are calculated to arrest the driver's attention, even if only momentarily, and to communicate a message in the few moments it takes to pass by them. In other words Ruscha's paintings accentuate the features of commercial facades that claim the momentary glance of the driver in transit through the streets of Los Angeles.

The fires engulfing buildings and signs or the floodlights encircling them increase the visual drama of the facades while also claiming the motorist's eye. Moreover, the diagonal beams of yellow light, momentarily stopped in their endless movement across the dark sky, or the flames of a fire consuming a restaurant or a gas station, temporarily arrested in paint, capture facades in moments of transition rather than as essential and timeless forms. Ruscha's paintings still the transitory moments of an urban landscape—both the haphazard transformation of buildings themselves and the mobile gaze of the driver. In these images Ruscha defined the nature of Los Angeles around commercial vernacular design and the mobile urban experience.

In the 1960s many others besides Ruscha characterized Los Angeles by its constantly changing built environment, encountered more often than not from a car; but usually they indulged, unlike Ruscha, in impassioned condemnation or hyperbolic praise of the city's growth. The speed with which Los Angeles spread outward, accommodating the housing needs of the approximately three million people who migrated to the Southland between 1945 and 1965, and the city's rapidly changing skyline, its horizontal sweep sprouting new skyscrapers in various locations, were sources of tremendous pride as well as easy targets of criticism.[29] On the one hand, the *Los Angeles Times,* a mouthpiece for growth, published photographs of skyscrapers under construction and aerial shots of freeways looping through the Southland as evidence of the second coming of Los Angeles as a modern city: "The ever-changing, upward-looking face of Los Angeles assumed an even brighter expression Thursday with news that a 42 story skyscraper will be constructed."[30] The freeways emerged as one

of the most recognizable landmarks of Los Angeles, and aerial photographs of cars dotting the freeway network promised mobility; in one memorable instance, the opening shot of the movie *The Loved One* from 1964 (based on the novel by Evelyn Waugh, with a screenplay by Christopher Isherwood) surveys cars speeding along the freeways from the window of a jet transporting British tourists to the city. On the other hand, books such as *Eden in Jeopardy,* Richard Lillard's jeremiad against rapid and unplanned growth, lamented the impermanence of the built environment in Los Angeles, with its institutions constantly shifting location, its buildings being torn down and replaced by new suburban homes and skyscrapers, and its freeways endlessly under construction.[31] Citizens periodically switching counties and homes, all the while driving daily through the city, according to Lillard, not only contributed to the mobility of the landscape but also meant that the inhabitants themselves experienced the city on the move. Even the Watts fires, like earthquakes and floods, could be related to the dizzying speed of urban change in Los Angeles: unexpected human and natural crises suddenly transformed the city's appearance, marking the instability of its urban fabric. Remember how Didion, adopting an apocalyptic tone, did not simply cast the Watts fires as the catastrophic destiny of Los Angeles, already preordained by the final scene in Nathanael West's *Day of the Locust,* when the hero, surrounded by a frightening mob, envisions the tongues of a fire licking at a Corinthian column of a Nutburger stand in his painting *The Burning of Los Angeles;*[32] she also preserved the very transitoriness of the city—its moment of destruction by violent fires—as its defining essence. In highlighting a transient urban landscape, all of these writers reached a moral verdict about the city's expected and unexpected growth.

Ruscha's paintings of transitory Los Angeles focused less on the rapid development of the city than on the orientation of its infrastructure to the driver's mobile eye. In delighting in the surface design and orientation of buildings and signs, Ruscha's paintings obviously parted ways with the naysayers. Nor did he adopt the booster's celebration of growth; after all, a number of his paintings do hint at standardization and norms. Ruscha avoided rhetorical extremes in his paintings, dramatizing instead the unique aesthetic of the city's commercial facades as well as the perceptual experience of viewing surfaces from behind the wheel of a car.

If works of art by Bengston, Chicago, and Anger relished the surfaces of a car, Ruscha's and Celmins's paintings looked out the windshield of a car on the urban landscape. From both sides of the windshield these artists appreciated radiant colors and dazzling design; together they defined an aesthetic sensibility in Los Angeles around surfaces, positing a metaphorical relationship

37 Dennis Hopper, *Double Standard*, 1961. Gelatin silver print, 16 × 24 in.
Courtesy of the artist.

between the reflective optics of car paints, the striking facades of commercial
structures, and the two-dimensional surfaces of their canvases. Exceptionally,
Kienholz was interested in interiority, equating the inside of a car with the
psychodynamics of sex. In the end, these artists, whether they appreciated the
car itself or the car as a means of seeing the city, singled out the automobile as
central to urban experience in Los Angeles and defined an aesthetic and per-
ceptual sensibility around it.

 More than once artists and curators embraced Dennis Hopper's *Double Stan-
dard* from 1961 as the best distillation of Ruscha's visual sensibility in particu-
lar and of the L.A. art scene more generally. Hopper's photograph, shot from
a car momentarily arrested at the intersection of Santa Monica Boulevard, Mel-
rose Avenue, and Doheny Drive, captures multiple perspectives on the built
environment and a cacophony of signs, as if they all were seen simultaneously
rather than in quick succession (figure 37). Accordingly, the front windshield
affords a sweeping vista of a gas station, Standard signs, advertising billboard,
and traffic symbols bordered by two receding streets; the panorama also includes
the prospect of the cars behind the driver reflected in the rearview mirror. The
Ferus Gallery's use of *Double Standard* on the exhibition announcement for

Ruscha's show in 1964 and the Robert Fraser Gallery's publication of it in *Artforum* in 1966 with text advertising an exhibition in London called L.A. Now indicate that Ruscha, Hopper, and others felt they had a proposition to make about contemporary Los Angeles. L.A. Now was a city of commercial facades glimpsed from the car, momentarily framed in the rearview mirror, and L.A. Now included a particular group of artists who took L.A. Now as their subject; specifically, they highlighted the surfaces, design, and double entendres of signage and car culture—Hopper's *Double Standard,* like several of Ruscha's canvases, contains an obvious send-up of the ideal of standards.[33]

Road Photographs and Urban Space

If Ruscha's paintings of the 1960s embracing the design and wordplay of the commercial landscape helped define an aesthetic sensibility peculiar to the L.A. art scene, his photographic books from this same decade espoused a deadpan view of the city that dovetailed with a new ideal of urban analysis applied to Los Angeles as well as to her debased sister city, Las Vegas. In his photographic books Ruscha, the debonair stud who winks at us in Hopper's photographic portrait (see figure 25), assumed a more detached perspective than in his paintings yet managed to uncover wordplay and instances of disorder in the apparently uniform urban landscape of Los Angeles. In a number of his artist's books, he keenly observed and documented the rhythms and banalities of modern Los Angeles from behind the windshield. In so doing he updated the means of travel but retained the posture of the nineteenth-century flaneur who strolled through Paris by foot, lured by commerce yet always aloof from it.[34]

From 1963 to 1978 Ruscha produced sixteen artist's books that combine careful craft and commercial production. From the start he insisted, "I am not trying to create a precious limited edition book, but a mass-produced product of high order."[35] A number of these books inventory the urban landscape of Los Angeles, each with a leitmotif: gas stations, apartment buildings, parking lots, and the Sunset strip. The small-scale, black-and-white snapshots printed on white pages with minimal text do more than simply catalog the modern yet mundane infrastructure of the city. In *Twentysix Gasoline Stations* of 1963, *Some Los Angeles Apartments* of 1965, and *Thirtyfour Parking Lots in Los Angeles* of 1967 the addresses locating each structure geographically mark movement around the city and across the country. Likewise, *Every Building on the Sunset Strip* of 1966 visualizes the trip—literally of Ruscha in a pickup truck with a motorized Nikon—down a two-mile stretch of one of Los Angeles's mythic arteries.

Ruscha's photographic books, even more than his paintings, capture the viewpoint of the driver in a car looking through the front windshield or the side window at the cityscape. Most of the photographs in *Twentysix Gasoline Stations,* for instance, reproduce a gas station seen at a 45-degree angle from the driver's side window of a car moving along the highway. Sometimes they convey the panorama through the front windshield as the driver pulls into the gas station; more rarely, they view a gas station from a car parked across the street. The various readings of *Every Building on the Sunset Strip* all place the observer in a car. This book consists of two continuous bands of photographs depicting facades from the north and south sides of the street printed on the top and bottom of a single accordion-folded sheet that extends to twenty-seven feet. A reader who stands at the end of the page, unfolded to its entire length, and peers down the white void bordered by facades can imagine straddling the median line of Sunset Boulevard, glancing at buildings left and right through the side windows of a car (figure 38). In another mode of perusing the book, a viewer might flip through each page while assuming the position of a passenger traveling east on Sunset, nose pressed to the window, looking at facades along the north side of the street; the reader who then turns the book upside down and leafs through the pages from end to beginning observes the buildings on the south side of the street as if traveling west. Exceptionally, one of Ruscha's books about Los Angeles does not evoke the view from the car exclusively: *Some Los Angeles Apartments* mixes perspectives from a car with those of the pedestrian on the sidewalk, either gazing down the sidewalk or up at buildings. *Thirtyfour Parking Lots in Los Angeles,* eschewing the car altogether, contains only aerial scenes shot by a professional photographer in a helicopter yet by virtue of its focus immediately evokes the car.[36]

The sequencing of photographs, whether shot from the angle of a driver in a car, a pilot in a helicopter, or a pedestrian on the sidewalk, charts a passage through an urban landscape whose prosaic structures look relentlessly the same. Ruscha's books use two different means to deny significant change in the scenery or arrival at a destination. Most catalog variety within type. Photographs of a single genre of building—apartment buildings, gas stations, parking lots—are distributed one or two to a page as if the driver in an urban landscape encountered relatively insignificant modifications of the same basic structure over and over again. In one instance, *Every Building on the Sunset Strip*, the photographs document different structures, ranging from apartment buildings to specialty stores. Nonetheless, this book highlights the consistency of the driver's visual and spatial experience of the built environment by running the photographs together in two unbroken bands.

38, 39 Ed Ruscha, *Every Building on the Sunset Strip* (detail), 1966. Artist's book with photomechanical reproductions, 7 1/8 × 5 5/8 in. Photographs courtesy of Gagosian Gallery. © Ed Ruscha.

The layout of the photographs in *Every Building on the Sunset Strip* mimics a filmstrip yet delineates no visual, spatial, or narrative development. Ruscha, by photographing buildings head-on, transforms the volume of the commercial structure or private residence into a flat facade; by overlapping the photographs in two continuous strips on one sheet of paper, he presents the buildings on Sunset Boulevard as continuous facades. A uniformly bleached sky frames them, and an almost deserted sidewalk stretches before them; no people, incidents, or movement infuse the setting with drama. Even the vehicles on the street are primarily parked rather than moving. The layout and the lack of incident invite the eye to scan surfaces rather than to rest on a single structure or progress along the street frame by frame. Nor do the filmstrips reach narrative closure. The last building depicted on the north side of the street, a Jaguar dealership at 9176 Sunset, is not even seen in its entirety; on the south side of the street, a telephone pole surrounded by garbage cans stands between the canopied entrance to a low-lying building and the corner edge of a multistory warehouse (figure 39). The isotropic sequence of facades in *Every Building on the Sunset Strip* delivers no change, climax, or conclusion, instead emphasizing the uniformity of the driver's visual and spatial experience of the urban landscape.

Even so, visual disjunctures occur, owing to Ruscha's superimposition of individual photographic frames. Typically the incoherencies have to do with cars so that, for instance, at the intersection of Sunset Boulevard and Crescent Heights the front of one vehicle and the back of another join at the seam between two photographs to create a car of wildly disproportionate parts, not one likely to have rolled off the assembly line or to advertise a customizer's skill (see figure 38). Spatial changes take place as well, thanks to the inclusion of streets that recede into depth and rupture the continuity of the facades along Sunset Boulevard. But because these visual discontinuities and spatial variations are extremely subtle, they require the viewer to adopt Ruscha's keenly observing mobile eye and to become self-conscious about the very process of perception.

With their focus on single structures laid out one or two to a double-page spread, *Some Los Angeles Apartments, Thirtyfour Parking Lots in Los Angeles,* and *Twentysix Gasoline Stations* evoke the visual rhetoric of architectural photography rather than film to depict the urban landscape.[37] A number of the photographs in *Some Los Angeles Apartments,* in particular, recall the angles from which architectural photographers memorialized apartment complexes built in Los Angeles by famous modernists, including Irving Gill, Richard Neutra, and R. M. Schindler.[38] Two of the leading exemplars of architectural photog-

raphy, Ezra Stoller on the East Coast and Julius Shulman on the West Coast, used the camera to emphasize the singular yet enduring abstract shapes of buildings. Stoller, who deliberately isolated quintessential architectural forms in the photographic frame, warned against the spontaneous, haphazard, or uncharacteristic view: "The camera's capacity to freeze a moment of time can also be a drawback, and a serious one, when dealing with a subject as timeless as architecture. It is one thing to show a building in its best light, but something quite different to see it in a freakish instant."[39] To foreground the distinguishing shapes and outlines of buildings, both Stoller and Shulman used black-and-white film, sharply focusing their camera lenses.[40] Awaiting the most propitious weather conditions and planting their feet solidly where they found the best vantage point, they accentuated the building's harmonious ensemble of abstract forms and sleek lines.[41] Not surprisingly, both men specialized in documenting modernist structures built according to the design principles governing their own photographic practices: Shulman's photographs of case-study houses built in Los Angeles at midcentury highlighted their blunt geometry—squat cubes, broad rectangles, square sliding glass doors. Stoller, awarded the first Medal for Architectural Photography in 1961 by the American Institute of Architects, favored the pure abstract planes of International Style architecture.[42] The coincidence of the photographers' and architects' minimalist style yielded memorable images that circulated widely in the press and publicized the construction of heroic modernist structures on either coast of the United States. Indeed, Stoller's reputation for showing buildings in their best light, transforming them into breathtaking modernist monuments, was such that Philip Johnson apparently considered his constructions complete only when they had been "Stollerized."[43]

In his photographic books Ruscha preferred the driver's transitory glimpse of the commercial vernacular to the archetypal view of a modernist structure. And his books always feature the mundane. As the curator Richard Marshall points out, *Some Los Angeles Apartments* avoids modernist monuments in Los Angeles in favor of "dingbats," two-story structures erected en masse in the 1960s.[44] Moreover, despite the different angles from which Ruscha photographed apartment buildings in Los Angeles, their changing addresses, and even variations in height, facade, and surrounding vegetation, the thirty-four apartment buildings more or less resemble one another: each one fills the width of the frame, stands outlined against a washed-out sky, and faces sidewalks and streets empty of life and movement (figure 40). The consistently deadpan documentary style of the sharp-focused black-and-white photographs, combined with the repeated sameness of building type, highlights standardization over singularity.

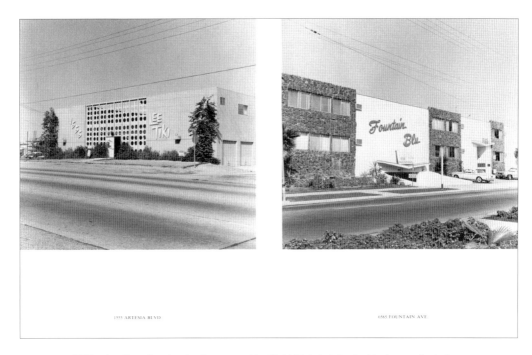

1555 ARTESIA BLVD. 6565 FOUNTAIN AVE.

40 Ed Ruscha, *Some Los Angeles Apartments* (detail), 1965. Artist's book with photomechanical reproductions, 7 1/8 × 5 5/8 in. Photograph courtesy of Gagosian Gallery. © Ed Ruscha.

While these photographic books stress uniformity of urban architecture and space, they often contain (much like *Every Building on the Sunset Strip*) eruptions of disorder and humor. In *Thirtyfour Parking Lots in Los Angeles* photographs of empty parking lots, each with a caption indicating location, are distributed one or two to each double-page spread in a book 10 by 8 1/8 inches. Ruscha's choice of aerial photography demonstrates his awareness of how the print media began to show the changing Los Angeles landscape: bird's-eye views of Los Angeles enjoyed increasing popularity during the 1960s, owing in part to the new prominence of helicopters.[45] Typically aerial photographs depicted the city's freeways and suburban developments, evoking, depending on one's perspective, the appalling or breathtaking magnitude of L.A.'s sprawl. Photographs in newspapers of massive parking lots and garages always included plenty of cars, conveying both the size of the population and the practical means of coping with geographic distances. *Thirtyfour Parking Lots in Los Angeles* asks viewers to consider not the functional role of the parking lots but their abstract patterns, their regular grids of white paint on concrete randomly splattered with oil (figure 41). The oil spots disrupt the functional order of the parking lot just as the aberrant cars parked along the Sunset strip break the uniformity of urban space. These dissonant signs, produced

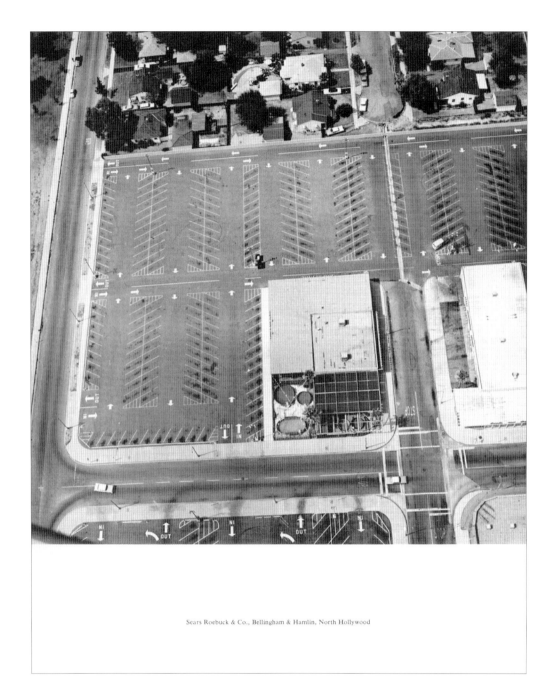

Sears Roebuck & Co., Bellingham & Hamlin, North Hollywood

41 Ed Ruscha, *Thirtyfour Parking Lots in Los Angeles* (detail), 1967. Artist's book with photomechanical reproductions, 10 × 8 1/8 in. Photograph courtesy of Gagosian Gallery. © Ed Ruscha.

either by chance or by the artist's design, resist the imposition of rationality on the urban landscape.

The relentless return of mundane commercial structures is not unique to Los Angeles; it also characterizes a road trip documented in Ruscha's first book, *Twentysix Gasoline Stations,* which began in Los Angeles and continued along Route 66 to Texas. As its title indicates, the book collates twenty-six photographs of gas stations, each accompanied by a brief caption indicating its place on the map. The artist Eleanor Antin perceptively observed in 1973: "That's about 1400 miles along Route 66 as any road map will show. It's sort of a travel narrative. Most of the shots were taken by day in varying degrees of light except for three night shots, one in Daggett, California, and a number of frames later, two consecutive ones in Tucumcari, New Mexico and Amarillo, Texas. That marks it as an actual trip lasting three days and two nights."[46] Even as the book plots a road trip across space and time, it documents not the changing natural landscape or noteworthy tourist sites but gas stations, with their various ornamentation, geographic locations, brands of gas seen at different angles and times of day. The variations culminate in a final photograph of yet another filling station: the Fina in Grooms, Texas, its brand name humorously appropriate for the end of the book.

Double entendres, yes; human drama, no. In *Twentysix Gasoline Stations* Ruscha divests the road photograph of all romanticism. From the completion of the transcontinental railroad in 1869 to the paving of Route 66 in the 1930s to the construction of interstate highways after World War II, westward travel promised opportunity or concluded in failed dreams.[47] Route 66, in particular, achieved mythic status with the movie *The Grapes of Wrath* in 1940, Bobby Troup's 1946 song "Get Your Kicks on Route 66," and the television series *Route 66,* which ran from 1960 to 1963.[48] Los Angeles was the final destination for travelers along Route 66, the place in which they invested all their hopes and desires for the future. Ruscha made the trip to transform himself from a midwestern boy into a successful artist, though in *Twentysix Gasoline Stations* he undertook the reverse journey, east toward his childhood home.

The promise of westward travel took visual form with the development of the road photograph in the 1930s. The stretch of asphalt from the bottom of the frame to the horizon mapped the expectations of westward voyagers onto one-point perspective, with the central vanishing point symbolic of a distant goal forever out of reach. Notably, some of the most famous documentary photographers, including Dorothea Lange and Robert Frank, included the road photograph in books that countered the hopefulness of westward travel with reminders of failed dreams and harsh realities. In *An American Exodus: A Record*

42 Robert Frank, *Santa Fe, New Mexico*, from the series *The Americans*, 1955. Gelatin silver print,
 8 11/16 × 12 13/16 in. The Museum of Fine Arts, Houston. The Target Collection of American
 Photography, museum purchase with funds provided by Target Stores.

of Human Erosion (1939), the book Lange co-produced with the sociologist Paul
Taylor, the photographer includes two shots of highways—U.S. 54 and U.S.
80—that evoked promise for migrants from the Cotton Belt, the Mississippi
Delta, and the dust bowl. But the final chapter, "Last West," catalogs the plight
of newly arrived migrants in California, seasonal laborers, their jobs threatened
by the industrialization of agriculture and their health jeopardized by the un-
sanitary conditions of labor camps.[49] Two decades later Robert Frank inserted
one photograph of U.S. 285 at nightfall at about the midway point in *The Amer-
icans*. The road at dusk, the time of day itself perhaps a metaphor for dimin-
ished hope, joins other pessimistic photographs of the road scattered through-
out Frank's book—three crosses alongside U.S. 91 in Idaho, for instance—as
well as sobering views of American politics, religion, economic disparity, and
racism. Often underlit and underexposed, Frank's road photographs register a
dark mood that surrounds and infuses them with human poignancy.

 Compare, for instance, any one of Ruscha's photographs in *Twentysix Gaso-
line Stations* with Frank's photograph of a Shamrock gas station in Santa Fe,
New Mexico, included in *The Americans* (1955; figure 42). The five pumps, seen
from the perspective of a pedestrian with his back to the station, stand forlorn,
outlined against a distant mountain ridge. Consisting each of a circular disk

SHELL, DAGGETT, CALIFORNIA

43 Ed Ruscha, *Twentysix Gasoline Stations* (detail), 1962. Artist's book with photomechanical reproductions, 7 1/16 × 5 1/2 in. Photograph courtesy of Gagosian Gallery. © Ed Ruscha.

resting on a rectangular shaft, they assume human proportions. The anthropomorphized pumps, the desolate landscape, the evocativeness of dusk, and the drama of the thick cloud cover endow the scene with a sense of loneliness. In contrast, emotion is entirely missing from Ruscha's small snapshots of gas stations framed by bleached skies. Even the photographs he took of filling stations at night lack mood; they resemble instead casual snapshots slightly out of focus because taken from a moving vehicle (figure 43). Finally, the very accumulation in one book of Ruscha's gas station photographs, with their uniformly deadpan style, makes each structure an example of the commercial vernacular dotting the road rather than a metaphor for the human condition in the United States.

Several of Ruscha's photographic books appear to document the Los Angeles infrastructure systematically. Titled simply by numbers (*Thirtyfour Parking Lots*) or by words indicating selection (*Some Los Angeles Apartments*) or even by comprehensiveness (*Every Building on the Sunset Strip*), the books promise a rational and quantifiable catalog of a building type. Within the books' covers, the black-and-white photographs, divested of all romanticism and human drama, record mundane, mass-produced commercial and residential architecture. Yet the idiosyncratic never fails to undercut claims to objectivity. The vi-

sual dissonances produced by the artist, who colludes with the banal commercial landscape while tweaking the rhetoric of documentary photography, play havoc with any effort at dispassionate visual analysis. The photographic books thus invite viewers to sample and to scan the Los Angeles landscape, attentive to both the deviant within the pattern and the wordplay within the mass-produced. These photographic books provide a model for an objective visual analysis of the city while always exceeding that model in sly ways.

A dispassionate visual analysis of the city from the perspective of the urban dweller enabled urban theorists, planners, and architects to avoid bombastic extremes in the debate about Los Angeles and to take the city seriously in the 1960s. For instance, the MIT professor Kevin Lynch, who emerged during this era as a key figure in urban planning, analyzed Los Angeles, Jersey City, and Boston with the aid of photographs, plans, and drawings in order to propose a roadmap for future urban development. In his most famous book, *The Image of the City*, published in 1960, Lynch presented the theory that the built environment inspired people to create mental maps of their location within cities; key elements contributing to the "imageability" of the urban landscape included the path, landmark, edge, node, and district. Los Angeles, in Lynch's analysis, exemplified the failure of a city to represent itself clearly to its inhabitants:[50] "When asked to describe or symbolize the city as a whole, the subjects used certain standard words: 'spread-out,' 'spacious formless,' 'without centers.'"[51] Urban sprawl, combined with the absence of landmarks, meant that Angelenos could not orient themselves in their city. "It's as if you were going somewhere for a long time, and when you got there you discovered there was nothing there, after all," commented one Angeleno interviewed by Lynch. This resident's description of driving in Los Angeles could just as easily have characterized his experience of perusing one of Ruscha's photographic books. Lynch valued spatial orientation above all else in urban design. The lack of cues for movement through the city and arrival at a destination gave him reason for concern. To improve orientation he proposed distinctive place markers, rich in visual, spatial, and historical information, in cities and along highways. In a second book, *The View from the Road*, Lynch teamed up with two colleagues at MIT, Donald Appleyard and John R. Myer, to demonstrate how well-designed highways could locate and orient drivers while deepening their understanding of the surrounding landscape. Lynch promoted a new creed of urban planning to bring the legibility of the pedestrian city to the vehicular one. His model inspired a generation of both behavioral geographers determined to elicit, draw, and measure the mental maps of cities and urban planners and architects wanting to produce "imageable" urban spaces.[52]

In the late 1960s another group of influential urban observers, who espoused dispassion, actually turned to Ruscha's photographic books for inspiration when they undertook a study of Las Vegas. The architects Robert Venturi, Denise Scott Brown, and Steven Izenour traveled to Los Angeles and Las Vegas with their studio of thirteen students from Yale University in the fall of 1968. In analyzing the Las Vegas strip, they specifically adopted Ruscha's photographic aesthetic as a model of detachment. Moreover, Ruscha participated in the final critique of the Las Vegas studio.[53]

Scott Brown, who took up residence in Los Angeles when she began teaching at UCLA in 1965, quickly gained familiarity with the local art scene. Particularly taken with Ruscha's visual example, she published a manifesto of sorts, "On Pop Art, Permissiveness, and Planning," illustrated with photographs from *Thirtyfour Parking Lots, Twentysix Gasoline Stations,* and *Some Los Angeles Apartments.* In this key text for understanding the aesthetic approach with which the studio studied Las Vegas, Scott Brown argues that architects and urban designers should dispense with their moralizing assessments of urban sprawl in favor of a new nonjudgmental attitude already influential in the arts, humanities, and social sciences. Ruscha's photographic books, according to Scott Brown, exemplify this deadpan way of looking at the world and remain receptive to the environment and tolerant of the everyday.[54] Scott Brown, Venturi, Izenour, and their students explicitly assumed this attitude to study what they called a "new type of urban form emerging in America and Europe," its archetype the Las Vegas commercial strip: "An aim of this studio will be, through open-minded and nonjudgmental investigation, to come to understand this new form."[55] Theirs was a daring stroke, for Las Vegas, more than any other city in the United States, generated moralizing evaluations, most often strident condemnations of the prostitutes and casinos purportedly seducing and manipulating the hapless tourist.

The book that resulted from the Yale studio collaboration, *Learning from Las Vegas,* included informational graphics meant to document an objective analysis of the city and to prove conclusions.[56] Notably, the label accompanying an elevation study of the famous Las Vegas strip specifically attributed the inspiration for the layout to Ed Ruscha. Indeed, in a manner reminiscent of *Every Building on the Sunset Strip,* eight paired photographic bands, produced by Douglas Southworth, stretch in four couplets across two double-page spreads. Bleached sky and empty streets unite the facades, much as they do in Ruscha's book. Southworth, however, does not run the facades of the Las Vegas strip together or playfully mismatch the fronts and backs of parked cars. Instead, his layout documents the vast expanse of empty space between casinos and the

low-lying silhouette of both the landscape and the commercial buildings punctuated only by bold billboards and huge signs. Words as signs on buildings—Stardust, Circus Circus, Thunderbird—assume a prominent place in the photographic study, but Southworth does not rearrange them in witty ways. In short, he looked to Ruscha's *Every Building on the Sunset Strip* as a prototype for objectively recording the Vegas strip.

Taking the commercial vernacular seriously and studying it through the windshield of a car, Venturi, Scott Brown, Izenour, and their students concluded that architecture had to be symbolic to be seen in a car-oriented urban environment: "The sign for the Motel Monticello, a silhouette of an enormous Chippendale highboy, is visible on the highway before the motel itself. This architecture of styles and signs is antispatial; it is an architecture of communication over space."[57] The participants in the Yale studio, like Lynch, Appleyard, and Myer in *The View from the Road,* found that two-dimensional signs contributed a new legibility to the city. But what they ultimately discovered about the commercial landscape built around cars was something Ruscha highlighted in his paintings: everyday signage and commercial buildings serve as effective place markers precisely when they communicate through dazzling surface design and dramatic placement in space.

The documentary approach that Lynch, Venturi, Scott Brown, Izenour, and Ruscha adopted to understand the city from the perspective of pedestrian and driver indicated a way to end a debate about Los Angeles dominated by strong passions for and against the design of the city and its impact on day-to-day life. Moral outrage or enthusiastic boosterism most often governed discussions of Los Angeles (and Las Vegas). The graph, the map, the diagram, the elevation study, and the photograph enabled another approach to urban analysis, a purportedly straightforward account of how urban dwellers viewed the city and imagined themselves in space. Even Ruscha's paintings that take overt delight in the surface design of buildings and signs while drawing attention to their orientation to the mobile eye avoid moralizing condemnations of the city. Nor can they be called blindly promotional, given that fires consume buildings, and signs hint at standardization and norms.

Ruscha, an artist, not an architect or urban designer, includes in his photographic books the sly wink of wordplay in the commercial environment and either singles out the disruptive oil stain on the pavement or creates humorous, nonfunctional cars. At the same time his insistence in his paintings on the facade and in his photographic books on the standardization of both the commercial vernacular and urban space also separated his perspective from that of Lynch, who, while taking roads, signs, and buildings in and around the city

seriously, called on designers, architects, and planners to invest signage with depth of meaning in order to orient bodies in space and time. Ruscha's art about Los Angeles avoids outrage, blind enthusiasm, or the call for more meaningful alternatives. His paintings and photographic books instead define a new urban aesthetic. In a city distinguished by broad empty streets and mass-produced buildings bleached by the blazing sun, only the keenest eyes scanning the landscape from the car can discern the oddities exploding here and there in the commercial landscape or appreciate the dazzling facade of a commercial structure.

3

The Erotics of the Built Environment

Why people leave home
live in the Southla

BY THE TIME HE LANDED IN LOS ANGELES IN 1963, DAVID HOCKNEY WAS already a celebrity in London. Widely photographed, the young artist called attention to himself with his flamboyant attire, owlish glasses, and blond hair. (He had dyed it during his first trip to New York in 1961 because, as he explained, mimicking Clairol's commercial jingle, "blondes have more fun.")[1] In one of his most sensational public gestures, he accepted the gold medal for painting at the Royal College of Art in 1962 wearing the signature costume of a rock-and-roll star: a gold lamé jacket. Lord Snowden photographed him on the streets of London clad in this same jacket and carrying a matching gold lamé shopping bag.[2] In his *Goodbye Baby & Amen* of 1969, the fashion photographer David Bailey, who by profession trained his eye on external appearances, attributed Hockney's flamboyance to Hollywood and Las Vegas: "spectacles Early Harold Lloyd, jackets Late Liberace, and his locks somewhere between Mid Monroe and Early Harlow."[3]

Though he left the lamé behind when he moved to Los Angeles, Hockney continued to make a colorful splash in public. The art historian Dickran Tashjian, recalling Hockney's memorable visit to the University of California, Irvine, campus in the mid-1960s, observed that "Hockney's arrival . . . in an orange velvet suit with an orange shirt and tie was a flamboyant and witty way to flaunt convention and remind students of a world abroad, represented by Carnaby Street."[4] At the very least, Hockney's florid persona presented itself as an alternative to the bare-chested California beach boy.

Hockney called the city of Los Angeles home from 1963 to 1968, during the height of London's famous swinging scene. His choice of Los Angeles over London seems to have had everything to do with his sexual orientation. He later remarked that "swinging London, was too straight for me. It wasn't really gay at all was it? I suppose that's the truth, that's why I didn't like it."[5] Los Angeles beckoned Hockney to savor sensual delights that he refused to conceal beneath surface appearances in either his persona or his paintings.

Indeed in Los Angeles, Hockney, like Ruscha, developed an aesthetic of surfaces. Just as Ruscha split the difference between modern art and the commercial sign through design, bringing attention simultaneously to the surface of the canvas and the urban facades of Los Angeles, Hockney highlighted both the self-conscious arrangement of color and form on the canvas and the external appearance of the city's architecture. But instead of depicting public structures oriented to the driver's eye, Hockney favored the single-family home, the icon of an Angeleno suburban lifestyle promoted in mass-circulation magazines throughout the 1960s. And, unlike Ruscha's views of the city, Hockney's Los Angeles landscapes were typically filled with male nudes, whose three-

dimensional corporeality he flattened to skin. Buildings leveled to facades and bodies reduced to skin drew attention to the two-dimensional surface of the canvas. Hockney's insistence on that surface also manifested itself in his use of acrylics, an unmodulated industrial paint applied like a skin over the warp and woof of the canvas, and in his predilection for stylization—in the ripples of water in backyard pools, the folds of shower curtains, the elongated leaves of plants. Hockney's surface artifice, so reminiscent of the fashionable flourish with which the artist defined himself in public, and the tropical colors, so different from Ruscha's bold palette, engaged mid-twentieth-century modernism with a queer eye. At the same time surface artifice gave material form to a seductive fantasy about a gay lifestyle enjoyed in the open, outdoors, in the light of day. Consequently, a new image of Los Angeles surfaced on Hockney's canvases: nude men, in a suburban setting of homes and pools, often touched one another, exposing their bodies, especially their buttocks.

The Superficiality of the City

Until the early 1980s those writing about Hockney's Los Angeles paintings generally avoided analyzing their homoerotics; few even acknowledged the nude men floating conspicuously in the painted swimming pools.[6] The one or two remarks ventured about Hockney's nudes were openly hostile: Robert Hughes sneered that they "have the bronzed stupid anonymity of the Hollywood Queen." And Mario Amaya wondered about the "strange magazine world of aging physical culture 'youths' living vapid lives under stall showers, or in slip-covered armchairs in narcissistic nudity."[7] These homophobic statements aside, the overwhelming majority of critical reviews published in the 1960s— most of which issued from Britain[8]—concurred that Hockney's paintings of Los Angeles highlighted the superficiality of the city's architecture and the empty lives of all its residents.

Whether proposing that Hockney merely reproduced the look of the city or derided it, critics repeatedly selected the word "artifice" (or a synonym) to characterize the self-conscious emphasis on framing, pattern, and color in Hockney's paintings. Often they conflated in a single sentence the contrived surface of the painting with the purported sham and shallowness of the city of Los Angeles. In the *London Magazine* Robert Hughes marveled at the way that "Hockney has caught an extraordinary flick of the artificiality of the Los Angeles environment, where not even the water in those blue-tiled swimming pools looks like water—it has the rippled, neutral look of liquid plastic, for which Hockney's

blue looping surface is a clever equivalent."[9] More often than not, critics interpreted Hockney's artifice as a metaphor for the lifestyle of the city's citizens: Christopher Salvesan, in 1970, remarked that Hockney's paintings "convey a disturbing sterility. And for Hockney, as for the Californian way of life, sterility of subject-matter and of style are not really separable."[10]

Not surprisingly, writers contemptuously dismissed the Angelenos populating Hockney's scenes, focusing their venom particularly on the California collectors prominent in a series of three paintings: two, *California Art Collector* (1964) and *Beverly Hills Housewife* (1966), juxtaposed a middle-aged woman with examples of modern sculpture, and the third, *American Collectors* (1968), situated a couple outside their sleek one-story home.[11] Paul Grinke's jeer in the *Spectator* was typical: "Rather more tongue in cheek is his *American Collectors, 1968:* a Beverly Hills couple standing proudly in front of their Henry Moore, with an Indian totem pole in the background, and looking very much as if they were caught, *en déshabille* on the way to a bankers' convention."[12] Such mockery of a nouveau-riche couple disclosed resentment toward new money and a general anxiety about the incursion into Britain of American mass culture, epitomized by Hollywood.[13]

As if to taunt the naysayers, *A Bigger Splash* burst across the cover of the book *Los Angeles: The Architecture of Four Ecologies,* by the English émigré Reyner Banham (figure 44). With the yellow, coral, and blue of Hockney's canvas repeated and emphasized by the type used for the book's title, Hockney's resolutely modern and brightly upbeat home took pride of place on the dust jacket and formed expectations about Banham's text on the sprawling city. Whether *A Bigger Splash* (1967) depicted a case-study house, as some critics claimed, or a commercial knockoff of the same, as Banham's comments indicated, Banham maintained that the unornamented rectangular box typified the built environment of Los Angeles. For him Hockney's painting thus demonstrated the artist's keen understanding, even celebration, of the city's ordinary architecture, capturing a "great dream, the dream of the urban homestead, the dream of a good life outside the squalors of the European type of city."[14] While Banham appreciated the aesthetics of both the painting and Los Angeles's vernacular architecture itself, he stopped short of evaluating the lifestyle such homes ushered in. In his concluding remarks about the city, Banham distanced himself from a moralizing perspective that took for granted architecture's shaping of the quality of life:

> Los Angeles emphatically suggests that there is no simple correlation between urban form and social form. Where it threatens the "human values"-oriented tradition of town planning inherited from Renaissance humanism it is revealing how

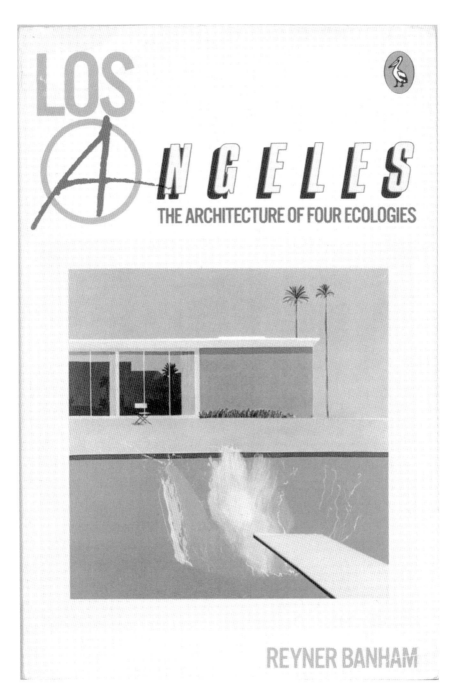

44 Cover, *Los Angeles: The Architecture of Four Ecologies,* by Reyner Banham, 1971.
A Bigger Splash © David Hockney; typography and logo © Penguin Group.

simple-mindedly mechanistic that supposedly humane tradition can be, how deeply attached to the mechanical fallacy that there is a necessary causal connexion between built form and human life, between the mechanisms of the city and the styles of architecture practised there.[15]

The placement of *A Bigger Splash* on the cover of Banham's book shed new light on Hockney's paintings—as celebrations of Los Angeles vernacular—just as Banham's analysis proved a turning point in the way the city itself was viewed.[16] Most of the early reviews welcomed Banham's book as an antidote to the texts scornfully enumerating the city's shortcomings, even if the reviewers periodically faulted Banham for ignoring its problems altogether.[17]

Before the publication of Banham's book, critics did not conceive of Hockney as a champion of the city's built environment, or part of the native Pop community in Los Angeles, or even a participant in the flourishing art scene in that city during the 1960s. But Hockney had contact with local artists; formed a friendship with Nicholas Wilder, who opened an art gallery in 1965 on La Cienega Boulevard across from the Ferus Gallery; and interacted with various collectors of Pop art in Los Angeles, such as Fred and Marcia Weisman.[18] Nevertheless, Hockney's art appeared in none of the exhibitions of West Coast Pop art during the 1960s. As early as 1963 Hockney had already distanced himself from the Pop label in Britain by declaring, "I am not a pop-painter."[19] Moreover, his British origins may well account for his absence from the many exhibitions and articles devoted to contemporary art in Los Angeles. Banham deserves credit for being the first to link Hockney to local artists when he included paintings in his book by both Hockney and Ruscha to exemplify a particular aesthetic he attributed to vernacular architecture in Los Angeles.

Since the publication of Banham's book, Hockney's paintings of Los Angeles have been plagued, however, by the suspicion that although they appreciate a southern California architectural aesthetic, they offer no penetrating perspective on the city. Mike Davis, one of the most famous urban theorists writing about Los Angeles, charged in his book *City of Quartz* that Los Angeles has been able to "afford to buy the international celebrity architects, painters and designers—Meier, Graves, Hockney, and so on—capable of giving cultural prestige and a happy 'Pop' *veneer* to the emergence of the world city" (emphasis mine).[20] Even assertions that Hockney condemned the superficiality of the city revealed a certain discomfort with the surface artifice of his paintings, as if artifice was acceptable only if it offered a moral evaluation or critical judgment. The surface (of the paintings, of the city) is assumed in such analyses to be

nothing but a shiny gloss that can be—and should be—removed to reveal an authentic city beneath. To be fair, an art historian such as Paul Melia, who quoted Davis, also cautioned: "While Hockney need not be criticised for avoiding these issues—he has never claimed to be a social realist—the ends to which his images have been put do give rise for concern."[21]

The City as Autobiography

As if to change the terms of the critical discussion about his art in the 1970s, Hockney repeatedly emphasized the erotic charge of his paintings of Los Angeles, while also firmly grounding the reality of the pictures in his particular experience of the city. Countering the critical assumption that his paintings manifested disdain for Los Angeles, the artist publicly expressed his ardent enthusiasm for the city over and again, starting with an interview published in the catalog accompanying his one-person retrospective at the Whitechapel Art Gallery in London in 1970: "And as I flew over San Bernardino and looked down—and saw the swimming pools and the houses and everything and the sun, I was more thrilled than I've ever been arriving at any other city, including New York, and when I was there those first six months I thought it was really terrific, I really enjoyed it, and physically the place did have an effect on me. For the first time I began to paint the physical look of the place."[22] While the reproduction of *A Bigger Splash* on the cover of Banham's book the year after the Whitechapel exhibition seems to indicate that Banham shared Hockney's sheer pleasure in encountering Los Angeles, he, like earlier critics, took no note of the homoerotic nature of Hockney's passion. Hockney, fondly remembering his first visit to Los Angeles, insisted that the city conformed to his fantasies, which had been shaped by the beefcake photographs published in the underground bodybuilding magazine *Physique Pictorial:* "When I first came to California, I came on an intuition; and it was correct. I came because I thought it would be very sexy. One of the things that prompted me to come here was a magazine called *Physique Pictorial.* I noticed that it was published in Los Angeles, so I assumed that's what life was like here. The photographs portrayed what a certain life was like in Los Angeles; and, in a way, it was true. They were accurate if you looked for it."[23]

Hockney's erotic attraction to the city cut against the grain of noir texts from the 1960s, from Alison Lurie's novel *The Nowhere City* to the movie *The Loved One* (based on Evelyn Waugh's eponymous novel), characterizing a reluctant or accidental visitor to Los Angeles encountering its architectural banality and Hol-

lywood absurdity. Equally, Hockney's emphasis on the attractive men in Los Angeles put a different spin on the lyrics of the Beach Boys and the typical scenario of the Gidget films that heralded the city's beautiful girls. Closer to Hockney's sentiments were those expressed in John Rechy's novels, including both *City of Night* of 1963 and *Numbers* of 1967, in which the male protagonist was attracted to Los Angeles by the ready accessibility there of other men for casual sexual encounters. Rechy's homoerotic novel *City of Night*, which like *Physique Pictorial* piqued Hockney's desire to visit Los Angeles in the first place, casts the city as the object of same-sex desire. Even its vegetation secretes a sexual fragrance; the main character observes the "joshua trees with incredible bunches of flowers held high like torches—along long, long rows of phallic palm-trees with sunbleached pubic hair."[24]

The autobiographical weight of Hockney's Angeleno paintings contrasted sharply with his reticence in the 1960s about his personal life and sexual orientation in his public statements. For instance, in a brief account of *Marriage*, he related the painting to an August 1962 visit he made to Berlin but immediately shifted to the complex formal challenges of a stylized Egyptian sculpture he had observed in a museum.[25] In the 1970s Hockney's emphasis in his accounts of his art changed from formal issues to his personal life, facilitated, no doubt, by historical circumstances, including the Stonewall Riots of 1969 and the subsequent birth of the gay liberation movement in the United States, the legalizing of homosexual acts between consenting adults in Britain in 1967, and the emergence of identity-based art.[26] In these accounts Hockney countered readings of his California paintings that ignored the erotics of his art in preference for speculating on his moral judgment of Angelenos in them or his celebration of the vernacular.

The filmmaker Jack Hazan, taking Hockney at his word, in 1974 made a sympathetic and multifaceted documentary drama, *A Bigger Splash*, about the artist and the romantic angst informing his paintings of Los Angeles. Despite its title, the film Hazan directed actually revolves around Hockney's painful struggles to complete *Portrait of an Artist (Pool with Two Figures)* of 1971, which depicts Hockney's former lover Peter Schlesinger, whom he met in California. The painting *A Bigger Splash* makes only two cameo appearances in the film, one of them during the opening credits. In this initial sequence, a collage combining publicity photographs of Hockney with reviews of his art precedes a shot of the painting; a close-up of *A Bigger Splash* is followed, in turn, by a succession of shots featuring Hockney's drawings of male nudes. From the start, then, the film positions the painting in relation both to Hockney as a media personality and to the artist's sexual orientation as expressed in his drawings. Later in

the film, the painting reemerges between a scene of Hockney taking a shower and a sequence of views juxtaposing paintings with their loose reenactments: Two California paintings portraying nude men, *Sunbather* of 1966 and *Two Boys in a Pool* of 1965, are succeeded by a scene in which four nude men, including Schlesinger, play together in a backyard pool. The movie, actually measuring the California paintings against the artist's life even more deliberately than Hockney did himself, interpreted *A Bigger Splash* (and other paintings) in light of the twists and turns of Hockney's love life.[27]

In insisting on a blind spot in critical interpretations of his art to date, Hockney invited a biographical interpretation of his Los Angeles paintings. From our historiographic perspective, we can see both salubrious and deleterious effects in this conflation of the paintings with the artist and place. While by the early 1970s Hockney's scenes of domestic retreats occupied by naked male bodies may have transfigured stereotypes about Angeleno suburban life inherited from the 1950s and 1960s, they also provided hostile critics with a ready means to belittle Hockney's art. Some writers, seeing in his representations of Los Angeles only damning stereotypes by a swank artist, questioned his seriousness of purpose. As Marco Livingstone pointed out, they assumed that the paintings and the artist himself were shallow.[28] Hockney's paintings of Los Angeles, whether equated with the city or the artist, ran the risk of superficiality.

Yet Hockney, while revealing his erotic attraction to Los Angeles and recalling his personal life in the city with enthusiasm, implicitly cautioned against interpreting the paintings as a reflection of his life. Even his rather conventional autobiography of 1976—tracing the chronological sequence of his life, divulging his sexual orientation, and describing his aesthetic concerns—raised questions about the authenticity of the confessional mode. Often Hockney highlighted the unreliability of personal revelation or at the very least implied that individual facts yielded meaning only when embedded in textual conventions that preexisted them. For instance, at one point in the text Hockney recounted, "After we left London in January 1968, Peter and I drove across America. I have extensive photographs of that trip; it was like an *Easy Rider* in a Volkswagen."[29] Referencing Dennis Hopper's infamous low-budget film, with Hopper and Peter Fonda as urban drifters traveling cross-country on motorcycles, Hockney situated his journey with Peter Schlesinger in a long tradition of books and movies that conceived of the road trip as a means to effectuate masculine heterosexuality independent of marital bonds. At the same time, by adding that he and Schlesinger drove in a diminutive Volkswagen rather than astride powerful motorcycles, Hockney undercut the outlaw persona he and Schlesinger borrowed to imagine their cross-county road trip. In *Easy Rider,* the motorcycles, long hair,

and hippie clothing mark Hopper and Fonda as targets for the Southern red-necks who viciously murder them at the end of the film. Yet even as Hockney relinquished the external trappings of the virile antihero, he introduced exactly the sort of relationship between men that was repressed in *Easy Rider*. Hopper and Fonda seek out casual sex with women, repudiating potential homoeroti-cism to cement their relationship as homosocial bonding. In contrast, Hock-ney openly claimed the identity of homosexual, an illegal, if not outlaw, status at the time, while also drawing attention to the homoerotic possibilities of male attachment denied by the film *Easy Rider*. Hockney revealed a truth in this reminiscence about his life—that he and Peter traveled across the country in a Volkswagen—but developed his story by modifying the narrative conventions he relied on in reporting the trip as much as by recounting the facts.

Hockney's self-revelatory statements about Los Angeles also typically em-phasized how visual precedents formed his life experience. For instance, time and again he cited *Physique Pictorial* as a source for his paintings:

> I painted *Domestic Scene, Los Angeles* from a photograph in *Physique Pictorial* where there's a boy with a little apron tied round his waist scrubbing the back of another boy in a rather dingy American room; I thought, that's what a domestic scene must be like there. It was painted before I ever visited Los Angeles. . . . California in my mind was a sunny land of movie studios and beautiful semi-naked people. My pic-ture of it was admittedly strongly coloured by physique magazines published there; *Physique Pictorial* often had street scenes of wooden houses and palm trees with motorcyclists acting out fantasies for 8mm movies. The interior scenes in the mag-azine were obviously (like old movies) shot in made-up sets out of doors. Bath-rooms had palm-tree shadows across the carpets, or the walls suddenly ended and a swimming pool was visible. . . . It was only when I went to live in Los Angeles six months later that I realized my picture was quite close to life.[30]

Los Angeles—as glimpsed in *Physique Pictorial*—beckoned Hockney to enjoy its fruits; the photographs in *Physique Pictorial,* though obviously staged, turned out to have some truth; even while based on fantasy, Hockney's painting *Domestic Scene, Los Angeles* "was quite close to life." The opposite was also true: Hockney indicated that both autobiography and painting revealed his actual experiences only to the extent that they were formed by and tallied with the nar-rative and visual inscriptions of the city that had aroused his erotic desires even before his arrival.

Two photographs of Hockney taken by Cecil Beaton in 1968 reflected upon and complicated the relation between Hockney's life and his California paint-ings well before any critic, historian, or even the artist thought to do so. They

had something important to say about the role of artifice in imagining personal realities. When Hockney returned to London in the late 1960s, he exchanged Carnaby flair for California casual, at least for a photo shoot published in British *Vogue*. The fashion spread, photographed by Beaton and entitled "The Great Indoors," included two shots of Hockney posed with friends in his London studio.[31] Beaton's photographs were meant to appeal to a style-conscious consumer tracking the latest chic trends in clothing design, interior decoration, and contemporary art, yet *Vogue* magazine also served Hockney's purposes. It announced his return to Britain as a Californian. Hockney, enacting a popular trope about California as a place of self-transformation, fashioned himself as a collegiate Beach Boy, his hair bleached as much by the sun as by Clairol, his dress casual—espadrilles, jeans, and a T-shirt with the word "California" emblazoned across his heart.[32]

One of the photographs in *Vogue* staged a biographical reading of Hockney's recent California paintings (see plate 12). Unquestionably, the "naive" reader of the fashion spread might simply have admired the chiffon culottes covered with pale lilac sequins and assumed that the four men (both painted and actual) were looking, perhaps longingly, at the female model. Indeed, the British expatriate novelist Christopher Isherwood, who in Hockney's painting turns his head to see his partner, the artist Don Bachardy, seems in this instance to be observing the model; Hockney pivots around to stare at her as well. But for those in the know—including ourselves—the interiors, both the actual studio and the painted living space, housed established same-sex couples and created a parallel between them: Hockney's painting of Isherwood and Bachardy in the background, the actual David Hockney and his lover Peter Schlesinger in the foreground. The two couples did indeed interact in Los Angeles, and Hockney's friendship with Isherwood culminated in this painted tribute to him and Bachardy, who lived together openly as a couple and served as an important role model for many in L.A.'s gay community. Beaton's photograph, in turn, honored both couples and posited their friendship as the interpretive frame for the painting.

Beaton's photographs raised some important questions about biography. To what extent is the relation between the life of the artist and his painting an artifice? How accurate are biographical readings facilitated by such self-conscious artifice? To begin with, fashion magazines as a genre promote the fantasy of self-transformation through artifice—of makeup, of hairstyle, of dress. Beaton's spread even celebrated the advantages of artifice with an opening byline proclaiming the domestic interior "a theatre, each room a stage and every girl a player. The object is to fill the room with your color and movement, so

that all eyes are directed to you." This particular domestic scene could not be more calculated in its composition: under Schlesinger's adoring gaze, Hockney pauses in putting the finishing touches on his canvas to observe a lithe blonde all ashimmer in sequins. But what precisely is this woman doing there in Hockney's studio, pointing at him? The domestic tableau, though absurd in its very artifice, connects the artist's private life to his painting of a famous gay couple. In this regard Beaton's photograph offered a key insight into the kinship between Hockney's biography and his California paintings: artifice, not a commitment to facts, facilitated a biographical reading of Hockney's art.

Provocatively, artifice opens up biographical readings that may or may not be true. For instance, the presence of the female model in Beaton's photograph enables matings between the men that extend beyond the two couples. Consider Bachardy, who appears to eye Hockney. An interior within an interior, a conversation piece within a conversation piece, the self-conscious circuitry of gestures and looks cuts across divisions of painting and studio to produce a variety of social and personal liaisons that confound any difference between artist and painting, biographical reality and fiction. Beaton's photo spread indicates that it would be a mistake to conclude that the surface artifice of Hockney's paintings merely reflects the superficiality of either the city or the artist.

Sex in the City

Some of Hockney's paintings from the 1960s purport to represent actual places and people he encountered in Los Angeles; the titles name friends, such as Peter Schlesinger or Nick Wilder, or identify specific streets and particular buildings, such as Olympic Boulevard or Pershing Square. Yet these paintings also engage in a dialogue with subcultural representations of gay life in the city and with midcentury modernism. In fact Hockney's reliance on photographs from physique magazines queered midcentury modernism while providing the scaffolding for his representations of a gay lifestyle enjoyed openly in suburban Los Angeles.

Hockney began painting the nude male body, which he would come to associate with the city of Los Angeles, while still in art school. The curriculum at the Royal College of Art in the late 1950s and early 1960s required students to draw the female nude, which, as in most art academies, had long eclipsed the male nude as the focus of figure painting. Hockney read Kenneth Clark's famous tome *The Nude: A Study in Ideal Form,* published in 1953, which provided the following historical perspective: "The predominance of the female nude over the male,

of which Raphael's *Judgment of Paris* is the first example, was to increase during the next two hundred years, till by the nineteenth century it was absolute. The male nude kept its place in the curriculum of art schools out of piety to the classical ideal, but it was drawn and painted with diminishing enthusiasm and when we speak of a nude study or académie of that period we tend to assume that the subject will be a woman."[33] Hockney did not react well to the school's mandate to represent the female nude, as he recalled in rather misogynistic terms: "I hated doing that because the models were fat women. . . . In the end I got my own models, and I got boys."[34] Increasingly, Hockney based his figures not on art school models but on homoerotic photographs of men printed in *Physique Pictorial,* published by Bob Mizer in Los Angeles.[35] After arriving in Los Angeles, Hockney continued to rely on photographs of young, strapping men published in bodybuilding magazines as sources for his painted nudes.

The *Physique Pictorial* photographs on which Hockney based his Los Angeles paintings envisioned a homoerotic alternative to the single-family home: muscle-bound youths living together in simply furnished interiors, performing such everyday tasks as cooking and taking showers, more or less in the nude. Photographed close-up and from slightly below, the male bodies fill the small, cramped bathrooms and kitchens like giants in a Lilliputian home (figure 45). Even as the nudes remain the focus of the photographs, the fixtures—narrow showers, tiny bathtubs, modest sinks, small aluminum mirrors—locate the men in lower-middle-class interiors. Mizer, while favoring indoor scenes, occasionally posed the nudes in the backyard pool. The stained concrete perimeter of the pool in figure 46 and the cinder block wall, weeds growing along its bottom edge, demarcating the backyard again situate the nude swimmer in a modest social milieu.[36] Hockney's remarks on the photographs and Mizer's studio indicate that, while attracted to the nudes, he noticed and judged the makeshift settings: "He has this tacky swimming pool surrounded by Hollywood Greek plaster statues."[37]

Hockney plucked Mizer's male models from their poky homes and painted them in larger, more tastefully decorated interiors or carefully maintained pools seen from a middle distance (see plate 13). The bathrooms in Hockney's paintings include multicolored tiles, lush carpets, and exotic plants, while manicured lawns surround expansive pools that abut suburban homes. The art historian Richard Meyer has astutely pointed out that in relocating the men to more up-scale dwellings, Hockney shifted male type and neighborhood, from the "rough trade" around Pico Union to the well-heeled men of Beverly Hills. The nudes of *Physique Pictorial,* moved from the cramped showers and serviceable kitchens Mizer depicted in black and white to the lavish bathrooms and attractive sub-

urban pools Hockney painted in full color, traveled, according to Meyer, from lower middle class to upper middle class.[38]

Undoubtedly Hockney's paintings memorialized some of his own experiences in Los Angeles. When Hockney arrived there, he actively sought out the gay subculture he had glimpsed in both *Physique Pictorial* and Rechy's *City of Night* by visiting Mizer's studio, where the photographs published in *Physique Pictorial* were shot, and by journeying to Pershing Square, a park in downtown Los Angeles that Rechy characterized as a center for gay hustlers. But he voiced disappointment with both places: Mizer's studio lacked taste, and Pershing Square was empty of life. Hockney did not join the gay subculture downtown but instead associated with Isherwood and Bachardy and spent time with the art dealer Nick Wilder and his friends, who were, according to Hockney, "always rather young and beautiful boys."[39] Integrating himself into a subculture of gay aesthetes that included an array of artists, writers, and expatriates living in Los Angeles, Hockney located himself in the more posh neighborhoods on the Westside of Los Angeles.

The identification of social class with place in Hockney's paintings corresponded as much to Rechy's vivid descriptions of Los Angeles neighborhoods as to the artist's own life. In *City of Night,* Rechy drew a sharp distinction between the "hustlers" and "queens" roaming the streets near downtown's Pershing Square and the middle-class gay men living in private dwellings. As the protagonist of *City of Night* strolls along Main Street, he easily identifies possible sexual partners:

> I walk along Main Street, Los Angeles, now. The juke-boxes blare their welcome. Dingy bars stretch along the blocks—three-feature moviehouses, burlesque joints, army and navy stores; gray rooming houses squeezed tightly hotly protesting against each other; colored lights along the street: arcades, magazine stores with hundreds of photographs for sale of chesty unattainable never-to-be-touched tempest-storm leggy women in black sheer underwear, hot shoeshine clipstands, counter restaurants . . . the air stagnant with the odor of onions and cheap greasy food. Instantly, I recognize the vagrant young men dotting those places: the motorcyclists without bikes, the cowboys without horses, awol servicemen or on leave.[40]

In contrast, white-collar professionals and aesthetes in Rechy's novels live in comfortable private homes tucked into more desirable neighborhoods. In *Numbers,* written four years after *City of Night,* Johnny Rio differentiates Pershing Square from the picturesque neighborhood in which his former boyfriend Tom, a successful architect in his late thirties, resides: "Now he turns into one of those side streets that lead into shady, crooked, peaceful lanes and hilly land-

45 *Physique Pictorial* 12, no. 3 (January 1963): 20.
Courtesy of Athletic Model Guild LLC.

scapes, all heavily treed, into an old, attractive section of the city: sturdy two-story houses perched on hills like fat satisfied wealthy ladies looking down on the newly arrived." Later in the novel Johnny visits Sebastian Michaels and his partner Tony Lewis in their "lovely house in the Santa Monica Canyon. An enormous open window greets a lush vista of Malibu and the magnificent ocean."[41] Sebastian, it turns out, is a famous writer, and his companion attended art school (the characters are thinly veiled allusions to Isherwood and Bachardy); their friends include gay writers, screenwriters, and actors. In these suburban

46 Cover, *Physique Pictorial* 10, no. 1 (June 1960).
Courtesy of Athletic Model Guild LLC.

homes, gay men enjoy sexual intimacy, personal commitment, and the amenities of middle-class life.

Although Rechy and Hockney may have linked professionally successful gay men with the private spaces in and around the suburban dwelling, the single-family home with backyard pool itself constituted one of the most public and visible icons of Los Angeles in the 1960s. Photographs of ranch-style houses with pools attracted a flood of newcomers to the city. Reproduced in publications ranging from women's home magazines to *Sunset*'s tourist guides, pro-

motional photographs depicted family and friends enjoying the pleasures of the pool under the California sun (figure 47). The writer Christopher Rand, describing Los Angeles in 1967, situated the pool at the center of family life: "The pool's role in L.A. is somewhat like the hearth's role in Western life from Homer down to now. It is what the guests and family gather around."[42] Given the prominence of the home and backyard pool as emblems of southern California, it is no coincidence that *The Graduate,* the hit movie of 1967, opened its memorable satire of upper-middle-class life in Los Angeles with a pool party.[43] Hockney, rather than mock this ideal of southern California life, chose to grant the promise of the suburban home and pool to gay men. To the extent that a normative model of heterosexuality circulating in booster imagery informed the constitution of the homosexual couple and its suburban residence in Hockney's paintings, the art historian Kenneth E. Silver shrewdly concludes, "No artist before or since has really given us as normalized, or perhaps 'normativized,' a picture of gay domesticity as David Hockney."[44]

Hockney's representation of gay domesticity and eroticism attained public visibility precisely because the male nude migrated from the small black-and-white photographs published in *Physique Pictorial* to the high-art practice of painting on canvas. In the culturally sanctioned space of the canvas Hockney combined nudes from physique magazines circulated belowground, so to speak, with pleasant suburban settings plucked from familiar promotional images of Los Angeles.[45] Hockney did more than recombine subcultural and promotional visual sources on the canvas, however.

Consider how the beach and the pool represented the good life of Los Angeles in the 1960s without ever being explicit about eroticism. I noted in chapter 1 that movies and photographs of Los Angeles from the 1960s cast the Pacific Ocean beach as a public place, its sensuality implicit in the jostling crowds of seminude men and women. Interaction at the domestic pool was more private than at the beach and more intimate than in public areas of the house such as the living room and the dining room. Even so, gatherings around the pool of friends and family clad in their bathing suits maintained conventions of middle-class respectability, at least in the pages of mass-circulation magazines.

Hockney's canvases irrevocably transformed that heterosexual norm. Nude men lounge by the pool, float in the water, and place their buttocks on view, right there, on the surface of the canvas. Hockney depicted a homoerotic fantasy of Los Angeles that functioned, when it was culturally approved by the institutions of exhibition and criticism, as an alternative to the booster's claims about California. In fact Hockney proposed, in titling his 1965 painting of nude

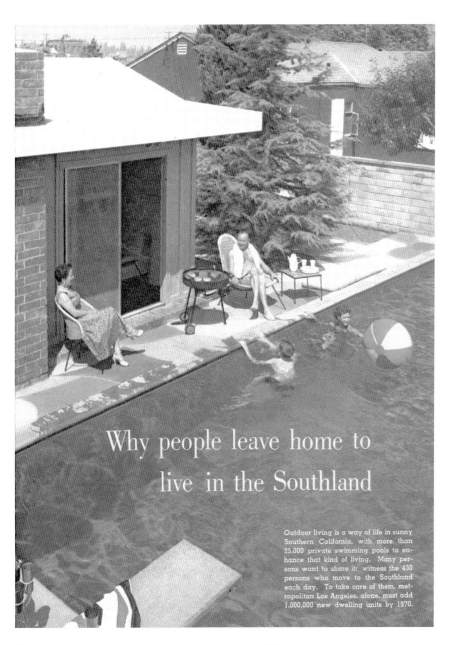

Why people leave home to
live in the Southland

Outdoor living is a way of life in sunny Southern California, with more than 25,000 private swimming pools to enhance that kind of living. Many persons want to share it: witness the 430 persons who move to the Southland each day. To take care of them, metropolitan Los Angeles, alone, must add 1,000,000 new dwelling units by 1970.

47 Swimming pool, *Los Angeles Examiner Annual*, 2 January 1957.
Courtesy of University of Southern California, on behalf of the
USC Specialized Libraries and Archival Collections.

men drifting on inflatable blue rafts in a swimming pool *California,* that these figures could legitimately serve as an allegory for the entire state (see plate 14).

Surface visibility—nude men claiming to represent the public facade of Los Angeles, if not California, in the painted canvases seen in gallery spaces and temporary museum exhibits—should not be underestimated in distinguishing Hockney's representation of same-sex desire from other cultural texts that imagined a gay subculture in Los Angeles during the 1960s and 1970s. As Richard Meyer has demonstrated, in the decade prior to Stonewall and the demand to "come out," "activist groups such as the Mattachine Society . . . typically presented homosexuality as dignified, nonthreatening, and assimilable to the mainstream."[46] The Mattachine Society, which originated in California, promoted a strategy of assimilation. The gay man could be visible in public space as long as he assumed the same appearance as the straight man in the gray flannel suit. According to this logic, lack of visible difference ensured that gay men would be less threatening and more acceptable to straight society. A number of cultural texts in the 1960s, including *Physique Pictorial,* novels by Isherwood and Rechy, and paintings by Hockney, however, proposed a more radically visible homosexuality that contested assimilationist tendencies; they depicted forms of gay erotic desire and difference visible to varying degrees in the image of public urban life in Los Angeles.

In *A Single Man* of 1964 by Isherwood gay characters in the guise of the white-collar professional nevertheless insist on their sexual difference from heterosexuals. An "army of Coke-drinking television watchers" and their tots fill the homes surrounding George and Jim's domestic retreat. George and Jim resemble their neighbors in profession, home ownership, and social class, but they enjoy a relationship that is distinctly physical: "Think of two people, living together day after day, year after year, in this small space, standing elbow to elbow cooking at the same small stove, squeezing past each other on the narrow stairs, shaving in front of the same small bathroom mirror, constantly jogging, jostling, bumping against each other's bodies by mistake or on purpose, sensually, aggressively, awkwardly, impatiently, in rage or in love."[47] Isherwood brazenly reclaims the space of the suburban home, repudiating the sterility of its architecture (and implicitly, of heterosexuality), for male bodies that touch one another both casually and passionately.

In the end, however, only George and Jim see and acknowledge their difference from the doltish heterosexuals around them. Certainly the taunts of children as well as tentative overtures from the adults manifest the neighbors' awareness that George and Jim differ from them. Yet George longs to proclaim defiantly to his neighbors: "The unspeakable is still here—right in your very

midst."[48] George's desire to confront his neighbors proceeds from the certainty that they do not in fact recognize his sexual difference from them. That George and Jim's relationship is only partly visible to those nearby finds its architectural parallel in the physical remove of their home, reached by way of a bridge over a creek. Indeed, the ivy-covered home initially appeals to George and Jim precisely because it stands, like an exotic island, isolated from the surrounding stucco bungalows and clapboard cottages.

Whereas Isherwood's gay couple remain somewhat sheltered from view in their suburban retreat, Rechy's "hustlers" and "queens" occupy a subterranean world that emerges aboveground only when exposed by vice squad raids. The sex between men in Los Angeles in Rechy's novels remains "hidden," as it were, in shadowy public spaces behind the facade of day-to-day life. Indeed, in *City of Night* Rechy characterizes the protagonist's introduction into a gay subculture in spatial terms: "In Dallas—*suddenly!*—with the excitement of someone exploring a new country I discovered that world. As abruptly as that, it happened; that sudden, that immediate: One day, nothing, and the next it was there . . . as if a trapdoor had Opened."[49] In Los Angeles Rechy's homosexual outlaws typically operate at night, cruising the bars, movie theaters, and bathrooms located in and around Pershing Square or, alternatively, city parks and beaches. In both *City of Night* and *Numbers* such shadowy settings enable the orchestration of rituals of seduction and sexual exchange around the desirability of male bodies. Teeming, active, and complex, Rechy's gay subculture thrives in underground spaces.

Hockney referred on canvas to the site of Rechy's subterranean community only once when he painted *Building, Pershing Square, Los Angeles* of 1964 (see plate 15). In his autobiography he recalled:

> I had read John Rechy's *City of Night,* which I thought was a marvellous picture of a certain kind of life in America. It was one of the first novels covering that kind of sleazy sexy hot night-life in Pershing Square. I looked on the map and saw that Wilshire Boulevard which begins by the sea in Santa Monica goes all the way to Pershing Square. . . . But of course, it's about eighteen miles, which I didn't realize. I started cycling. I got to Pershing Square and it was deserted.[50]

In Hockney's painting of Pershing Square spindly palm trees stand starkly outlined against the flat gray facade of the Pacific Mutual Building. The street on Hockney's canvas, barren and sterile by day, perhaps commemorates his disillusionment with Pershing Square as a pilgrimage site.

No sign of gay sexuality on the surface of this painting. No sign of the tur-

bulent nightlife Rechy so vividly evokes. Possibly the sleek forms of the Pacific Mutual Building and vacant sidewalk even indict the developer's dream of a downtown that has foreclosed Hockney's sexual fantasies. In 1964 Ridgeley Cummings angrily condemned the impact of urban renewal on Pershing Square in the *L.A. Free Press:*

> It was debenched, bulldozed, torn-up and in process of being changed from a pleasant tropical garden-like oasis in the center of the city to a routine concrete park that could be duplicated anywhere. Cost of the remodeling designed to inconvenience the pensioners and reduce the free speech aspects of the square is $147,400 . . . this attack on the old folks, the unemployed, the free speechers and others including homosexuals who have made the square their headquarters in the past.[51]

Rechy, likewise, cursed the developers and vice squads for transforming Pershing Square. In *Numbers* the narrator recounts how Johnny, who returns to Los Angeles after an absence of three years, laments the change: "It is no longer the Pershing Square he knew. Vengefully, the enemy, known as 'The City Authorities,' had removed the benches and ledges that outlined the park. . . . Now it was a concrete skeleton. In two pitiful little squares surrounded by grass and no trees, a handful of the old denizens of a freer Pershing Square—preachers, winos—still gathered intrepidly."[52] None of the indignation palpable in the newspaper report and the novel colors Hockney's painting. Hockney based it on a visit to Pershing Square that even slightly predated the redevelopment. Plans to remodel the public space were approved in the summer of 1963; the actual construction work took place in the fall of 1964, a number of months after Hockney visited the site. Any critique of it that viewers find in Hockney's painting results from their measuring its implications retrospectively in relation to his life and the bleak aftermath of urban redevelopment in downtown Los Angeles.

Hockney, drawn to Los Angeles by the "sleazy sexy hot night-life in Pershing Square" he found in Rechy's text, located same-sex desire on his canvases in and around the swimming pool rather than in shabby rooms or on dark streets. Much like Isherwood, Hockney reclaimed for gay men the private home with pool, the quintessential icon of Los Angeles in the 1950s and 1960s. Hockney's accomplishment was to make same-sex desire part of the surface image of Los Angeles: the nude men are there for all to see. Rather than hide in the dark recesses of night, they flaunt their bodies in the sunlight and enjoy the poolside intimacy that is protected by the rights of the homeowner.

Hockney's nudes do not simply colonize the most visible symbols of Los Angeles—the suburban house and backyard pool—and rest on the surface of the canvas; they themselves are materially about surface. Male bodies, their torsos flattened and their surfaces composed of visible swatches of paint, draw attention to the two-dimensional flat surface of the picture. As such these nude bodies allegorize a process of painting that is all about surface: that of the canvas, of sexuality, and of the city.

The male bodies on Hockney's canvases look particularly flat when compared with the muscularity of the men in the physique photographs that served as Hockney's sources. The young men in Mizer's photographs appear nude, except for a posing strap. At one extreme, snug and skimpy bits of fabric and, at the other, highly theatrical and often comical disguises—a gliding snake, a jutting baseball bat, a perpendicular sword—draw attention, as Richard Meyer argues, precisely to what could not legally be seen.[53] Though necessarily coy in covering their groins, the men in Mizer's photographs expose the rest of their bodies: whether striking a classical stance, participating in an athletic activity such as swimming or wrestling, or enacting a domestic scenario, the male models boast firm buttocks and display rippling biceps, well-developed pectorals, and compact abdominals, accentuated by the light glinting off hairless and oiled chests.[54] These bodies boast the hard physicality of the sculpted figure.

The medium of the photograph, especially a close-up and sharply focused shot, asserts the reality and availability of these bulging bodies, as does the men's direct engagement with the viewer. Often the men in Mizer's photographs wink at their anticipated audience, as if to acknowledge that they self-consciously play a role in an imaginary scenario. For instance, on the cover of *Physique Pictorial* from 1960 (see figure 46), the young blond who steps out of the pool and exposes his rippling ribcage, taut forearm muscles, and sharply defined thighs grins widely. When Jerry Fanning shampoos the head of John Krivos in the bathroom sink, Krivos makes direct eye contact with the viewer (see figure 45).[55] Even if the men pose as if unconscious of an onlooker, they are identified in the accompanying text, like celebrities, by name, age, height, and Athletic Model Guild movie credit (Mizer founded the AGM studio in 1945); these are real men with actual bodies, whose photographs—at the very least—are for sale to the readers of *Physique Pictorial*.

In moving the men from indoors to outdoors, from the downtown underworld to suburban retreats, and from subculture to high culture, Hockney transforms them from buffed-up studs to flattened forms and painted surfaces. The physiques of Hockney's nudes are less well developed than those of the men in Mizer's photographs. For instance, in Hockney's *Man Taking Shower in Bev-*

erly Hills of 1964 (see plate 13), the nude looks slight of stature and has a rather underdeveloped torso, in contrast to the model in *Physique Pictorial* on whom he is based, who has fantastically developed thighs and muscular calves (figure 48). The patches of darker color on the man's torso evoke mottling from the sun rather than three-dimensional solidity and corpulence; at the same time, the swatches of dark brown insist on their materiality as paint applied with broad strokes of the brush. The extremities of the body likewise read both figuratively, as identifiable parts of the man's physique—arms, hands, legs, feet—and materially, as paint. The left arm dissolves into a long patch of paint, left ragged and unfinished at the end where one would expect to find a hand. The right hand, in the meantime, consists of a horizontal daub of white paint next to a bit of brown. The flattened body calls attention to skin rather than to bulging muscle; skin, in turn, materializes as paint brushed across the surface of the canvas.

Hockney's nudes typically lack expression and do not engage the viewer as accessible individuals. The face of the figure in *Man Taking Shower in Beverly Hills,* although turned to the viewer, lacks articulation. Even when the title of the painting names the model, as in *Peter Getting Out of Nick's Pool* of 1966 (figure 49), the face includes too few individual details to make it recognizable as that of a particular person. In other words, the men present themselves not as real, identifiable, and available bodies in suburban Los Angeles homes but as anonymous, flattened painted torsos. The paintings—not the bodies—wink at us, offering themselves up for visual delectation and purchase.

In Hockney's paintings only bare buttocks coalesce as three-dimensional parts of the male body. Over and again, decorative patterns both frame the buttocks and draw attention to the two-dimensional surface of the canvas. For instance, the white squiggles on the water in *Peter Getting Out of Nick's Pool* of 1966 lead directly to Peter's rounded buttocks, insisting on anality and explicitly eroticizing his body. On the one hand, those loops of white paint evoke rippling water in sunlight; on the other hand, they overlap one another on the expanse of flat blue acrylic paint to form ornamental figure eights. Similarly, in *California* dark blue lines designating undulations surround the protruding buttocks of the nudes floating in the pool (see plate 14). At the same time, the lines take the form of amoebas filled with white or blue paint. These organic shapes recall Henri Matisse's cutouts or Jean Dubuffet's *Hourloupe* series as much as they evoke the decorative motifs of 1960s fashion. The Italian designer Emilio Pucci, whose brightly patterned synthetic clothes were popular in the United States during the 1960s and 1970s, fashioned bathing suits and sportswear in the late 1950s noteworthy for the squiggles animating their surfaces.[56] Again

EARL DEANE 14, 5'5 1/2 1 27 lbs waist loose 27.5, tight
25.5, chest 36.5/37, thighs 20,25, calve 14,25/ ankle 8.25.
shoulders 44. All-around athlete, active in football swimming,
basketball, and wrestling.
 This is AMG photo VI-1-CL. Catalog of other photos of
Earl 90 cents; Ask for pages 2 thru 7 of VI-13.
A beautiful movie was made with Earl, but it was among a
group of original films which were stolen from our studio be-
fore we installed a burglar alarm. All that we have are a few
cuttings from the film which may be released at a later time as
part of a pot-pourri group.

page 6

48 *Physique Pictorial* 10, no. 4 (April 1961): 6. Courtesy of Athletic Model Guild LLC.

49 David Hockney, *Peter Getting Out of Nick's Pool*, 1966. Acrylic on canvas, 60 × 60 in. Photograph courtesy of National Museums Liverpool (The Walker).

and again, Hockney's painted line describes waves and sunlight dancing on the water, calling attention to itself as a decorative ornament that speaks to both modernism and fashion.

The stylized shapes, flattened forms, and broad strokes of paint that highlight the two-dimensional surface of the canvas simultaneously emphasize the erogenous zones of the body. Elegant male nudes in attractive suburban homes and in backyard pools elicit desire, including that of the viewer—for the rounded buttocks and for the paintings themselves—precisely through their material realization as decorative artifice.

Both Banham and Hockney's earliest British critics assumed that his paintings had gotten Los Angeles right, that he had captured the city in all of its wonder or emptiness. Hockney himself claimed to have depicted what he saw around him: "The one thing that happened in Los Angeles . . . was that I had begun to paint real things I had seen. . . . In Los Angeles I actually began to paint the city round me."[57] Yet at the same time both Banham and Hockney referred to the artist's paintings of the city as dreams or fantasies. Even Hazan's film, which repeatedly links the paintings to actual events in Hockney's life, casts the California canvases into dream sequences or flashbacks. The unselfconscious ease with which writers, including Hockney himself, characterize Hockney's paintings of Los Angeles alternatively as reality and illusion is a consequence of the paintings themselves—their claim to represent actual buildings and people in the city of Los Angeles, while always highlighting their own surface artifice. An insistence on stylized flourishes and patterns as well as the material presence of paint draws attention to Hockney's representation of the bodies, homes, and pools as fabricated, engaging modernist abstraction with a visual rhetoric equally suited to the fashion industry. Artifice, instead of reflecting the superficiality of the city or the artist's lifestyle in Los Angeles, covering over the city's blemishes, or condemning the banality of its architecture and inhabitants, opens up the city of Los Angeles to the fantasy of a gay lifestyle lived out in the open, under sunny skies, by the poolside. Contrary to the popular understanding of dreams, illusions, and fantasies that opposes them to reality, Hockney's paintings depict Los Angeles as a city where erotic fantasy takes material form on the surface of the canvas, and where reality becomes the stuff of illusion.

A Bigger Splash Revisited

And what about Hockney's paintings of Los Angeles that forgo the nude male body altogether? After all, Banham enthusiastically embraced one such painting, *A Bigger Splash,* as a figment of a "great dream . . . the dream of a good life."[58] This same painting provided the catchy title for Hazan's docudrama entangling Hockney's paintings of Los Angeles with his tumultuous love life. Despite the absence of bodies, *A Bigger Splash* gave form to Banham's and Hazan's fantasies about Los Angeles. Certainly the motifs of the single-family home and backyard pool expressed domestic sensuality, if not eroticism. While transforming the modernist house into a self-consciously seductive surface, Hockney's painted surface also referenced the actual case-study houses dotting the landscape.

The dust jacket of *Los Angeles: The Architecture of Four Ecologies,* with pale yellow printed over the unprimed border of *A Bigger Splash,* undercuts the painting's insistence on its status as a representation, by seeming to treat the work as a window onto the city (see figure 44). In the painting itself, the threads of exposed unprimed canvas along the edge are material reminders, always visible, that *A Bigger Splash* is a painting (not a window, not a mirror) of Los Angeles (see plate 16). Marco Livingstone has wisely remarked about unprimed canvas as a framing device that it reminds viewers that they are looking at a reconstruction of reality on a two-dimensional surface.[59] The publishers of Banham's book, by coloring the frame yellow, seem to deny the painting as a representation, conflating its surface with that of the actual city.

At the same time, the dust jacket's design underscores the importance of color in Hockney's painting by repeating its tropical coral, blue, and yellow hues in the type used for the title and the author's name. Like a travel poster advertising the city's amenities, the jacket of *Architecture of Four Ecologies* catches the eye with its bold, bright colors, arranging them to arrest our attention, casting them as characteristic of the southern California landscape and thus countering black and white as the governing principle of architectural photography. Indeed, a photograph of an actual building was de rigueur at the time on the cover of any serious study of architecture. All of the reproductions in Banham's tome conform to the conventions of architectural photography.[60] As I noted in chapter 2, a photographer like Julius Shulman selected black-and-white film to highlight the blunt geometric forms of these modernist structures in southern California—their squat cubes, broad rectangles, square sliding glass doors. The geometric components of the buildings cast crisp black shadows, animating the white surfaces of the homes.[61] Shulman, explaining his selection of print film, contended: "Black and white is more dramatic in its portrait, while color only adds a veneer to the picture."[62]

"Veneer": Shulman disdains color as surface gloss. His biting repudiation of color photography is not surprising, given that color, as Sally Stein has insightfully demonstrated, emerged in the interwar period in advertisements to promote a range of ever-changing consumer products.[63] This practice continued well into the 1960s, as seen in women's home magazines in which color photographs displayed the appealing new hues of fixtures and furnishings for the home. Advertisements securely linked color and consumers' passing whims. Architectural photography, in contrast, associated black and white with the enduring quality of modernist structures; indeed, the black-and-white prints did not fade, just as modernist architecture promised not to go out of fashion. Shulman's selection of the noun "veneer" not only equates color with surface

but also implies that the deceptive qualities of color arouse suspicion, undoubtedly based on the assumption that color, like advertising itself, appeals to the passing desires of frivolous shoppers and "tricks" them into buying goods.

In California paintings such as *A Bigger Splash,* Hockney revels in color. On the one hand, his choice of acrylic and its application manifested a dialogue with color field abstraction. Hockney, citing the artist Kenneth Noland as an inspiration, commented that in the mid-1960s, "I still consciously wanted to be involved, if only peripherally, with modernism."[64] The blue and coral paint in *A Bigger Splash,* evenly applied, defines a series of alternating geometric bands, with only the yellow diving board jutting into space at an oblique angle to suggest three-dimensional recession into space. In the spirit of color field art Hockney draws attention to the two-dimensional surface of the painting with flat fields of acrylic paint. Acrylic paints themselves are all about surface. David Batchelor observes in *Chromophobia* that "the use of flat screen-printed and industrial colours will always appear cosmetic—applied, stuck on, removable—in a way that the modulated colours and tones of oil paint do not."[65] Only the splash of water disrupts the still surface of the pool, implying a passing human presence, the eruption of noise, and a momentary chaos of water; the squiggles, rivulets, and broad strokes of white paint applied with small brushes to form the splash likewise disrupt the smooth uniform layers of paint.[66] The application of the color and paint that describe the southern California homestead always simultaneously engages the aesthetic problems of midcentury modernism and brings attention to the two-dimensional surface of the canvas.

On the other hand, Hockney's choice of color has everything to do with the local environment. When Hockney moved to Los Angeles, his palette changed dramatically, apparently in an attempt to capture the characteristic light and hues of his new surroundings. Referring to one of his paintings completed in southern California, *Man Taking Shower in Beverly Hills,* he recollected his first impressions of southern California (see plate 13): "Beverly Hills houses seemed full of showers. . . . They seemed to me to have elements of luxury: pink fluffy carpets to step out on, close to the bedrooms (very un-English that!)."[67] Both the number of showers and the presence and type of carpeting—its pink color and fluffy texture verging on the vulgar—invoke a feminine sumptuousness presumably at odds with ascetic English taste. As this passage indicates, the pinks, blues, and yellows that Hockney applied to his California canvases captured the actual colors of the Los Angeles landscape but also tarted up both the city and color field abstraction. These are emphatically not the bold primary colors that characterize Ruscha's canvases. Rather, the flat fields of acrylic paint that form the blue skies, green lawns, and coral homes in Hockney's paintings

engage color field abstraction with a queer twist: tropical, vulgar colors (and in some cases, male nudes) not sanctioned by modernist critics.

With his sumptuous colors Hockney transformed the surface of the canvas into "erotic camouflage," a rubric coined by the architectural critic Jeffrey Kipnis in a discussion of the stunning materials and reflective facades of buildings designed by two contemporary architects, Jacques Herzog and Pierre de Meuron. Kipnis expostulates: "They (cosmetics) relate always and only to the skin, to particular regions of skin. Deeply, intricately material, cosmetics nevertheless exceed materiality to become modern alchemicals as they trans-substantiate skin into image, desirous or disgusting."[68] Kipnis's equation of the beautiful skin of HdM's buildings—their surface artifice—and cosmetics sheds light on Hockney's transubstantiation of Los Angeles into appealing illusion by his choice and application of color. Hockney, attentive to, even emphasizing, tropical colors in *A Bigger Splash,* treats the house, with its backyard pool, as a cosmetic surface, susceptible to changing fashion, consumer whim, extravagant taste, and fantasy. Yet the surface of this painting neither celebrates nor indicts the superficiality of the city and its lifestyle; nor does it hint at some reality lurking beneath a cosmetic surface. Rather it foregrounds the way that color transmutes home into a seductive chimera indistinguishable from reality—so much so that on the cover of *Architecture of Four Ecologies* the painting could be cast as a window onto the actual city.

Hockney in his surfaces deliberately engaged modernist painting at midcentury. The acrylic paint applied evenly onto the canvas, the unfinished and flattened bodies, the decorative patterns—all bring attention to the canvas as a two-dimensional surface while the framing device of unprimed canvas insists on the paintings' representational status. Yet the choice of sensual tropical hues, much like the looping waves in the swimming pools, turned color field abstraction into something else—stylization, contrivance—and thus aligned it with cosmetics and fashion. In other words, Hockney altered color field abstraction by selecting "debased" motifs such as nude men and suburban pools. But he also used midcentury modernist practices to achieve an artifice of surface, granting material form to seductive illusions—about himself, about the city of Los Angeles, about gay life.

Hockney and other artists whose works I have examined in chapters 1–3 represented the changing megalopolis of Los Angeles during the 1960s. Hockney joined Ruscha in positing a parallel between the surface of the canvas and the city's surface urbanism. Yet neither artist treated the two-dimensional expanse

of the canvas as a metaphor for the city's empty facades and movieland illusions or for the banality of Angeleno lifestyles. Rather Hockney, by highlighting the surface artifice of painted canvases, suburban homes, and young men, found a means to imagine male bodies taking visual delight in one another while enjoying the vaunted amenities of sunny Los Angeles. And Ruscha, locating a meeting ground between the design principles of commercial culture and modern art on his canvases, accentuated both the standardization of the urban environment and the exhilarating drama of building facades and advertising signs oriented to the driver's mobile eye. Still other artists, such as Foulkes and Celmins, emphasized the painted or graphite skin to allude to the flattening of the natural environment into cliché through photographic reproduction, while at the same time stirring memories of sublime nature now lost in the past or located elsewhere in other times and places. The surface of these canvases and of the city of Los Angeles was anything but superficial.

The chapters that follow turn attention to artists who did not depict Los Angeles in paint or with pencil but instead intervened in the built environment either by claiming permanent structures for aesthetic purposes or by building temporary markers in the landscape. Such artistic actions concentrated public attention on nondescript spaces, neglected areas, or neighborhoods riven by economic disparity and social despair. Incongruous and often fleeting landmarks transformed place with fanciful flights of imagination, accident, or planned performances and drew attention to spaces outside the urban map imagined by the artists in the first three chapters. Chapter 4 looks at the Watts Towers, which, although completed in 1955, suddenly became the focus of cultural and urban controversy in the 1960s, and chapter 5 discusses artists who mounted Happenings and Performances throughout the city. Together, the Watts Towers, Happenings, and Performances exemplified two different, and sometimes simultaneous, roles that the artistic landmark played in the city during the 1960s: on the one hand, redeeming, if not countering, the deadening uniformity of the urban environment and, on the other, identifying groups of people and neglected neighborhoods that demanded political and cultural recognition.

The Watts Towers as Urban Landmark

IN THE LATE 1950S CONTROVERSY ERUPTED OVER DETERMINED EFFORTS by Los Angeles city officials to demolish a group of seventeen imaginative structures popularly known as the Watts Towers, located in South Central Los Angeles (figure 50).[1] During a thirty-four-year period (1921–1955), the Italian immigrant Simon Rodia erected three tall spires—one ascended nearly one hundred feet into the sky—several smaller towers, a gazebo, a fishpond, a mock ship, and a patio in his backyard. Pouring cement over bent steel rods and wire mesh, Rodia constructed soaring, twisting, and spiraling edifices, their surfaces sparkling with fragments of glazed tile, colored glass, and broken ceramic (see plate 17). Pathways decorated with engravings wound past the structures, and a scalloped wall ornamented with mosaics enclosed the entire enchanted garden (figure 51). After Rodia abandoned his home and whimsical creations in 1955, at the age of seventy-six, to move to northern California, the Watts Towers deteriorated from neglect and vandalism. In February 1957 officials from the City Building and Safety Department, expressing serious concern about the damaged state and stability of the Watts Towers, peremptorily announced plans to tear them down.

The Committee for Simon Rodia's Towers in Watts formed quickly and, with financial and professional support from individuals and organizations around the world, campaigned vigorously to preserve the ensemble. It collected statements testifying to the aesthetic importance of the towers from artists, museum curators, architects, and art critics and presented these statements to city officials. But it was the structural integrity of the towers more than their artistic merit that carried the day. One of the committee's members, the engineer Norman J. "Bud" Goldstone, proposed a stress test for the towers, to which the city finally consented. When the tallest tower successfully withstood the pressure of a 10,000-pound load (comparable to that of a 70-mile-per-hour wind), city officials agreed to let the Watts Towers stand, provided that the committee undertake to repair them. The committee's triumph led to plans to restore and permanently preserve the Watts Towers and also ushered in an era of cultural prominence for these fanciful structures. From their preservation as a Los Angeles Cultural Heritage Monument in 1963 to their inspirational role in the advent of the California Assemblage art movement, from their appearance on the cover of *Artforum* in 1965 to their inclusion in Reyner Banham's book *Los Angeles: The Architecture of Four Ecologies,* the Watts Towers emerged in the 1960s as a monument testifying to the artistic and architectural originality of the city and redeeming it from utter banality.

If in the late 1950s and early 1960s the Watts Towers were themselves the

50 Simon Rodia, *Watts Towers*, 1921–1955. Photograph by the author.

focus of controversy, in the mid-1960s they became a prominent symbol for a neighborhood in crisis. After the Watts uprising in 1965, members of the predominantly African American community of Watts increasingly claimed the towers, designed and built by an Italian immigrant, as a rallying point for the black cultural arts movement. The Watts Towers even inspired a group of Assemblage artworks made with burned debris from the uprising.

In contrast to Ruscha's mobile eye scanning the new urban landscape of Los

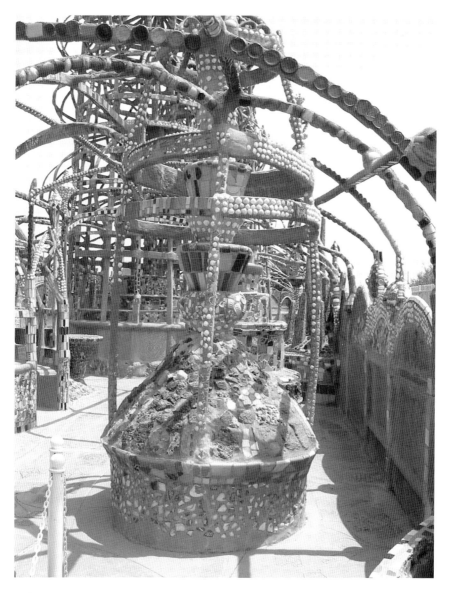

51 Simon Rodia, *Watts Towers* (detail of pathways), 1921–1955. Photograph by the author.

Angeles, then, the Watts Towers marked a specific place in a neglected neighborhood. Like the hub of a wheel, Simon Rodia's work sent out spokes to different groups over time, some local, some civic, and some national. Nevertheless, by the late 1960s the Watts Towers had acquired a split identity: on the one hand, emblem of the local African American community's efforts to heal through a cultural renaissance and, on the other, a symbol of the city's artistic achievement in the realm of modern art. In other words, at virtually the same

moment as the Watts Towers were preserved as part of the city's cultural heritage, arguments broke out over whose heritage they represented.

Immigrant Dream

Rodia moved to Watts in 1921 when African Americans migrating from the southern United States as well as European and Mexican immigrants inhabited the small homes in this dusty landscape south of downtown Los Angeles, and Japanese families lived on the small truck farms around it.[2] Rodia acquired a modest house on a triangular lot near the railroad tracks and sought work as a tile setter. In his free time he began to fabricate a group of imaginative structures in his backyard with sand, cement, and steel he purchased and with the discarded materials he collected from his workplace, his neighborhood, and the beach.

Rodia's extraordinary creations first captured public notice when a beat reporter for the *Los Angeles Times* published a brief article about them in the late 1930s.[3] But until the late 1950s the towers drew relatively little public notice. The attention they did receive stressed their oddity and their creator's ethnic origin. As the eccentric fulfillment of an immigrant's dream, the Watts Towers contributed to a mythology spun about Los Angeles in the painting, film noir, and detective fiction of the 1930s and 1940s: that neighborhoods with dilapidated and unusual structures embodied the city's mystery and intrigue.

In one of the most detailed accounts of Rodia's life printed prior to the publicity surrounding the campaign to save the towers, a reporter for the *Los Angeles Times* recited a heroic tale of a humble immigrant who had bettered himself in the New World. Born in 1880, Rodia arrived in the United States when he was eight years old and later moved to California, where he became an American citizen, found a job, bought a house, and converted an imaginative vision into reality. Given Rodia's modest background and some of his statements to the press, most writers accepted the towers as an immigrant's expression of warm gratitude to his adopted country and city. "I'm gonna do something for the U.S.A. before I die—something big," Rodia proclaimed in the *Los Angeles Times*. "Immigrant Builds Towers to Show His Love for U.S." was the sentimental headline for this article.[4] The Watts Towers accordingly exemplified the realization in California of the most far-fetched dream of an immigrant from a humble background who despite a minimum of education evinced great know-how and determination. Glossing over Rodia's poverty and his failure to assimilate, the article championed his achievement as an example of immigrant

self-fulfillment that confirmed a long-standing myth about southern California: "It is the land of the second chance, of dreams come true, of freshness and opportunity, of the wideness of out-of-doors," as one early twentieth-century writer enthusiastically declared.[5]

If writers attributed the conception of the Watts Towers to an ingenious immigrant's vivid imagination, they also noted analogies between the spires and a surprising array of other famous monuments. Rodia himself listed various buildings, legends, and historical narratives that had incited his imagination, though he never consistently claimed one particular antecedent. Responding to Rodia's revelations, the earliest article on the spires compared them to "quaint towers remembered from Italy." Writers soon speculated on other sources that might have influenced Rodia, including the "conception of Columbus's ships discovering America, the heroism of Joan of Arc, and Indian house chimneys and Spanish patio grillwork."[6] The multiple cultural associations that precluded the simple dismissal of the towers as bizarre also contributed to their appreciation by some as an eccentric artistic achievement.

Owing to their humble creator and their imaginative form, the towers earned a place in *Nuestro Pueblo: Los Angeles, City of Romance,* which presented itself as both an art book and a guidebook to the city. Published in 1940, it reproduced illustrations by the newspaper artist Charles Owens alongside articles by Joe Seewerker reprinted from the *Los Angeles Times.* The guidebook, in its opening pages, aligned itself with the newspaper, adopting its enthusiastic rhetoric in promoting the City of Angels:[7] "I have never known any other city that offers such infinite variety as this ever-growing, ever-changing laboratory, in which the newest and most revolutionary is continually being grafted on the old, the traditional, and the historic," the writer Lee Shippey boasted in the book's introduction.[8] The title *Nuestro Pueblo,* or "our town," referred to the city's transformation from a Spanish pueblo—originally El Pueblo de Nuestra Señora la Reina de los Angeles de Porciúncula, founded in 1781 by Felipe de Neve—into the modern city of Los Angeles. The book itself, however, hardly mentioned the city's specifically Spanish past. Instead, presenting Los Angeles as "the city of romance for the youth of the whole world, having succeeded Paris as the city of their dreams," *Nuestro Pueblo* contained drawings of monuments distinguished by age and/or peculiarity.[9]

The text of *Nuestro Pueblo* animates each building with a story, endowing places with human personalities. The book opens with the old central jail at the intersection of Hill and First Streets, prized for its arched windows. The lieutenant in charge of it claims to "have a prize collection of thieves, vags, and drunks." The ensuing pages include stories about an enormous wooden fish

erected in the 1920s on Sunset Beach and a dilapidated square-rigger, the *Santa Clara,* from the 1870s. Toward the middle of the book, Simon Rodia's words ring out: "It is plenty fun! So I build my wall so much I am forget to drink. Then I am think of towers and not to drink."[10] *Nuestro Pueblo* casts Rodia as a guileless immigrant, amusing the reader with his broken English, his circular reasoning, and his towers that "shimmer like peacock feathers." Rodia and the Watts Towers thus take their place among the other unique architectural creations built or inhabited by idiosyncratic personages in Los Angeles. In its tour of the city, *Nuestro Pueblo* highlights odd and aging landmarks, touchstones of a distinctive past, and the heterogeneous population of Los Angeles, while white-washing the city's more troubling conflicts and ethnic tensions.

The nostalgic romanticism of *Nuestro Pueblo* exemplified precisely the sentiment Carey McWilliams roundly criticized as bunk. In his *Southern California Country,* McWilliams, the most famous nonfiction writer about the state of California at midcentury, ridiculed mythmaking about the Spanish colonial past in the enormously popular romantic novel *Ramona,* by Helen Hunt Jackson, and in the restoration and preservation of the missions: "The restored Mission is a much better, a less embarrassing, symbol of the past than the Mexican field worker or the ragamuffin *pachucos* of Los Angeles."[11] Yet even McWilliams, who never missed an opportunity to puncture sentiment with his sharp analyses of social classes, ethnic differences, and labor difficulties in the region, attributed the region's unique identity to its inhabitants: "It is the heterogeneity of its population that serves to make Southern California the ideal testing ground for ideas, styles, manners, and customs."[12] He took a particularly keen interest in examples of self-invention in California. According to the historian and state librarian Kevin Starr:

> For McWilliams, the story of Southern California . . . is most fundamentally a story of assimilative encounter. No one group ever fully repudiates what has gone before. Somehow, amid horrendous exploitation and inequality, a torrent kept running forward in which all elements of past and present remained part of the flow.
>
> Self-invention is for McWilliams the region's most distinctive characteristic—hence his fascination when it veers into eccentricity. Each Southern California generation, moreover, seems to create itself out of the shattered fragments of the inherited past.[13]

A pronounced appreciation of the varied characters who populated Los Angeles and the ways in which they fashioned new identities for themselves in this frontier landscape—their fads, social customs, and creations—cut across the booster and antibooster myths of southern California during the interwar years.

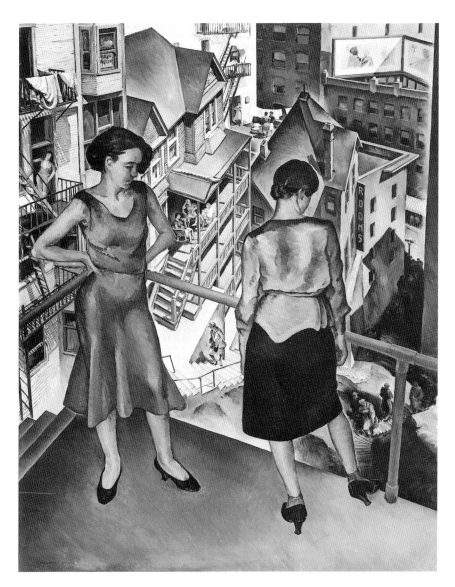

Similarly, the taste for the eccentric, dilapidated, and aged monument evident in *Nuestro Pueblo* manifested itself in urban-realist painting and the L.A. school of hardboiled fiction writing of the 1930s and 1940s. In Millard Sheet's painting *Angel's Flight* of 1931, for instance, two young women gaze down from a balcony at the drab tenements clinging to the steep slope of Bunker Hill in downtown Los Angeles (figure 52). The funicular railway that gave the painting its title had operated on this hill since 1901.[14] Some of the most famous

writers of Los Angeles fiction—including Nathanael West, John Fante, and Raymond Chandler—also ruminated about Bunker Hill, its gritty streets lined by old buildings populated by a range of characters, from the disillusioned dreamer to the hardened criminal.[15] McWilliams himself selected both West's *Day of the Locust* and Fante's *Ask the Dust* as two of the four novels that he claimed "suggest what Southern California is really like."[16] Shabby architecture in these novels testified to the California dream gone awry—in *Ask the Dust,* the "horrible frame houses" on Olive Street; in *Day of the Locust,* Tod Hackett's kitschy apartment house, painted mustard color, its windows framed by pink Moorish columns. Precisely such neglected or idiosyncratic buildings lent mystery to the city in fiction and ultimately in film noir of the 1940s and 1950s. Raymond Chandler's famous description of Bunker Hill from *High Window,* of 1942— "Bunker Hill is old town, lost town, shabby town, crook town"—according to the film historian Edward Dimendberg, "became permanently associated with the neighborhood, almost to the point of usurping its actual physical identity." The "romance of urban blight" in Chandler's novel, as the scholar Norman Klein astutely argues, itself attracted tourists to the city.[17]

Not until the 1950s did the urban settings of film noir include modern buildings as well as decrepit boarding houses. Exemplifying this trend, the movie *Kiss Me Deadly* of 1955, as the film historian Robert Carringer remarks, "flows with views of Los Angeles old and new, often strikingly juxtaposed: early-twentieth-century downtown, with houses on Bunker Hill and Angel's Flight in operation; a postwar, International Style hospital on the outskirts; 1920s bungalow neighborhoods; a sparkling, bright, moderne gas station; quiet commercial and residential streets; a traffic-flooded, six-lane boulevard."[18] In its successive views of modern commercial architecture and shabby Bunker Hill boarding houses, the film attests to the transformation of aged and neglected neighborhoods in Los Angeles as they fell prey to urban renewal. Dimendberg argues further that Bunker Hill, officially designated an urban renewal site in 1951 by the Community Redevelopment Agency and razed at the end of the 1960s, "assumes [in film noir] the role of the repressed historical unconscious of Los Angeles in juxtaposition to its recently constructed suburban present."[19]

Whether evoking the California dream or its failure, a nostalgia for the urban past or anxiety about its future, the decrepit and idiosyncratic structure and the eccentric individual captivated perceptible interest at midcentury and contributed to a romantic image of Los Angeles. The appreciation of the Watts Towers as the realization of an immigrant dream in all its originality exemplified such a taste for the quaint and anomalous. This taste would dissipate in a city devoted to growth, modernization, and urban renewal. Indeed the historian

Sarah Schrank argues that efforts to remove the Watts Towers had everything to do with urban renewal: "Watts had been targeted in the late 1950s as a slum-clearance area . . . [and] the Watts Towers were simply in the way."[20] The Watts Towers, seen initially as whimsical creations, by the late 1950s were attacked as a dangerous folly and an eyesore.

Modern Monument

"It's the biggest pile of junk I've ever seen. A king-sized doodle. It's an eye-sore and should be pulled down," jeered the chief inspector of the City Building and Safety Department.[21] Rising to the inspector's provocation, advocates of Rodia's creations in the art community focused the debate about the Watts Towers on aesthetics, arguing against the ignorance of the city officials. "These towers have been recognized the world over as an inimitable artistic achievement," pronounced Henry J. Seldis, the art critic for the *Los Angeles Times*.[22] Other august individuals in the arts, including the architects Buckminster Fuller and Philip Johnson, defended the towers, drafting statements on behalf of the Committee for Simon Rodia's Towers in Watts attesting to their artistic importance, originality, and creativity.[23] The battle between the arts community and city officials generated greater celebrity for the towers, making them a cause célèbre as museum directors, art critics, artists, and architects joined to defend Rodia's monument as a work of art.

In 1959 the Los Angeles art critic Jules Langsner first labeled the Watts Towers "Surreal folk art."[24] Increasingly art critics evaluated the towers according to formalist criteria first adopted in the 1920s, when modern artists had embraced folk art for its expressive forms, repetitive patterns, and bold colors.[25] From the beginning, an aesthetic standard of abstract design enabled artists and critics to group a wide array of objects, including Shaker furniture, seventeenth-century paintings, and trade signs, under the rubric folk art. Continuing to rely on this same standard in the 1960s, many in the art world categorized the Watts Towers as folk art, singling out the beauty and significance of their intricate patterns and stunning colors. Countless color photographs isolated Rodia's structures from their surroundings and invited the eye to judge them by formal considerations alone. The abstract patterns of the latticework, iridescent tiles, and shimmering glass filled the pages of art magazines, as did photographs framing the magnificent height of the three spires. In 1962 the Los Angeles County Museum of Art organized an exhibition of photographs by Seymour Rosen that focused on the expressive forms of the Watts Towers.[26]

Interest in the towers as the creative handiwork of someone untutored in the formal principles of the fine arts inspired more and more attention to Rodia's life and especially interest in his raw artistic talent. Interviews conducted with Rodia in the early 1960s after committee members discovered him living in Martinez, near San Francisco, enabled art critics and news reporters to elaborate on his background, persona, and aesthetic ambitions; tributes to Rodia culminated in eulogies circulated in the printed press at the time of his death in 1965. Rodia, according to art critics, had realized his innate artistic talents and inner visions despite lack of training in the arts. Such achievement led commentators to compare him to a French postman by the name of Ferdinand Cheval, who spent thirty-three years building a mausoleum, Le Palais Idéal, out of stone.[27] Rodia's less admirable traits—three failed marriages, two children he abandoned, a caustic and contradictory personality—contributed to the new theory that building the Watts Towers was an act of personal atonement rather than Rodia's gift to his adopted country. As Paul Laporte solemnly declared, "A self-destructive tendency was converted into creative construction."[28]

The arts community's interest in the Watts Towers led to an even more specific connection between Rodia's monument and the fine arts. In 1961 the Museum of Modern Art in New York mounted a landmark exhibition, The Art of Assemblage; the Watts Towers played a pivotal role in conceptualizing and defining the Assemblage art movement. This show recognized the emergence of Assemblage art in Europe and on both coasts of the United States and traced the art movement's historical lineage in the works of Joseph Cornell, Marcel Duchamp, Pablo Picasso, and Kurt Schwitters.[29] A chapter in the exhibition catalog titled "Collage Environment," which bridged historical precedent and current practice, juxtaposed photographs of the modern city and the Watts Towers. The exhibition of Assemblage art at MOMA, which institutionalized the art movement while endowing it with historical legitimacy, included the Watts Towers to link the past and present and to demonstrate that Assemblage art was a specifically urban phenomenon. More: with two color photographs of the Watts Towers, the MOMA catalog granted Rodia's creations a significance comparable to that of the other nine works of art featured in color, including Pablo Picasso's *Verre et bouteille de Suze,* 1912, and Robert Rauschenberg's *Canyon,* 1956.[30]

The catalog chapter "Collage Environment" attributed the recent resurgence of Assemblage art to patterns of consumption in the modern city. The text opened beneath a photograph by Herbert Loebel featuring an urban strip with its chaotic assortment of neon signs, billboards, streetlights, and commercial establishments. The frenzied production, sale, and consumption of goods designed according to the principle of planned obsolescence generated an explo-

sion of commercial signage and piles of discarded goods in the modern city. Objects thrown away because of stylistic or functional obsolescence nevertheless provided raw materials for the contemporary artist.[31] Accordingly, Rodia had taken advantage of the urban environment, and "transform[ed] the copious waste of an industrial society into structures of soaring magnificence."[32]

Indeed while some of the materials embedded in the mortar of the towers belonged to the natural world—for example, seashells and stones—most of the glittering bits were pieces of manufactured products, including green 7-Up bottles, blue Milk of Magnesia containers, Malibu and Batchelder tiles, teapot spouts, and ceramic cups (see plate 17). Rodia had collected fragments of obsolete, forgotten, or no-longer-fashionable goods. Endowing these detritus with new purpose, he estranged them from their original functions and revitalized them as purely decorative. As a result, these artifacts evoked the past—cataloging changing tastes in color and design, for instance—but did not survive solely as antiquarian relics that invited nostalgia for bygone days. With their new decorative function, the shards of commerce ornamenting the Watts Towers shimmered with vivacity, enchanting passersby.[33]

The Art of Assemblage show traveled to San Francisco in 1962, just as artists, curators, and critics on the West Coast began to promote local Assemblage art in San Francisco and Los Angeles. In Los Angeles during the early 1960s Assemblage art emerged from informal, artist-run spaces or coffeehouses to enter the galleries on La Cienega Boulevard and museums such as the Los Angeles County Museum of Art and the Pasadena Art Museum.[34] Assemblage artists, including Bruce Conner, Edward Kienholz, and Gordon Wagner, enjoyed increasing local and national attention. At the same time, exhibitions in galleries and museums in Los Angeles highlighted works by Cornell, Duchamp, and Schwitters, the artists MOMA sanctioned as providing the historical precedents for the Assemblage art movement. Other exhibitions in Los Angeles featured the art of contemporary Europeans who manifested an Assemblage sensibility: Arman, Martial Raysse, Niki de Saint Phalle, and Jean Tinguely.

Whereas the Museum of Modern Art included the Watts Towers in a worldwide Assemblage art movement, numerous art critics in Los Angeles positioned Rodia's monument as the origin of a specifically native Assemblage tradition. By the mid-1960s writers regularly cited Rodia's towers to authenticate the indigenous roots of the Assemblage art movement in Los Angeles. As Donald Factor asserted in the pages of *Artforum:* "No discussion of assemblage art in southern California can omit mention of Simon Rodia's Watts Towers, the great proto-assemblage of southern California."[35] National opinion concurred. In 1965 an essay titled "Assemblage at the Frontier," published in *Time* magazine, jux-

taposed photographs of William Wiley, the Watts Towers, and Kienholz and explained that the Watts Towers exemplified "California's crazy tradition for assemblage and the object."[36] By the time Peter Plagens published *Sunshine Muse: Art on the West Coast, 1945–1970,* still the chief history of modern art on the West Coast, he designated Assemblage the "first home-grown California modern art" and gestured to the Watts Towers as the preeminent example of an "unconscious proto-assemblage" work.[37]

Creative structures preserved despite uncomprehending city officials, the Watts Towers verified that Los Angeles had somehow nurtured and protected an indigenous Assemblage tradition all along. The triumph of the Committee for Simon Rodia's Towers in Watts countered an alternative story about the city's cultural history: that Los Angeles—its city officials and established museums—consistently ignored modern art, even expressing hostility to it. Of course, recent events supported this story, most famous among them the failure of the Louise and Walter Arensberg collection, with its impressive works by Duchamp, to find a home in Los Angeles during the 1950s.[38] Instances of city bureaucrats' censoring Assemblage art also abounded. As we have seen, in 1966 the County Board of Supervisors, targeting one of the key Assemblage artists in southern California, threatened to close down the Los Angeles County Museum of Art if it did not remove *Back Seat Dodge* from the Kienholz retrospective. The vociferous defense mounted on behalf of that work and others, including the Watts Towers, established the existence of a committed cadre in the city prepared to oppose the incursions of narrow-minded, pompous officials against local contemporary art.

As a large-scale Assemblage artwork sited out of doors, the Watts Towers achieved recognition in the 1960s as a monument on a par with notable examples of modern architecture throughout the city. *A Guide to Architecture in Southern California* by David Gebhard and Robert Winter, the chief tome on architecture in Los Angeles prior to the publication of Banham's book, extolled the Watts Towers as worthy of a visit, along with houses by Richard Neutra, R. M. Schindler, Raphael Soriano, and other famous architects.[39] The *Los Angeles Times West,* capitalizing on the growing awareness and appreciation of modern architecture in the city, published a list of the twelve most significant structures in Los Angeles after surveying leading citizens and experts in architecture, urban planning, and art. Eight of the twelve buildings were houses designed by modernist architects such as Irving Gill, Charles and Henry Greene, Neutra, Schindler, and Frank Lloyd Wright; three were public buildings; and the last was the Watts Towers. Among the winning structures, the Watts Towers

received the greatest number of accolades; it alone won eight of the possible ten votes.[40] It is not surprising, given the bland architecture creeping over the landscape in the 1960s, that many would see the Watts Towers as a beacon of originality. Only Banham praised their originality as compatible with, rather than resistant to, the city's commercial signs, especially the most fanciful and inventive of them.[41]

Cast as a monument of both modern art and architecture, the Watts Towers quickly emerged as a pilgrimage site. Local artists and visiting luminaries, including Saint Phalle, Tinguely, and Andy Warhol, toured the Watts Towers and cited them as an inspiration.[42] Warhol even filmed several scenes of *Tarzan and Jane Regained, Sort Of,* his first underground film, at the Watts Towers. Boosters of the city, hoping to entice the broader public to visit the towers, published travel tips. *Los Angeles: Portrait of an Extraordinary City,* with its paean to the city's beaches, popular entertainment, and suburban amenities, also proclaimed the Watts Towers "a heartfelt tribute to beauty" and "one of the genuine marvels of this century."[43] Many compared the Watts Towers to other famous cultural monuments dotting sites around the world such as the Leaning Tower of Pisa, the golden stupas of Thailand, and the Eiffel Tower of Paris. Calvin Trillin reported that "a curator of the Los Angeles County Museum of Art has said, 'The towers are Los Angeles's only art monument; we usually suggest that visitors go there, because they are really Los Angeles's Parthenon.'"[44] By the mid-1960s advocates of the Watts Towers had transformed Rodia's creations from picturesque landmark to modern monument and emblem of the city of Los Angeles.[45]

Where Ruscha, Hockney, and Banham took the facades of commercial architecture and suburban homes seriously, promoting the surface urbanism unique to Los Angeles, most in the art community embraced the Watts Towers as a counterpoint to the blandness of suburban sprawl, the uniformity of space, and the placelessness of the city. The art community adopted the Watts Towers in the 1960s to redeem the city's cultural heritage. As a modern monument, the Watts Towers established the indigenous roots of the exploding Assemblage scene and, with other distinctive works of modern architecture, lent cultural distinction to the Southland. City boosters went even further, pushing the Watts Towers to center stage to demonstrate that Los Angeles offered the amenities of a significant modern city—a flourishing cultural scene with some historical depth. As a unique, imaginative monument, a tribute to artistic creativity, and an inspiration to local Assemblage artists, the Watts Towers could serve as a symbol of the city's cultural history and heritage.

Neighborhood Cultural Politics

The art community, by rallying around the Watts Towers in the late 1950s and early 1960s, defending their aesthetic merit and fighting to preserve them as part of the cultural heritage of Los Angeles, inevitably brought attention to the neighborhood of Watts. Aesthetic debates about the towers put Watts on the map, literally and cognitively, encouraging those who did not live there to visit the neighborhood. Even so, the public notice the art community brought to Watts was, for the most part, negative. References to Watts in the exhibition catalog *Art of Assemblage* are generally dismissive: "From the flat surroundings of dusty streets, one-story habitations, vacant lots, and railroad tracks that make up the drab neighborhood of Watts in Los Angeles, the three spires ascend in a concentric tracery as logical and weightless in appearance as the last Gothic architecture."[46] Indeed the art community typically extracted the monument from the neighborhood altogether by focusing almost exclusively on spiraling forms and dazzling colors rather than on the towers' surroundings. Almost no photographs of the Watts Towers published in art magazines included the neighboring homes.[47]

To be fair, the Committee for Simon Rodia's Towers in Watts that worked to restore and preserve the Watts Towers also tried to contribute to the cultural life of the neighborhood by establishing the Watts Towers Art Center on the foundations of Rodia's home, which had burned in 1955. Art classes took place there beginning in 1961 before moving into an abandoned house next to the towers. The committee hoped these classes would instill in neighborhood residents an appreciation of the Watts Towers as a work of art. Encouraging local pride would, presumably, stop the vandalism of the towers.[48] The committee seems to have largely succeeded in this objective.[49]

Further, the Watts Towers Art Center developed an educational program based on the assumption that art could provide cultural uplift to economically deprived children. In a press release dated 23 June 1961, Lucille Krasne, hired from the staff of the Pasadena Art Museum to organize the art classes for children, disclosed the committee's motivations in establishing an art center: "The Committee wanted to do something special for the community that gave rise to the Towers, and nothing seemed more perfect than promoting good-will by encouraging creative children's art."[50] With the inauguration in 1964 of the Summer Crash Program and the Teen Post at the Watts Towers Art Center, the committee expanded the art curriculum to reach teenagers.[51] That same year the committee invited Noah Purifoy, an African American artist from the area, to become the director of the art school. At the Watts Towers Art Center Puri-

foy collaborated with Krasne, the musician Judson Powell, and the teachers Sue Welch and Debbie Brewer to design art programs for children and teenagers.[52] Purifoy, who shared the committee's belief in aesthetic uplift, listed the goals of the art classes: teaching aesthetics, improving the self-esteem of neighborhood children, and enhancing the appearance and well-being of the community.[53] Purifoy continued to teach art classes to children in his own studio well into the late 1960s and to embrace the cause of personal improvement through aesthetic awakening: "When a youngster creates a piece of sculpture out of the detritus of his own surroundings, he may get—for the first time in his life—a feeling of accomplishment. The resulting self-confidence may carry him into other kinds of learning. This is the lesson Noah is now teaching to the disciples who come to his Watts studio."[54] The cultivation of artistic skills and aesthetic appreciation in children presumed various positive social consequences for both the individual and the community at large.

In founding an art center to reach children and teens at risk, the Committee for Simon Rodia's Towers in Watts addressed immediate local concerns about juvenile delinquency. The committee had collected numerous pamphlets on the growth of gangs and youth-related crimes in underprivileged neighborhoods such as Watts. For instance, it had the statement released by the Youth Opportunities Board of Greater Los Angeles, established in 1962 to study how the school dropout and unemployment rates contributed to the rise in youth crimes. It read in part: "The concern for unemployed youth, school drop-outs, culturally deprived youth and for the prevention of juvenile delinquency is as great as ever. . . . Some of the objectives . . . are: to improve the opportunities for youth to develop themselves toward gainful employment and other constructive participation as citizens." A booklet entitled "Youth Problems and Needs in the South Central Area" recommended the establishment of settlement houses and community centers for youth.[55] The term "settlement house" recalls the progressive era reform movement that originated, as the art historian Grant Kester points out, in late-nineteenth-century Victorian evangelism and took for granted that personal transformation was the key to social change.[56] The assumed link between art and redemption had prompted the establishment of community art centers in African American neighborhoods as early as the 1930s.[57] In other words, the committee established and justified art classes for young people out of anxiety about increased delinquency in Watts combined with a belief in the transformative powers of culture and education.

The Watts Towers Art Center, however well intentioned, could do little to solve systemic problems or stem the tide of mounting resentment in Watts. The Watts uprising began in August 1965 only a few blocks from the Watts Tow-

ers when two white police officers arrested and physically abused a young African American man for drunk driving. Frustrations about repeated instances of police persecution, the repeal of the fair housing law, and the high unemployment rate fueled the six days of fires and looting that followed, which resulted in thirty-four deaths and forty million dollars in property damage.[58] The worst race rebellion in the nation to date drew sudden attention to the neighborhood of Watts and a flurry of initiatives from the city and state to address economic problems in that area. The John McCone Commission, established by the governor of California, investigated the root causes of the riots, while numerous social scientists studied the community and published articles about poverty there.[59] Others urged community-based and -administered projects to reinvigorate Watts politically, economically, and culturally.

Writing almost a year after the uprising, the novelist Thomas Pynchon, in "A Journey into the Mind of Watts," beheld the Watts Towers as a "dream of how things should have been: a fantasy of fountains, boats, tall openwork spires encrusted with a dazzling mosaic of Watts debris."[60] In Pynchon's evaluation the Watts Towers stood as a tragic reminder of the limitations and failures of urban renewal and development in Watts both before and after the uprising. In fact during the thirty-odd years that Rodia lived in Watts, its demographics shifted considerably as did its building stock. Small houses and commercial structures increasingly filled the open tracts of land, and the population swelled while becoming less diverse, so that by the early 1960s the residents of the area were almost exclusively African Americans.[61] At the same time, policies of urban renewal mandated freeways cutting through disadvantaged districts such as Watts, destroying low-income housing and driving property values down even further.[62] Rodia himself, who may have abandoned his home in 1955 because of the changing population around him, seems to have envisaged the towers at certain times as a refuge from deteriorating conditions in Watts.

Rodia was never consistent in the mission he accorded the towers in the neighborhood, and sometimes he shunned neighbors altogether. Yet he invited them on occasion to conduct sacramental rites such as baptisms in his backyard.[63] Such celebrations marked the setting as a sacred space where bonds of family, friendship, and religious community could be consolidated. Still, evidence exists that Rodia conceived of the towers as something more than a neighborhood church. The words *nuestro pueblo,* spelled out on the south face of the west tower in green and blue tiles, refer, like the title of the guidebook mentioned earlier in this chapter, to the original Spanish name for Los Angeles. Rodia thus casts his towers as an alternative model of the city—how, in Pynchon's words, things should have been. When economic conditions in the area dete-

riorated further in the years following Rodia's departure from Watts, culminating in the uprising, Rodia's ideal of a city loyal residents would call Our Town acquired the poignancy Pynchon so eloquently recognized.

Despite Pynchon's bleak assessment of Watts in the aftermath of the uprising, the Watts Towers—they were protected by local residents during the uprising and survived the fires unscathed—emerged as an inspiration for community cultural initiatives. Dialogue ensued between the Watts Towers Art Center and members of the local community who wished to establish cultural centers. The Committee for Simon Rodia's Towers in Watts increased its ties with the neighborhood, initiating conversation with other local organizations as well as with city, state, and federal agencies promising aid to Watts. For instance, the committee continued to participate in the federal poverty programs in Watts by extending its sponsorship of a local Teen Post, and it advocated for a municipal project to provide a fifteen-acre site for a community art center.[64] At the same time, the committee discussed how to expand the art program at the Watts Towers Art Center while preserving the center as a refuge for young people.[65] In turn, various local constituencies approached the committee after the uprising to seek advice and gain support for their efforts to develop more parks and recreational facilities. Many residents of Watts exuded not only optimism but even militant determination to effect political, social, and economic reform; they took note of the Watts Towers Art Center as a model they could use for community-based initiatives.

While the Watts Towers Art Center provided practical assistance in the community, the Watts Towers themselves after the uprising became a potent symbol of a local black cultural awakening. In 1966, during the summer following the Watts uprising, the Watts Summer Festival took place in Will Rogers Park on 103rd Street.[66] Planned as an annual summer event, the festival did more than memorialize the uprising, it also celebrated the ideal of a black cultural renaissance. In "From the Ashes: A Personal Reaction to the Revolt of Watts" published in the brochure printed on the occasion of the Watts Summer Festival, the writer Jimmie Sherman recounted his own cultural achievement in the wake of the Watts uprising: "What happened in Watts was definitely not a riot. It was a revolt—a revolt that I, like many others, was proud to be a part of and fortunate to be a product of. . . . Then came salvation! It came with the flames of the Watts revolt and changed my life completely. . . . I wanted to scream it out and let the whole world hear. . . . Instead, I wrote it."[67] Sherman wrote poems, songs, and plays and founded a theater group that performed at the Watts Summer Festival. The brochure in which Sherman published his triumphal tale was devoted to the theme "Pride and Progress"; its cover featured

the Watts Towers next to a photograph of Muhammad Ali. By linking the Watts Towers with a national sports star who had adopted a Muslim name, the festival appropriated the imaginative creation of an Italian immigrant for the cause of black cultural pride.

According to the historian Gerald Horne, the celebration of black cultural expression institutionalized by the Watts Summer Festival was "part of an overall initiative designed to recruit among youth—which the uprising had shown were restive—and teach them 'race rhetoric,' history classes, Swahili."[68] Other community-based projects in Watts and nearby neighborhoods that fostered black cultural pride included the Studio Watts Workshop, the Watts Happening House, and the Communicative Arts Academy.[69] As the 1960s progressed, black cultural pride took a more insistently nationalist turn as demonstrated by the emergence of the Black Arts movement.[70] Such cultural initiatives overlapped with and sometimes opposed the various political and social movements competing to shape black nationalism. Horne usefully distinguishes between two key nationalist groups in Watts after the uprising: "the 'cultural' nationalists . . . and the 'revolutionary' nationalists. . . . The cultural nationalists did not tend toward confronting the state, but they did believe in black pride."[71] Horne goes further and suggests that the state actually embraced expressions of black cultural pride: "Not surprisingly," he writes, "the United States government eagerly supported such expressions of nationalism as less threatening than say the militancy of the Black Panthers."[72]

The Watts Towers, transformed into an emblem of black cultural nationalism after the Watts uprising, also inspired a specific art project, organized by Noah Purifoy and Judson Powell. Several months after the August events, Purifoy resigned from the Watts Towers Art Center and, galvanized by the example of Rodia's towers, invited six Assemblage artists from around the city to fabricate objects out of the burned debris from the uprising still littering the streets.[73] The sixty-six finished artworks, exhibited together in a show titled Junk Art: 66 Signs of Neon, both remembered the uprising and re-imagined Watts.[74] The rhetoric surrounding the creation, exhibition, and circulation of these artworks, moreover, conflated aesthetic uplift and black cultural awakening—two ideals that had informed the roles the local community imagined for the Watts Towers.

Fabricating artworks out of objects damaged during the Watts uprising marked a significant change in Assemblage art. Kienholz raided city dumps and thrift shops for the raw materials he used in his assemblages. He so prided himself on his expert knowledge of junkyards that he volunteered to serve as tour guide to European Assemblage artists visiting the city. Kienholz actively

romanticized this sort of scavenger hunt and took pleasure in collecting stuff in Los Angeles, even as he drew attention to the waste generated in the city by unrestrained consumerism:

> That's one of the reasons that I like Los Angeles, because Los Angeles throws away an incredible amount of value every day. I mean, it's just discarded, shit-canned. From automobiles to desks, to clothes, to paint, to—you know, half bags of cement that are hardened up. I mean, whatever it is, there is an incredible amount of waste in a city like Los Angeles, and if you're living on the edge of [an] economy like that, all that waste filters through your awareness and you take what you want.[75]

Purifoy, unlike Kienholz, did not have to visit junkyards and city dumps for materials. He had only to turn to his own neighborhood to find what he needed strewn about the landscape.

> In Watts it [junk] was extremely accessible. Number two, it relates to poor people. Wherever there are poor people, there's piles of junk. People bring the junk here. In Watts, there were mounds of scrap metal all over the place and defunct foundries where there were piles of metal and junk. Garbage day was a time when people put their trash out, but it was often not picked up, and so it stayed there for weeks. In some places there was no pickup at all. People would buy furniture and household appliances cheaply, but they had to throw it away before they got it paid for.[76]

In Purifoy's account, the economic precariousness of households and businesses, combined with the unpredictability of municipal services, turns a neighborhood such as Watts into a repository for the detritus of modern production and consumption. The uprising added more rubble. Since it had started only a few blocks from Rodia's towers, the teachers and students at the Watts Towers Art Center both witnessed the events and picked up what was left after the fires had ebbed. As Purifoy recalled:

> Judson and I, while teaching at the Watts Tower[s] Art Center, watched aghast the rioting, looting, and burning during the August happening. And while the debris was still smoldering, we ventured into the rubble like other junkers of the community, digging and searching, but unlike others, obsessed without quite knowing why. By September, working during lunch time and after teaching hours, we had collected three tons of charred wood and fire-molded debris. Despite the involvement of running an art school, we gave much thought to the oddity of our found things. Often the smell of the debris, as our work brought us into the vicinity of the storage area, turned our thoughts to what were and were not tragic times in Watts and to what to do with the junk we had collected, which had begun to haunt our dreams.[77]

Purifoy's memories highlight just how different his experience of collecting materials was from that of other Assemblage artists in Los Angeles.

Purifoy, Powell, and six other Assemblage artists converted the neighborhood from a junkyard into an artist's studio where they created works of art commemorating the uprising. Selecting from the charred wood, melted neon signs, and burned rubbish collected at the Watts Towers Art Center, the artists fabricated objects whose very materiality remembered the uprising. "Noah and Judson began with six assemblages created from the lead drippings of melted neon signs, artifacts of the riots. As their work continued they recruited six other professionals skilled in the plastic and graphic arts. . . . They labored literally night and day, groping through the glittering, twisted, grotesquely formed materials, each interpreting in his own way the August happening."[78] The very fact that Purifoy and others identified their art as "junk art" rather than "assemblage" brought attention to the materials rather than to the process. Scorched by the fires, the physical surfaces of the artifacts preserve the memory of a ruined landscape. Sometimes the title of a finished work of art specifically recalled the August events. In Purifoy's *Watts Riot* of 1966 chipped, scarred, and burned pieces of wood form a bleak, sober rectangle. Only a few printed letters remain on the disc at lower left, ghosts of some prior, perhaps commercial, message; the word SIGNS, stenciled onto the burnt wood at the top of the canvas indicts the language of advertising while offering itself as a tragic logo for Watts itself (see plate 18).

Purifoy envisioned more than a commemorative role for these works of art, however. Indeed his idealistic conviction—that these objects could provide aesthetic uplift and encourage personal transformation—matched that expressed by the Committee for Simon Rodia's Towers in Watts when it founded the Watts Towers Art Center. Listing his reasons for undertaking the project Junk Art: 66 Signs of Neon, Purifoy stressed that art could provide a productive and meaningful form of self-expression:

> The validity of its [junk's] use as an art expression did not occur to us until we came across the McCone Report, the findings of the Governor's Commission on the causes of the riots. We thought it a good report—that it advocated most things necessary for the betterment of the community. However, we observed that there was no mention of art education. . . . This was our cue. . . . Thus 66 Signs began as an expression of the necessity for art education, affirming the importance of this avenue of self-expression to individuals in the community of Watts.[79]

More than reinforcing the need for art education, the works for Junk Art: 66

Signs of Neon, according to Purifoy, could surpass the topical and speak in universal terms about social crisis: "The assemblage of junk illustrated for the artists the imposition of order on disorder, the creation of beauty from ugliness . . . it transcends it and rises above social protest. It seems to be saying that there is some uncertainty about our direction. That we all take equal responsibility for the Wattses of the world." At the very least, the scorched debris resulting from violent circumstances could be transformed and given new aesthetic purpose. The cover of the exhibition catalog *Junk Art: 66 Signs of Neon* (1966) captured this ideal: against a mound of rubble in the background, two joints of stovepipes, part of a roof made of tar paper and tin, and a metal brace soar from a pedestal in a sweeping curve reminiscent of Brancusi's *Bird* of 1940 (figure 53).[80] Given Purifoy's goals, his assumption that the artist, by dint of professional qualification and special insight, could both represent the community's experience in Watts and shape artworks that transcended the particularities of Watts comes as no surprise. Thus he invited artists who did not necessarily live in Watts to participate in the project; nor did he ever privilege the works by artists from Watts as more authentic testimonies to recent events than those fabricated by outsiders.

Initially the artists planned to situate the junk art near the Watts Towers to improve the appearance of the neighborhood after the devastation wreaked by the fires.[81] Several photographs capture views of *Sunflowers,* by Debby Brewer, installed outdoors, across the train tracks from the Watts Towers. Purifoy's project, then, as initially conceived, extended Rodia's aesthetic practice from his private property into the surrounding neighborhood.

With time, however, the ambitions of the artists changed, and they decided to show their junk art in The Simon Rodia Commemorative Watts Renaissance in the Arts, an exhibition held during Easter week in the spring of 1966 at the Markham Junior High School not far from the Watts Towers.[82] Junk Art: 66 Signs of Neon appeared alongside art by children, professionals, and amateurs—theatrical performance, dance, music, photography—to celebrate a cultural renaissance in Watts that took its inspiration from Rodia's Watts Towers. Subsequently Purifoy and the other artists organized Joined for the Arts in Watts and participated in the Watts Summer Festivals.[83] In the meantime Junk Art: 66 Signs of Neon circulated to nine universities in California and other venues outside the state from 1966 to 1969, promoting a view of Watts rising like a phoenix from the ashes of the rebellion. "This exhibit became the Ambassador for Community Art as it traveled about the state and country," Purifoy explains, "telling its story and stories about the happening back home in L.A."[84] As it

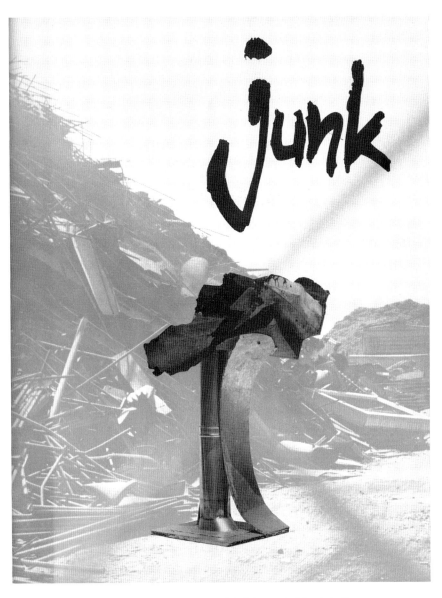

53 Noah Purifoy, *Breath of Fresh Air*, catalog cover of *Junk Art*, 1966. © Noah Purifoy estate.

traveled around the nation, the exhibition became closely identified with a black cultural renaissance in Watts even though the participating artists represented various ethnic and racial heritages and lived all over the city.

Junk Art: 66 Signs of Neon challenged, or at least nuanced, mainstream reports about the grim aftermath of the uprising by demonstrating the vibrant presence of an arts community in Watts. Purifoy's rhetoric of aesthetic uplift

carried the day to capture outside interest and financial support. One reporter made explicit the hopes lodged in the effort to connect artistic transformation and self-improvement: "The transfiguration [of junk into art] represents what the group hopes eventually to accomplish in Watts: out of former nothingness, an art education program for the community and a gallery where art can be exhibited. The group believes that a creative seed exists in every person; encouraged to grow, it can make possible a personal affirmation that might not otherwise develop."[85] Both the sale of artworks and the exhibition's reception in the press indicated that the cultural pride represented by 66 Signs of Neon found a receptive audience. Commenting on the sale of junk art, Purifoy exclaimed: "They went like hotcakes. . . . Gregory Peck owns one. He came to the festival at Markham in '66. He was then representing the N.E.A., and he participated in some way in deciding where the grants go. He ultimately provided a grant for me to ship Signs of Neon to Washington D.C."[86] The acclaim accorded a cultural expression such as Junk Art: 66 Signs of Neon resulted in part from the larger public's greater comfort with the rhetoric of aesthetic uplift and personal transformation than with displays of black separatism by politically militant groups.

The Watts Towers—as a touchstone of black cultural pride or a modernist monument—evoked clashing perspectives on Los Angeles cultural life. The neighborhood initiatives launched immediately before and after the Watts uprising of 1965 by those affiliated with the Committee for Simon Rodia's Towers in Watts were conceived as a means to spread cultural resources more evenly throughout the city and to nurture neighborhood pride in a local monument that nevertheless had nothing to do with the particularities of Watts. Rather, the Committee for Simon Rodia's Towers generated civic, national, and international recognition of the towers as unique works of art that soared above their drab local surroundings. As the art historian Francis Frascina emphasizes, even when Artforum placed a photograph of the Watts Towers on its cover in October 1965, it failed to mention the uprising, which had taken place two months before.[87] Embraced as the origins of an Assemblage art movement in Los Angeles, the towers contributed to the city's changing cultural reputation: more than just Disneyland, the beach, and suburban housing, the Southland boasted modern art.

Purifoy's initiative to invite Assemblage artists from all around the city of Los Angeles to make works of art from the debris of the Watts uprising relocated both Assemblage art and the Watts Towers right back in the heart of the African American neighborhood. Inspired by Rodia's towers, the artists joined

Purifoy in an effort to make fanciful art that spoke to the specific economic, po-
litical, and social plight of an urban area strewn with detritus as much because
of poor municipal services as because of the uprising. They reimagined the
neighborhood by filling it with whimsical creations, some of which ruminated
on the landscape ruined by the recent fires. These works also became emis-
saries for Watts and the black cultural renaissance as they traveled around the
country. The towers, because they served as a model for Purifoy's project as
well as other art initiatives in Watts, quickly became associated with the neigh-
borhood and the emerging black arts movement.

Despite the varied expressions of local, city, and state interest in the Watts
Towers in the 1960s, the city's commitment to the monument and its neigh-
borhood waned dramatically in the 1970s. Unable to raise the funds needed to
preserve the towers, the Committee for Simon Rodia's Towers in Watts deeded
them to the city of Los Angeles in 1975. Delays in restoration efforts and, more
serious, a botched attempt by the architect the city selected to repair Rodia's
structures, however, caused serious damage to them. The interest in junk art
dwindled at approximately the same time. Purifoy recalled:

> "Signs of Neon" came back from some place or other, maybe Tennessee or Alabama.
> It got down as far as Tennessee, I believe. . . . About 1969 it came back in a truck
> just about in the same shape it was when we found it in Watts, in the smoldering
> embers of the Watts riot. In other words that was the end of "Signs of Neon." It
> was back in its original state: Junk! . . . it just deteriorated in somebody's garage
> someplace in Watts. That's the last I heard of it.[88]

The neglected towers and languishing junk art were symptomatic of the fate
of Watts: the neighborhood slipped away from the city's grasp in the 1970s, over-
looked and ignored until another uprising, in 1992.[89]

Only the Watts Towers have emerged successfully from this era of neglect.
A lawsuit in the late 1970s forced the city to halt restoration and to turn the
towers over to the state of California. The state began restoration in 1979; a
court settlement in 1985 mandated that the city take over the restoration pro-
gram once again. The Watts Towers finally now have shed their scaffolding,
testifying triumphantly to restoration efforts by dedicated city officials, con-
sultants on the staffs of several museums in Los Angeles, and, most notably,
members of the Getty Conservation Institute.[90] Moreover, the rhetoric sur-
rounding Rodia's towers has reconciled the two views of them prevalent in the
1960s: a monument of modern art created by an untutored Italian immigrant
and a hallmark of the local community. In fact the arts center has remained

near the towers since 1965 and not only continues to hold classes for neighborhood children but also features programs highlighting the art and music that are part of the heritage of the African American and now increasingly Latino populations of Watts. The restored Watts Towers speak to efforts to promote Los Angeles today as a city of multiethnic communities replete with diverse cultural offerings. Nonetheless, the extent to which the Watts neighborhood itself has benefited from the restoration of the Watts Towers and their newly minted reputation remains to be seen.

Ken and Richard shove ice dollys into field
Ice remains to end of all *poems*, melting
CLAES OLDENBURG,
Autobodys, 1963

During three days, about twenty rectangular enclosures of ice
blocks (measuring about 30 feet long, 10 wide and 8 high) are built
throughout the city. Their walls are unbroken. They are left to melt.
ALLAN KAPROW,
Fluids, a Happening, October 1967

Multi-Colored Atmosphere, entrance, Pasadena Art Museum
JUDY CHICAGO, 1970

Womanhouse, performances Friday and Saturday nights
JUDY CHICAGO, MIRIAM SCHAPIRO,
students in the Feminist Art Program, 1972

L.A.
Happenings
and
Performance
Art

DURING THE 1960S SEVERAL WELL-KNOWN CONTEMPORARY ARTISTS orchestrated outdoor Happenings in urban Los Angeles. The scripts for these theatricals, when they existed at all, more or less eliminated characters, costumes, dialogue, and narrative development, although they did name participants, identify props, and confer directives. Rarely rehearsed or repeated, Los Angeles Happenings occurred in one or multiple places during a predetermined length of time, lasting as little as one hour or as long as four months.[1] These Happenings, announced by posters and word of mouth, have endured only in scripts, photographs, advertisements, and personal reminiscences.

The melting ice in both Claes Oldenburg's *Autobodys* of 1963 and Allan Kaprow's *Fluids* of 1967 as well as the colored smoke in Judy Chicago's *Multi-Colored Atmosphere* of 1970 insisted on the ephemeral nature of Happenings. Unlike a permanent monument such as the Watts Towers, these three Los Angeles Happenings intervened in public space as temporary place markers; they brought sudden and brief attention either to nondescript sectors of the city such as parking lots, gas stations, and underpasses, or to facades of newly erected commercial and public institutions from McDonalds to art museums. The Happenings organized by Oldenburg, Kaprow, and Chicago, like much art of the 1960s discussed in this book, expressed a keen interest in the changing urban environment of Los Angeles. They highlighted, even if only fleetingly, the new physical forms and spaces of the city, while their ad hoc nature resisted the deadening functionality of the urban environment.

Two years after the smoke from *Multi-Colored Atmosphere* swirled dramatically outside the Pasadena Art Museum, Chicago and her feminist colleagues mounted several Performance pieces in Womanhouse, which, in retrospect, marked the advent of new multimedia events erupting all across the urban landscape of Los Angeles, often far from recently constructed art museums and galleries. Chicago, motivated by her firm commitment to the women's movement, replaced the stunning yet momentary visual effects of billowing smoke featured in her Happening of 1970 with planned, rehearsed, and repeated performances in which artists wore costumes, assumed roles, and delivered dialogues whose feminist advocacy was unequivocal.[2] Instead of subverting institutional spaces, Performance artists at Womanhouse reenacted life's everyday routines and its more momentous events in a domestic setting. Hunched in misery, exploding in hilarity, and twisted in anger, the performers manifested the private desires and frustrations of middle-class white women on their bodies. That the Performances in Womanhouse happened indoors rather than outdoors, however, should not obscure their engagement of the public sphere.

Happenings

When Oldenburg arrived in Los Angeles from New York, via Chicago, in the fall of 1963, he settled into the beach community of Venice for six months. His art immediately registered the local setting. Abandoning plaster, which he had been using to construct small, chunky objects splashed with vivid commercial colors, Oldenburg began to fabricate large-scale home furnishings, electrical objects, and food items with soft vinyls, often in cool blacks and whites. The artist has attributed this dramatic shift in scale and materials to his spacious Venice studio and the ready availability of plastics in Los Angeles.[3] In his evening performances of *Autobodys* on 9 and 10 December 1963, Oldenburg likewise responded to the surrounding environment, arguably even more than in his sculpture. Confronting a sprawling metropolis built around the car, he reimagined, in *Autobodys,* the function and rational organization of the parking lot.

The siting of *Autobodys* outdoors in a city parking lot not only set it apart from Oldenburg's previous Happenings but also highlighted what distinguished Los Angeles from other urban environments the artist had visited. Earlier Happenings had certainly evoked cities: Oldenburg titled the first Happening he organized, in Manhattan in March 1960, *Snapshots from the City;* and *Gayety,* which he directed in a hall at the University of Chicago in 1963, included a diorama evoking different streets and buildings in downtown Chicago.[4] But *Autobodys* was his first Happening arranged in an outdoor public space: Rehearsals occurred both in a parking lot in Venice and on the third floor of a parking garage on Wilshire Boulevard, and the final event took place in a rented parking lot behind the American Institute of Aeronautics and Astronautics at 7660 Beverly Boulevard.

Autobodys transformed a parking lot into a stage for an audience seated in cars (figure 54). On the evening of the performance, according to the art critic Michael Kirby, "Visitors' automobiles were carefully positioned side by side to form the perimeter of a rectangle about fifteen cars long and nine cars wide with openings at each corner."[5] The audience watched from their cars while illuminating the parking lot with their headlights. During the hour-long performance, various cars and participants maneuvered across the rectangular lot; liquids such as milk, soapy water, and melting ice spilled across the asphalt; flashlights and flares lighted up the night sky; and those observing heard the sounds of a radio, a loudspeaker, horns, car engines, the spinning drum of a concrete mixer, and the breaking of glass.[6] Seated in their cars, they were more like the audience at a drive-in movie theater than like a theater audience. A poster the artist designed to announce the Happening made this point explicit by la-

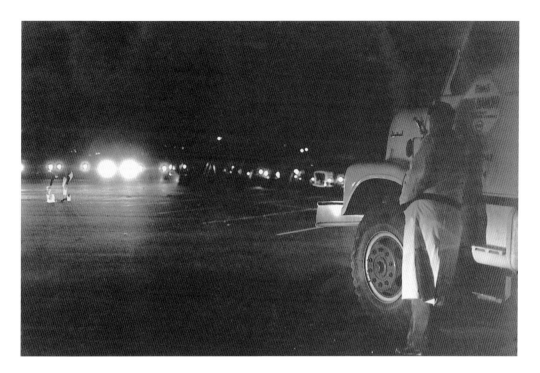

54 Claes Oldenburg, *Autobodys*, 1963. Performance view in the parking lot of the American Institute of Aeronautics and Astronautics, Los Angeles, 9–10 December 1963. Photograph by Charles Eames. Courtesy of Claes Oldenburg Coosje van Bruggen, New York.

beling *Autobodys* a "Drive In" and by featuring a highly schematic view of a drive-in cinema at night (figure 55).[7] In *Autobodys* Oldenburg conflated parking lots and drive-in movies, both constructed to accommodate cars in the sprawling, multicentered city of Los Angeles, while inviting the audience to consider the car less a mode of transportation and more a vehicle of theater.

Oldenburg selected a variety of automobile brands and styles to perform in *Autobodys* in recognition of the range of cars on the roads that cut through the megalopolis. As we have seen in chapter 2, many artists in Los Angeles were attentive to car culture in the 1960s and drew inspiration from automotive styling. For instance, Bengston and Chicago adapted the syntax of kustom kar kulture to paintings on canvas and to sculpture, while Kienholz cast a psychosexual drama on the backseat of a Dodge, treating the car interior as both substitute bedroom and psychological arena. Like some of the other artists discussed in this book, Oldenburg highlighted car surfaces in his Happening. According to Kirby's report, he "auditioned" cars for the event, placed a premium on appearance, and selected both foreign and domestic vehicles—sedans, convertibles, and station wagons. Overall he manifested a preference for black-and-white ex-

55 Claes Oldenburg, announcement for *Autobodys*, 1963. Lithograph, 11 × 8 1/2 in.
Photograph courtesy of Claes Oldenburg Coosje van Bruggen, New York.

teriors (figure 56).[8] That the twenty human participants dressed in black and
white to match the cars incorporated them visually into the car-dominated set.

Oldenburg designed a second poster for *Autobodys* that featured a photograph
of himself behind the wheel of a Dodge Dart with a vanity license plate that
read RAY GUN (see plate 19).[9] By obtaining such a license plate, Oldenburg en-
dorsed the link between the styling of a car and the identity of the driver. The
text on vanity license plates, which sometimes requires the passerby to deci-

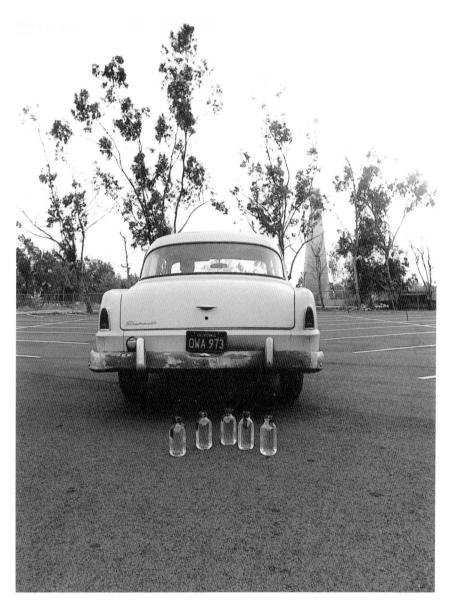

56 Dennis Hopper, *Autobodys*, 1963. Gelatin silver print. Courtesy of the artist.

pher a clever abbreviation, typically refers to professional identity or personal tastes; more rarely, it circulates an obscure private meaning. The viewer of Oldenburg's poster would easily have been able to decode Oldenburg's license plate and to grasp the obvious allusion to the toy gun and weapon of science fiction fame. But "Ray Gun" also had a more specific personal meaning. For those in the know, it was Oldenburg's name for much of his sculpture to date, including both handmade and found objects. Some of this work resembled guns; some

57 Claes Oldenburg, *Empire ("Papa") Ray Gun*, 1959. Newspaper soaked in wheat paste over wire frame, painted with casein, 35 7/8 × 44 7/8 × 14 5/8 in. Photograph by Robert McElroy. Courtesy of Claes Oldenburg Coosje van Bruggen, New York.

simply assumed the configuration of a right angle. Given Oldenburg's propensity to think metaphorically, the shape could have other resonances as well; for instance, the big lumpy object titled *Empire ("Papa")* of 1959 practically shouts its resemblance to a phallus (figure 57).[10] *Empire ("Papa"),* in other words, emphasizes with humorous explicitness the associative links that account for the collection of things, ranging from toy guns to a piece of rope bent at a right angle, catalogued under the rubric Ray Gun. "Ray Gun," when printed on Oldenburg's license plate, thus named an aesthetic practice that turned on metaphor as well as a set of objects collected, fabricated, and displayed by the artist.

Promoting an artistic event rather than a car sale, the text on the poster for *Autobodys* disclosed even more about the nature of the Happening. The word AUTO printed above BODYS, each printed in the same size type and black ink, posited two separate but equal entities. Indeed, whereas Oldenburg's Ray Gun project relied on metaphor to establish a formal likeness between things—gun and penis, for instance—*Autobodys* favored parataxis, whereby unlike phenomena are juxtaposed without coordination or subordination.[11] All five poems that constitute the script for *Autobodys* direct the cars, bodies, white cement mixer truck, milk bottles, motorcycle, flashlights, milk bottles, and ice cubes to move in and around the parking lot in arbitrary ways, none taking precedence over the others. The opening to poem one reads:

Lloyd drives in from NE
Maneuvers
Stops center facing south
Sits

Pat enters from NW
Walks to trunk
Opens trunk
Takes out milk bottles

Milk bottles out, Lloyd drives forward
Stops
Sits

Pat leaves field

Bottles isolated

In the first poem, car motors hum, bottles clink, the drum of a concrete mixer turns, the sound track plays old movies, car radios blare music, milk spills, soapy

water splashes, people walk, and cars move around the lot. Visual and aural associations abound, but no sequential links based on formal similarity coordinate the different elements with one another or create a meaningful hierarchy.

Arbitrary directives in the script and aleatory effects during the Happening itself ensured that autos, bodies, and props failed to conjoin metaphorically in any predictable way, to develop a logical story, or even to convey an obvious meaning individually. At one point in the third poem, the directions instruct all performers to "walk slowly in individual patterns, indifferent to one another, like scattered particles. Autobodys."[12] In this passage the term "Autobodys" captures the transformation of the automated into the unpredictable. Indeed the bodies moved in ways both prescribed and random; they did not engage in meaningful dialogue or actions. Participants blinked car headlights, honked horns, played music on the transistor radios, and drove cars without communicating anything about their taste, status, personality, or intentions, as they might if they were traveling on the road. Even the text on the poster announcing *Autobodys* as a drive-in conveyed no coherent meaning: Printed across the paper, the word "Autobodys" divides arbitrarily into three units, each consisting of three letters, to create a nonsense word AUT OBO DYS (see figure 55). Oldenburg, breaking the link between signifier and signified by inventing arbitrary rules and by initiating random variations he could not control, explored the limits of logical sense in a dramatic setting complete with characters, props, stage, and audience.

Although he exploited sound, light, and movement onstage, Oldenburg relied for inspiration more on the textual conventions of poetry than on the dramatic narrative of theater. The critic Michael Kirby has already linked Happenings and poetry, while pointing to Oldenburg's experiments in writing poetry at the time: "Certain types of literature, especially poetry, also must be recognized for their formative influence on Happenings. Certainly the general tendency in much modern poetry to base structure on association and implication rather than on traditional formal patterns and sequential logic is a precedent for Happenings. . . . Oldenburg published three poems in *Exodus* (spring / summer 1960), a small review."[13] In New York City during the 1950s and 1960s frequent exchanges between poets, dancers, musicians, and visual artists nourished a rich array of avant-garde practices. Oldenburg's Happening may well have been informed by performative trends in poetry manifested in readings that restored kinetics to words by emphasizing how the body enunciated with sound, breathing, and gesture. Oldenberg may also have responded to poems that depended on chance and the incorporation of found text.[14] The script of *Autobodys* itself reads like stage directives laid out in stanzas. The equal treatment given bodies, cars, and props as enunciating entities and the exploitation of chance associa-

tions during the Happening invited the audience to consider *Autobodys* as a visual and aural enactment of contemporary poetry in three-dimensional space.

As poetry onstage, *Autobodys* disrupted the logic of the parking lot grid. A stage to be watched rather than a space in which to park cars; random, arbitrary movement, sound, and light crisscrossing a black asphalt surface neatly divided by white diagonal lines—*Autobodys* temporarily overturned expectations about the purpose of the parking lot in the city. Ruscha, as we have seen, likewise manifested an interest in structures built for cars, producing photographic books about gas stations and parking lots. The aerial photographs in *Thirtyfour Parking Lots in Los Angeles* treated the empty parking lots not as stages but as abstract canvases that combined the orderly format of the grid and the random forms produced by oil stains on the asphalt (see figure 41). But where Ruscha documented the accidental residue of cars on pavement, Oldenburg actively orchestrated random effects that subverted the rational syntax of the parking lot.

Dennis Hopper's photograph of Oldenburg's soft sculpture *Giant Blue Shirt with Brown Tie* in 1963 conveys Oldenburg's urban aesthetic (figure 58). In Hopper's photograph, Oldenburg's fantastically huge blue shirt and brown tie (63 5/8 × 74 5/8 × 24 1/8 inches), fashioned from cotton fabric, rest sideways on a dolly parked next to a gas pump at a Mobil station; at the right edge of the photograph stands a sleek skyscraper, punctuated by pilasters and tall rectangular windows. The shirt, with its looming size and bulk, loudly declares itself a one-of-a-kind, individually crafted, and useless example of the shirts typically mass-produced and displayed in department stores. The unexpected appearance of a shirt for a giant at a gas station resists, with humor, the standardization of the landscape by brand-name gas stations and anonymous skyscrapers. Hopper's photograph memorializes Oldenburg's placement of objects in urban space so as to embrace the everyday spatiality of the city as his stage and, at the same time, subvert the rationality of the infrastructure built for cars.

If in the early 1960s only a few artists chose to intrude upon the Angeleno urban landscape with Happenings, two events organized by Allan Kaprow in 1966 and 1967 ushered in a fertile period of multimedia theatrics directed by artists throughout the city.[15] Kaprow conducted *Self-Service* from June through September 1966 simultaneously in Los Angeles, New York, and Boston; he planned *Fluids* in 1967 in conjunction with his retrospective at the Pasadena Art Museum. Both Happenings occurred in multiple places citywide and captured local and national attention, galvanizing other artists in Los Angeles to experiment with Happenings in public spaces. Ultimately Kaprow was able to institutionalize his artistic practice when in 1969 he relocated permanently to southern California, teaching first at the California Institute of the Arts and then at

58 Dennis Hopper, *Giant Blue Shirt with Brown Tie,* by Claes Oldenburg, 1963. Cotton and canvas
filled with kapok, Plexiglas and chromed metal rack with wheels, 63 5/8 × 74 5/8 × 24 1/8 in.
Photograph courtesy Claes Oldenburg Coosje Van Bruggen, New York.

University of California, San Diego. At both schools he helped generate a lively
curriculum in performance studies, and many of the students went on to mount
Performance artworks throughout the city of Los Angeles.

Two Happenings in Los Angeles exemplified Kaprow's determination to re-
think his artistic practice in the mid-1960s. Along with Oldenburg, Jim Dine,
Red Grooms, and Robert Whitman, Kaprow had introduced Happenings to New
York City in the late 1950s and early 1960s. In fact Kaprow coined the term in
1959 when he produced *18 Happenings in 6 Parts* at the Reuben Gallery.[16] He
subsequently defined and redefined the concept of Happenings in a number
of published scholarly articles, heady manifestos, interviews, and even a book
entitled *Assemblages, Environments, and Happenings.*[17] In the mid-1960s Kaprow
resolved to shift Happenings from lofts and galleries to outdoor arenas to dis-
tance them from the model of theater and to align them instead with the rhythms
of everyday life. With this goal in mind, Kaprow conceived of Happenings con-
sisting of different components occurring simultaneously in multiple places
outdoors rather than in an interior space. The new Happenings that took place
at various sites in the countryside or the city did away with the theatrical audi-

ence, because no one individual observer or participant could possibly watch the entire event. Moreover, to insert Happenings into the spaces of everyday life (on a bus or in a supermarket) and to include mundane activities (making a call in a phone booth or whistling in a supermarket) was to envision the environment not as background setting but as integral to the artistic event.[18]

Self-Service constituted Kaprow's most ambitious scheme to date and realized his changing convictions about Happenings. Kaprow, although siting the work in Boston, New York, and Los Angeles, did not yet use it to reflect on the specificity of any one of these cities. Rather he scripted a series of arbitrary actions that, unrehearsed and unannounced, took place over a four-month period in each setting. Some of the actions transpired multiple times over four months; some occurred in more than one of the three cities. Twenty-three actions intruded on the landscape in Los Angeles, sometimes with calm deliberateness and other times with hearty gusto.[19] Arguably, some of them did acknowledge distinctive features of the urban landscape. For instance, Kaprow's final scheme for the segment of *Self-Service* prescribed several activities in Los Angeles involving cars: "Cars drive into filling station, erupt with white foam pouring from windows"; "cars blinking, beeping at night"; "count 200 red cars." Some of the exploits with cars, however, happened in both Los Angeles and one of the other two cities; for instance, Kaprow enlisted a participant to count two hundred red cars in Los Angeles and in New York. Other activities specific to Los Angeles brought attention to the city's new skyscrapers but could just as easily have been performed in New York City: for instance, "some torn paper is released from a high window, piece by piece and slowly watched." In the end only in choosing Los Angeles as one of the three urban sites for *Self-Service* did Kaprow acknowledge the city as a city and pay tribute to it as the fastest-growing metropolis in the United States and an important new capital of contemporary art.

The next Happening Kaprow mounted in Los Angeles, however, took greater advantage than *Self-Service* of the city, highlighting its distinctive architecture and spatiality. *Fluids,* proposed in conjunction with Kaprow's first retrospective at the Pasadena Art Museum in the fall of 1967, sited a number of large ice houses in Pasadena and Los Angeles. A description of *Fluids* printed on the last page of the retrospective's catalog, below a schematic drawing of a structure built out of blocks of ice, reads: "During three days, about twenty rectangular enclosures of ice blocks (measuring about 30 feet long, 10 wide and 8 high) are built throughout the city. Their walls are unbroken. They are left to melt" (figures 59–63). The ice houses drew momentary attention to the functional and leftover spaces created by an infrastructure developed for cars as well

59, 60, 61 Dennis Hopper, *Fluids*,
1967. Gelatin silver prints.
Courtesy of the artist.

62 Dennis Hopper, *Fluids*, 1967. Gelatin silver print. Courtesy of the artist.

63 Julian Wasser, *Fluids*, 1967. Photograph courtesy of Research Library,
the Getty Research Institute, Los Angeles (980063). © Julian Wasser.

64 Julian Wasser, *Fluids*, 1967. Photograph courtesy of Research Library,
the Getty Research Institute, Los Angeles (980063). © Julian Wasser.

65 Anonymous photographer, *Fluids*, 1967. Photograph courtesy of Research Library,
the Getty Research Institute, Los Angeles (980063).

66 Anonymous photographer, *Fluids*, 1967. Photograph courtesy of Research Library,
the Getty Research Institute, Los Angeles (980063).

as to the facades of commercial and domestic buildings newly erected throughout the city. Participants built fifteen of them, according to the art historian Robert Haywood, "near a McDonald's franchise in Pasadena, at a body shop in Los Angeles, on an estate in Beverly Hills, under two bridges in Pasadena, in parking and vacant lots."[20] Photographs memorialize the ice blocks in their locations—between a modern ranch-style house and a pool of the sort Hockney might have painted, beneath an overpass (figure 64), beside a pair of McDonald's arches (figure 65), and melting in the CBS parking lot (figure 66).

The ice houses did more than draw attention to mundane spaces, domestic abodes, and commercial buildings in the city. The art historian Philip Ursprung has insightfully proposed two ways in which Kaprow's ice structures both imitated and critiqued surrounding architecture. First, he argues: "The structure of *Fluids* obviously mimics the architecture of the museum. . . . The title *Fluids*, however, suggests that something is being represented in sharp contrast to the 'timeless stability' which one expects from such an institution."[21] Second, Ursprung says of suburban storage halls and distribution centers that "such purely functional and ephemeral buildings follow the economic criteria of 'planned obsolescence.' Made of cheap materials and leased out under short-term rental contracts, the buildings provide maximum profit for the landowner and are doomed to be replaced after only a couple of years."[22] Ur-

67 Dennis Hopper, *Fluids*, 1967. Gelatin silver print. Courtesy of the artist.

sprung concludes that Kaprow's ice houses borrow the standard of obsolescence from functional architecture to parody a heroic building type meant both to last and to preserve treasures. Such an interpretation certainly conforms to Kaprow's well-established antipathy for museums as institutions that ossify art and separate it from everyday life. Consider his aggressive statement in the catalog for his retrospective: "I am put off by museums in general; they reek of a holy death which offends my sense of reality." Given this stance, he seems to have felt compelled to account for the placement of his retrospective in an institution such as the Pasadena Art Museum. In the catalog he explained that although he had agreed to exhibit his past work, conceived for the space of the gallery, his Happening *Fluids* represented his new work and would take place outside the museum.[23]

To Ursprung's analysis I would add that the ice houses of *Fluids,* while perhaps a repudiation of the museum, also resisted the functionality of urban planning and the uniformity of tract housing (figure 67). Richard Schechner's interview with Kaprow, conducted prior to the implementation of *Fluids* but published afterward, reveals how the artist perceived the Happening as an intervention in urban planning. It is worth reprinting their exchange about *Fluids* at length:[24]

KAPROW: If you were crossing the city you might suddenly be confronted by these mute and meaningless blank structures which have been left to melt. Obviously, what's taking place is a mystery of sorts; using common material (at considerable expense) to make quasi-architectural structures which seem out of place amid a semitropical city setting. The structures indicate no significance. In fact, their very blankness and their rapid deterioration proclaims the opposite of significance.

SCHECHNER: But it does have a significance, and you can't be ignorant of it. It's almost a parody. Here we are, a country that builds monuments at great expense helter-skelter; a terribly property-conscious country with people who want to own everything. But plainly ice in sunlight is something that can neither be possessed nor preserved.

KAPROW: I called it *Fluids* after the fact. I usually name things after I've thought of them and planned them. *Fluids* is in a state of continuous fluidity and there's literally nothing left but a puddle of water—and that evaporates. If you want to pursue the metaphor further, it is a comment on urban planning and planned obsolescence.

SCHECHNER: I suppose you wouldn't be happy with just one ice structure?

KAPROW: Well, after all, in this country we're brought up on multiplicity; it's the very stuff of our spiritual and economic life. The sense of seriality, of continuousness—within which everything quickly grinds down only to be replaced by something else.

Multiple ice houses planned with the eye of a developer melt but are not replaced by new structures; *Fluids* literally exemplifies a meltdown in urban planning.

The working notes Kaprow made in preparation for *Fluids* also meditate on urban planning, suggesting that in his interview with Schechner he stated a settled conviction instead of making a passing comment. Among those notes, a lampoon titled "L.A.'s New Architecture?" casts Kaprow as a newspaper investigator who writes, "It was reported in this and other newspapers yesterday that strange, unexplained activities were going on around our city. Large houses of ice without doors or windows appeared in at least ten different public places around town. Today more such enclosures were constructed. For no apparent reason their makers leave them upon completion and they are melting slowly."[25] In Kaprow's scenario, the ice structures resemble houses more than museums. But the amateur carpenters who stacked the blocks of ice to approximate the dimensions of substantial dwellings ready to accommodate home owners failed to provide doors and windows and, even more outrageous, abandoned the ice houses to melt in the sun (figure 68). As Ursprung suggests, the ice houses

68 Dennis Hopper, *Fluids*, 1967. Gelatin silver print. Courtesy of the artist.

take the principle of planned obsolescence to a parodic extreme: they are obsolete as soon as they are built. Yet in Kaprow's science fiction scenario the vanishing ice houses claim public notice more for their number than for their oddity; many ice houses melting challenge expectations about not only the permanency of housing but also the rational planning of housing developments.

The placement of the ice houses of *Fluids* focused attention on tract houses, commercial chains, and the in-between spaces of overpasses and empty lots that characterized the changing built environment of Los Angeles after World War II. More than that, the ice houses both accelerated planned obsolescence and subverted the principles of urban development in Los Angeles. Disappearing soon after they appeared, the ice houses mocked the planned construction of tract homes in multiples and their continual replacement as soon as they became obsolete.

Judy Chicago, rather than organize Happenings as far away from the museum as possible, sited hers at the Pasadena Art Museum itself. Some months after her solo exhibit at the old Pasadena Art Museum closed in the spring of 1969—

Chicago had displayed her recent sculptures, whose iridescent colors and reflective acrylic surfaces aligned them with the Finish Fetish group—she organized a pyrotechnic performance at the new museum's entrance entitled *Multi-Colored Atmosphere* (see plate 20). For this event, which took place 10 January 1970, Chicago ignited flares around the edge of the outdoor reflective pool at the museum's entrance.[26] Like Kaprow and Oldenburg before her, she used the temporary and random effects of a Happening to bring attention to a particular urban site. Unlike her predecessors' Happenings, however, Chicago's *Multi-Colored Atmosphere* did not so much subvert the functional syntax of the built environment as animate the bland monumentality of a cultural institution.

Clouds of colored smoke billowed up into the air, eventually obscuring the facade of the new Pasadena Art Museum, whose opening two months earlier, in late 1969, had been marred by disappointment at the disparity between its cost, which seemed exorbitant at five million dollars, and the banality of its architecture. Like Chicago, Ruscha too had drawn attention to the construction of a new museum in southern California (see plate 9). But whereas the Los Angeles County Museum of Art (LACMA) had been erected to establish a center for art in Los Angeles, the Pasadena Art Museum had been built to house an ongoing curatorial program that in the past decade had turned Pasadena into a showcase for modern and contemporary art and music.[27] During *Multi-Colored Atmosphere,* however, these ambitions literally went up in smoke; or, alternatively, the smoke enhanced these ambitions by obscuring the building's banality. Yet only during the brief moment when the beautiful colors and billowing clouds of smoke hid the building did the museum itself emerge as compelling. Just as the fire consumes the roof of the museum in Ruscha's *Los Angeles County Museum of Art on Fire,* this evanescent smoke lends the structure of the Pasadena Art Museum the visual interest that could match its ambitions to represent and promote the contemporary art scene.

The unpredictable and random effects of ice, smoke, props, and participants in Happenings organized by Oldenburg, Kaprow, and Chicago animated nondescript spaces and anonymous buildings while undercutting their rational functions. Like many artworks from the 1960s, these L.A. Happenings highlighted places such as parking lots, gas stations, overpasses, ranch-style houses, McDonald's arches, and art museums that had been carved into the urban environment by the massive construction campaign of the 1950s and 1960s. The ad hoc and temporary nature of the Happenings, unlike a permanent monument such as the Watts Towers, an assemblage work by Purifoy, a tableau by

Kienholz, or a landscape by Foulkes, however, made no attempt to invest the urban setting with depth of meaning by stirring memories about place, hinting at death and the passage of time, or proffering judgments. Rather, Happenings resisted the banality, rationality, and functionality of urban space while offering the pleasure of brief unexpected sounds and sights.

Womanhouse and Feminist Performance Art

Car Hood of 1964 and *Multi-Colored Atmosphere* of 1970 indicate Chicago's keen interest in both the commercial culture and art institutions of southern California. As I noted in chapter 2, Chicago attended auto body school and mastered techniques used to style car surfaces. In her subsequent sculptures, she incorporated the new materials and commercial design practices of car culture and the plastics and aerospace industries, both thriving in southern California. Like many other artists in Los Angeles, she also recognized the changing built environment in her art; her ethereal Happening at the Pasadena Art Museum both paid tribute to and challenged the flat surfaces of architectural modernism.

In the late 1960s Chicago reinvented herself and dramatically changed artistic direction. Having competed fiercely to claim recognition in the local art scene according to the aesthetic standards of the artists affiliated with the Ferus Gallery, Chicago broke ranks with the "studs," their cool machismo, and their emphasis on surface finish to form an altogether separate artistic identity. Her increasing involvement with the women's liberation movement in the late 1960s caused her to rethink her art and her choice of artistic companions. Hired in 1970 to inaugurate a program in feminist art at Fresno State College (now California State University, Fresno), Chicago began to teach women students and to collaborate with them in a studio off campus. In 1971 she returned to Los Angeles and joined forces with Miriam Schapiro to initiate a feminist art program at Cal Arts.

With a full-page advertisement published in *Artforum* in October 1970, Chicago announced to the art world her newfound feminist convictions (figure 69). The photograph, printed twice on the page, one print a mirror image of the other, flaunted Chicago's recently acquired "butch" look, complete with shorn hair, a bandana tied around forehead, and dark sunglasses. The handwritten script at the top of the page read: "Judy Gerowitz hereby devests [sic] herself of all names imposed upon her through male social dominance and freely chooses her own name: Judy Chicago." The printed text at the bottom disclosed the lo-

cation and dates of her exhibition in an art gallery on the campus of California State University, Fullerton. In this passage "Gerowitz" was crossed out by hand and replaced by "Chicago," substituting the city in which she had been born for her first husband's surname. To underscore how social ritual and everyday language defined females according to a male standard, Chicago substituted "woman" for "man" in the phrase "one man exhibition." Moreover, the personalized script itself emphasized how anonymous type transformed gender biases into authoritative truth.

Chicago elaborated on her newly acquired toughness two months later in a second, sensationalist, advertisement promoting her exhibition at California State University, Fullerton. Donning boxing gloves, shorts, and high-top shoes as well as a sweatshirt with her new name emblazoned across the chest, Chicago relaxed in the corner of a boxing ring in front of her female trainer (figure 70). At first it might seem that in fashioning herself as male stud, Chicago espoused the very masculine norm—and even the mode of self-advertising—favored by the Ferus studs. Nevertheless, Chicago exaggerated her aggressive stance and defiant expression just enough to denaturalize the macho pose, signaling that it either excluded women or forced them to accommodate themselves to its norm. Indeed, in remembering her participation in the art scene in Los Angeles during the 1960s, Chicago has famously divulged: "I still felt that I had to hide my womanliness and be tough in both my personality and my work. . . . [I]f I wanted to be taken seriously as an artist, I had to suppress anything in my work that would mark it as having been made by a woman."[28] To expose the male standards of conduct taken for granted in the art world of Los Angeles, according to which women artists, like Chicago, had to define themselves, called not for mimicry of the Ferus studs' bravado but for exaggeration.[29]

Four months later, in April 1971, a photograph printed in *Everywoman,* a magazine with the motto "Every Woman Is Our Sister," completed the artist's transition from Gerowitz to Chicago and proclaimed her membership in the local feminist art community (figure 71). Entitled "Miss Chicago and the California Girls," the photograph documented all the participants in Chicago's Feminist Art Program at Fresno State. Dressed in bikinis and identifying sashes—Ms. Burbank, Ms. North Hollywood—the students adopted the standard poses of participants in beauty pageants. Only the clunky work boots on their feet signaled their parody of such events and of stereotypical southern California bombshells. The publication of "Miss Chicago and the California Girls" in a feminist journal distanced it from Ruscha's or even Chicago's studly high jinks in art publications and endowed it with an explicitly feminist political meaning. In fact this particular issue of *Everywoman* embedded the photograph in a his-

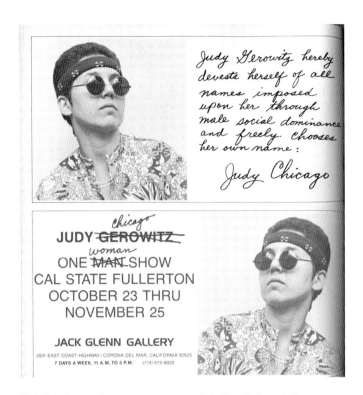

69 Judy Chicago exhibition announcement, Jack Glenn Gallery, *Artforum*, October 1970. Photograph courtesy of Through the Flower Archives.

tory of the Feminist Art Program at Fresno State, while advertising the opening, in October 1971, of Chicago and Schapiro's Feminist Art Program at Cal Arts. An interview with Chicago in this same issue and personal statements written by Schapiro and several of the students in the Fresno class summarized the curriculum of the Feminist Art Program, whose fruits were illustrated with a selection of artworks, poems, and performances. The introductory statement in the journal, given the same title as the photograph, "Miss Chicago and the California Girls," reads as part poetry and part manifesto:

> Miss Chicago and the California Girls
> Sixteen women with a lot of cunt.
> Sixteen bitches.
> Sixteen witches.
> Strong soft loud bossy weak quiet vulnerable

These short, staccato lines aggressively assume the most negative stereotypes of women as a badge of honor. In this context the photograph "Miss Chicago

JUDY CHICAGO Exhibition, Cal State Fullerton, Oct. 23 - Nov. 25
Preview 6 - 8 PM, Oct. 23, Faculty Club, Cal State Fullerton
Manager, Jack Glenn Gallery, 2831 E. Coast Highway, Corona Del Mar, Calif. 92625

70 Judy Chicago advertisement, *Artforum*, December 1970.

71 Miss Chicago and the California Girls, *Everywoman*,
 April 1971.

and the California Girls" exemplified the students' self-conscious effort to address how sexist stereotypes of women (and not just men) necessarily mediated their identity as artists.

In the fall of 1971 the graduate students who enrolled in the Feminist Art Program co-taught by Chicago and Schapiro at Cal Arts joined with their teachers to develop a large-scale art project that addressed the topic of the home. Womanhouse, the first project undertaken by the Feminist Art Program, decisively and publicly turned its back on the new urban infrastructure of Los Angeles. Even if motivated by economic necessity, the group's selection of an abandoned seventy-five-year-old mansion in midtown Los Angeles as the home for its environmental and performance artworks did not simply reject the modernist ranch-style house.[30] By redirecting attention to forgotten structures, replete with historical references, in rundown neighborhoods, the group contested, at least implicitly, the aesthetic vision of the city promoted by Banham as "instant architecture in an instant townscape." The group initiated its collaboration on Womanhouse the same year that Hockney's painting *A Bigger Splash* graced the cover of *Los Angeles: The Architecture of Four Ecologies,* marking the opening of a crack in the edifice of urban theory about Los Angeles just as it began to consolidate itself.[31]

By locating themselves in a neglected and marginal corner of the city and granting visibility to a dilapidated mansion, the group not only questioned Banham's celebration of "a giant city, which has grown almost simultaneously all over"[32] but also claimed space for a feminist art project far from the galleries on La Cienega Boulevard, LACMA, and the Pasadena Art Museum. One critic for the *Los Angeles Times* interpreted the aloofness of Womanhouse from the newly established centers of artistic production and exhibition as "a metaphor for the emerging Los Angeles woman artist."[33] Indeed while the women artists, art historians, and curators who organized the Los Angeles Council of Women Artists (LACWA) endeavored to reform institutions from within—insisting, for instance, on an increase in the number of women artists exhibiting at LACMA—most artists who came out as feminists in Los Angeles espoused separatism.[34] This practice began when Chicago decided to admit only women into the Feminist Art Program at Fresno State College and to hold the class in a studio off campus. Even when that program continued under the joint direction of Chicago and Schapiro at Cal Arts, it separated itself from the rest of the school by its women-only admissions policy and by locating Womanhouse a significant distance from the Valencia campus. Chicago and others championed separatism along the lines of women-only colleges out of a concern that women students would not realize themselves artistically as long as men still dominated the class-

72 Catalog cover of *Womanhouse*, 1972. Design by Sheila de Bretteville.
Miriam Schapiro and Judy Chicago, directors of the Feminist Art Program
at the California Institute of the Arts, seated on the steps to the exhibition.
Photograph courtesy of Through the Flower Archives.

room. Provoked as well by the failure of art institutions and schools to include women equally, women developed an alternative institutional framework throughout the city in the 1970s of art galleries, schools, and journals run exclusively for women.[35] For instance, Womanspace, a non-profit feminist art gallery, opened on Venice Boulevard in Culver City in January 1973, and several months later the Women's Building occupied the complex that had housed the former Chouinard Art School (before it became Cal Arts and relocated to Valencia), on South Grandview Avenue near MacArthur Park. The institutional separatism that characterized the feminist art movement in Los Angeles manifested itself in the requisitioning of aged, decaying buildings located geographically apart from the lively contemporary art scene that preferred lodgings in modernist structures erected in the 1960s.[36]

Womanhouse redefined standards of home ownership and renovation according to the evolving feminist ideals of the women artists involved in the project. A photograph on the cover of the *Womanhouse* catalog captured Chicago and Schapiro seated at the threshold to the house looking intently at each other, perhaps caught in conversation (figure 72). Even as the photograph of Chicago

and Schapiro secured their public visibility as a different breed of home owner, it granted the two older women a certain authority, perhaps as parental figures. Reasserting the privilege of teachers, the photograph obscured the presence of the students and the collaborative work undertaken by the entire group of women to renovate the exterior and to mount the tableaux within it. In fact the group found the seventeen-room mansion on Mariposa Street in such a state of disrepair that it spent two months refurbishing the house.[37] The women completed all of the renovations themselves, mastering carpentry and construction work typically reserved for men. Their labor certainly brought attention to them and to the house, at least in the immediate neighborhood. Chicago and Schapiro reported that local residents expressed dismay at the women's work clothes and their lack of bras: "They thought they were being invaded by hippies and they complained to the school about all of the 'longhairs.'"[38] The women artists, unconstrained by protocols of feminine clothing and grooming, asserted their bodily presence in the neighborhood as they labored to renovate, although not necessarily to perfect, the house. That their work was not meant to transform the house into a real-estate centerfold is evident in the remark one reporter made after Womanhouse opened: "Pale yellow columns peel their paint like makeup on an aging movie queen."[39] The deteriorating body of the house and the imperfect bodies of the women artists claimed a place on the urban map of Los Angeles.

The renovation affected the interior more than the exterior of the home. The elaborate tableaux the women designed inside reoriented the rooms around the private needs, desires, and frustrations of women rather than the demands of the nuclear family. The feminist installation works included spaces given such titles as Personal Environment, Leaf Room, Dollhouse Room, Crocheted Environment, Menstruation Bathroom, Bridal Staircase, Red Moon Room, Nightmare Bathroom, Leah's Room from Collette's *Cherie,* and Lipstick Bathroom. At times the artists altered rooms to such an extent that their previous function was no longer recognizable. In the Crocheted Environment (also called the Womb Room) by Faith Wilding, for instance, woven rope overtook and redefined the space by creating a large tent to shelter visitors (figure 73). Other rooms dramatized artifacts usually masked by the demands of housework and expectations about privacy and hygiene: the wastebasket in the Menstruation Bathroom overflowed with used tampons and pads (figure 74). In other parts of the home, luxuriant fabrics, glossy cosmetics, fashionable attire, opulent furnishings, and painted and sculpted food transformed rooms into displays of pleasurable feminine abundance.

Nurturant Kitchen, created by Susan Frazier, Vicki Hodgetts, and Robin Weltsch, like other interiors of the home, captured both the pleasures and en-

nui of the homemaker (figure 75). Pink paint covering all surfaces, including walls, ceiling, shelves, cupboards, stove, refrigerator, and kitchen implements, identified the kitchen as an exclusively feminine domain. The fried eggs qua breasts, produced in five different sizes, decorating the ceiling and swelling in size as they descended the walls, conflated the domestic ritual of preparing food with the sustenance provided by breastfeeding. As much as the kitchen cast the homemaker in the role of nurturer, it also equated the pleasure of the nurtured in eating food with that of the infant suckling. The kitchen emphasized the gratification of giving and eating food, with only the sheer number of eggs hinting perhaps at the deadening routine of breakfast preparation. Yet the cupboard drawers contained eye-catching photo collages that invited the homemaker to dream about exotic places. Secreted away, these brightly colored photographs offered escape. They also documented recognizable public heroines, such as Angela Davis, who in the 1960s assumed roles of leadership and dissent in the feminist and civil rights movements. Such glimpses of models of public activism and scenes of fantasy vacations revealed the pent-up dissatisfactions of the homemaker lying just below the surface.

The theatrical settings of Womanhouse recall Kienholz's own tableaux of the 1960s. In his often morbid environments that reimagined the interior of the car, brothel, state hospital, and bar, Kienholz featured horrific social, sexual, and medical practices and dramatized the psychic and social pain he attributed to the occupants of these spaces. The installations at Womanhouse allied horror with pleasure while concentrating exclusively on the private spaces and daily domestic rituals of middle-class white women. Unlike Kienholz, however, the feminist artists inserted themselves physically into these spaces and implicated themselves in the social drama of the home by including Performance pieces set within the interior.

The artists based the Performance pieces at Womanhouse on their exploration, in consciousness-raising groups, of their personal experiences, fears, and desires. Chicago introduced consciousness-raising techniques from the woman's liberation movement into her Feminist Art Program at Fresno State College; she and Schapiro continued to organize classes at Cal Arts around group discussions of personal feelings and experiences and to awaken a feminist consciousness. Schapiro has described the classroom dynamics:

> Classes begin by sitting in a circle; a topic for discussion is selected. We move around the room, each person assuming responsibility for addressing herself to the topic on her highest level of self-perception. In the classical Women's Liberation technique, the personal becomes the political. Privately held feelings imagined to be

73 Crocheted Room, installation by
 Faith Wilding at Womanhouse, 1972.
 © Judy Chicago 1972. Photograph
 courtesy of Through the Flower
 Archives.

74 Menstruation Bathroom, installation from Womanhouse, 1972. In Division of Labor
 exhibition, Museum of Contemporary Art, Los Angeles. © Judy Chicago 1972 and
 1995. Photograph © Donald Woodman, courtesy of Through the Flower Archives.

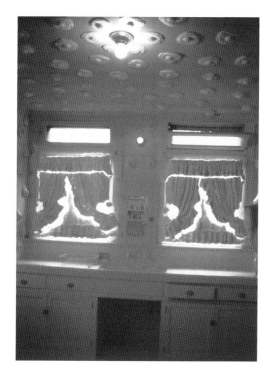

75 Nurturant Kitchen, installation by Susan Frazier, Vicki Hodgetts, and Robin Weltsch at Womanhouse, 1972. © Judy Chicago, 1972. Photograph courtesy of Through the Flower Archives.

personally held "hang-ups" turn out to be everyone's feelings, and it becomes possible to act together in their solution.

Womanhouse began as a topic for discussion in one of our class meetings.[40]

Confessional exchanges among the students and teachers served therapeutic purposes, secured a bond of trust, established a common set of experiences, and provided materials for artwork. In preparation for the opening of Womanhouse to the public, several of the women artists met specifically to brainstorm about the meaning of the environments and to explore "the entrapment that the house meant for many women." Chicago elaborated: "We started by 'playing around.' Our experiments grew out of our ability as women to put out direct feeling."[41] These sessions, involving spontaneous individual expression of inner feelings combined with ongoing group discussions and revision of scenarios, yielded a number of Performance pieces for the house; in addition, one work Chicago had scripted at Fresno was performed at Womanhouse.

Distancing itself from the disjointed poetic structure and the ephemeral materials typical of Happenings produced in Los Angeles during the 1960s, Performance art at Womanhouse incorporated props from the home, cast women as homemakers, and manifested the private frustrations, angers, and pleasures

76 *Waiting*, performance by Faith Wilding
 at Womanhouse, 1972. Written by Ms.
 Wilding in 1971. Photograph courtesy
 of Through the Flower Archives.

77 *Cock and Cunt Play*, performance by Faith
 Wilding and Janice Lester at Womanhouse, 1972.
 © Judy Chicago 1972. Photograph courtesy of
 Through the Flower Archives.

of homemakers on the surface of the female body, while adopting dramatic nar-
rative form. A number of the Performance artworks at Womanhouse enacted
the drudgery of domestic labor and the burden of self-fashioning: a woman
ironed, another scrubbed the floor, another applied and removed makeup. Typ-
ically the body of the performer enacted the weight of a homemaker's life. In
Waiting, for instance, Faith Wilding rocked back and forth, reciting in a mon-
otone all the episodes in a woman's life, from birth to death, that were charac-
terized by waiting (figure 76). With her shoulders slumped and her eyes down-
cast, Wilding's posture effectively captured the passivity of a woman caught up
in a life whose rhythm was measured by waiting. For instance, as a mother and
a homemaker she was "waiting for my children to come home from school;
Waiting for them to grow up, to leave home; Waiting to be myself." Sometimes
the performances voiced the angers and frustrations bottled up inside middle-
class white women trapped in their role as homemaker. Their repressed feel-
ings burst out, manifesting themselves as much by the movements of the per-
formers' bodies as by the intonations of their voices. In Chicago's piece *Cock
and Cunt Play* two artists, Faith Wilding and Janice Lester, assumed the stereo-
typical roles of husband and wife (figure 77). Costumed simply in black leo-

tards and tights, the two women were distinguished as He and She by the enormous prosthetic sex organs attached to their waists. The directives instructed them to mimic the poses and movements of puppets, with "arms and legs . . . held akimbo, palms upright, and feet pointing out. Voices are highly exaggerated and in sing-song rhythm. . . . Male voice is low and authoritarian. Female voice is high and obsequious."[42] In one scene, Lester, in the character of the wife, plaintively asks Wilding to help with the dishes and later to satisfy her sexually. He reacts defensively, rebukes her, and becomes violent at the end, clobbering her to death with his penis. Even so, moments of hilarity punctuated the exchange—this one in the first act, for instance:

SHE: Will you help me do the dishes?
HE: (Shocked) Help you do the dishes?
SHE: Well, they're your dishes as much as mine!
HE: But you don't have a cock! (grasps cock and begins stroking it proudly)[43]

The jerky mechanical movements of the performers and their unexpected physical violence embodied the frustration, bewilderment, and anger of the characters, while generating both laughter and discomfort in the viewers.

At times, performers reenacted and exaggerated gender stereotypes not just in ironic jest but also to hint at the seductive pleasure of the roles. For example, in her part as the "whore with a heart" in *Three Women,* the character named Sparkyl visibly enjoyed her flamboyant costume and beguiling flirtations.[44] All smiles, Sparkyl expansively expresses her femininity with a belly dance and fully dominates the interior space with her physicality. In these small-scale theatrical events, facial expression, voice, and bodily gesture all worked together to stage the shifting emotions of women in the home.

The opening of Womanhouse transformed the installations and performances into a public event, to be seen, discussed, and debated. Chicago claims that "almost ten thousand people came to see it."[45] According to *Time* magazine some four thousand people visited the house, while others toured it on television.[46] Whatever the final figures, many entered the home in person or experienced it indirectly through the mass media. Others attended the performances, which took place at regularly scheduled times in Womanhouse from 30 January to 28 February 1972. Unlike Kaprow's Happenings, these performances were meant to be seen by an audience; seated on the floor around the perimeter of the living room, observers watched, sometimes silent, sometimes gasping, laughing, and applauding.[47] Capturing wide media attention, Womanhouse succeeded in channeling the private into a public discourse, generat-

ing and participating in both a local and a wider national discussion of the status of women.

A forty-minute film of Womanhouse by Johanna Demetrakas documented in color the theatrical environments and dramatic performances there and preserved the site for posterity before it was dismantled. The film blurred the difference between private and public spaces by presenting the rooms out of sequence, moving arbitrarily inside and outside the house, and intercutting views of the rooms with shots of the performances or interviews with visitors. The film did more than confuse domestic interiors with public space and highlight the radical reorganization of the home. The voice-over at the beginning of the film invited viewers to consider Womanhouse a revelation of the "longings, fears that women have." The film implicated the feelings of visitors as well, documenting their anger, laughter, and disbelief. In one of the opening scenes, a woman strolling through Nurturant Kitchen squeezed a breast-egg, expressing both erotic pleasure and daring humor. A man admitted that he had never before discussed sexual difference with women. Another of the women interviewed, identified as an engineer, expressed her appreciation and shock at seeing things "out in the open," "in public," "with other people." Being "in public" seems to have meant more than occupying public space or exposing private interiors to public view; it involved the discussion of private feelings with a broad, diverse, and anonymous audience.

Architecturally, the astonishing installations and powerful performances at Womanhouse succeeded in shifting attention from the surfaces of buildings to their interiors, from the new modern infrastructure of Los Angeles to its forgotten homes and rundown neighborhoods. Even more important, Womanhouse defined a feminist aesthetic around the bodily expression of private frustrations and pleasures of middle-class white homemakers. Womanhouse made the interior—both private domestic space and confessional body art—insistently visible in the urban landscape and introduced it into a public discourse about women. Given the media attention it garnered, this project had a direct impact on the cultural identity of Los Angeles by making it, with New York, one of the two leading centers for feminist art production in the United States.[48]

Many of the women artists active in Womanhouse, including Chicago herself, went on to direct feminist performances in public spaces in Los Angeles. For instance, in the same year as Womanhouse, Chicago's atmosphere projects acquired an overt feminist significance as exemplified by *Smoke Goddess V,* in which a woman played the role of earth goddess on a sandy beach near the city.[49] Suzanne Lacey, who performed *Waiting* in Womanhouse, collaborated with Leslie Labowitz in 1977 to produce *In Mourning and in Rage* on the steps of Los

Angeles City Hall both to commemorate the victims of the Hillside Strangler rape-murders and to pressure the media and judicial system to take crimes against women more seriously.[50] Holding various institutions dotting the built environment responsible for the image, status, and fate of women, Lacey, Labowitz, and other feminist artists planned Performance pieces throughout the 1970s at carefully selected, politically charged public sites.[51] Other artists, likewise galvanized by identity politics, began organizing Performances around the city or representing their concerns in a variety of media, including photography, painting, sculpture, and murals: together these artworks gave visual form to a politicized, feminist, and multicultural imaginary of the city that ultimately competed with and sometimes supplemented representations of Los Angeles dating from the 1960s.

Happenings and Performance art burst upon the urban landscape of Los Angeles during the 1960s and early 1970s. Happenings flared up in front of commercial, residential, and monumental public buildings or in functional spaces such as parking lots. They demanded attention and then disappeared, leaving no permanent mark in the urban sprawl. If anything, Oldenburg, Kaprow, and Chicago took the mobility of Los Angeles—its essential transitoriness as defined by Joan Didion—and thematized it as an artistic event. The ephemeral and unpredictable events organized by artists focused attention on the growing presence of bland tract houses built in multiples; of the expanding system of freeways; of new modern museums in the city. Happenings, fleeting by nature, necessarily distinguished themselves from the brute reality of urban renewal and development—its imposed uniformity of space and architecture on the urban landscape.

Rather than engage the new built environment of Los Angeles, the feminist project of Womanhouse featured what was concealed as the urban map of the city consolidated in the 1960s: the marginal, forgotten, and dilapidated building. The house on Mariposa Street provided a physical setting for private, often unmentionable, feelings and desires to be unveiled by dramatic installations and by imperfect female bodies that inhabited domestic space heartily, noisily, and fiercely. And while the artworks and performances at Womanhouse were temporary, they entered into a public dialogue about the status of middle-class white women that extended their impact beyond their geographic location and time frame. In counterpoint to the chorus of voices that crescendoed into either a lament or a celebration of the new, sprawling megalopolis, the feminist artists at Womanhouse whistled an amusing, irritating, and insistent tune that aired the fantasies, imperfections, and disappointments of neighborhoods and residents ignored by the city's modernization in the 1960s.

Conclusion

"THE URBAN LANDSCAPE, AMONG ITS MANY ROLES, IS ALSO SOMETHING
to be seen, to be remembered, and to delight in," Kevin Lynch, the urban plan-
ner, proclaimed in the preface to *The Image of the City*, published in 1960.[1]
Lynch's conversations with residents in Los Angeles revealed, however, that the
burgeoning city lacked legibility; no identifiable districts, memorable land-
marks, or distinctive pathways oriented pedestrians and provided them with
the bricks and mortar to build a mental map of Los Angeles. Residents Lynch
interviewed in the late 1950s, when a growing freeway system had accelerated
suburbanization and had brought about the development of a sprawling, frag-
mented metropolis, called the city "spread out" and complained that it had no
centers.[2] The city was hard to read, Lynch determined, because it was so de-
centralized and because its uniform grid pattern and its relentless building cam-
paigns had destroyed urban memory, tearing down historic structures and re-
placing them with gleaming skyscrapers. According to Lynch's benchmark of
"imageability," Los Angeles failed miserably as a city, sucking its citizens into
an amorphous black hole.[3]

At the end of the 1960s Reyner Banham wrote his paean to Los Angeles,
making sense of the city's geographic expanse by adopting the perspective of
the driver. Lynch had focused his study on downtown Los Angeles and on the
pedestrian; Banham acknowledged the city's center only near the end of *Los
Angeles: The Architecture of Four Ecologies*. Banham began a chapter called "A
Note on Downtown . . . ," with a damning phrase to complete that title: "be-
cause that is all downtown Los Angeles deserves." Indeed, he praised only a few
historic structures such as the Bradbury building while lamenting the other-
wise "gutless" commercial and civic architecture downtown. Dismissing the
"pueblo-centric historians . . . [who] have always tended to see the development
of the city as a 'normal' outward sprawl from a centre which is older than the
rest of the city,"[4] Banham divided Los Angeles into what he termed four ecolo-
gies: the beach and coastline, the Santa Monica Mountains, the plains of the
central valley, and the freeway. By featuring the term "ecology" in his analyti-
cal lexicon, Banham shifted urban analysis from the social sciences to the nat-
ural sciences to encompass changes in the environment over time. Banham
punctuated his broad geographic sweep with observations about individual
buildings—an eclectic array of structures ranging from case-study houses to
hot-dog stands. Equally important, he summarized the geography, history, and
architecture of Los Angeles with as much attention to the processes of per-
ception in a car-oriented city as to particular buildings. As the architectural his-
torian Anthony Vidler observes in his introduction to the most recent edition
of Banham's book: "While the 'eye of the beholder' that looks in the rear-view

mirror or across the Mojave is first and foremost Banham's eye, by extrapolation it stands for a sense of the meaning of objects in space that goes far beyond the architectural, the urban, the regional, to engage the phenomenology of experience itself."[5]

Lynch's and Banham's books bracket a decade during which many artists residing in Los Angeles represented the city or intervened in the built environment, concentrating on L.A.'s architecture, infrastructure, and urban space as well as on mechanisms of seeing unique to the city. None of the artists followed Lynch into downtown Los Angeles or condemned the city for failing to live up to the model of an older northeastern or European city built around a historic core. Only Hockney depicted a particular downtown site, in *Building, Pershing Square, Los Angeles* (see plate 15), characterizing it as a banal gray bank facade and a street emptied of human life. The crowded and eroticized downtown of John Rechy and the aging and mysterious Bunker Hill of Raymond Chandler did not manifest themselves in paint. Rather, artists depicted the city's new commercial facades, suburban homes, parking lots, and freeways, or they brought attention to older, dilapidated, and ignored neighborhoods in an attempt either to comprehend, appreciate, or contest the city's new, sprawling built environment.

L.A. artists did not assume the perspective of the pedestrian, whose archetype was best described by Charles Baudelaire and Walter Benjamin: the flaneur appraising the shop windows of Paris and the crowds congregating on Haussmann's broad boulevards. Instead they, like Banham, viewed the city from behind the wheel of a car; barreling down the 405 freeway or maneuvering on the streets of Los Angeles, glimpsing overpasses, signage, and buildings through the windshield or in the rearview mirror. An artist such as Ruscha exaggerated the orientation of signs and facades to the driver's eye and dramatized the design of the commercial exterior—the crisp lines and bold colors—bringing attention to the way in which the city was organized around the car. According to the art of the 1960s, the driver's view of buildings—focused straight ahead, with quick pans to the periphery and choppy glances to the side and rear—was fundamentally different from that of the pedestrian approaching them slowly from a distance, to stand before them. We are often conscious in L.A. art of the 1960s of our containment in cars and their shaping of our perception of urban space.

The buildings and commercial signs depicted by artists typically stand as isolated structures, not located in the historical or geographic fabric of the city as described by Banham. Ruscha's paintings of Norms restaurant, Standard filling stations, and even the Los Angeles County Museum of Art and Hockney's suburban homes eliminate the surrounding streets that would identify a

neighborhood. Ruscha's photographic books, which identify sites by name or address, typically separate buildings from their environs. The reiteration of building types in these books—or the isotropic layout of structures in *Every Building on the Sunset Strip*—highlights the uniformity of the city instead of distinguishing it by neighborhood or ecology. Even Happenings by Oldenburg and Kaprow, which disrupt the bland functional space of parking lot and concrete passageway, point to the standardization of urban space. All of these works hint at the emergence of an increasingly depersonalized city in which drivers, isolated in their cars, move through a rationalized urban space emptied of disorder and human life.

Nevertheless, scanning the modern built environment from the car provides its rewards. Artists suggested that commercial facades and city streets peered at over the dashboard or through a car window, while numbing in their sameness, could be stunning in their design and surprising in their idiosyncrasies. Observing the landscape with quick, rapid glances, Foulkes sees traffic signs whose hazard stripes recall canvases by the abstract artist Kenneth Noland; Ruscha juxtaposes the drama of commercial design characterizing Norms restaurant and the unpredictable fires consuming its signage; and Hopper captures the cacophony and wordplay of commercial signage at a street intersection. Artists attentive to the urban environment uncover surprises and incongruities amid the seeming sterility of modernization.

Other artists were less interested in representing the processes and particularities of perception in a car-oriented city than they were in reclaiming and often disrupting the new urban infrastructure of Los Angeles. These artists also fanned out from the city center to the sprawl of greater Los Angeles and the infrastructure developed around the car. But they often stepped out of their cars and settled, temporarily at least, into the buildings and spaces of the modern megalopolis: Hockney in a suburban home, Oldenburg in a parking lot, Kaprow in a nondescript space below an overpass. With their ad hoc events Kaprow and Oldenburg, in particular, transformed bland areas fleetingly into landmarks. They resisted the standardization of franchises, freeways, and suburban homes on the urban landscape by investing utilitarian places with an unpredictability worthy of attention.

Still other artists discovered buildings and neighborhoods of Los Angeles untouched by the process of modernization: Purifoy in Watts, Chicago in east Hollywood. By erecting cultural monuments, even temporary ones, in neighborhoods whose structures testified to a history of economic, social, and cultural neglect, artists altered the cognitive map of Los Angeles to include the ruined landscape. Various groups claimed Simon Rodia's fantastical creation, the

Watts Towers, as a cultural landmark, while Assemblage artists under Purifoy's direction reimagined the neighborhood with objects constructed out of the detritus of the Watts uprising. And the feminist collective organized by Chicago and Schapiro turned a dilapidated house on Mariposa Street for two months into Womanhouse. These structures did not constitute fixed landmarks steeped in nostalgia for locality and the past. The artists producing such incongruous, unexpected, and typically temporary place markers claimed attention for neighborhoods bypassed by modernization while enabling strategic alliances to take shape around contemporary cultural or political ideals.

Many of these artists claimed urban space for living, breathing, laboring bodies to reassert a form of sociality within the sprawling megalopolis. Max Yavno's famous photograph of Muscle Beach, packed with people wearing only bathing suits, reveals how Los Angeles relocated the urban crowd of the modern city to the coastline, contributing to an eroticized fantasy of the city promoted in many magazines after World War II (see figure 15). Yet time and again, artists of the 1960s emptied the urban landscape of bodies. Celmins ignored the social life of the beach in her drawings of waves; Hockney placed nudes in private spaces in and around the home. Bodies did not reemerge in public space in the art of the 1960s until Happenings: photographs document the participants in *Autobodys* performing in both scripted and unpredictable roles, or they depict crews consisting of ten to fifteen volunteer men, women, and children building Kaprow's ice houses. As the critic Jeff Kelley tells it, even passersby joined the groups at work in *Fluids;* in one instance, a motorcycle cop tossed several road flares into one enclosure, illuminating it with gaseous pink light.[6] These collaborative events that unfolded in space and time allowed for a sense of civic belonging—temporary, unpredictable gatherings of people—in a city that was becoming increasingly rationalized by freeways, extended by urban sprawl, and privatized by shopping malls and single-family homes.

When the eroticized body manifested itself in the art of the 1960s, it went beyond the idealized heterosexual bodies on Yavno's beach to encompass other sorts of bodies and to create new collectivities within the city. It is true that the many photographs depicting the Ferus studs consolidated an art scene that capitalized (often with tongue in cheek) on the eroticized heterosexual male body participating in a stereotypical Angeleno lifestyle (see figure 1). In contrast, Hockney's paintings imagined male bodies taking pleasure in one another, outdoors, under the bright southern California sun. Chicago, Schapiro, and the feminist artists at Womanhouse formed an exclusively female family around performances that exaggerated and parodied the ideal female body. Both Hockney's paintings and the performances at Womanhouse extended the Angeleno

ideal of the nuclear family residing in a single-family home to single-sex couples or groups. These imagined and real communities refashioned stereotypes about Los Angeles and created a new public discourse about the city—its residents, its culture, and its lifestyle.

Whether instigating ad hoc and unpredictable events, reinserting bodies into the built environment, or seeking incongruities in urban space, artists were drawn as much to the new infrastructure of Los Angeles as to the disruptive elements that resisted being swallowed by the sprawling, modernizing city. To be sure, Los Angeles in the 1960s was not New York, whose vibrancy Rem Koolhaas celebrated in *Delirious New York*—a city that draws together an unbelievable variety of people and buildings into a relatively small geographic space and generates from that mix a disorienting energy.[7] In the art of the 1960s Los Angeles hovers between the urban nightmare of rationalization—sameness, sprawl, isolation, emptiness—and the utopia of delirium and difference. Yet this was no simple dichotomy: even the most functional urban spaces could manifest complexity through wordplay, ambiguity, and eroticism.

In the years since Womanhouse, Los Angeles has expanded into a major global city with one of the most diverse populations in the world. And even as the city's art scene has changed dramatically, recent art about Los Angeles continues to recalibrate the relationship between urban space and social life, between sameness and difference. Revising representations of Los Angeles from the 1960s, many artists today place more weight on the diversity and frictions of its multicultural citizenry than on the promises and limitations of its modern infrastructure. For instance, where Hockney pictured young, groomed men comfortably enjoying suburban homes and pools, Cathy Opie's photographs find no such alliance between lavish single-family homes and Angeleno subcultures. Instead, Opie provides close-ups both of the facades of gated, exclusive Beverly Hills homes and of friends in the S and M community in Los Angeles. Or consider Robbert Flick's conceptual photographs of major arteries cutting through different neighborhoods in Los Angeles. Flick's works, which run together photographs selected from thousands of images and stack the resulting photographic strips in a single frame, recall the precedent of Ruscha's photographic book *Every Building on the Sunset Strip*. Yet each of Flick's images captures diverse histories, geographies, and residents of Los Angeles streets. In Lincoln Tobier's ongoing project *(It all comes together in) Ruckus L.A.*, the artist has designed an architectural model of the city of Los Angeles inspired by Ruscha, Rodia's Watts Towers, the *Names Project* quilt, the urban planner Robert Moses' *Panorama of New York City*, and Red Grooms's *Ruckus Manhattan;* ultimately it will include participation by city residents, who will provide scale mod-

els of favorite structures or of their own neighborhoods. Tobier thus combines a bird's-eye view of the city with the personal perspectives of individuals.[8] The complex social life of Los Angeles, the multicentric city, spreading ever outward, continues to generate representations of the city, to revise what we know about it, and to encourage fantasies of what it might mean to be an Angeleno in the twenty-first century.

Notes

INTRODUCTION

1 Joseph Mascheck, "California Color," *Artforum* 9 (January 1971): 72. *Artforum* began to be published in New York in June 1967. On the magazine's history, see Amy Newman, *Challenging Art: Artforum 1962–1974* (New York: Soho, 2000).

2 Claes Oldenburg lived in Venice, California, briefly between 1963 and 1964.

3 Andy Warhol and Pat Hackett, *Popism: The Warhol '60s* (London: Hutchinson, 1981), 39.

4 Alison Lurie, *The Nowhere City* (1965; New York: Coward-McCann, 1966).

5 The role of these institutions, critics, and curators in promoting Angeleno artists and art has been detailed in a number of important books including Anne Ayres, ed., *L.A. Pop in the Sixties* (Newport Harbor: Newport Harbor Art Museum, 1989); Jay Belloli et al., *Radical Past: Contemporary Art and Music in Pasadena 1960–1974* (Pasadena: Armory Center for the Arts; Art Center College of Design, 1999); Lars Nittve and Helle Crenzien, *Sunshine & Noir: Art in L.A., 1960–1997* (Humlebaek, Denmark: Louisiana Museum of Modern Art, 1997); Peter Plagens, *Sunshine Muse: Contemporary Art on the West Coast* (New York: Praeger, 1974); Maurice Tuchman, *Art in Los Angeles: Seventeen Artists in the Sixties* (Los Angeles: Los Angeles County Museum of Art, 1981); and Betty Turnbull, *The Last Time I Saw Ferus, 1957–1966* (Newport Harbor: Newport Harbor Art Museum, 1976).

6 Roland Barthes writes, "Quadrangular, reticulated cities (Los Angeles, for instance) are said to produce a profound uneasiness: they offend our synesthetic sentiment of the City, which requires that any urban space have a center to go to, to return from, a complete site to dream of and in relation to which to advance or retreat; in a word, to invent oneself." Barthes, *Empire of Signs*, trans. Richard Howard (New York: Hill and Wang, 1982), 30.

7 Jules Langsner, "America's Second Art City," *Art in America* 51 (April 1963): 127. Langsner was, claimed Suzanne Muchnic, "the most respected art critic in Los Angeles." Muchnic, "No More Nutburgers," in *Radical Past* (see note 5), 10.

8 Charles Champlin, "Los Angeles in a New Image," *Life*, 20 June 1960, 80.

9 Champlin, "Los Angeles in a New Image," 89.

10 John Coplans, "Los Angeles: The Scene," *Art News* 64 (March 1965): 28.

11 Plagens, *Sunshine Muse,* 139.

12 Carl Belz, *Mel Ramos: A Twenty-Year Survey* (Waltham, Mass.: Rose Art Museum, Brandeis University, 1980), 12.

13 Susan Ruth Snyder, "Mel Ramos, David Stuart Gallery," *Artforum* 4 (December 1965): 16.

14 See, for instance, Barbara Rose, "Filthy Pictures: Some Chapters in the History of Taste," *Artforum* 3 (May 1965): 24; and Robin Skelton, "The Art of Mel Ramos," *Malahat Review* 8 (October 1968): 62.

15 Herb Caen, "Why San Franciscans Don't Like Los Angeles," and Jack Smith, "Why San Franciscans Really Don't Like Us," *Saturday Evening Post,* 3 November 1962, 72–75.

16 From the first, critics used the term "Pop art" quite loosely in Los Angeles. In 1963 the curator Lawrence Alloway tried to correct this tendency, by selecting artists for the exhibition Six More at the Los Angeles County Museum of Art to complement his show Six Painters and the Object, which traveled to Los Angeles from New York's Guggenheim Museum. In his introduction to the catalog, Alloway distinguished a core Pop group (Billy Al Bengston, Joseph Goode, Phillip Hefferton, Mel Ramos, Ed Ruscha, Wayne Thiebaud) who used signs and common objects from "object-makers." Alloway, *Six More* (Los Angeles: Los Angeles County Museum of Art, 1963), n.p.

 California Pop did not fit snugly within Lucy Lippard's definition of Pop art; hence she commissioned a separate chapter on it for her book *Pop Art.* To highlight the "disparate body of Pop Art on the West Coast," the author, Nancy Marmer, cited Ed Ruscha, Edward Kienholz, and Vija Celmins, pointing up the term's use, in the mid-1960s, less as an aesthetic category and more as a signal of distance from earlier artists in Los Angeles: especially on "the fluid Southern California scene, Pop Art has rightly been considered the active ingredient in a general housecleaning that during the past three or four years has all but exterminated the last traces of prestige for local and imitative versions of Abstract Expressionism." Marmer, "Pop Art in California," in *Pop Art,* ed. Lucy Lippard (London: Thames and Hudson, 1966), 147. For a discussion of Lippard's definition of Pop art, see Cécile Whiting, *A Taste for Pop: Pop Art, Gender, and Consumer Culture* (New York: Cambridge University Press, 1997), 135–37, 189–95.

17 Henry Hopkins, personal communication, 14 March 2001. Emerson Woelffer, asked if he was aware of the influence of the so-called [Rico] Lebrun school, stated, "I was very aware of that. That was very strong—Lebrun, Howard Warshaw, and the Herbert Jepson school . . . and they were all in that vein of heavy à la Picassoesque draftsmanship work." Woelffer, interview by Joann Phillips, 1976, transcript, p. 123, Oral History Program, Special Collections, University Library, University of California, Los Angeles (UCLA), 1977.

18 Examples include Los Angeles Now in London in 1966, Los Angeles 6 in Vancouver in 1968, and Kompass IV–West Coast USA in Amsterdam in 1969.

19 Ayres, *L.A. Pop in the Sixties;* Stephanie Barron, Sheri Berstein, and Ilene Susan Fort, eds., *Made in California: Art, Image, and Identity, 1900–2000* (Los An-

geles: Los Angeles County Museum of Art; Berkeley and Los Angeles: University of California Press, 2000); Stephanie Barron, Sheri Bernstein, and Ilene Susan Fort, eds., *Reading California: Art, Image, and Identity* (Los Angeles: Los Angeles County Museum of Art; Berkeley and Los Angeles: University of California Press, 2000); William Alexander McClung, *Landscapes of Desire: Anglo Mythologies of Los Angeles* (Berkeley and Los Angeles: University of California Press, 2000); Nittve and Crenzien, *Sunshine & Noir;* Plagens, *Sunshine Muse.* The bibliography of *Made in California* covers modern and contemporary art.

20 See for instance, Mike Davis, *City of Quartz: Excavating the Future in Los Angeles* (New York: Verso, 1990); Norman M. Klein, *The History of Forgetting: Los Angeles and the Erasure of Memory* (New York: Verso, 1997); Peter Schrag, *Paradise Lost: California's Experience, America's Future* (Berkeley and Los Angeles: University of California Press, 1998); Allen J. Scott and Edward W. Soja, eds., *The City: Los Angeles and Urban Theory at the End of the Twentieth Century* (Berkeley and Los Angeles: University of California Press, 1996); Michael Sorkin, ed., *Variations on a Theme Park: The New American City and the End of Public Space* (New York: Hill and Wang, 1992).

21 A number of writers have studied the relation between visual representation and urban form. However, I have found an account by James Donald to be particularly useful: "To put it polemically, there is no such thing as a city. Rather the city designates the space produced by the interaction of historically and geographically specific institutions, social relations of production and reproduction, practices of government, forms and media of communication, and so forth. By calling this diversity 'the city,' we ascribe to it a coherence or integrity. The city, then, is above all a representation. But what sort of representation? By analogy with the now familiar idea that the nation provides us with an 'imagined community,' I would argue that the city constitutes an imagined environment. What is involved in that imagining—the discourses, symbols, metaphors and fantasies through which we ascribe meaning to the modern experience of urban living." Donald, "Metropolis: The City as Text," in *Social and Cultural Forms of Modernity,* ed. R. Bocock and K. Thompson (Cambridge: Polity Press, 1992), 422.

22 A few crucial texts include T. J. Clark, *The Painting of Modern Life: Paris in the Art of Manet and His Followers* (New York: Knopf, 1985); Wanda Corn, "The New New York," *Art in America* 61 (July–August 1973): 58–65; Robert L. Herbert, *Impressionism: Art, Leisure, and Parisian Society* (New Haven: Yale University Press, 1988); Rebecca Zurier, Robert Snyder, and Virginia Mecklenburg, *Metropolitan Lives: The Ashcan Artists and Their New York* (Washington, D.C.: National Museum of American Art; New York: Norton, 1995); Lynda Nead, *Victorian Babylon: People, Streets and Images in Nineteenth-Century London* (London: Yale University Press, 2000); Griselda Pollock, "Vicarious Excitements: London: A Pilgrimage by Gustave Doré and Blanchard Jerrold, 1872," *New Formations* 2 (Spring 1988): 25–50; Alex Potts, "Picturing the Modern Metropolis: Images of London in the Nineteenth Century," *History Workshop Journal* 26 (Autumn 1988): 28–56.

23 Michael Dear characterizes the dramatic economic boom that swept the state after World War II: "After 1945, a long period of economic prosperity settled upon California. The Cold War and the conflicts in Korea and Vietnam prompted con-

tinuing high levels of defense-related expenditures. By 1960, aerospace industries employed 70 per cent of San Diego's and 60 per cent of Los Angeles's manufacturing workers. Such growth, together with furthur diversification in employment patterns, pushed population to new heights. California became the nation's most populous state in 1962, passing New York, having grown from 6.9 million in 1940 to 15.7 million in two short decades." Dear, "Peopling California," in *Made in California* (see note 19), 58.

24 Schrag, *Paradise Lost,* 27.

25 David W. Lantis and John W. Reith, "Los Angeles," *Focus* (American Geographical Society of New York) 12 (May 1962): 1.

26 Wes Marx and Gil Thomas, "A New City," *Los Angeles: Magazine of the Good Life in Southern California,* February 1962, 17.

27 Edward Soja, "Los Angeles, 1965–1992: From Crisis-Generated Restructuring to Restructuring-Generated Crisis," in *The City* (see note 20), 431. Peter Schrag makes a convincing case for tracking the start of California's decline to the passage of Proposition 13 in 1978, though he also finds fine cracks in the boom mentality emerging in the 1960s. Schrag, *Paradise Lost,* 43–48, 65.

28 Lewis Mumford, *The City in History: Its Origins, Its Transformations, and Its Prospects* (New York: Harcourt, Brace and World, 1961), 510. For a good overview of Mumford's writings, see his *Art and Technics,* with a new introduction by Casey Nelson Blake (New York: Columbia University Press, 2000), vii–xxx.

29 Marx and Thomas, "A New City," 17.

30 A reporter for *Time* magazine stated, "Most U.S. cities have a single downtown core, but Los Angeles has dozens." "Cities: Magnet in the West," *Time,* 2 September 1966, 15.

31 Many urban theorists have characterized Los Angeles as a postmodern urban landscape, even as they debate whether Los Angeles is unique or representative of the new conditions of urban life in a global economy. See Roland Barthes, "Center-City, Empty City," in *Empire of Signs* (see note 6), 30–32; Davis, *City of Quartz;* Michael Dear, "In the City, Time Becomes Visible: Intentionality and Urbanism in Los Angeles, 1781–1991," in *The City,* 76–105; Phillip J. Ethington, "Into the Labyrinth of Los Angeles Historiography: From Global Comparisons to Local Knowledge," http//cwis.usc.edu/dept/LAS/history/historylab/LAPUHK/Text/Labyrinth_Historiography.htm; Robert Fishman, *Bourgeois Utopias: The Rise and Fall of Suburbia* (New York: Basic Books, 1987); Fredric Jameson, "Postmodernism, or The Cultural Logic of Late Capitalism," *New Left Review* 146 (July–August 1984): 53–92; Norman M. Klein and Martin J. Schiesl, eds., *20th Century Los Angeles: Power, Promotion and Social Conflict* (Claremont, Calif.: Regina Books, 1990); Arthur Krim, "Los Angeles and the Anti-Tradition of the Suburban City," *Journal of Historical Geography* 18 (1992): 121–38; Roland Marchand, *The Emergence of Los Angeles: Population and Housing in the City of Dreams 1940–1970* (London: Pion, 1987); Scott and Soja, *The City.*

32 Soja, "Los Angeles, 1965–1992," 433.

33 Soja, "Los Angeles, 1965–1992," 434 and 436.

34 Barron, Bernstein, and Fort, *Made in California,* 164–65.

35 Marco Livingstone, *David Hockney* (New York: Holt, Rinehart and Winston, 1981), 70. Livingstone is quoting from the *Listener,* 22 May 1975.

36 For an insightful and thorough analysis of the relation between surface and depth in modern and postmodern art and criticism, see David Joselit, "Notes on Surface: Toward a Genealogy of Flatness," *Art History* 23 (March 2000): 19–34.

37 In discussion James D. Herbert and I have developed this concept of the "profound surface," which we each use for our own purposes. See Herbert, "Bad Faith at Coventry: Spence's Cathedral and Britten's *War Requiem,*" *Critical Inquiry* 25 (Spring 1999): 535–65.

CHAPTER ONE

1 Foulkes achieved the sharp edge of the mountain ridge from masking. Letter from Llyn Foulkes to author, 8 June 2004.

2 "Realism with Reverence," *Time,* 4 June 1951, 69.

3 As Sally Stein writes, "Edward Weston and Ansel Adams were featured in major 1930s exhibitions in New York, Chicago, and San Francisco, along with numerous smaller cities, and in these cosmopolitan venues their photographs offered contemporary views of California at its most sublime." Stein, "On Location: The Placement (and Replacement) of California in 1930s Photography," in *Reading California: Art, Image, and Identity, 1900–2000,* ed. Stephanie Barron, Sheri Bernstein, and Ilene Susan Fort (Los Angeles: Los Angeles County Museum of Art; Berkeley and Los Angeles: University of California Press, 2000), 171.

4 Other examples of twentieth-century landscape paintings of the West Coast can be found in Nancy Dustin Wall Moure, *California Art: 450 Years of Painting and Other Media* (Los Angeles: Dustin Publications, 1998). As she points out, however, California's "Golden Age of Landscape Painting" dates to the 1860s and 1870s. For paintings of the northern California landscape, see Steven A. Nash, ed., *Facing Eden: 100 Years of Landscape Art in the Bay Area* (San Francisco: Fine Arts Museums of San Francisco; Berkeley and Los Angeles: University of California Press, 1995). John Ott attributes the decline of sublime paintings of the western wilderness to the emergence of the auto-touristic landscape in the 1920s. Ott, "Landscapes of Consumption: Auto Tourism and Visual Culture in California, 1920–1940,"in *Reading California* (see note 3), 51–67.

5 Fidel A. Danieli, "Llyn Foulkes, Rolf Nelson Gallery," *Artforum* 2 (September 1963): 17.

6 Foulkes explains that, although he had been to Death Valley many times, the landscape in *Death Valley, USA* came entirely from the process of applying rags to wet paint. Letter from Foulkes to author, 8 June 2004.

7 See, for instance, Ben Maddow, *Edward Weston: His Life and Photographs* (Millerton, N.Y.: Aperture, 1973); Beaumont Newhall, *Supreme Instants: The Photography of Edward Weston* (Boston: Little, Brown, 1986); and Nancy Newhall, ed., *Edward Weston: The Flame of Recognition* (1965; reprint, New York: Grossman, 1971); Karen E. Quinn and Theodore E. Stebbins, Jr., *Weston's Westons: California and the West* (Boston: Museum of Fine Arts; Bullfinch Press, Little, Brown,

1994). This is not to say that earlier publications on Weston did not champion his close-up views of nudes and objects from the natural world but rather that they did not emphasize the photographs of Death Valley that exemplified a formalist aesthetic. See, for instance, Nancy Newhall, *The Photographs of Edward Weston* (New York: Museum of Modern Art, 1946).

8 Quinn and Stebbins, *Weston's Westons,* 24.

9 Amy Conger states that this picture was considered 'the real sensation' of Weston's first month's work. Her catalog of Weston's photographs from the collection of the Center for Creative Photography contains the complete list of where Weston's *Sunset over Panamints, Death Valley* was reproduced. Conger, *Edward Weston: Photographs* (Tucson: Center for Creative Photography, University of Arizona, 1992).

10 For cultural histories documenting changing attitudes toward the southwestern desert, see Anne Farrar Hyde, *An American Vision: Far Western Landscape and National Culture, 1820–1920* (New York: New York University Press, 1990); Patricia Limerick, *Desert Passages: Encounters with the American Deserts* (Albuquerque: University of New Mexico Press, 1985); Earl Pomeroy, *In Search of the Golden West: The Tourist in Modern America* (New York: Knopf, 1957). For promotional advertisements, movies, and novels set in Death Valley, see Richard E. Lingenfelter, *Death Valley and the Amargosa: A Land of Illusion* (Berkeley and Los Angeles: University of California Press, 1986), 441–67.

11 Ott, "Landscapes of Consumption," 64. All of Weston's photo-essays in *Seeing California with Edward Weston* had appeared in *Westways;* both were published by the Automobile Club of Southern California.

12 Federal Writers Project of the Works Progress Administration of Northern California, *Death Valley: A Guide* (Boston: Houghton Mifflin, 1939), 3.

13 Ansel Adams with Mary Street Alinder, *Ansel Adams: An Autobiography* (Boston: Little, Brown, 1985), 246.

14 Jonathan Spaulding, *Ansel Adams and the American Landscape: A Biography* (Berkeley and Los Angeles: University of California Press, 1995), 273. Nancy Newhall and Ansel Adams later published the book *Death Valley* (San Francisco: 5 Associates, 1963).

15 Ansel Adams and Nancy Newhall, "Death Valley," *Arizona Highways* 29 (October 1953): 33.

16 Spaulding, *Adams and the American Landscape,* 275.

17 "This popular attraction was viewed by an estimated 650,000 commuters and tourists every business day." Described in the Kodak Web site, "History of Kodak, Milestones 1933–1979."

18 Spaulding, *Adams and the American Landscape,* 232, 275.

19 For a discussion of the southwestern deserts and canyons as setting in westerns, especially those directed by John Ford, see Edward Buscombe, "Inventing Monument Valley: Nineteenth-Century Landscape Photography and the Western Film," in *Fugitive Images: From Photography to Video,* ed. Patrice Petro (Bloomington: Indiana University Press, 1995), 87–108.

20 For more on how *Sunset* promoted a regionally specific standard of architecture

for outdoor living, see Robert Alexander González, "*Sunset* Magazine: Setting Standards in the West," *Architecture California* 18 (1998): 52–59.

21 Kenneth Clark, *Landscape into Art* (Edinburgh: R. R. Clark, 1949), 134.

22 In the 1960s critics concluded that the handwriting on Foulkes's canvases dated to another era. For instance, Fidel A. Danieli refers "to the graphic and diagrammatic memorabilia" in Foulkes's canvases from this period. Danieli, "Llyn Foulkes," 17. Sidra Stich first identified the sentence as a variation of Grant's dedication with the assistance of Betty Factor, who along with her husband Monte, own this canvas. Stich, *Made in U.S.A.* (Berkeley and Los Angeles: University of California Press, 1987), 171–72.

23 John Coplans, "Three Los Angeles Artists," *Artforum* 1 (April 1963): 31; Danieli, "Llyn Foulkes," 17.

24 Anne Hammond, *Ansel Adams: Divine Performance* (New Haven: Yale University Press, 2002), 58, 61. In ch. 3 Hammond discusses the nineteenth-century western photographers admired by Adams, some of whom he even met. See too Mary Street Alinder, *Ansel Adams: A Biography* (New York: Henry Holt, 1996), 173–75.

25 Geoffrey Batchen makes the case that Szarkowski promoted a modernist formalist agenda comparable to that of Clement Greenberg. Batchen, *Burning with Desire: The Conception of Photography* (Cambridge, Mass.: MIT Press, 1997), 12.

26 Both Rosalind Krauss and Joel Snyder point out that very few of the survey photographs taken by Timothy O'Sullivan reached the general public in the nineteenth century, although, as Krauss states, some circulated as stereographs. Krauss, "Photography's Discursive Spaces: Landscape/View," *Art Journal* (Winter 1982): 311–19; Snyder, "Territorial Photography," in *Landscape and Power,* ed. W. J. T. Mitchell (Chicago: University of Chicago Press, 1994), 175–201.

27 Snyder, "Territorial Photography," 182–83.

28 Sally Stein argues that this short-lived organization, which was based in the San Francisco Bay area, was the most visible and vocal locus for straight photography in the United States. Stein, "On Location," 171.

29 Snyder, "Territorial Photography," 190–93. Adams also borrowed some of Jackson's negatives and made new prints for Photographs of the Civil War and the American Frontier. Alinder, *A Biography,* 175. Martha Sandweiss asserts, "In the 1930s, as historians first began to write a coherent linear story of the development of photography in the United States, the survey pictures garnered praise for two distinctive reasons: their value as an accurate historical record of the 'frontier scene,' and their contribution to what photohistorian Beaumont Newhall and photographer Ansel Adams argued was a uniquely American esthetic, emphasizing clear, straightforward description of the physical world." Sandweiss, *Print the Legend: Photography and the American West* (New Haven: Yale University Press, 2002), 183.

30 Even as the means of evaluation have shifted since the early 1960s, many continue, like Szarkowski, to trace a historical lineage of landscape photography that reaches its pinnacle of achievement in the work of Adams. As the photography historian Vicki Goldberg recently wrote: "He [Adams] was, in a sense, the last of the great nineteenth-century landscape photographers. Not only did he

profit from the aesthetic examples of photographers like Jackson and especially Watkins, but he seems to have shared their transcendentalism, their belief in the immanence of spirit in the landscape, their faith in the power of unspoiled nature." Goldberg, *The Power of Photography: How Photographs Changed Our Lives* (New York: Abbeville Press, 1991), 46–47.

31 Stein, "On Location," 175.

32 Nancy Newhall, *Ansel Adams: The Eloquent Light* (New York: Harper and Row, 1963), 13, 16.

33 Spaulding, *Adams and the American Landscape,* 129. I am indebted to Spaulding's careful and illuminating examination of Adams's relationship with the Sierra Club.

34 Ansel Adams, "Problems of Interpretation of the Natural Scene," *Sierra Club Bulletin* 30 (December 1945): 47–50.

35 Spaulding, "Yosemite and Ansel Adams: Art, Commerce, and Western Tourism," *Pacific Historical Review* 65 (November 1996): 636. *This Is the American Earth* sold approximately 25 thousand hardcover copies and 50 thousand paperback. Spaulding, *Adams and the American Landscape,* 313.

36 In the spring of 1933 Adams exhibited his photographs at Mills College Art Gallery in Oakland. When the new director of the M. H. de Young Museum in San Francisco decided to devote exhibits to photography in the early 1930s, Adams reviewed the exhibits and wrote a regular column on photography for *The Fortnightly.* That relationship between the photographer and city of San Francisco continued into the 1960s, when the de Young mounted a retrospective exhibition of Adams's photographs, the largest show to date of a single photographer's work ever held. This exhibit coincided with the publication of Newhall's biography, *Eloquent Light,* in 1963. See Hammond, *Divine Performance,* 77; Newhall, *Eloquent Light,* 74, 77; Spaulding, *Adams and the American Landscape,* 322. For a history of San Francisco's urban design, see Michael R. Corbett, "Rearranging the Environment: The Making of a California Landscape 1870s to 1990s," in *Facing Eden* (see note 4), 3–29.

37 Ansel Adams and Nancy Newhall, *Fiat Lux: The University of California* (New York: McGraw-Hill, 1968), 16.

38 Ott, "Landscapes of Consumption," 56.

39 Robert Bobrow, "Wilshire Boulevard," *Westways,* May 1964, 2 (emphasis mine).

40 Spaulding, *Adams and the American Landscape,* 247.

41 In its 2 November 1953 issue *Time* magazine published the "Amateur Photographer: Every Man His Own Artist" on its cover and championed photography as a national folk art.

42 Ansel Adams, "Creative Photography," *Art in America* 45 (Winter 1957 1958): 33.

43 Henry J. Seldis, "Camera Artistry of Ansel Adams," *Los Angeles Times,* 6 September 1964, 7.

44 Even in the Sierra Club itself, Adams's view of nature would come under fire during the 1960s, as Spaulding points out, when two views of nature clashed: "Where earlier generations of activists had confined their efforts to preserving limited segments of nature as "natural resources" and "scenic wonders," con-

servation after the Second World War began a transition to environmentalism—the effort to protect the health of biological systems as a whole." Spaulding, *Adams and the American Landscape*, 286.

45 The ground for such a contention was tilled by the exhibit Nature in Abstraction: The Relation of Abstract Painting and Sculpture to Nature in Twentieth-Century American Art, organized by John I. H. Baur at the Whitney Museum of American Art in 1958; the show singled out a tradition of American abstract art ostensibly inspired by nature, including works by Georgia O'Keeffe and Jackson Pollock. According to Baur, early modernism was an effort to distill and intensify the artist's experience of nature, while the Abstract Expressionists, consciously or unconsciously, identified with elemental rhythms of nature. Baur, *Nature in Abstraction: The Relation of Abstract Painting and Sculpture to Nature in Twentieth-Century American Art* (New York: Whitney Museum of American Art, 1958).

46 Robert Rosenblum, "The Abstract Sublime," *Art News* 59 (February 1961): 57–58.

47 Susan Landauer points out that Still "spent most of the war working in the Bay Area as a steel checker for the navy and an engineer for Hammond Aircraft, and Morley had given him his first museum exhibition at the San Francisco Museum of Art in 1943." Landauer, *The San Francisco School of Abstract Expressionism* (Berkeley and Los Angeles: University of California Press, 1996), 54.

48 Rosenblum, "Abstract Sublime," 39, 40.

49 Belle Krasne, " Still's Non-Objective Cartography," *The Art Digest* 24 (1 May 1950): 22; J. F., "Clyfford Still," *Art Digest* 25 (1 February 1951): 17; Hubert Crehan, "Clyfford Still: Black Angel in Buffalo," *Arts* 58 (December 1959): 60.

50 Crehan, "Clyfford Still: Black Angel in Buffalo," 60.

51 Rosenblum, "Abstract Sublime," 39. That the large-scale abstract canvases of Abstract Expressionism breathed new life into the sublime first captured in the romantic landscapes of the nineteenth century continues to have some resonance forty years later as demonstrated by John Updike's recent review of the exhibition American Sublime: Landscape Painting in the United States, 1820–1880, in which he asserts: "When one tries to think of twentieth century heirs of these landscapes, one nets a modest catch: John Marin's sketchy sea views, Marsden Hartley's glowering Maine Mountains, Arthur Dove's semi-abstract suns, Georgia O'Keeffe's parched mesas, eroded and orange and littered with cattle bones. Perhaps Edward Weston's desert photographs and the John Ford movies set in Monument Valley most directly inherit the vision of a dwarfed, ineffable, God-haunted Nature. The Sublime . . . was reborn in the mid-twentieth century in the oversize, utterly abstract work of Pollock and Kline, Motherwell and Still, Rothko and Newman." Updike, "O Beautiful for Spacious Skies," *New York Review of Books*, 15 August 2002, 28.

52 In my book *A Taste for Pop: Pop Art, Gender, and Consumer Culture* I explore this crisis in Abstract Expressionism at length in terms of anxieties about masculinity.

53 Biographical information on Foulkes can be found in Marilu Knode, *Llyn Foulkes: Between a Rock and a Hard Place* (Laguna Beach, Calif.: Laguna Art Museum, 1995); and Peter Selz, *Llyn Foulkes: The Sixties* (New York: Kent Art Gallery, 1987).

54 Linda S. Ferber, "Albert Bierstadt: The History of a Reputation," in *Albert Bierstadt: Art and Enterprise,* ed. Nancy K. Anderson and Linda S. Ferber (New York: Brooklyn Museum; Hudson Hills Press, 1991), 21.

55 Wanda Corn, "Historical Scholarship in American Art," *Art Bulletin* 70 (June 1988): 195. In the 1960s Gordon Hendricks penned the most substantive, and generally positive, scholarly analysis of Bierstadt's paintings. Hendricks, "The First of Three Western Journeys of Albert Bierstadt," *Art Bulletin* 46 (September 1964): 333–65.

56 Barbara Novak, *American Painting of the Nineteenth Century: Realism, Idealism, and the American Experience* (New York: Praeger, 1969), 94.

57 Peter Selz, "Llyn Foulkes' Works of the 1960s: Images of Disruption and Illusion," in *Llyn Foulkes,* 17.

58 Karen Current, *Photography and the Old West* (New York: Abrams, 1978), 31.

59 Richard N. Maestcllcr, "Western Views in Eastern Parlors: The Contribution of the Stereograph Photographer to the Conquest of the West," in *Prospects: The Annual of American Cultural Studies* 6 (New York: Burt Franklin, 1980), 59.

60 Beginning in the nineteenth century with Oliver Wendell Holmes's three-part essay on stereographs of 1859, published in *Atlantic Monthly,* many have described the stereograph and its spatial effects. More recent analyses include Jonathan Crary, *Techniques of the Observer: On Vision and Modernity in the Nineteenth Century* (Cambridge, Mass.: MIT Press, 1990); Edward W. Earle, ed., *Points of View: The Stereograph in America—A Cultural History* (Rochester, N.Y.: Visual Studies Workshop Press, 1979); Krauss, "Photography's Discursive Spaces"; and Goldberg, *Power of Photography.*

61 Selz, "Foulkes' Works of the 1960s," 17.

62 Anita Ventura, "Pop, Photo, and Paint," *Arts* 38 (April 1964): 51.

63 John Szarkowski, "Photography and the Mass Media," *Aperture* 13 (1967): 55–56.

64 Sandy Ballatore, "Llyn Foulkes: Commentary and Interview," *Los Angeles Institute of Contemporary Art Journal* 3 (December 1974): 16.

65 Editors of *Sunset* magazine and books, *Los Angeles: Portrait of an Extraordinary City* (Menlo Park, Calif.: Lane Magazine and Book, 1968).

66 *Portrait of an Extraordinary City,* 86.

67 As Sarah Whiting remarks, in analyzing the nature of the crowds depicted along the urban beach of Los Angeles, "From *Gidget* to *Beach Blanket Bingo,* the beach has been mythologized as a locus of equality; yet the public depicted is often curiously homogenous for such an ostensibly democratic place." Whiting, "Lines Drawn in Sand: The Public/Private Urban Beach," *ANY* 1 (July–August 1993): 48–53.

68 "Examiner Annual: Pictorial Southland, Southern California—The Golden Empire," *Los Angeles Examiner,* 2 January 1957, 30.

69 "The Mad Happy Surfers," *Life,* 1 September 1961, 47.

70 "No longer simply an athletic or poetic sensibility, it [surfing] had become a recognized sport and the basis for a marketable lifestyle as well as a new esthetic," writes Timothy White in his exhaustive biography of the Beach Boys. White,

The Nearest Faraway Place: Brian Wilson, the Beach Boys, and the Southern California Experience (New York: Henry Holt, 1994), 117.

71 Susan Larsen, "A Conversation with Vija Celmins," *Los Angeles Institute of Contemporary Art Journal* 20 (October–November 1978): 38.

72 Larsen, "Conversation with Celmins," 38.

73 Neil Armstrong, after setting foot on the moon in 1968, made this comment, broadcast widely at the time on television and radio: "It has a stark beauty all on its own . . . it's much like the high desert of the United States."

74 Melinda Wortz, "Vija Celmins' Graphics," *Artweek* 6 (29 November 1975): 3.

75 John Coplans, *Ten from Los Angeles* (Seattle: Seattle Art Museum, 1966), 9.

76 Jerry McMillan explains that when Coplans invited him to design the catalog *West Coast, 1945–1969,* he decided on an image to fit the show's title and photographed the West Coast right at its very edge. McMillan in phone conversation with author, 11 June 2004.

CHAPTER TWO

1 Hopper's collection was featured in an article by Terry Southern, "The Loved House of the Dennis Hoppers," *Vogue,* 1 April 1965, 138–42, 153, 162, 164.

2 Caroline A. Jones discusses the Romantic trope in photographs of the artist in *Machine in the Studio: Constructing the Postwar American Artist* (Chicago: University of Chicago Press, 1996), 20–41.

3 My thanks to Ed Halter, director of the New York Underground Film Festival, for pointing out how Ruscha's advertisement resonated with posters for sexploitation films. Robert Sklar discusses the movie industry's attempt, facing increasing competition from television, to corner a market by featuring more sex and violence. Sklar, *Movie-Made America: A Cultural History of American Movies* (New York: Vintage Books, 1975). Commentators in the 1960s cited movies in general, not just sexploitation films, as evidence of new sexual permissiveness. See, for instance, "Anything Goes: Taboos in Twilight," *Newsweek,* 13 November 1967, 74–78. In *The Erotic Revolution* Lawrence Lipton implies that unmarried sex takes place primarily on college campuses. Lipton, *The Erotic Revolution: An Affirmative View of the New Morality* (Los Angeles: Sherbourne Press, 1965). The book *Sex in the '60s* drew a connection between the new morality on college campuses and the lifestyle of the postgraduate or "swinger." Joe David Brown, ed., *Sex in the '60s: A Candid Look at the Age of Mini-morals* (New York: Time-Life Books, 1968).

4 Peter Plagens, for instance, asked whether Ruscha "is only 'just as good as' Warhol/Oldenburg in his knife-edge banality, or whether he's a lighthearted Hollywood gadfly." Plagens, "Before What Flowering? Thoughts on West Coast Art," *Artforum* 11 (September 1973): 34. Similarly, David Bourdon wrote of Ruscha, "In both his work and personal manner, he appears to be a sort of cowboy Magritte gone Hollywood." Bourdon, "A Heap of Words about Ed Ruscha," *Art International* 15 (20 November 1971): 25.

5 Jay Belloli, "Pop Art: Europe, N.Y., L.A.," in *L.A. Pop in the Sixties,* ed. Anne Ayres (Newport Harbor: Newport Harbor Art Museum, 1989), 39.

6 My thanks to David Joselit for encouraging me to think about Ruscha's persona in contrast to Warhol and Hockney.

7 My thanks to Ed Halter, who related the proportions of Ruscha's Hollywood canvas to Cinemascope. For a description of Cinemascope, see Ira Konigsberg, *The Complete Film Dictionary* (New York: Penguin, 1997), 56. The standard widescreen ratio is 1.33:1.

8 Course catalog, from the Chouinard archives, located at the the California Institute of the Arts. My thanks to Coco Halverson for making the Chouinard Archives available to me.

9 Ed Ruscha speaking in a film on the artist by Gary Conklin, produced by Mystic Fire Video in 1981.

10 Carol Armstrong, "Diane Arbus: A House on a Hill, Hollywood, Cal. 1963," *Artforum* 38 (November 1999): 123.

11 Joan Didion, *Slouching Towards Bethlehem* (New York: Dell, 1968), 220.

12 In November 1965, barely eight months after the museum opened, its director, Richard F. Brown, resigned to become director of the Kimbell Art Museum in Fort Worth, Texas. In an unusually nasty and public exchange, Brown charged the trustees with meddling in the operations of the museum, while the trustees accused him of administrative incompetence. The fire in Ruscha's canvas could allude to the battle that erupted over the Kienholz exhibition in 1966, when the County Board of Supervisors, having viewed *Back Seat Dodge '38*, tried to censor the show. My thanks to Grant Rusk for making the Los Angeles County Museum of Art Archives available to me. The painting was certainly understood at the time as a possible critique of the museum's institutional politics, if not its architecture, as is evident from an article illustrated by a preliminary sketch for Ruscha's image that raised the question: S. J. Diamond, "Should We Set Fire to the Art Museum?" *Los Angeles Magazine,* March 1968, 30, 67–69.

13 Ed Ruscha, box 1, folder 34, series II, transcripts of interviews with artists, critics, dealers, ca. 1962–1989, Barbara Rose Papers, Special Collections, Getty Research Library, Los Angeles.

14 Dave Hickey, "Available Light," in *The Works of Edward Ruscha,* ed. Henry T. Hopkins (San Francisco: San Francisco Museum of Modern Art, 1982), 24.

15 My thanks to Patrick Andersson for suggesting this point to me.

16 Reyner Banham, *Los Angeles: The Architecture of Four Ecologies* (London: Penguin Books, 1971), 240.

17 Jack Flam writes about Diebenkorn's fascination with aerial views of the landscape in his monograph, *Richard Diebenkorn: Ocean Park* (New York: Rizzoli, 1992).

18 In 1977 Ruscha was invited by the Eyes and Ears Foundation to display a work on billboard space donated by Foster and Kleiser, National and Pacific Outdoor Advertising.

19 Tom Wolfe, "There goes (VAROOM! VAROOM!) that Kandy Kolored (THPHHH-HHH!) tangerine-flake streamline baby (RAHGHHHH!) around the bend (BRUM-MMMM . . .)," *Esquire,* November 1963. Wolfe, *The Kandy-Kolored Tangerine-Flake Streamline Baby* (New York: Farrar, Straus and Giroux, 1965).

20 Pat Ganahl, "Direct Descent: Von Dutch to Robert Williams," in *Kustom Kul-*

ture: Von Dutch, Ed "Big Daddy" Roth, Robert Williams and Others, ed. C. R. Ste-cyk with Bolton Colburn (Laguna Beach, Calif.: Laguna Art Museum; Last Gasp of San Francisco, 1993), 8.

21 For an example of a review issued from the motorcycle industry, see "Brush-Strokes of a 4-Stroke," *Motorcyclist,* February 1962, 20.

22 "Artists Take to the Place, Wide Open and Way Out," *Life,* 19 October 1962, 84.

23 Judy Chicago, *Through the Flower: My Struggle as a Woman Artist* (New York: Doubleday, 1975), 36.

24 Chicago, *Through the Flower,* 36–37.

25 Anger's prospectus for the film is published in P. Adams Sitney, *Visionary Film: The American Avant Garde* (New York: Oxford University Press, 1974), 125.

26 Gerald Silk, "Ed Kienholz's 'Back Seat Dodge '38,'" *Arts* 52 (January 1978): 112. Robert L. Pincus has a slightly different story: He says the car door was opened by a guard every fifteen minutes. Pincus, *The Art of Edward and Nancy Reddin Kienholz* (Berkeley and Los Angeles: University of California Press, 1990), 33.

27 Pincus, *Art of Edward and Nancy Reddin Kienholz,* 32–33.

28 Banham, *Architecture of Four Ecologies,* 213.

29 The population of Los Angeles County grew from 3,365,000 in 1945 to 6,664,000 in 1965. U.S. Bureau of the Census. California grew from 6.9 million in 1940 to 15.7 million in 1962. Michael Dear, "Peopling California," in *Made in California: Art, Image, and Identity, 1900–2000,* ed. Stephanie Barron, Sheri Bernstein, and Ilene Susan Fort (Los Angeles: Los Angeles County Museum of Art; Berkeley and Los Angeles: University of California Press, 2000), 58.

30 "Another Skyscraper for Los Angeles," *Los Angeles Times,* 17 December 1965, in Architecture and Urban Planning Archives, collection 1180, box 1, Los Angeles City Planning Folder, Special Collections, University Library, UCLA.

31 Richard G. Lillard, *Eden in Jeopardy* (New York: Knopf, 1966), 4–13.

32 Nathanael West, *The Day of the Locust* (New York: Vail-Ballou Press, 1939), 166.

33 The catalog for the exhibition at the Fraser Gallery, which took place between 31 January and 19 February 19, 1966, contains an essay by John Coplans to introduce the show. By stating that the seven artists in the exhibit "are not only a segment of a larger and denser core of activity originating within the area, but they are also without stylistic unity," Coplans would seem to interpret the title, "Los Angeles Today," in only one way—as presenting artists active in contemporary Los Angeles. The format of the catalog, however, includes a number of photographs by Dennis Hopper of Los Angeles and of artists juxtaposed with commercial signage. The catalog and the exhibit, thus, not only introduced a British audience to a small group of Angeleno artists, but also presented a particular view of the urban landscape of Los Angeles.

34 My thanks to the anonymous reader who suggested these connections to the nineteenth-century flaneur. The literature on the flaneur is extensive. Several key texts include Charles Baudelaire, *The Painter of Modern Life and Other Essays* trans. and ed. Jonathan Mayne (London: Phaidon, 1964); and Walter Benjamin, "On Some Motifs in Baudelaire," *Illuminations* (New York: Schocken Books, 1969), 155–94. A crucial essay that first rethought the flaneur from a feminist

perspective was Janet Wolff, "The Invisible Flaneuse: Women and the Literature of Modernity," *Theory Culture and Society* 2 (1985): 37–48.

35 John Coplans, "Edward Ruscha Discusses His Perplexing Publications," *Artforum* 3 (February 1965): 25.

36 I am indebted to David Bourdon for the technical description of how Ruscha's books were photographbed and collated. Bourdon, "Ruscha as Publisher [or All Booked Up]," *Art News* 71 (April 1972): 32–36. See also Clive Phillpot, "Sixteen Books and Then Some," in *Edward Ruscha: Editions, 1959–1999: Catalogue Raisonné*, ed. Siri Engberg and Clive Phillpot (Minneapolis: Walker Art Center, 1999), 58–78.

37 My thanks to David Joselit who in a response to a talk I gave in the Getty Works in Progress series in May 2000 pointed out that the series of parking lots or the sequential portrait of every facade on the Sunset strip propose two abstract formats for L.A. urbanism: the grid or typology on the one hand, and the narrative or syntagmatic sequence on the other. Though my conclusion about the narrative differs, his comments inspired me to pursue this line of analysis.

38 I am indebted to Richard Marshall's exhibition catalog, *Edward Ruscha: Los Angeles Apartments,* for its insightful comparisons between Ruscha's photographs and drawings of dingbats and photographs, many by Julius Shulman, of apartment buildings by famous architects. Marshall, *Edward Ruscha: Los Angeles Apartments 1965* (New York: Whitney Museum of American Art, 1990).

39 Ezra Stoller, "Photography and the Language of Architecture," *Perspecta* 8 (1963): 43–44. My thanks to Eugene J. Johnson for directing me to Stoller's photographs.

40 "Stoller's view of color photography is that it often imposes a gaudy unreality that is paradoxically more unreal than the obvious unreality of black and white." William S. Saunders, *Modern Architecture: Photographs by Ezra Stoller* (New York: Abrams, 1990), 214.

41 "Stoller would wait for the environmental conditions that most effectively complemented the building." Robert A. M. Stern, Thomas Mellins, and David Fishman, eds., *New York 1960* (New York: Monacelli Press, 1995), 1170. Andy Grundberg points out that Stoller not only carefully selected his camera angle but also darkened skies with filters to throw the sides of buildings into high relief and used long exposures to eliminate pedestrians. Grundberg, "Lies for the Eyes," *Soho Weekly News,* 17 December 1980, 28.

42 Paul Goldberger, "Architecture: Portraits by Ezra Stoller," *New York Times,* 26 December 1980, C20; "Photographer Ezra Stoller Is the Subject of an Exhibition at New York's Max Protetch Gallery," *Architectural Record* 168 (December 1980): 35; Stern, Mellins, and Fishman, *New York 1960,* 1170.

43 Stern, Mellins, and Fishman, *New York 1960,* 1170.

44 Marshall explains: "Dingbats . . . are typically two-story walk-up structures with a side-loaded exterior corridor and exterior circulation. Usually a boxy rectangle of wood construction with stuccoed exterior walls, these 1960s apartments display an eccentric, embellished, cheap, and often ridiculous version of the pure Modern style exemplified by Neutra and Schindler." Marshall, *Los Angeles Apartments 1965,* 11.

45 Robert Bobrow, "Up in the Air, Over the City," *Westways,* May 1963, 4–5.

46 Eleanor Antin, "Reading Ruscha," *Art in America* 61 (November–December 1973): 66.

47 On rail travel and western photography, see Jennifer A. Watts and Claudia Bohn-Spector, *The Great Wide Open: Panoramic Photographs of the American West* (London: Merrell, 2001), 34–41.

48 Kerry Brougher, "Words as Landscape," in *Ed Ruscha,* ed. Kerry Brougher (Washington, D.C.: Hirshhorn Museum and Sculpture Garden, 2000), 157–59.

49 Dorothea Lange and Paul Taylor, *An American Exodus: A Record of Human Erosion* (New York: Reynal and Hitchcock, 1939).

50 Kevin Lynch, *The Image of the City,* Publications of the Joint Center for Urban Studies (Cambridge, Mass.: Technology Press, 1960), 41. Donald Appleyard writes that "more than any other work, [*The Image of the City*] initiated what has become a flourishing and significant new field of activity in planning and design, the study of environmental psychology, relating the physical environment to human behavior." Appleyard, "The Major Published Works of Kevin Lynch, An Appraisal," *Town Planning Review* 49 (October 1978): 552.

51 Lynch, *Image of the City,* 40.

52 Steven Pile, *The Body and the City: Psychoanalysis, Space and Subjectivity* (New York: Routledge, 1996), 25.

53 Deborah Fausch, "Ugly and Ordinary: The Representation of the Everyday," in *Architecture of the Everyday,* ed. Steven Harris and Deborah Berke (New York: Princeton Architectural Press, 1997), 96.

54 Denise Scott Brown, "On Pop Art, Permissiveness, and Planning," *Journal of the American Institute of Planners* 35 (May 1969): 184–86.

55 Robert Venturi, Denise Scott Brown, and Steven Izenour, *Learning from Las Vegas* (Cambridge, Mass.: MIT Press, 1972), ix.

56 Michael Golec carefully examines the design and graphics of *Learning from Las Vegas* in his "'Doing It Deadpan': Venturi, Scott Brown and Izenour's Learning from Las Vegas," *Visible Language* 37, no. 3 (2003): 266–87. The entire issue of the journal is devoted to this book.

57 Venturi, Scott Brown, and Izenour, *Learning from Las Vegas,* 4.

CHAPTER THREE

1 Hockney states, "I came home slightly drunk one evening and saw an advertisement on television which said that blondes have more fun." Hockney quoted in David Bailey and Peter Evans, *Goodbye Baby & Amen: A Saraband for the Sixties* (New York: Coward-McCann, 1969), 47. The actual jingle was "Is it true blondes have more fun?" For an interesting account of the Clairol advertising campaigns, see Malcolm Gladwell, "True Colors," *New Yorker,* 22 March 1999, 70–81.

2 Simon Faulkner points out that the gold lamé jacket was popularized by the rock-and-roll stars of the 1950s and notes that Hockney's bleached hair and stylish clothes undercut the affiliation with working-class masculinity from northern

England his accent suggested. Faulkner, "Dealing with Hockney," in *David Hockney*, ed. Paul Melia (Manchester: Manchester University Press, 1995), 16, 20–23.

3 Bailey and Evans, *Goodbye Baby & Amen,* 47.

4 Dickran Tashjian, "A Hotbed of Advanced Art," in *A Hotbed of Advanced Art: Four Decades of Visual Arts at UCI* (Irvine, Calif.: The Art Gallery, 1997), 6. The new boutiques on Carnaby Street had, as David Mellor points out, a "'modernist' and 'ted' clientele [and] they also catered for and shaped patterns of homosexual dress tastes." Mellor, *The Sixties: Art Scene in London* (London: Barbican Art Gallery, 1993), 120.

5 Valerie Wade, "The Annual David Hockney Interview," *Andy Warhol's Interview* 3 (July 1973): 20. Paul Melia points out that despite the fact that a network of meeting places for homosexuals existed in London in the early 1960s, gay men of Hockney's generation often sought out New York and Berlin with their flourishing subcultures. Hockney visited both cities before going to Los Angeles. Melia, "Showers, Pools and Power," in *David Hockney* (see note 2), 51–52.

6 Kenneth E. Silver, as far as I know, was the first to analyze the homoerotics of Hockney's California canvases in a talk, "Belated Notes on Camp" presented at the College Art Association in 1986. See Silver, *David Hockney* (New York: Rizzoli Art Series, 1994); and Silver, "Master Bedrooms, Master Narratives: Home, Homosexuality and Post-War Art," in *Not at Home: The Suppression of Domesticity in Modern Art and Architecture,* ed. Christopher Reed (London: Thames and Hudson, 1996), 206–21. More recently, other important texts on the gay politics of Hockney's art have included Melia, *David Hockney;* Ulrich Luckhardt and Paul Melia, *David Hockney* (Munich: Prestel, 1994); and Jonathan Weinberg, "A Rake Progresses: David Hockney and Late-Modernist Painting," in *Famous Artists: Essays on Ambition and Love in Modern American Art* (New Haven: Yale University Press, 2001). In recent talks Richard Meyer has analyzed the photographs in *Physique Pictorial* that served as sources for David Hockney's paintings from the 1960s.

7 Robert Hughes, "Blake and Hockney," *London Magazine,* January 1966, 72; and Mario Amaya, *Pop Art and After: A Survey of the New Super-Realism* (New York: Viking Press, 1966), 118.

8 Only a couple of American critics reviewed Hockney's art in the 1960s. Even Vivien Raynor, who detected in Hockney's paintings "humorous-innocent remarks on the Western American life and landscape," did not take the work very seriously. Raynor, "David Hockney," *Arts* 39 (November 1964): 61.

9 Hughes, "Blake and Hockney," 72.

10 Christopher Salvesan, "David Hockney's California," *Listener,* 23 April 1970, 565.

11 Hockney comments that most of the collectors he met were women, in *My Early Years: David Hockney,* ed. Nikos Stangos (New York: Abrams, 1975), 103.

12 Paul Grinke, "Love and Friendship," *Spectator,* 11 April 1970, 489.

13 Dick Hebdige examines changes in British cultural and social life after World War II, focusing on how debates about popular culture and taste in England reflected a perceived threat posed by American mass culture to British social

hierarchies. See, in particular, his essays, "Towards a Cartography of Taste 1935–1962," and "In Poor Taste: Notes on Pop," both of which are reprinted in his book, *Hiding in the Light* (London: Routledge, 1988).

14 Reyner Banham, *Los Angeles: The Architecture of Four Ecologies* (London: Penguin Books, 1971), 238.

15 Banham, *Architecture of Four Ecologies,* 237.

16 As Anthony Vidler points out—in his preface to the latest edition of *Architecture of Four Ecologies* (Berkeley and Los Angeles: University of California Press, 2000), xvii—"the book was immediately embraced as a new and fresh look at a city that had for many decades defied the attempts of visitors and residents to characterize it in any unified sense, it was also a book written by a British architectural historian with a declared mission to revise the way in which the history of buildings and cities had traditionally been written."

17 In 1971, reviewers of Banham's *Architecture of Four Ecologies* included Alastair Beal in *Design* 268 (April 1971): 92; John Donat in *R.I.B.A. Journal* 78 (May 1971): 218; J. F. H. Sergeant in *Town Planning Review* 42 (July 1971): 314–16; Esther McCoy in *Progressive Architecture* 52 (October 1971): 50; and John S. Margolies in *Architectural Forum* 135 (November 1971): 10, 23. They continued throughout 1972, with Archie McNab, "Almost the Centre of the World," *Architectural Design* 42 (February 1972): 121; Peter Self, "Los Angeles: All Our Futures or America's Past?" *Town and Country Planning* 40 (March 1972): 173–75; Geoffrey Wickham, "Los Angeles," *Art and Artists* 7 (May 1972): 57; and Peter Plagens, "Los Angeles: The Ecology of Evil," *Artforum* 11 (December 1972): 67–76. One critic, however, presuming that Hockney's paintings did indeed apprehend the drawbacks to Los Angeles, praised *A Bigger Splash* for revealing that which Banham's enthusiasm for the city apparently ignored, interpreting the case-study cottage in Hockney's painting "as a symbol of affluent solitude." William Ellis, "On Reyner Banham's *Los Angeles: The Architecture of Four Ecologies,*" *Oppositions* 2 (January 1974): 79.

18 Hockney states in his autobiography that he did meet the artists affiliated with the California Pop art scene, and that he even went to Barnie's Beanery. Hockney, *My Early Years,* 98.

19 Hockney quoted in Guy Brett, "David Hockney: A Note in Progress," *London Magazine,* April 1963, 73. Brett also points out that Hockney refused to appear in a film about Pop art produced in England.

20 Mike Davis, *City of Quartz: Excavating the Future in Los Angeles* (New York: Vintage Books, 1992), 22.

21 Melia, "Showers, Pools and Power," 50–67; the quotation is from p. 67.

22 Mark Glazebrook, *David Hockney Paintings, Prints and Drawings, 1960–1970* (London: Whitechapel Art Gallery, 1970), 11.

23 Robert Wennersten, "Hockney in L.A.," *London Magazine,* August–September 1973, 35.

24 John Rechy, *City of Night* (1963; New York: Grove Press, 1984), 87.

25 David Hockney, "Painting with Two Figures," *Cambridge Opinion* 37 (Spring 1964): 57–58. His statement about his illustrations of Cavafy's poetry mentions homo-

sexuality, but only to point out the ways in which the poetry is old-fashioned in its reference to sexuality. See "Colin Self and David Hockney Discuss Their Recent Work," *Studio International* 176 (December 1968): 178.

26 J. Montgomery Hyde, *The Love That Dared Not Speak Its Name* (Boston: Little, Brown, 1970).

27 Though Hockney starred in Hazan's movie, he later disavowed the project, perhaps discomfited by the one-to-one correspondence it posited between painting and life. Hockney confessed, "When I saw it I was stunned and shattered, partly because it was like living through the . . . there is something very real about it." Hockney, *My Early Years,* 286.

28 Marco Livingstone, *David Hockney* (New York: Holt, Rinehart and Winston, 1981), 10–11.

29 Hockney, *My Early Years,* 151–52.

30 Hockney, *My Early Years,* 93.

31 "The Great Indoors," *Vogue,* December 1968, 92, 94–95.

32 The Beach Boys went collegiate in the mid-1960s.

33 Kenneth Clark, *The Nude: A Study in Ideal Form* (New York: Pantheon Books, 1953), 356. See also Abigail Solomon-Godeau, *Male Trouble: A Crisis in Representation* (New York: Thames and Hudson, 1997).

34 Peter Webb, *The Erotic Arts* (Boston: New York Graphic Society, 1975), 377. Hockney goes into furthur detail about the nude model, with the same misogynistic tone, in *My Early Years,* 88.

35 See Wayne E. Stanley, introduction to *The Complete Reprint of Physique Pictorial,* vol. 1, *1951–1960* (Cologne: Taschen, 1997).

36 This image was published in Penelope Curtis, ed., *David Hockney: Paintings and Prints from 1960* (London: Tate Gallery, 1993), 25.

37 Curtis, *Paintings and Prints from 1960,* 26.

38 Richard Meyer, "Warhol, Hockney and the Secret of Physique Photography" (paper delivered at "Media Pop," Getty Research Institute, 6–7 April 2001).

39 Hockney, *My Early Years,* 151.

40 Rechy, *City of Night,* 88.

41 John Rechy, *Numbers* (1967; New York: Grove Press, 1984), 30, 161.

42 Christopher Rand, *Los Angeles: The Ultimate City* (New York: Oxford University Press, 1967), 146.

43 Robert Carringer writes, "Richard Sylbert, production designer on the film, confirms that this image was deliberately intended to stand metonymically for Los Angeles as a whole." Carringer, "Hollywood's Los Angeles: Two Paradigms," in *Looking for Los Angeles,* ed. Charles G. Salas and Michael S. Roth (Los Angeles: Getty Research Institute Publications, 2001), 251–52.

44 Silver, "Master Bedrooms," 219.

45 Thomas Waugh refers to one Mizer photograph "that was taken to demonstrate 'intent to exhibit partial erections' through the mails." Waugh, "Photography, Passion, and Power," *Body Politic* 101 (March 1984): 30. On *Physique Pictorial* see

also Waugh's "Gay Male Visual Culture in North America During the Fifties: Emerging from the Underground," *Parallelogramme* 12 (1986): n.p.

46 Richard Meyer, *Outlaw Representation: Censorship and Homosexuality in Twentieth-Century American Art* (New York: Oxford University Press, 2002), 165.

47 Christopher Isherwood, *A Single Man* (New York: North Point Press, 1996), 12.

48 Isherwood, *Single Man*, 29.

49 Rechy, *City of Night*, 21.

50 Hockney, *My Early Years*, 97.

51 Ridgeley Cummings, "Pershing Square Is Defoliated," *L.A. Free Press*, 3 September 1964, front page.

52 Rechy, *Numbers*, 27.

53 Meyer, "Warhol, Hockney and Physique Photography." Thomas Waugh explains, "full frontal nudes only became systematically available over the counter around 1966, after a set of crucial court decisions." Waugh, "Classical Ideals: From the Temple to the Weightroom," *Body Politic*, March 1984, 30.

54 *Physique Pictorial*, which Bob Mizer began to publish in 1951, was affiliated with the Athletic Model Guild founded by Mizer in Los Angeles in 1945. Stanley, introduction to *Complete Reprint*, 6, 15.

55 The source for *Man Taking Shower in Beverly Hills* was published in Curtis, *Paintings and Prints from 1960*, 25.

56 Paul Melia points out the reference to Dubuffet's *Hourloupe* series, in Luckhardt and Melia, *David Hockney*, 76. My thanks to Ruth Phillips for bringing my attention to Emilio Pucci's fashion designs. On Pucci, see Mauriucca Casadio, *Emilio Pucci* (New York: Universe, 1998).

57 Hockney, *My Early Years*, 104.

58 Banham, *Architecture of Four Ecologies*, 238.

59 Livingstone, *David Hockney*, 111.

60 See, for instance, David Gebhard and Robert Winter, *A Guide to Architecture in Southern California* (Los Angeles: Los Angeles County Museum of Art, 1965); and Esther McCoy, *Modern California Houses* (New York: Reinhold, 1962).

61 As Lisa A. Goodgame points out, Julius Shulman, the leading photographer of modern architecture in southern California, pictured eighteen of the twenty-six completed houses for the case-study house program initiated by John Entenza, editor of *Arts and Architecture*. Goodgame, "Reinterpretations of Modernism, Shulman Style," in *L.A. Obscura: The Architectural Photography of Julius Shulman* (Los Angeles: Fisher Gallery, 1998), 21. Joseph Rosa suggests that Shulman self-consciously composed his photographs to draw attention to the formal aspects of the architecture that he was depicting. Rosa, *A Constructed View: The Architectural Photography of Julius Shulman* (New York: Rizzoli, 1994), 69. An indispensable text on the history of the case-study houses is Elizabeth A. T. Smith, *Blueprints for Modern Living: History and Legacy of the Case Study Houses* (Los Angeles: Museum of Contemporary Art, Los Angeles; Cambridge, Mass.: MIT Press, 1989). See also Lesley Jackson, *Contemporary Architecture and Interiors of the 1950s* (London: Phaidon Press, 1994).

62 Rosa, *Constructed View,* 76.

63 Sally Stein, "The Rhetoric of the Colorful and the Colorless: American Photography and Material Culture between the Wars" (Ph.D. diss., Yale University, 1991).

64 Hockney, *My Early Years,* 100, 101.

65 David Batchelor, *Chromophobia* (London: Reaktion Books, 2000), 62.

66 Hockney recounted, "So I rolled it [*A Bigger Splash*] on with rollers, and the splash itself is painted with small brushes and little lines." Hockney, *My Early Years,* 124.

67 This passage from David Hockney's autobiography is cited in Curtis, *Paintings and Prints from 1960,* 25. Note that cultural critics in the United States expressed a particular antipathy to the color pink as emblematic of the worst of middlebrow taste. William L. Bird, Jr., *Paint by Number* (Washington, D.C.: Smithsonian Institution, National Museum of American History; New York: Princeton Architectural Press, 2001), 62.

68 Jeffrey Kipnis, "The Cunning of Cosmetics," *El Croquis* 84 (1977): 26.

CHAPTER FOUR

1 For all factual information about the Watts Towers, I have relied on Bud Goldstone and Arloa Paquin Goldstone, *The Los Angeles Watts Towers* (Los Angeles: Getty Conservation Institute / J. Paul Getty Museum, 1997). Another important text that offers insight into the way race and urban politics shaped perceptions of the Watts Towers, including the shift in its reputation from work of art to symbol of the black community, is Sarah Schrank, "Picturing the Watts Towers: The Art and Politics of an Urban Landmark," in *Reading California: Art, Image, and Identity, 1900–2000,* ed. Stephanie Barron, Sheri Bernstein, and Ilene Susan Fort (Los Angeles: Los Angeles County Museum of Art; Berkeley and Los Angeles: University of California Press, 2000), 373–86. The most comprehensive article about Rodia's towers from the 1960s is Calvin Trillin, "I Know I Want to Do Something," *New Yorker,* 29 May 1965, 72–120. See also Leon Whiteson, *The Watts Towers* (New York: Modaic Press, 1989).

2 Goldstone and Goldstone, *Los Angeles Watts Towers,* 80–81.

3 "Flashing Spires Built as Hobby," *Los Angeles Times,* 13 October 1937, pt. 2, p. 2.

4 "Immigrant Builds Towers to Show His Love for U.S.," *Los Angeles Times,* 8 June 1952, pt. 1A, p. 26.

5 Julia M. Sloane, quoted by Carey McWilliams, *Southern California Country: An Island on the Land* (New York: Duell, Sloan and Pierce, 1946), 110. Sloane, *The Smiling Hill-Top, and Other California Sketches* (New York: Scribner, 1920). Although news reporters heralded Rodia's towers as an example of immigrant self-fulfillment, Rodia, as John Beardsley points out, never achieved financial stability, much less wealth; nor did he ultimately assimilate, for he spoke broken English his entire life. Beardsley instead interprets the Watts Towers as manifesting a desire for physical or spiritual deliverance on the part of someone who was severely disadvantaged. Beardsley, *Gardens of Revelation: Environments by Visionary Artists* (New York: Abbeville Press, 1995), 163, 169.

6 "Flashing Spires Built as Hobby," *Los Angeles Times,* 13 October 1939, pt. 2,

p. 2; "Immigrant Builds Towers to Show His Love for U.S.," *Los Angeles Times,* 8 June 1952, pt. 1A, p. 26.

7 On the *Los Angeles Times,* at that time a forum for Republican boosters, see Mike Davis, *City of Quartz: Excavating the Future in Los Angeles* (New York: Verso, 1990); and Dennis McDougal, *Privileged Son: Otis Chandler and the Rise and Fall of the L.A. Times Dynasty* (Cambridge, Mass.: Perseus, 2001).

8 Lee Shippey, introduction to *Nuestro Pueblo: Los Angeles, City of Romance* (Boston: Houghton Mifflin, 1940), xi.

9 Shippey, introduction to *Nuestro Pueblo,* xi.

10 Joseph Seewerker, "Glass Towers and Demon Rum," in *Nuestro Pueblo,* 56.

11 McWilliams, *Southern California Country,* 83. For the role of visual culture in promoting both booster and antibooster myths about California, see Stephanie Barron, Sheri Bernstein, and Ilene Susan Fort, eds., *Made in California: Art, Image, and Identity, 1900–2000* (Los Angeles: Los Angeles County Museum of Art; Berkeley and Los Angeles: University of California Press, 2000).

12 McWilliams, *Southern California Country,* 369–70.

13 Kevin Starr, "Carey McWilliams's California: The Light and the Dark," in *Reading California* (see note 1), 16. On McWilliams, see also Kerwin L. Klein, *Apocalypse Noir: Carey McWilliams and Posthistorical California,* Morrison Library Inaugural Address series 1079–2732, no. 7 (Berkeley: Doe Library, University of California, 1997), 5–34.

14 For other examples of urban realist paintings by Los Angeles artists, see David Stary-Sheets, *California Style 1930s and 40s* (Sebastopol, Calif.: Sebastopol Center for the Arts, 1997).

15 Blake Allmendinger, "All about Eden," in *Reading California,* 113–26. See also Davis, *City of Quartz,* 36–54; and David Fine, ed., *Los Angeles in Fiction* (Albuquerque: University of New Mexico Press, 1984).

16 The other two are *A Place in the Sun,* by Frank Fenton, and *The Boosters,* by Mark Lee Luther. McWilliams, *Southern California Country,* 364.

17 Edward Dimendberg, *Film Noir and the Spaces of Modernity* (Cambridge, Mass.: Harvard University Press, 2004), 151. Norman M. Klein, *The History of Forgetting: Los Angeles and the Erasure of Memory* (New York: Verso, 1997), 51.

18 Robert Carringer, "Hollywood's Los Angeles: Two Paradigms," in *Looking for Los Angeles: Architecture, Film, Photography, and the Urban Landscape,* ed. Charles G. Salas and Michael S. Roth (Los Angeles: Getty Research Institute, 2001), 248.

19 Dimendberg, *Film Noir,* 151–52, 159.

20 Schrank, "Picturing the Watts Towers," 376.

21 Jules Langsner, "Los Angeles," *Art News* 58 (September 1959): 49.

22 Henry J. Seldis, "Watts Towers in Need of Aid: City Threatens Demolition of Rodilla's *[sic]* Work of Art," *Los Angeles Times,* 5 July 1959, pt. 5, p. 8.

23 "In 1959 when the towers' demolition seemed imminent, delegates from fifteen nations attending the Eleventh Assembly of the International Association of Art Critics passed a resolution [in support of the Watts Towers]. . . . Joining the international chorus of concern, New York's Museum of Modern Art champi-

oned the towers in a telegram." Goldstone and Goldstone, *Los Angeles Watts Towers*, 3–4.

24 Jules Langsner, "Fantasy in Steel, Concrete, and Broken Bottles," *Arts and Architecture* 76 (September 1959): 27.

25 On the discovery of folk art by modern artists in the 1920s and the way in which they cast folk art as the indigenous source of American modernism, see in particular Virginia Tuttle Clayton, Elizabeth Stillinger, and Erika Doss, *Drawing on America's Past: Folk Art, Modernism, and the Index of American Design* (Washington, D.C.: National Gallery of Art, 2002); Wanda Corn, *The Great American Thing: Modern Art and National Identity, 1915–1935* (Berkeley and Los Angeles: University of California Press, 1999); and Karen Lucic, *Charles Sheeler in Doylestown: American Modernism and the Pennsylvania Tradition* (Allenstown, Pa.: Allentown Art Museum, 1997).

26 The photographic exhibition Simon Rodia's Towers in Watts, by Seymour Rosen, was sponsored by the Contemporary Art Council and the Committee for Simon Rodia's Towers in Watts.

27 Langsner, "Fantasy in Steel, Concrete," 27; E. M., "Miraculous Madness of Simon Rodia," *Apollo* 78 (September 1963): 236; and Trillin, "I Want To Do Something," 80.

28 Paul Laporte, "The Man," in *Simon Rodia's Towers in Watts*, (Los Angeles: Los Angeles County Museum of Art, 1962).

29 Anne Ayres points out that the exhibition at MOMA coined the term "assemblage" and defined the art according to medium and technique. Ayres, "Directions in California Assemblage," in *Forty Years of California Assemblage* (Los Angeles: Wight Art Gallery, University of California, Los Angeles, 1989), 50.

30 The other works reproduced in color include Carolo Carra, *Patriotic Celebration*, 1914; Marcel Duchamp, *Tu m'*, 1918; Kurt Schwitters, *Merz Construction*, 1921; Jean Dubuffet, *Georges Dubuffet in the Garden*, 1956; Robert Motherwell, *In Grey with Parasol*, 1947; Alberto Burri, *Sack Number 5*, 1953; and John Chamberlain, *Esex*, 1960. Because there are four additional black-and-white photographs of the Watts Towers, the catalog devotes more photographs to Rodia's monument than to any other artwork.

31 The catalog quotes Lawrence Alloway: "Junk Culture is city art. Its source is obsolescence, the throwaway material of cities." William C. Seitz, *The Art of Assemblage* (New York: Museum of Modern Art, distributed by Doubleday, 1961), 73.

32 Seitz, *Art of Assemblage*, 72–73.

33 Rodia's practice evokes the ragpicker of Anaïs Nin: "The ragpicker never looked at anything that was whole. His eyes sought the broken, the worn, the faded, the fragmented. A complete object made him sad. What could one do with a complete object? Put it in a museum. Not touch it. But a torn paper, a shoelace without its double, a cup without saucer, that was stirring. They could be transformed, melted into something else. . . . Fragments, completed worlds, rags, detritus, the end of objects, and the beginning of transmutations." Nin, "Ragtime," in *Under a Glass Bell and Other Stories* (Chicago: Swallow Press, 1948), 59.

34 Gordon Wagner describes a coffeehouse in Topanga and Kienholz's Now Gallery

in the mid-1950s. Wagner, interview by Richard Candida Smith, 1989, transcript, Oral History Program, Special Collections, University Library, UCLA. Anne Ayres discusses exhibits held in the merry-go-round building at the Santa Monica pier as well as Kienholz's Now Gallery. Ayres, "Directions in California Assemblage," 55.

35 Donald Factor, "Assemblage," *Artforum* 2 (Summer 1964): 38. See also John Coplans, "Circle of Styles on the West Coast," *Art in America* 52 (June 1964): 37.

36 "Assemblage at the Frontier," *Time,* 15 October 1965, 106.

37 Peter Plagens, *Sunshine Muse: Art on the West Coast, 1945–1970* (1974; Berkeley and Los Angeles: University of California Press, 1999), 74.

38 Plagens recounts other examples in *Sunshine Muse,* 18–24.

39 David Gebhard and Robert Winter, *A Guide to Architecture in Southern California* (Los Angeles: Los Angeles County Museum of Art, 1965), 77.

40 Art Seidenbaum, "Los Angeles Landmarks: The Top Dozen," *Los Angeles Times West,* 19 February 1967, 8–13.

41 Reyner Banham, *Los Angeles: The Architecture of Four Ecologies* (London: Penguin Books, 1971), 129–34.

42 Goldstone and Goldstone, *Los Angeles Watts Towers,* 19. In 1962 Jean Tinguely visited California to exhibit his work at the Everett Ellin Gallery and tour the Watts Towers; Niki de Saint Phalle also visited Watts Towers. See Maurice Tuchman and Carol S. Eliel, *Parallel Visions* (Los Angeles: Los Angeles County Museum of Art, 1992), 205, 207.

43 Editors of *Sunset* magazine and books, *Los Angeles: Portrait of an Extraordinary City* (Menlo Park, Calif.: Lane Magazine and Book, 1968), 192. In 1966 one writer extended his "congratulations to the editors of the new Fodor-Shell Travel Guides, USA. Their regional volume on the Pacific states is the first guide book I've come across that includes what I consider the most fascinating tourist attraction in southern California." Les Barry, "The Legacy of Simon Rodia," *Popular Photography* 59 (October 1966): 34.

44 Trillin, "I Want To Do Something," 83.

45 "Wheels, Funnels and Junk Art," in *Art Treasures in the West,* ed. William Davenport and Sunset editors (Menlo Park, Calif.: Lane Magazine and Book, 1966), singles out the Watts Towers as the chief monument to the tradition of assemblage.

46 Seitz, *Art of Assemblage,* 77.

47 Exceptionally, the exhibition catalog produced by the Los Angeles County Museum of Art on the occasion of Rosen's exhibition of photographs of the Watts Towers contains one photograph with two African American children flying a kite near the towers. Another aerial photograph, entitled *Watts,* clearly meant to give a sense of the locale, situates the spires in the distance, where they rise dramatically above the small houses nearby.

48 Box 30, folder 2, Committee for Simon Rodia's Towers in Watts Archives, Special Collections, University Library, UCLA (cited hereafter as Committee for Towers Archives).

49 Alfred Frankenstein, "Los Angeles's Monument to Non-Conformity," *San Francisco Chronicle,* 23 August 1961, 35.

50 Box 17, folder 12, Committee for Towers Archives. "Neighbors reported," Schrank writes, "that neighborhood teens made sport of throwing rocks and chipping away at the bottles and tiles pressed into the towers' mortar." Schrank, "Picturing the Watts Towers," 374.

51 As Schrank points out, federal funds made available through President Johnson's War on Poverty were granted to the Watts Towers Art Center to establish a Teen Post. Schrank, "Picturing the Watts Towers," 380.

52 "African American Artists of Los Angeles: Noah Purifoy," interview by Karen Anne Mason, 1992, transcript, pp. 58–60, Oral History Program, Special Collections, University Library, UCLA (cited hereafter as Interview with Noah Purifoy). See too Schrank, "Picturing the Watts Towers," 380; and Elizabeth Christine Lopez, "Community Arts Organizations in Los Angeles: A Study of the Social and Public Art Resource Center, Visual Communications and the Watts Towers Art Center" (master's thesis, University of California, Los Angeles, 1995).

53 Interview with Noah Purifoy, p. 141.

54 John Fischer, "The Easy Chair," *Harper's,* December 1969, 33–34.

55 Box 29, folder 5, Committee for Towers Archives.

56 Grant Kester, "Aesthetic Evangelists: Conversion and Empowerment in Contemporary Community Art," *Afterimage,* January 1995, 5–11.

57 Cécile Whiting, "More Than Meets the Eye: Archibald Motley and Debates on Race in Art," *Prospects: An Annual of American Cultural Studies* 26 (2001): 461–62.

58 Proposition 14, passed by voters in 1964, repealed the Rumford Act of 1963, which banned racial discrimination in housing. Michael Dear, "Peopling California," in *Made in California* (see note 11), 58.

59 Gerald Horne, *Fire This Time: The Watts Uprising and the 1960s* (Charlottesville: University Press of Virginia, 1995), 39.

60 Thomas Pynchon, "A Journey into the Mind of Watts," *New York Times Magazine,* 12 June 1966, 78. Richard Candida Smith interprets the Watts Towers as the means by which Rodia, a laborer in an industrial society, could assert his imaginative freedom and claim the right to narrate his own experiences and traditions. Candida Smith, "The Elusive Quest of the Moderns," in *On the Edge of America: California Modernist Art, 1900–1950,* ed. Paul J. Karlstrom (Berkeley and Los Angeles: University of California Press, 1996), 31.

61 Goldstone and Goldstone, *Los Angeles Watts Towers,* 78–84.

62 Schrank, "Picturing the Watts Towers," 376. See also Sheri Bernstein, "The California Home Front, 1940–1960," in *Made in California,* 164–68. Box 30, folder 1, Committee for Towers Archives contains a summary of the State Division of Highways plans, completed in 1963 to construct an east–west freeway route from Southgate to Venice. Apparently three alternative routes were proposed, two of which would have put the freeway four hundred feet south of the Watts Towers.

63 Richard Candida Smith writes that "weddings and baptisms were celebrated under the towers." Candida Smith, "Elusive Quest of the Moderns," 31.

64 Schrank, "Picturing the Watts Towers," 380. Note that Mayor Tom Bradley continued to link the Watts Towers to improvements in the neighborhood in a 5 March 1987 letter to Leon Whiteson, published in *Watts Towers,* 6.

65 Box 30, folders 2 and 5, Committee for Towers Archives.

66 "The festival was founded by Tommy Jacquette, Booker Griffin, Stan Sanders, and others. . . . It was backed by the Westminster Neighborhood Association and John Buggs of the Human Relations Commission." Horne, *Fire This Time*, 202.

67 Jimmie Sherman, "From the Ashes: A Personal Reaction to the Revolt of Watts," in *Watts Summer Festival: Pride and Progress* [brochure], Noah Purifoy Papers, Archives of American Art, Smithsonian Institution, Washington, D.C. (cited hereafter as Purifoy Papers, Smithsonian).

68 Horne, *Fire This Time*, 202.

69 Noah Purifoy, "Art in the Community," p. 6, transcript of a talk prepared for the seminar "A Day with the Experts in the Arts," 26 October 1974, Purifoy Papers, Smithsonian. As Rochelle Nicholas writes, "The socio-cultural facilities that rose from the 1965 revolt were: the Studio Watts Workshop, the Mafundi Institute, Westminister Neighborhood Association, Frederick Douglas Writer's House, the Meeting at the Watts Towers, the Community Arts and Crafts Council and the Coffee House." Nicholas, "The Children and the Watts Towers Arts Center," in *Watts Towers* (see note 1), 49.

70 Kobena Mercer, "African-American Modernism at Mid-Century," in *Art History, Aesthetics, Visual Studies,* ed. Michael Ann Holly and Keith Moxey (Williamstown, Mass.: Sterling and Francine Clark Art Institute, 2002), 43.

71 Horne, *Fire This Time*, 187.

72 Horne, *Fire This Time*, 351–52.

73 The six artists were Frank Anthony, Debbie Brewer, Max Neufeldt, Arthur Secunda, Leon Saulter, and Gordon Wagner. Interview with Noah Purifoy, p. 75. Among the other artists who participated were Davis Mann, Roy Johnson, and Ruth Saturensky. See "Signposts That Point the Way," *Los Angeles Times Home,* 9 October 1966, 30.

74 It is not exactly clear why Purifoy resigned. Apparently he sensed the Committee for Simon Rodia's Towers in Watts wanted a more professionalized art school, which he resisted. See Interview with Noah Purifoy, p. 68. Elsewhere Purifoy says that the committee announced that the money for the Watts Towers Art Center had almost run out and that come March 1966 he would be unemployed. Purifoy, "The Art of Communication as a Creative Act," in *Junk Art: 66 Signs of Neon* (Los Angeles: 66 Signs of Neon, 1966), 4.

75 Ayres, "Directions in California Assemblage," 52. The quotation is from "Los Angeles Art Community: Group Portrait, Edward Kienholz," interview by Lawrence Weschler, 1976, p. 109, Oral History Program, Special Collections, UCLA, 1977.

76 Interview with Noah Purifoy, pp. 77–78.

77 Purifoy, "Art of Communication," 3.

78 Purifoy, "Art of Communication," 4.

79 Purifoy, "Art of Communication," 4, 5.

80 Interview with Noah Purifoy, p. 79.

81 "The two artists at last decided to build with the found objects 'a sculptured garden' around Tower Art Center." Purifoy, "Art of Communication," 4.

82 Horne, *Fire This Time*, 202.

83 Purifoy discusses organizing "Joined for the Arts in Watts," in Interview with Noah Purifoy, p. 74.

84 Purifoy, "Art in the Community," p. 6.

85 "Signposts That Point the Way," *Los Angeles Times Home,* 9 October 1966, 30.

86 Interview with Noah Purifoy, p. 82. Purifoy says further (pp. 91–92): "Debbie [Brewer] participated in *Signs of Neon* by making things and sending them to us. We sold lots of stuff, we'd send the money back and we would make some more stuff. So we always had sixty-six pieces to display, but there were different pieces from time to time because we made sales."

87 As Francis Frascina points out, the October 1965 issue was also the first to be published out of Los Angeles rather than San Francisco. Frascina, *Art, Politics, and Dissent: Aspects of the Art Left in Sixties America* (Manchester: Manchester University Press, 1999), 46.

88 Interview with Noah Purifoy, pp. 96–97.

89 Schrank highlights how Proposition 13 enabled "white homeowners to stop the funding of schools, housing, and public services in inner-city neighborhoods such as Watts." Schrank, "Picturing the Watts Towers," 381. See also Davis, *City of Quartz,* 300–309.

90 The history of the restoration of the Watts Towers is detailed in Goldstone and Goldstone, *Los Angeles Watts Towers,* 99–103.

CHAPTER FIVE

1 Oldenburg's *Autobodys* ran for approximately one hour, while Kaprow's *Self-Service* occurred over four months (June–September 1966) in three different cities: Los Angeles, New York, and Boston.

2 The key text on feminist Performance art in Los Angeles is Moira Roth, ed., *The Amazing Decade: Women and Performance Art in America, 1970–1980* (Los Angeles: Astro Artz, 1983). An important recent analysis of Performance art in Los Angeles is Meiling Cheng, *In Other Los Angeleses: Multicentric Performance Art* (Berkeley and Los Angeles: University of California Press, 2002).

3 Thomas Lawson describes this as a shift "from consumer goods to consumer durables" and attributes it to "a new environment of skilled producers. Venice was a community of small craft businesses, of carpenters, upholsterers, and metal workers." Lawson, introduction to *Claes Oldenburg: Multiples in Retrospect, 1964–1990* (New York: Rizzoli, 1991), 12. In an interview with Barbara Rose, Oldenburg mentions that when he left Los Angeles and moved briefly to Paris, he could not find vinyl as he could in Los Angeles. Claes Oldenburg, Box 1, folder 28, p. 15. Transcripts of interviews with artists, critics, and dealers ca. 1962–1989, Barbara Rose Papers, Special Collections, Getty Research Library, Los Angeles.

4 Copies of the scripts, complete descriptions, and photographs of *Gayety* and *Autobodys* can be found in Michael Kirby, *Happenings: An Illustrated Anthology* (New York: Dutton, 1965).

5 Kirby, *Happenings*, 274.

6 A complete description of the Happening can be found in Kirby, *Happenings*, 272–87.

7 As Gerald Silk observed, "the event became a kind of 'drive-in happening.'" Silk, *Automobile and Culture* (New York: Abrams, 1984), 155.

8 The cars included a white four-door Plymouth sedan, a small black Mercedes, a white Jaguar convertible, a black Buick station wagon, a white Volkswagen pickup truck, a four-door Dauphine, a Willys station wagon, and a black Cadillac convertible. Kirby, *Happenings*, 272–73. Kirby points out that the television images of Kennedy's funeral procession solidified Oldenburg's vision.

9 Oldenburg comments: "By 1964 the Ray Gun, which was a potent theme in the late 1950s, existed only as a kind of souvenir. There were two kinds of Ray Guns: found and made. The found Ray Gun was an accidental configuration of material, or combination of materials, in the form of a right angle or gun, picked up in a particular place and seen as an emblem of that place." Oldenburg, in *Multiples in Retrospect*, 20.

10 Ellen H. Johnson, *Claes Oldenburg* (Baltimore: Penguin Books, 1971), 13.

11 My understanding of parataxis is indebted to Bob Perelman, "Parataxis and Narrative: The New Sentence in Theory and Practice," in *Artifice and Indeterminacy: An Anthology of New Poetics*, ed. Christopher Beach (Tuscaloosa: University of Alabama Press, 1998), 24–48.

12 Kirby, *Happenings*, 266.

13 Michael Kirby, introduction to *Happenings*, 27.

14 Sally Banes, *Greenwich Village 1963: Avant-Garde Performance and the Effervescent Body* (Durham, N.C.: Duke University Press, 1993), 25–26.

15 Sponsored by the Everett Ellin Gallery, Niki de Saint Phalle performed a *tir à volonté* (shot at will, at random) in a parking lot on Sunset Strip in March 1962, shooting a .22 rifle and puncturing packets of paint that released their contents onto her plaster relief *Tir Tableau Sunset Strip*. This was her first shooting event in the United States; others took place in nearby Malibu. See *Niki de Saint Phalle Catalogue Raisonné, 1949–2000* (Lausanne: Éditions Acatos, 2001), 141–42. Robert Whitman performed a Happening entitled *Water* in a two-car garage attached to a private home in Los Angeles in September 1963. Moira Roth describes the history of Performance art in southern California as it began in the 1960s, "Toward a History of California Performance: Part Two," *Arts* 52 (June 1978): 114–23. For a comprehensive history of Performance art in southern California, see Cheng, *In Other Los Angeleses*.

16 Kirby, *Happenings*, 10.

17 Allan Kaprow, *Assemblages, Environments, and Happenings* (New York: Abrams, 1966). Many of Kaprow's essays are reprinted in *Essays on the Blurring of Art and Life: Allan Kaprow*, ed. Jeff Kelley (Berkeley and Los Angeles: University of California Press, 1996).

18 See the exchange about *Self-Service* in Richard Schechner, "Extensions in Time and Space: An Interview with Allan Kaprow," in *Happenings and Other Acts* (see note 13), 221–22.

19 *Self-Service* is described in Michael Agnello, "The Art of Nothing—*Self Service in 3 Cities*," *Los Angeles Free Press*, 19 August 1966, 8, 13. Notes for *Self Service* are in the Allan Kaprow Papers, Special Collections, Getty Research Institute. Kaprow's script for *Self-Service* is reprinted as "*Self-Service*: A Happening," in *Happenings and Other Acts*, 230–34.

20 Robert E. Haywood, "Critique of Instrumental Labor: Meyer Schapiro's and Allan Kaprow's Theory of Avant-Garde Art," in *Experiments in the Everyday: Allan Kaprow and Robert Watts: Events, Objects, Documents*, ed. Benjamin H. D. Buchloh and Judith F. Rodenbeck (New York: Miriam and Ira D. Wallach Art Gallery, Columbia University, 1999), 43.

21 Philip Ursprung, "Monuments on the Move: Allan Kaprow's *Fluids* (1967) and the Urban Landscape of Los Angeles," in *Paisagem e Arte*, ed. Heliana Angotti Salgueiro (São Paulo: I Coloquio Internacional de Historia da Arte, 2000), 178.

22 Ursprung, "Monuments on the Move," 179.

23 Allan Kaprow's opening statement in *Allan Kaprow* (Pasadena: Pasadena Art Museum, 1967), 6. Earlier in the year he had labeled museums fuddy-duddy and obsolete and asserted that they enshrined objects as *nature morte*: "Death in the Museum," *Arts* 41 (February 1967): 40–41. In another article published a few years earlier Kaprow had also called art museums obsolete: "Should the Artist Become a Man of the World?" *Art News* 63 (October 1964): 58.

24 Schechner, "Extensions in Time and Space," 221–29.

25 Allan Kaprow Papers.

26 Michelle Deziel identifies this Happening as *Grand Gala Smoke Extravaganza*, and explains that it "is the eighth event in a series of twelve performances entitled Atmospheres presented by Chicago in various California settings." Deziel, "Chronology," in *Radical Past: Contemporary Art and Music in Pasadena, 1960–1974*, by Jay Belloli et al. (Pasadena: Art Center College of Design / Armory Center for the Arts, 1999), 136.

27 For an excellent history of the Pasadena Art Museum, see *Radical Past*.

28 Judy Chicago, *Through the Flower: My Struggle as a Woman Artist* (New York: Doubleday, 1975), 40.

29 In her autobiography Chicago put a slightly different feminist spin on her masquerade: "Though I had intended it as a satiric comment on the macho ads of my male artist friends in Los Angeles, it obviously embodied the fact that in the early seventies women artists 'came out fighting.'" Chicago, *Through the Flower*, 61. For an excellent discussion of Chicago's early career, see Laura Meyer, "From Finish Fetish to Feminism: Judy Chicago's Dinner Party in California Art History," in *Sexual Politics: Judy Chicago's Dinner Party in Feminist Art History*, ed. Amelia Jones (Los Angeles: UCLA at the Armand Hammer Museum of Art and Cultural Center; Berkeley and Los Angeles: University of California Press, 1996), 48–61.

30 Chicago explains that the women located the owners of the abandoned house who agreed to let the group use it for three months. Chicago, *Through the Flower*, 104.

31 Reyner Banham, *Los Angeles: The Architecture of Four Ecologies* (London: Penguin Books, 1971), 21. Banham's comprehensive perspective set him apart from traditional architectural and urban historians who had focused on monuments or

planning histories (see Anthony Vidler's preface to the latest edition of Banham's work [Berkeley and Los Angeles: University of California Press, 2000], xix).

32 Banham, *Architecture of Four Ecologies*, 36.

33 Betty Liddick, "Emergence of the Feminist-Artist," *Los Angeles Times*, 17 January 1972, pt. 4, p. 1.

34 Betty Liddick reported that the LACWA found "only 29 women of 713 artists in group shows over 10 years at the museum and only one woman in 53 one-artist shows." Liddick, "Emergence," pt. 4, p. 7.

35 Meyer, "Finish Fetish to Feminism," 55.

36 The desire to mark difference from the mainstream art world by geographical distance was recognized at the time. Nancy Marmer, for instance, commented: "Deliberately situated away from the La Cienega gallery area, Womanspace identifies itself as an alternative to the commercial gallery structure." Marmer, "Womanspace, a Creative Battle for Equality in the Art World," *Art News* 72 (Summer 1973): 38.

37 Chicago describes the renovations to the house on Mariposa Street. See Chicago, *Through the Flower*, 104–6. So does Miriam Schapiro in "The Education of Women as Artists: Project Womanhouse," *Art Journal* 31 (Spring 1972): 268–70.

38 Judy Chicago and Miriam Schapiro, introduction to *Womanhouse* catalog, designed by Sheila de Bretteville, typed on the IBM Composer at the California Institute of the Arts, and printed by Wood and Jones, 1972, n.p.

39 Liddick, "Emergence," pt. 4, p. 1.

40 Schapiro, "Education of Women as Artists," 268. Chicago describes the Feminist Art Program's performance workshop as well as the individual pieces performed at Womanhouse in *Through the Flower*, 118–32. Laura Meyer, relying on comments by students about the curriculum at Fresno and Cal Arts, summarizes consciousness-raising techniques in the Performance art produced. See Meyer, "Finish Fetish to Feminism," 56.

41 Chicago, *Through the Flower*, 118.

42 Chicago, *Through the Flower*, 208. The entire script of Faith Wilding's *Waiting* is also printed in *Through the Flower*, 213–17.

43 Chicago, *Through the Flower*, 209.

44 In the film by Johanna Demetrakas (see below in the text), the woman who plays Sparkyl reveals that she is a dyke and takes pleasure in performing this stereotypically feminine role.

45 Chicago, *Through the Flower*, 117.

46 Sandra Burton, "Bad-Dream House," *Time*, 10 March 1972, 77.

47 Chicago describes the performances and audience's reaction in *Through the Flower*, 123–24. See also Moira Roth, "Autobiography, Theater, Mysticism and Politics: Women's Performance Art in Southern California," in *Performance Anthology: Source Book for a Decade of California Performance Art*, ed. Carl E. Loeffler and Darlene Tong (San Francisco: Contemporary Arts Press, 1980), 463–89; Roth, *Amazing Decade*; Roth, "California Performance: Part Two," 114–23; Cheng, *In Other Los Angeleses*, 36–38.

48 The antagonism between the feminist communities in Los Angeles and New York was exposed in various articles published in the 1970s. See, for instance, Cindy Nemser, "The Women Artists' Movement," *Feminist Art Journal* 2 (Winter 1973–1974): 8–10; and Martha Rosler, "The Private and the Public: Feminist Art in California," *Artforum* 16 (September 1977): 66–74.

49 Moira Roth describes an overnight excursion to the desert organized by Chicago in which her Fresno students assumed various positions suggestive of earth goddesses while colored smoke played over their nude and painted bodies. Roth, "California Performance: Part Two," 117.

50 Roth, *Amazing Decade,* 112.

51 I am thinking here of several key Performance pieces: Leslie Labowitz, *Record Companies Drag Their Feet,* 1977, performed at 8301 Sunset Boulevard, Los Angeles; and Feminist Art Workers, *Traffic in Women: A Feminist Vehicle,* 1978, performed en route between Los Angeles and Las Vegas. Both performances are discussed in Roth, *Amazing Decade.*

CONCLUSION

1 Kevin Lynch, *The Image of the City,* Publications of the Joint Center for Urban Studies (Cambridge, Mass.: Technology Press, 1960), v.

2 Lynch, *Image of the City,* 40.

3 Loss of spatial orientation would become in future years a sign of the postmodern city, for which Los Angeles emerged as a paradigm. Commenting on John Portman's Bonaventura Hotel in downtown Los Angeles, Fredric Jameson wrote, "this latest mutation in space—postmodern hyperspace—has finally succeeded in transcending the capacities of the human body to locate itself, to organize its immediate surroundings perceptually, and cognitively to map its position in a mappable external world." Jameson, "Postmodernism, or The Cultural Logic of Late Capitalism," *New Left Review* 146 (July–August 1984): 83.

4 Reyner Banham, *Los Angeles: The Architecture of Four Ecologies* (London: Penguin Books, 1971), 201.

5 Anthony Vidler, preface to the latest edition of Banham's work (Berkeley and Los Angeles: University of California Press, 2000), xxxii.

6 Jeff Kelley describes the group dynamics of *Fluids* in detail in *Childsplay: The Art of Allan Kaprow* (Berkeley and Los Angeles: University of California Press, 2004), 120–27.

7 Rem Koolhaas, *Delirious New York: A Retroactive Manifesto for Manhattan* (New York: Oxford University Press, 1978).

8 Brochure, *Ruckus L.A. Meets (Dom-Ino Effect): Lincoln Tobier and Rirkrit Tiravanija,* Los Angeles County Museum of Art, 3 June–29 August 1999.

Illustrations

Index

Abstract Expressionism, 30, 32, 42–43, 63, 81, 212n16, 219nn45,51

Abstraction: and Diebenkorn's work, 81; and Foulkes's work, 30, 32, 43–44; and Hockney's work, 133, 135–36; and Noland's work, 30, 32, 135, 207; and Pollock's work, 30–31, 219n45; and Rodia's work, 149; and Weston's work, 25–26, 27, 29

Adams, Ansel: artistic practice and techniques of, 34–36; and association with Group f/64, 34; and association with Sierra Club, 35–36, 218n44; city/nature relation in work by, 23–24, 33, 36, 40, 59; and collaboration with Beaumont Newhall, 33, 34, 217n29; and collaboration with Nancy Newhall, 26–27, 35–36, 39; color photography by, 27, 29; commercialization of work by, 27, 41–42, 43; critical reception of work by, 41–42, 217–18n30; Death Valley photographed by, 26–27, 29, plate 3; exhibitions of work by, 27, 29, 33–35, 215n3, 218n36; modernism in work of, 34–35, 42, 78; natural conservation promoted by, 35–36, 39–40; San Francisco photographed by, 36, 37; Sierra Nevada photographed by, 21, 37, 39; sublime in work of, 23–24, 33–35, 37, 40–42, 47; Tetons photographed by, 35; Yosemite National Park photographed by, 27, 28, 41

Advertising: and artist-stud identity, 66, 66–68, 68–70, 71, 189; and color photography, 134–35. *See also* Commercial motifs

Aerial views, 37, 38, 39, 40, 41, 59, 76, 81, 89, 93, 97, 177

Aerospace industry, 12, 58, 188, 214n23

Angel's Flight, 147, 147, 148

Anger, Kenneth, 11, 15, 84–86, 87, 90

Ankrum gallery (Los Angeles), 6

Antin, Eleanor, 99

Antonioni, Michelangelo, 29

Appleyard, Donald, 102, 225n50

Arbus, Diane, 74

Architecture, in Los Angeles, 7, 11; and Banham's writing, 80, 81, 83, 111, 113, 152–53, 192, 205–6, 238n31; and Chicago's work, 187, 188; and dingbats, 96, 224nn38,44; Gebhard and Winter's guide to, 152; Gill's designs for, 95, 152; Greene's designs for, 152; and Hockney's art, 109, 111, 113, 133–34, 153, 206; and Jameson's writing, 240n3; and Kaprow's art, 183–86; and Marshall's writing, 96, 224nn38,44; Neutra's designs for, 81, 95, 152, 224n44; and Portman's work, 240n3; and romance of urban blight, 147–48; and Ruscha's art, 63, 80, 81, 83, 153; and Ruscha's photography, 92–93, 95–97, 153, 224n38; Schindler's designs for, 95, 152, 224n44; and Shulman's photography, 96, 134, 224n38, 229n61; and skyscrapers, 12, 13, 89, 179, 205; Soriano's designs for, 152; and Tobier's work, 209–10; and Watts Towers, 141, 146, 152–53; and Womanhouse, 193, 200; Wright's designs for, 152

Arman (Armand Fernandez), 10, 151

Artforum, 3, 6, 11, 63, 66–67, 71, 73, 92, 151, 163, 188

Art in America, 6–7

Art News, 6, 7

Artweek, 57

Assemblage art: and confluence with Pop
art, 9; critical reception of, 151–52; and
Foulkes's work, 43–44; and Junk Art, 158–
63; Los Angeles exhibits of, 151; New York
exhibit of, 150, 151, 232n29; San Francisco
exhibit of, 151; and Watts Towers, 141, 142,
150–53, 158, 160, 163, 208, 233n45; and
Watts uprising, 10, 160, 208
Assemblage art, by individual artists: Arman,
151; Burri, 232n30; Carra, 232n30; Cham-
berlain, 232n30; Conner, 151; Cornell, 150,
151; Dubuffet, 232n30; Duchamp, 150,
151, 232n30; Kienholz, 151, 152, 158–59;
Motherwell, 232n30; Picasso, 150; Purifoy,
10, 158–64, 187, 208; Rauschenberg, 150;
Raysse, 151; Saint Phalle, 151; Schwitters,
150, 151, 232n30; Tinguely, 151; Wagner, 151
Automobiles: and Anger's filmmaking, 11,
15, 84–86, 87, 90; artistic media and tech-
niques derived from, 83–87, 90–91; and
Chicago's art, 15, 84, 85, 86, 87, 90, 171,
188; customized, 67, 80, 83–84, 86; and
Kaprow's art, 179; and Kienholz's art, 15,
86–87, 87, 171; and Oldenburg's art, 169,
170–73, 171–73, 175–77, 237n8, plate 19;
and sexuality, 84–87, 91; subculture of, 67,
83–84, 87, 92; and vanity license plates,
172–73, 175; and Wolfe's writing, 83. See
also Driving; Freeways; Gas stations;
Parking lots
Avedon, Richard, 49

Banham, Reyner, *Los Angeles: The Architecture
of Four Ecologies* by: architecture described
in, 80, 82, 111, 113, 152–53, 192, 205–6,
238n31; compatibility of high and low in,
82; critical reception of, 113, 227nn16–17;
driving described in, 80, 82, 206; ecologi-
cal concept in, 205; freeways described in,
88; Hockney's art as cover illustration for,
111, *112*, 113, 114, 133–34, 136, 192, 227n17;
Ruscha's work compared to, 80, 81; Rus-
cha's work included in, 113; Vidler's preface
to, 205–6, 227n16; Watts Towers included
in, 141, 152–53
Baudelaire, Charles, 206
Beach Boys, 50, 115, 220n70
Beaches and beach culture, 48–50, 124, 208,
220n67
Beaton, Cecil, 117–19, plate 12
Beat subculture, 6
Bell, Larry, 64, 65
Bengston, Billy Al: artistic practice and tech-

niques of, 84, 87; cars and motorcycles
thematized in work of, 15, 67, 68, 69, 83–
84, 171; critical reception of work by, 84;
exhibitions of work by, 68, 69–70, 83–84;
as Pop artist, 8, 212n16; stud identity of,
68, 69–70
Benjamin, Walter, 206
Berkeley hills, 23
Bierstadt, Albert, 21, 30, 44–45, 44, 78–79,
80, 220n55
Black Arts Movement, 158, 164
Blum, Irving, 6
Body: and beach culture, 49–50, 208; and
Happenings, 208; and Performance art,
208. *See also* Nudes
Brewer, Debbie, 155, 161, 235n73, 236n86
Bunker Hill, 147–48, 206

Cal Arts. *See* California Institute of the Arts
California Institute of the Arts (Los Angeles),
72, 177, 188, 190, 192, 193, 195, 239n40
California School of Fine Arts (San Francisco),
43
Car culture. *See* Automobiles
Celmins, Vija: artistic practice and techniques
of, 50–54, 87–88; critical reception of work
by, 57; drawings of lunar surface by, 54, 57;
drawings of the ocean by, 21, 48, 51–59, 52,
208; freeways depicted by, 15, 87–88, 88;
and interview with Susan Larsen, 52–53;
mechanical reproduction thematized by,
24, 59, 137; motorist's perspective in work
of, 87–88, 90; photography incorporated
in work of, 21, 50–53, 58–59, 137; Pop art
exemplified in work of, 8; sublime in work
of, 24, 48–49, 58, 59, 137; works by: *Free-
way*, 87–88, 88; *Moon Surface (Luna 9)
#2*, 54, 57, 57; *Pink Pearl Eraser*, 53–54, 53;
Untitled (Big Sea #1), 53; *Untitled (Big Sea
#2)*, 52, 52, 54
Chandler, Raymond, 148, 206
Cheval, Ferdinand, 150
Chevrons, 66–67, 81
Chicago, Judy: architecture thematized by,
187, 188; artistic practice and techniques
of, 84, 87, 187, 188; and association with
Schapiro, 188, 190, 192–95, 208; auto body
school attended by, 84, 188; automobiles
thematized by, 15, 84, 85, 86, 87, 90–91,
171, 188; and feminism, 9, 10, 169, 188–
90, 192–95, 200–201, 208, 238n29;
Happenings staged by, 10, 169, 186–88,
201, 238n26; and Performance art, 10, 169,

92, 96, 101, 103; design principles in, 72–74, 76, 78, 109, 137, 207; exhibitions of, 71, 91–92, 224n38; fire thematized in, 76–78, 80, 89, 105, 188, 207; gas stations depicted in, 63, 73, 73–74, 77–78, 80, 92, 93, 95, 99–101, *101*, 103, plate 8, 206; Hockney's art compared to, 109, 110, 136–37; Hollywood depicted in, 71–72, 74, 80, 81; Los Angeles depicted in, 14, 63, 71–74, *73*, 76–81, 88–93, *94*, 95–97, *97*, *98*, 99–105, *101*, 109, 153, 209; motorist's perspective in, 10, 15, 63, 88–89, 90–91, 92–93, 137, 142, 206; nature depicted in, 78–80, 81; parking lots depicted in, 92, 93, 95, 97, 98, 101, 103, 177; photographic, 14, 15, 63, 73, *73*, 92–93, *94*, 95–97, *97*, *98*, 99–105, *101*, 177, 207, 209; as Pop artist, 8, 9, 212n16; standardization thematized in, 63, 77–78, 90, 92, 96, 104, 137; Sunset Strip depicted in, 92–93, *94*, 95, 97, 101, 103–4; urban theorists' reference to, 14, 102–4; by title: *The Burning Gas Station*, 78; *Damage*, 77; *Every Building on the Sunset Strip*, 92–93, *94*, 95, 97, 101, 103–4, 207, 209; *Hollywood*, 71–72, 74, 80, 81, plate 7; *Large Trademark with Eight Spotlights*, 71–74, plate 6; *Los Angeles County Museum of Art on Fire*, 76–78, 188, 206, plate 9; *Norms, La Cienega on Fire*, 77, 78, 206, 207, plate 10; *Some Los Angeles Apartments*, 92, 93, 95–96, 97, 101, 103; *Standard Station, Amarillo, Texas*, 73, 206, plate 8; *Thirtyfour Parking Lots in Los Angeles*, 92, 93, 95, 97, *98*, 101, 103, 177; *Twentysix Gasoline Stations*, 73, *73*, 92, 93, 95, 99–101, *101*, 103; *Various Small Fires and Milk*, 77

Saint Phalle, Niki de, 10, 151, 153, 233n42, 237n15
San Francisco: Adams's depiction of, 36, *37*; contrasted with Los Angeles, 7, 8, 9; exposition in, 33; Golden Gate Park in, 48; Thiebaud's depiction of, 78–79
Santa Monica, 80, 81, 233n34
Saturday Evening Post, 8, 9
Schapiro, Miriam, 188, 190, 192–95, 208
Schindler, R. M., 95, 152, 224n44
Schrag, Peter, 12
Schrank, Sarah, 149, 231n20, 234nn50–51, 236n89
Schwitters, Kurt, 150, 232n30
Scott Brown, Denise, 14, 103–4
Seattle Art Museum, 58

Secunda, Arthur, 235n73
Seewerker, Joe, 145
Seldis, Henry J., 42, 149
Selz, Peter, 45, 46
Sexuality: and Anger's filmmaking, 84–86; and artist-stud identity, 65–68, 71; and beach culture, 50, 208; and car culture, 84–87, 91; and Chicago's art, 84; and Hockney's art, 109–10, 114–24, 126–30, 132; and Isherwood's writing, 126–27; and Kienholz's art, 86–87, 91, 171; and Rechy's writing, 115, 121, 127–28; and sexploitation films, 67, 221n3; and swimming pools, 124
Sheets, Millard, 147, *147*
Sherman, Jimmie, 157
Shippey, Lee, 145
Shulman, Julius, 96, 134, 224n38, 229n61
Sierra Club, 35–36, 218n44
Sierra Nevada, 21, 37, 39, 41
Signage, 15, 63, 65–66, 71–72, 74, 76, 91–92, 103–4, 151, 206–7, 223n33
Smog, 12, 13, 37, 38, 40, 48, 74, 76, 80
Soja, Edward, 13, 14
Soriano, Raphael, 152
Southworth, Douglas, 103–4
Spaulding, Jonathan, 27, 218n44
Standardization: and Happenings, 177, 207; and Ruscha's work, 63, 77–78, 90, 92, 96, 104, 137
Starr, Kevin, 146
Stein, Sally, 35, 134, 215n3, 217n28
Stereographs, 45–47, 58, 217n26, 220n60
Still, Clyfford, 43, 45, 47, 219nn47,51
Stoller, Ezra, 96, 224nn40–41
David Stuart gallery (Los Angeles), 8
Studs, artistic, 63–71, 92, 188, 189, 208
Sublime: and Abstract Expressionism, 42–43, 219n51; and commercialization, 41–42, 43; and landscape art, 21, 23–24, 33, 43–47, 58, 59, 78, 215n4; and landscape photography, 21, 23–24, 26, 33–36, 37, 40–42, 47, 58; and marine art, 24, 48, 58, 59; and mechanical reproduction, 43, 137; and modernization, 23–24, 33, 40–41; and tourism, 21, 30, 41, 46–47, 58–59, 215n4; and Updike's writing, 219n51
Sublime, in works by individual artists: Adams, 23–24, 33–36, 37, 40–42, 47; Bierstadt, 21, 44, 78–79; Celmins, 24, 48, 58, 59, 137; Foulkes, 24, 30, 32, 45–47, 58, 59, 137; Hill, 21; Keith, 21; Kline, 219n51; Moran, 21; Motherwell, 219n51; Newman, 42, 219n51;

216n9; Death Valley photographed by, 21, 24–27, *25, 29,* 216n7; exhibitions of work by, 215n3; formalism in work of, 25, 216n7; modernism in work of, 34; sublime in work of, 26, 29, 41, 219n51

Westways magazine, 26, 40, 41, 47

Whitman, Robert, 178, 237n15

Wilder, Nicholas, 113, 121

Wilding, Faith, 194, *198,* 198–99, 239n42

Wiley, William, 152

Winter, Robert, 152

Wolfe, Tom, 83

Womanhouse, 9, 10, 169, 192–95, *193, 196–98, 197*–201

Womanspace, 193, 239n36

Yavno, Max, 49, *49,* 208

Yosemite National Park, 27, *28,* 41, 79

Zabriskie Point (Antonioni), 29

Designer: Sandy Drooker
Compositor: Integrated Composition Systems
Indexer: Andrew Joron
Text: 10/15 Scala
Display: Folio
Printer and Binder: Friesens Corporation